Playing Darts with a Rembrandt

Playing Darts with a Rembrandt

Public and Private Rights in Cultural Treasures

Joseph L. Sax

with a Foreword by Lee Bollinger

Ann Arbor

THE UNIVERSITY OF MICHIGAN PRESS

2002 2001 2000 1999 4 3 2 1

A CIP catalog record for this book is available from the British Library.

Library of Congress Cataloging-in-Publication Data

Sax, Joseph L.
 Playing darts with a Rembrandt : public and private rights in
cultural treasures / Joseph L. Sax.
 p. cm.
 Includes bibliographical references and index.
 ISBN 0-472-11044-6 (alk. paper)
 1. Cultural property—Protection—Law and legislation.
2. Cultural property. I. Title.
K3791.S29 1999
344'.094—dc21 99-26356
 CIP

for Elli

Contents

Illustrations

Foreword

A few years ago, while attending a conference at Mesa Verde, Colorado, on international protection of cultural treasures, I was invited to accompany one of the participants on a side trip that turned out to be more revealing about the subject of the conference than nearly anything said at it. I tagged along with an archaeologist employed by the Bureau of Land Management to help investigate an illegal destruction of an ancient Anasazi site in the sagebrush plateau just north of Mesa Verde. The ruin was not of the scale or the magnificence of those within the National Monument, but it was of sufficient archaeological value to have been professionally documented several decades earlier. Oddly, a local and otherwise respectable farmer was the alleged villain. He had—so the story went—become annoyed because pothunters had been digging in the ruins for pottery, which fetched fine prices in Santa Fe and Los Angeles. Believing he might as well reap the benefits for himself, he turned to a not uncommon and considerably more efficient method of recovery than a shovel—he took a bulldozer to the site. Using the edge of the blade, the farmer carefully scraped away the hillside ruin, using the rubble as he went to make a rising platform for the machine. The technique demands close attention to the first signs of the fragile pottery, which must be removed by hand once it becomes visible. The technique also thoroughly destroys the site. Astonishingly, at least to me, the farmer was entirely within his legal rights in doing what he did—that is, so long as the Anasazi ruin was on his land, which nearly all of it was. His mistake was to go just over his property line, by twenty feet, and onto land owned by the U.S. Government. That made it a crime under the Archaeological Resources Protection Act of 1979, for which he faced prosecution.

The shocking vulnerability of archaeological sites on private land turns out not to be an isolated problem in the larger scheme of preserving our cultural heritage. It is, sadly, illustrative. What other parts of the nation's cultural patrimony are bereft of public protections against the whims of private ownership? A great many things, indeed: Art (e.g., Rembrandts), the papers of presidents and Supreme Court justices (and other public officials), architecturally significant buildings (other than those designated

as historic sites), just about all things collectible, and the bones of dinosaurs. What should be done about it? That, it turns out, is a very complicated question and the subject of Joe Sax's compelling book *Playing Darts with a Rembrandt.*

No one could undertake this novel and important assignment better than Professor Sax. He is one of the intellectual founders of the environmental movement in the United States. Laws bear his name, and anyone who has any interest in environmental issues, of nearly any variety, will eventually encounter his numerous and classic writings. Professor Sax is the leading scholar of water law in this country. He has written enormously influential works on the complex and important area of Constitutional law known as the "Takings Clause." In the past decade, his attention has shifted increasingly to the subject of cultural heritage and the public interest in preserving it. He has written the best book we have about the purposes and functions of our National Parks (*Mountains Without Handrails*) and seminal articles about the justifications for public lands, about the origins of the idea of preservation (locating them in the imaginative writings of the eighteenth century French cleric, The Abbe Gregoire), and about the protections other societies afford public monuments (such as Stonehenge). The range of his work is impressive, but it is its subtle and intertwining influence on our understandings of our natural and cultural environment that is truly remarkable. *Playing Darts with a Rembrandt* is the fruitful culmination of this intellectual labor.

A major theme winding its way through all of Professor Sax's work is the importance for any society of the vitality of its collective or public values. He knows the difference between hiking on land owned by someone else and generously "made available" to the public, and hiking on land owned by no one and secured for all people. In an era in which the free market system has achieved undreamed of successes and vanquished all competing economic models, simultaneously casting shadows of suspicion on public ownership (generating calls for sale of public lands, for divestiture of public collections of art, and for ending public endowments for support of culture), Joe Sax has been a wise voice for moderation and for recognition of the benefits of pursuing multiple approaches to controlling the fate of things. As well as anyone, Professor Sax articulates the widespread yearning in society for a collective as well as an individual identity, and for the universal sense that some things just can't be "owned," not by anyone, not even by all of us.

The problem, however, is not as easy as that. As Professor Sax tells us, the system of private property works not only to insure the freedom of indi-

viduals to possess and to indulge their wishes through rights of ownership, including establishing dominion over objects of great cultural and historical significance. It also can be an effective means of preserving those objects and materials for public benefit. A quick survey of the holdings in the country's greatest museums—a great proportion of which derive from private collections and charitable impulses—is sufficient to dispel the misconception that we would be better off, as a community, if we simply left all collecting and preserving to public officials and institutions. The conjoining of self-interest with the public interest—the Invisible Hand—is a brilliant insight of capitalism applicable to culture as well as to ordinary goods and services. And tax laws also help prime the pump of charitable instincts and complete the cycle of creation to public access.

The focus of this book, however, is not only on how the systems of law and private property might be reconfigured but also, and even more importantly, on the elusive area between them where norms of behavior are created and flourish. Joe Sax urges us to recognize that at the core of these competing but sometimes mutually beneficial systems there must be an idea, a norm, that whoever we are, whether private owners or public officials, we are also stewards and trustees with higher obligations than simply the fulfillment of our own preferences. This is a mentality with many roots: a respect for genius and a sense that its creations transcend ownership; a caring about our history and a wish that everyone share in its meaning; and a general presumption that time is our best editor and curator.

Therefore, the problem for us ultimately is not one merely of law or of private property rights, as important as those are, but rather is a daunting mix of these together with some general understandings and working principles about how our cultural heritage should be sculpted from the present as it turns into the past. To do that we must grasp the limits and potential distortions of law and of our natural impulses. The issues are fascinating and classless: from pothunters to presidents. It is telling about human nature, for example, to find presidents, Supreme Court justices, and academic administrators trying to control public access to documents and facts because otherwise there might be "misunderstandings" or "misinterpretations" or lead to unflattering and disrespectful attitudes in the public. The desire to be thought well of by others (and by oneself) is as powerful and universal a human motivation as the wish to exert absolute control over all we "own." On the other hand, the idea of letting the sun shine in can be overvalued too. Open meetings and freedom of information acts seem to grow at an exponential pace. Yet they may discourage documentation and

deprive us of a historical record with which to understand how we arrived at where we are. All this and more makes the intellectual explorations of this book an adventure.

Finally, it should be said, this book bears all the admirable markings of Joe Sax's best writings: A text unmarred by jargon; a mind always present at the surface of the writing; an ability to find the essence in a detail; and a wit forever alert for the humorous in human affairs, of which fortunately there is plenty in this solemn area of creating a cultural heritage.

LEE BOLLINGER

Acknowledgments

In gathering the diverse materials that made this book possible, I relied on the generous help of many people, in particular officials at libraries, archives, and museums, as well as biographers and scholars who shared with me some of the little-known conventions that prevail within their specialties. I have tried to be diligent in acknowledging their specific contributions in the notes. A 1989 article by Avis Berman in *Connoisseur*, "Art Destroyed," particularly inspired me to think about some of the problems discussed here.

I am grateful to the University of Michigan which permitted me to deliver earlier versions of several chapters as the William W. Cook Lectures on American Institutions in 1997, under the title "Who Owns History." I began drafting the book during a sabbatical leave granted by the University of California. My dear friend and former colleague, Terry Sandalow, and my current colleague Jan Vetter kindly read versions of my manuscript and offered me extremely helpful comments, as did Jeff and Amber Rosen. Elli Sax suffered through each draft of each chapter.

I was especially fortunate to have three superlative research assistants while I was working on this book: Cymie Payne, Freya McCamant, and Stacey Simon. Hail to them!

Introduction

Just after the Last Emperor of China stepped down in 1912, the
royal family was preparing to sell the entire palace art collections
and took steps to open negotiations with J. P. Morgan, who was
told he might get it for $4 million. As one journalist delicately put
it, "the idea of one man's buying the entire national patrimony of
one of the world's great civilizations seems absurd, not to mention
impious. Yet both China scholars and Morgan experts agree that
the deal could have been consummated."
—*New Yorker*, March 18, 1966

This is a book about a very odd matter: Many of the greatest artifacts of our
civilization can be owned by anyone who has the money to buy them, or
the luck to find them, and their owners can then treat the objects however
their fancy or their eccentricity dictates. A standard text puts it bluntly
enough: "[A]n eccentric American collector who, for a Saturday evening's
amusement, invited his friends to play darts using his Rembrandt portrait
as the target would neither violate any public law nor be subject to any pri-
vate restraint."[1] This is just a version of a familiar image, to be sure—a par-
tygoer throwing his champagne glass into the fire, or the plutocrat lighting
his cigar with a ten-dollar bill. The difference is that not all objects are the
same.[2]

The fate of most things is of interest only to its owner. Some objects,
however, regardless of who owns them, are important to a larger commu-
nity: a fossil of great scientific importance, historic documents, the papers
of a renowned writer, or a work of artistic genius. In an essay entitled "The
Cultural Biography of Things," Igor Kopytoff wrote: "To us, a biography
of a painting by Renoir that ends up in an incinerator is as tragic, in its way,
as the biography of a person who ends up murdered. That is obvious. But
there are other events in the biography of objects that convey more subtle
meanings. What of a Renoir ending up in a private and inaccessible collec-
tion? Of one lying neglected in a museum basement? . . . The cultural
responses to such biographical details reveal a tangled mass of aesthetic,

historical, and even political judgments, and of convictions and values that shape our attitude to objects labeled 'art.'"[3]

Why do we feel diminished when something that does not belong to us is destroyed, or taken away? If ownership imports the full right to enjoyment, it would seem that loss of something we don't own could not deprive us (the nonowners) of anything. If the proprietor of a great painting keeps it locked in his house and then destroys it, how have the rest of us been harmed? In one respect we haven't. Yet there would undoubtedly be a profound sense of loss. Perhaps the most obvious reason is that the community has a long view, and likely the work would not have been locked away forever; so an opportunity has been lost. In addition, to destroy a work of art is an act of vandalism, a triumph of ignorance over genius; so there is the rending of a value that is important to the community, a symbolic loss that can occur to others even though the thing destroyed was not theirs. The same feeling of violation arises from a symbolic book-burning, no less if the perpetrators burn their own books.

Perhaps most importantly, destruction of a major work of art or science is felt as a loss to the community because it undermines pursuit of a common agenda. In the contemporary world, most societies prize scientific endeavor, as they do artistic and scholarly achievement.[4] Any loss of objects—a rare fossil, or an archive of unique historical material—containing ideas and information upon which those activities build and rely affects the community at large because it impedes that common agenda. Insofar as such work relies on the accomplishments of those who went before, genius and the work it produces are a sort of common pool in which we all have an interest.[5] Newton's famous epigram, "If I have seen further, it is by standing on the shoulders of giants," is the classic expression of the point.[6] To the extent that artifacts contain ideas, knowledge, and inspiration upon which further work relies, and insofar as they are amenable to private ownership and disposal (as they generally are), the fate of such objects concerns the community as a whole.

The implications of this proposition for art, where private ownership is pervasive, have often been noted. In a little book entitled *What Is a Masterpiece?* Sir Kenneth Clark observes, "Whatever he may mean to us, there is no doubt about what Caravaggio meant to his immediate successors. . . . No painter has had so many men of genius among his followers; . . . we may safely say that neither Rubens, nor Velázquez nor Rembrandt would have been the same without him."[7] Earlier in the same work, Clark, speaking of Donatello's *Annunciation* in Sta Croce, says the painter had "seen a Greek

stele, either an original of the fifth century or a Hellenistic replica. . . . He determined to bring it back to life, and in doing so reveals two of the characteristics of a masterpiece: a confluence of memories and emotions forming a single idea, and a power of recreating traditional forms so that they become expressive of the artist's own epoch and yet keep a relationship with the past."[8] Clark, paraphrasing the English architect William Lethaby, concludes a masterpiece is not one man thick, but many men thick.[9]

Recognition that our accumulated knowledge and insight should be viewed as elements of a common heritage undergirds the basic premise of intellectual-property rules that govern patents and copyrights. As one judge put it in a recent case, "[C]reativity is impossible without a rich public domain. . . . Culture, like science and technology, grows by accretion, each new creator building on the works of those who came before."[10] In copyright, the law is parsimonious in granting property rights. Even those who have thought up an idea, or discovered a fact, frequently get no right of property in that accomplishment—despite their efforts—because the law so greatly values open access to the basic building blocks of human achievement. The core idea is not so much to reward the labor of authors or inventors, but to promote our common enterprise: in the words of the Constitution, "to promote the Progress of Science and useful Arts."[11] "Every book in literature, science and art, borrows, and must necessarily borrow, and use much which was well known and used before."[12]

These propositions are well known and widely accepted. Paradoxically, however, where no labor or creativity whatever is expended, where one is simply the proprietor of an artifact that embodies data or ideas of the sort that the courts have so jealously reserved to the public, no notion of a public realm exists. On the contrary, such objects—and, in consequence, what is contained within them—are left entirely to the dominion of the owner, with no duty to make them accessible to an interested public, or otherwise to protect them. That is because the dominant modern idea of ownership is understood as entitlement to possess an object as an exclusively private thing, devoid of any public element except a broad obligation to avoid doing conventional harm such as trespassing on the territory of others. Ownership of physical things, in contrast to intellectual property, is conceived of as private and unqualified. As we shall soon see in one setting after another, that conception enables owners to exercise unbridled power over owned objects, whatever the loss to science, scholarship, or art.

Such power was wryly portrayed in A. S. Byatt's fictional work *Posses-*

sion, which describes the scholarly pursuit of privately held literary papers. In the novel, a woman named Beatrice Nest owns and controls a journal that another researcher named Mortimer Cropper wants to see:

> If there was one matter in the world he regretted more than any other, it was Beatrice's lien, her semi-exclusive propriety in Ellen Ash's Journal. Had he himself and his team of research assistants had proper access to that work, much of it would be in print by now, annotated, indexed, ready to be cross-referenced and to illuminate his own findings. But Beatrice, with what he saw as a truly English costiveness and dilettantism, continued to sit . . . like the obstructive sheep in *Alice Through the Looking-Glass* . . . as some kind of guardian octopus, an ocean Fafnir, curled torpidly round her hoard, putting up opaque screens of ink or watery smoke to obscure her whereabouts.[13]

Despite the powers that owners have to do as they wish with the objects they own, public attitudes reflect an understanding that is in advance of legal theory. A sense that the fate of some objects is momentous for the community at large has certainly insinuated itself into the public consciousness. Who today does not think that we all have a stake in the preservation of Stonehenge, or of Leonardo's notebooks? I have elsewhere explored the evolution of these notions of a public heritage.[14] They generated a reaction to the iconoclasm of the French Revolution in the name of preserving a national patrimony, and they led to today's historic-preservation laws.

The emergence of a concept of cultural heritage has produced some limited formal protection for important objects and structures. Historic buildings are protected by law in most places today. Similarly, antiquities are treated as inherently public property in many countries. Even art gets some special protection, usually in the name of protecting artists' "moral rights" in their work, though concern for protecting the art itself is often not far beneath the surface. Yet there are no consistent patterns. Objects of scientific interest—archaeological and paleontological relics—are subject to an extraordinary diversity of rules and are provided remarkably little protection in this country when they are found on private lands. In most places you *can* throw darts at your Rembrandt. The rules governing papers and manuscripts left by renowned people are also a jumble, often at the whim of capricious heirs, sometimes determined by the law of copyright, at others by the policies of museums or libraries where they have been deposited. In these settings, conventional proprietary ideas still dominate.

While J. P. Morgan never did buy China's national patrimony, it is chastening to recall some of the things that have been and are today privately

owned. Stonehenge itself was part of a private country estate until the early part of the twentieth century. The great Assyrian sculptures that now grace the Metropolitan Museum not many decades ago belonged to an English lady named Charlotte Guest, the wife of a rich industrialist. Lady Charlotte "never seems to have doubted her right to own them. . . . [I]t apparently didn't bother her that there were two major collections of Assyrian antiquities in England, one for her and the other [in the British Museum] for everyone else."[15] The contemporary billionaire Bill Gates in 1994 paid $30 million for a notebook of scientific drawings and writings of Leonardo da Vinci, known as the Codex Hammer, whose former owner, the oil magnate Armand Hammer, had vaingloriously named it after himself.[16] Happily, Gates soon announced his intention to make the document available to the public, prompting one museum trustee to say, "I'm delighted that the manuscript . . . will not . . . get hidden away in a vault in Switzerland,"[17] a telling comment on both the power and practices of many who own world-class treasures.

Some of the most surprising things turn out to be ordinary private property, and subject to an owner's whims. Not until Richard Nixon left the White House and sought to maintain dominion over his papers and tapes did the general public have any idea that presidential papers had always been considered the personal property of a departing president. Every president for many years, beginning with George Washington, had boxed up his papers as he left office and taken them home with him. Though Congress finally changed the law, and papers that reflect the official business of a presidency now belong to the people of the United States, the law only became effective for the future, and no doubt many newspaper readers were surprised to learn—as negotiations proceeded in the later 1990s—that the Nixon estate was likely to get millions of dollars for the former president's papers and tapes.

Privatization of culturally important objects takes varied forms. Perhaps the most notorious case of recent decades involved the Dead Sea Scrolls, which were turned over to a small group of scholars who proceeded to treat them as their personal property for over forty years, neither publishing certain important parts of the texts, nor allowing access to any but those within their own circle. It took an intensive public campaign, which finally attracted national press attention, to break the monopoly and open the scrolls to the scholarly community. Other arrangements for exclusive control of scientific and historical materials by favored researchers, though less common than they once were, still exist and constitute one of the dimly lit alleys of the scholarly world.

The very idea that things can be both private goods serving private needs, and at the same time objects in which the public has a crucial stake, can be difficult to grasp. It is much easier to imagine one or the other extreme: either a fully private object, like a wristwatch, or a fully collective one, such as a king's crown. We even recognize a handful of very special things that are entirely incapable of ownership: infants and children, fetal gestational services, blood, human organs, and sexual services.[18] Some other things were thought inappropriate for ownership and remained as commons open to all, such as the sea and the seashore, and navigable waters.[19] Less common are things where ownership is recognized but carries affirmative obligations on behalf of the public. In ancient Roman society, there were temples on private lands, where the landowners bore some duty of care, protection, and preservation. In medieval times the owners of buildings built against city walls had a duty of maintenance that was a sort of public obligation. Laws in Colonial America sometimes required property to be used in ways that benefited the community and not just the owner: a rule against leaving land uncultivated, for example, when it could be made productive.[20] In the nineteenth century, ordinary ownership rights in some businesses were restricted because they were "affected with a public interest."[21]

Perhaps the closest analogy to the issues with which the following pages will deal, however, though it comes from a very esoteric setting, is the way that religious relics were treated in the Middle Ages.[22] Because relics were actual parts of saints, they were thought to have great power to ward off harm to those who possessed them. For that reason individuals very much wanted to own relics, and wealthy individuals did so. However, because relics were not mere objects, but part and parcel of the person of the saint, their fate was believed to affect all the faithful. The religious community had a stake in their protection and preservation. Though private ownership and use was recognized, owners were required to protect the relics in various ways—for example, by safeguarding them from danger (not displaying them when going into battle), or by depositing them in a secure and appropriately dignified place such as a religious institution. The importance of the relic to the community thus generated a special kind of qualified, obligation-bearing ownership. Remote as it seems from our world, medieval society's engagement with the status of relics suggests how powerfully one can affect the larger community simply by virtue of ownership of an object if the object is considered important enough to the community. Awareness of that history may help to explain why it is intuitively unsettling to us to imagine a collector destroying his Rembrandt, though it is his private possession.

While one might expect that owners could be depended on to protect precious artifacts, that is unfortunately not always the case. Important objects have always been at risk even from their owners, not only in the old days of spiritual or revolutionary iconoclasm, but in our own times as well. As we shall soon see, the Rockefellers demolished Diego Rivera's politically unwelcome mural, and Winston Churchill's widow burned a portrait by a distinguished artist because it portrayed her husband unfavorably. In his memoir, *Diary of an Art Dealer,* the Paris gallery owner René Gimpel had this to say about two well-known collectors: "Madame Arthur Meyer assured me that two days before his death, feeling his end near, Groult [a leading French collector of the nineteenth century] wished to burn his collection. Though it sounds incredible, one can believe it if one has known that capricious and irascible man who loved his collection like a mistress." Gimpel also described "A shot-up Toulouse-Lautrec. It's precisely that. George Bernheim, who showed it to me, told me that the last owner amused himself by shooting at it with a gun."[23] In 1991 the press reported that a millionaire named Ryoei Saito who had bought two of the world's most expensive paintings ever sold at auction, Renoir's *Au Moulin de la Galette* and van Gogh's *Portrait of Dr. Gachet,* for a total of $160 million (and kept them locked in a Tokyo warehouse), said he wanted the works to be cremated with him, presumably to avoid inheritance taxes. In the ensuing public uproar, Saito said it was a joke, taken seriously only because "westerners have a jealousy complex . . . because Japanese buying power is able to acquire so much important art."[24]

Some years ago, Julius Held, a professor of art history, delivered a lecture entirely devoted to a report on the alteration, mutilation, and destruction of works of art, mostly by their owners. A typical example "concerned a picture of a man portrayed with two children on one canvas, his wife on another. When his wife died, he married again, but his second wife objected to these portraits. The portrait of the first wife was put away in a smokehouse. . . . On the portrait of the husband, the second wife had the children of the first marriage painted over so that they disappeared. When the second wife died, the picture came to the oldest son of the first marriage who had himself and his younger sister restored. Later the picture came into the possession of a son of the second wife who promptly covered them up again. . . . [T]he picture had become a veritable battlefield for a family feud."[25]

Held also describes numerous instances in which paintings—including works by Sassetta, Rogier van der Weyden, Jan van Eyck, and Jackson Pollock—were cut up and the fragments sold separately in order to increase

economic value. Another author reported that in the 1920s a collector cut Toulouse-Lautrec's *La Baraque de la Goulue* into ten pieces because he "hoped he could sell the parts more easily than he could the ensemble."[26] As Held put it, "[P]eople who carve up old works of art quite often proceed like real-life butchers who cut from a carcass those parts that can be sold and then throw out the rest as useless and without value."[27]

At a culturally less serious level, television celebrity Phil Donahue spent $6.8 million to buy the property next door to his Connecticut estate and then razed it to the ground, obliterating what was said to be the most architecturally significant building in the town.[28] Another television actor, Mr. T, bought an estate in Chicago's priciest suburb, Lake Forest, and promptly cut down more than a hundred old oak trees because he thought it would help his allergies. He apparently failed to notice that there were also trees on his next-door neighbor's property.[29]

Inaccessibility is an even more pervasive problem than destruction or mutilation. Some of the greatest objects in the world, even though they were in a sense public, have been secreted away. The Chinese imperial art collection remained unseen by the public for a thousand years, until the last emperor was evicted from the Forbidden City.[30] A book of magnificent miniatures commissioned by the builder of the Taj Mahal, known as the *Chronicle of the King of the World*, was acquired by George III of England. It was then sequestered in the Royal Library of Windsor Castle. Only a few of its images had ever been published, and the book itself was rarely exhibited, never with more than two pages shown. It was fully opened to the public for the first time in 1997, 358 years after its creation.[31] A similar fate befell the great Catesby watercolors of North American fauna and flora, closed in the British royal archives since 1768, unpublished and seldom seen even by scholars.[32]

During the booming 1980s some of the greatest impressionist paintings in the world were purchased by corporations and haven't been seen since.[33] The Art Loss Register in London reported that banks held one thousand paintings worth $1.4 billion, as a result of loan defaults. Though some of the most notable works were reportedly privately resold in the United States in the late 1990s, the buyers were not revealed, and the whereabouts of the art remains unknown.[34] For decades the fabulous Barnes collection of French impressionist art was held in a mansion outside Philadelphia, open only to the select few whom the capricious Dr. Barnes wished to favor, while both reproduction and travel was prohibited. Many of its masterpieces had never been seen by scholars, critics, or artists, to say nothing of the interested public. In 1998, the *New York Times* reported that

the only surviving version of a tenth century text containing Archimedes' two most celebrated scientific works—"Method of Mechanical Theorems" and "On Floating Bodies"—had been held inaccessible to scientists for nearly a century by the French family that owned them, while important new techniques for studying such texts have been developed.

There may at first seem an obvious response to any effort to define a category of special objects whose owners should bear special burdens: the public can always acquire what it needs through its power of eminent domain, compensate the owner, and then devote those objects to public use, enjoyment, or edification, as it wishes. The issues raised in the following pages, however, are intended to pose a prior question: what powers and responsibilities should be recognized in the owners of such objects in the first instance? Should the purchaser of a work of art be entitled to destroy, mutilate, or conceal it, as against the claim of the artist or the public? Should a single scholar or biographer be entitled to exclusive access for decades to the papers of a great writer or scientist? May an heir destroy historically valuable papers to protect the reputation of a progenitor? Such issues are not resolved by recognition of the government's power to expropriate such interests if they exist. They are questions about the relation that *ought* to exist between certain things that are physically capable of exclusive ownership and control and the larger community's claim upon them.

In addition there is a question of autonomy. Ownership is not just an economic interest, though it is usually treated that way today. It can also involve a claim of entitlement to decide the fate of an object. That is commonly the position of officials who burn papers they consider unworthy or inappropriate for history's delectation, or protective heirs and executors who want to keep unpublished letters and other sensitive material out of the hands of biographers. Whatever the merits of such claims, they are not resolved by exercise of the power of eminent domain.

The thesis of this book is quite straightforward. It is simply this: There are many owned objects in which a larger community has a legitimate stake because they embody ideas, or scientific and historic information, of importance. For the most part it is neither practical nor appropriate that these things be publicly owned. It is, for example, highly desirable that private individuals collect art according to their own tastes and have the enjoyment of it. The conjunction of legitimate private and public interests, however, suggest that ordinary, unqualified notions of ownership are not satisfactory for such objects. I propose that several qualifications are gener-

ally appropriate: a bar on destruction and on denial of access, and at least a presumption against grants of exclusive access to particular individuals (such as authorized biographers or favored researchers). Of course, no such general prescription can resolve the numerous and fascinating variant situations that arise: Must the heir of a famous writer make her love letters public? How long should material—admittedly of historic interest—be embargoed in library collections? Should libraries distinguish between scholars and journalists in granting access? Is an archaeologist who wants exclusive rights to a site different from an authorized biographer who wants exclusive control of his subject's papers? Should anyone be allowed to destroy a great artist's work? The artist himself? The artist's heirs or executors? A patron, who is displeased with a commissioned work?

These are some of the issues raised in the pages that follow. I cannot promise to provide satisfactory answers to every dilemma, or even to offer an adequate analysis of all the rich and varied issues presented. But it is time to open debate upon them.

Part 1. The Fine Arts

On the one hand, is a work of art, once lawfully acquired, to be looked upon as a piece of personal property, which may be disposed of as the owner sees fit? On the other hand, does a work of art possess an intangible value not involved in a transfer of ownership? . . . May art be scrapped? Conceivably a definitive answer both legal and artistic to this moot question will one day be given.

New York Times, February 14, 1934

The Diego Rivera Mural

When a man, hereinafter referred to as a patron, contracts with an artist to paint a picture for him, of whatever nature it may be, the contract is essentially a service contract, and when the picture has been painted and delivered to the patron and paid for by him, the artist has no right whatever left in it.
—*Yardley v. Houghton Mifflin Co.,*
U.S. District Court, New York
25 F. Supp. 361, 364 (1938)

When the authorities admitted that the removal had involved the destruction of the mural, indignant protests were showered on the Rockefellers for "cultural vandalism" and "art murder."
—*Newsweek,* February 24, 1934

In 1932, Diego Rivera, who was even then a world-renowned artist, was engaged to paint a mural on the wall opposite the main entrance of the newly built RCA building in Rockefeller Center in Manhattan. It was a curious arrangement. To embellish the headquarters of a family enterprise that was the very embodiment of American capitalism, the Rockefellers hired an outspoken communist whose murals famously illustrated his political views. The stated theme was "Man at the Crossroads Looking with Uncertainty but with Hope and High Vision to the Choosing of a Course Leading to a New and Better Future," but the family certainly knew they weren't going to get some conventional progress and uplift painting.

Rivera had previously ridiculed the Rockefellers in one of his murals in Mexico, which showed John D. along with Henry Ford and J. P. Morgan enjoying a dinner of gold coins and ticker tape. Rivera said "The owners of the building were perfectly familiar with my personality as artist and man and with my ideas and revolutionary history. There was absolutely nothing that might have led them to expect from me anything but my honest opinions honestly expressed. . . . There was not in advance, nor could there have

been, the slightest doubts as to what I proposed to paint and how I proposed to paint it."[1]

That was a fair assessment. Nelson's mother, Abbey Aldrich Rockefeller, had organized a one-man show by Rivera at the Museum of Modern Art the previous year, featuring a fresco entitled *Frozen Assets*, which depicted depression-era scenes of New York, characteristic of Rivera's politically themed work. And Nelson had just been embroiled in a controversy over a mural exhibition at the museum, where the contributions of left-wing artists had scandalized the trustees, and nearly cost the Modern some of its richest supporters.

Nonetheless, the Rockefeller authorities watched and admired the work as the mural grew, even as it showed May Day marchers in Moscow, gas masks and death rays, and venereal-disease germs hovering over dissolute society ladies. It wasn't until the press started running headlines trumpeting the fact that John D. Rockefeller Jr. was paying the bill for communist propaganda that his son, Nelson, began to get nervous. Rivera, on the other hand, always the provocateur, loved the controversy. It was probably at this point that he got the idea of including a portrait of Lenin in the lower-right-hand part of the fresco and that things began to fall apart.

Nelson first wrote Rivera a letter in which he said:

> [Y]esterday viewing the progress of your thrilling mural I noticed that
> . . . you had included a portrait of Lenin. The piece is beautifully painted
> but it seems to me that his portrait appearing in this mural might very
> seriously offend a great many people. . . . As much as I dislike to do so,
> I am afraid we must ask you to substitute the face of some unknown man
> where Lenin's face now appears.[2]

Predictably, Rivera refused. On May 4, 1933, he sent the directors of Rockefeller Center a letter in which he said that "rather than mutilate the conception, I should prefer the physical destruction of the conception in its entirety."[3] The Rockefellers then paid Rivera the agreed-upon price in full, twenty-one thousand dollars, and on May 9 ordered him to cease work, which he did. As Rivera described it, "[B]efore I left the building an hour later, the carpenters had already covered the mural, as though they feared that the entire city, with its banks and stock exchanges, its great buildings and millionaire residences, would be destroyed utterly by the mere presence of an image of Vladimir Illyitch."[4]

The mural was boarded up. Nelson finally suggested that it be removed and donated to the Museum of Modern Art, but the museum trustees refused the offer, presumably because the Rivera fresco promised more controversy than they wanted or were willing to handle.[5] Though the

technique is delicate and difficult, frescoes can be moved. A critic at the time noted gifts by Cornelius Vanderbilt and J. P. Morgan, the first a fresco by Pollaiuolo, and the other a wall from a villa near Pompeii. Each had been removed and brought to the Metropolitan Museum "under conditions physically identical with those at Rockefeller Center," and (he pointedly added) "preserved for the world by men who had a sense of the importance of art."[6] In February 1934, with no warning or notice of any kind, workmen were brought in, and they hacked the mural to bits, totally destroying it. Moreover, in an announcement that was certain to inflame the critics, a spokesman for the Rockefellers disingenuously announced that some structural changes about to be made in the great hall of the building necessitated the removal of the fresco, noting that a new information booth was being built. He also explained that the work was done at midnight only in order to avoid inconvenience to the building's tenants.

Once it was learned that the fresco had been destroyed, indignant protests were showered on the Rockefellers for "art murder." Artists' groups protested and threatened boycotts, mass protest meetings were held, and the press covered the controversy extensively. Rivera himself cabled a message from Mexico City saying "in destroying my paintings the Rockefellers have committed an act of cultural vandalism. There ought to be, there will yet be, a justice that prevents the assassination of human creation as of human character."[7]

The New York controversy generated a chain reaction. Nor was Rivera the only artist affected: David Siqueiros's outdoor mural in the Plaza Art Center in Los Angeles was whitewashed over;[8] and Ben Shahn's mural for Riker's Island Penitentiary in New York, depicting prison life past and present, was suppressed as well on the ground that it would incite antisocial attitudes among the prisoners.[9] Religious groups protested Rivera's famous industrial murals in the Detroit Institute of Arts. Catholic students resolved to boycott the Detroit museum until the frescoes, which they said were an affront to patriotism and religion, were either removed or altered.[10] A Detroit priest named Higgins said that he detected in a panel called the *The Vaccination*—in which a child, held by a nurse, is inoculated by a white-coated physician, with some animals grouped beneath the child—an attempt to satirize the Holy Family, and that religious Detroiters were violently upset. Rivera wrote of the furor:

> If my Detroit frescoes are destroyed, I shall be profoundly distressed, as
> I put into them a year of my life and the best of my talent; but tomorrow
> I shall be busy making others, for I am not merely an "artist," but a man
> performing his biological function of producing paintings, just as a tree

produces flowers and fruit, nor mourns their loss each year, knowing
that the next season it shall blossom and bear fruit again.[11]

Happily, the Detroit murals remain in place, and they are the most cele-
brated and popular holding of the museum. The same year of the contro-
versy in Detroit, 1934, shots were fired through the windows of Rivera's res-
idence in San Angelo, Mexico, because Nazi sympathizers were incensed at
his unfavorable treatment of Adolf Hitler in the Rockefeller Center
murals. And in November 1936, the management of the Hotel Reforma in
Mexico City defaced Rivera's satirical frescoes in the hotel's Hall of Diplo-
mats, erasing a depiction of countries Rivera considered under dictatorial
rule, and retouching his drawing of a Mexican army officer dancing with an
Indian woman, on the ground that they were "offensive."[12]

The Rockefellers were entirely within their legal rights at the time in
destroying the mural, as even their harshest critics, and Rivera himself,
acknowledged. In the event, Rivera was, as he had promised, an artistic
version of the annual fruit-bearing tree. Following the Rockefeller Center
fiasco, he announced that he would reproduce the mural in the Palace of
Fine Arts in Mexico City,[13] and he did so.[14] In addition, it turns out that
Rivera used the twenty-one thousand dollars the Rockefellers paid him to
repaint the mural as twenty-one portable fresco panels that he donated to
the New Workers School in Manhattan. Fourteen of the panels were sub-
sequently destroyed by a fire, but the remaining seven are apparently in the
hands of collectors.[15]

The Rockefeller/Rivera incident is important because it illustrates that the
impulse to destroy is not always—perhaps is not usually—simply an act of
proprietary caprice or unreason, like that of the collector who amused
himself by using his Toulouse-Lautrec for target practice. On the con-
trary, the central history of art destruction is a history of iconoclasm, and
there is nothing more logical than iconoclasm. Through much of history,
art was produced to convey a message. Pope Nicholas V, speaking of
church architecture, said: "To create solid and stable convictions in the
minds of the uncultured mass there must be something that appeals to the
eye. . . . Noble edifices combining taste and beauty with imposing propor-
tions would immensely conduce to the exaltation of the Chair of St.
Peter."[16] A great deal of art was equally purposeful, if rather less elevated
in its intention. Piero de Cosimo's *Passage of the Red Sea* depicts the vic-
tory of Pope Sixtus IV's troops over the army of Alphonso, the prince of
Calabria. Botticelli's *Punishment of the Children of Korah* alludes to the

suppression of a rebellious archbishop who had called Sixtus IV a son of a devil. And Michelangelo's design for Pope Julius's tomb included symbolic figures of all the provinces subdued by the pope. "The galleries of the world are full of works of art which set forth the supreme merits of a Borgia [or] a Medici."[17]

With this background, it is not surprising that destruction or rejection of art has been a conventional way of communicating that the message is not, or is no longer, welcome. A pope's wish to obliterate a work that is seen as promoting impiety is perfectly understandable. Pope Paul ordered that the nudities of Michelangelo's *Last Judgment* be covered up;[18] and Pope Gregory XIII reportedly decided to efface Michelangelo's frescoes in the Sistine Chapel because he thought them immoral. He is said to have had a recurrent nightmare in which he saw naked people bathing, who came to torment and persecute him. Fortunately, he died before his plan to destroy the frescoes could be carried out.[19] The Inquisition required Veronese to paint out several figures on one of his paintings, said to be sinful because it gave an imaginary interpretation to the Bible. Paintings have regularly been mutilated on the charge of indecency, including works by El Greco, Titian, and Boucher. Nor need one rely on the distant past for examples. Less than twenty years ago a case was reported of a sculpture commissioned for a church, and later mutilated by an angry parish priest and parishioners who found the work blasphemous.[20] Even today we would not rest easily if the greatest artists of the twentieth century had made magnificent paintings depicting Hitler or Eichmann. We are fortunate that the statues of Stalin demolished all over Eastern Europe in recent years were aesthetic mediocrities.

Where the would-be iconoclast is also the patron who has commissioned the work, as in the Rockefeller/Rivera affair, the logic of riddance is even stronger, for there is the added risk that the artist's unwanted message will not only be disseminated, but will be associated with the patron. The point is important, for it shows that in some instances owners can have interests that go beyond mere proprietorship. In a subsequent chapter, we shall see a variety of related instances, as where heirs or executors seek to embargo or destroy historically significant papers that they consider an invasion of family privacy. What makes such cases problematic is not that the owner has no credible interest, but that there is another legitimate interest in tension with it.

The Rockefellers can only be seen as "cultural vandals" if the community's interest in preserving the achievements of genius is understood to be more important than its role in advancing the political or religious agenda

of the owner or patron. That is exactly the position the modern world has taken; it is, ironically, the great triumph of the decontextualization of art, and it is directly traceable to the reaction against the iconoclasm of the French Revolution. In 1794, when the worst excesses of the Terror had not yet subsided, the revolutionary government asked one of its members, the abbé Henri Grégoire, to respond to a proposal to destroy, as unrevolutionary, all Latin inscriptions on monuments. Grégoire produced a series of reports, *On the Destruction Brought About by Vandalism,* that addressed for the first time the fundamental question why the artifacts that had been made to glorify the ancien régime and its institutions should not be demolished.

Grégoire summed up his view in a sentence, and in doing so, set forth modernity's answer to the arguments against "tainted" art. "Because the pyramids of Egypt had been built by tyranny and for tyranny," he asked, "ought these monuments of antiquity to be demolished"?[21] Grégoire set out to show that no patron's motives, however base, can demean the genius of the artist; that the human spirit can never be made the mere instrument of tyranny or any other cause. This was in fact a more revolutionary concept of art than that of the iconoclasts. The ability to see art as the work of the individual genius behind the aristocrat or clerical patron was a radically modern and secular idea. It conceived the achievements of genius through its history as a fundamental element of the community's human capital, and as a part of its collective entitlement.

The power of that idea is so great that to modern sensibilities the claims of iconoclasts only seem pathetic: John D. Rockefeller Jr.'s statement that Rivera's "picture was obscene and . . . an offense to good taste";[22] or the 1950s effort of the mayor of Jirgu Jiu in Communist Romania to pull down Constantin Brancusi's great sculpture, *Endless Column,* because it was "subversive."[23] (The Brancusi was not destroyed, though time and weather damaged it greatly in the ensuing decades.) And of course there was Hitler's 1937 exhibition of "degenerate art," perhaps the most detestable such affair ever,[24] and uniquely egregious because it rested on the identity of the artist, rather than the content of the work, the assumption being that inferior people could not, by definition, produce anything but degenerate work.

Grégoire's view that the genius overrides the message has triumphed, and today it seems obvious that our collective interest in perpetuating art should trump an owner's sensibilities. It is Rivera's ironic destiny that we esteem his art even as we are indifferent, or even hostile, to the political impulses that energized it and the political message it seeks to convey.

Who now cares about the political ideas of Gustave Courbet or the fact that some of his work was meant to embody those ideas? Today his name brings to mind works like his great canvas at the Musée d'Orsay in Paris, *The Burial at Ornans.* In his time, though, he was considered a dangerous radical, and he held a position in the Paris Commune. It was said that his unpopularity was so unanimous and so persistent that none of his pictures passed unmolested for a period of thirty years.[25] His 1863 work, *Return from the Conference,* showing a procession of drunken priests, was purchased by a devout Catholic who bought the painting for the express purpose of destroying it and promptly did so. Ironically, Courbet himself as a member of the Commune ordered the Vendôme Column destroyed because, he said, it honored war and conquest. When the Commune fell, he was jailed for his own act of cultural vandalism and ordered to pay the costs of the monument.[26]

Today Courbet is accepted as one of the leading precursors of modern art and is recognized as a great creator and innovator, but he has not ceased to be controversial, though now the focus is sex rather than politics. In October 1995, *ARTnews* magazine carried a story that began with the following sentence: "Almost 130 years after its completion, Gustave Courbet's painting, *The Origins of the World,* continues to shock. The canvas, which depicts a naked woman from below the waist, her legs provocatively parted, went on display in late June at the Musée d'Orsay, behind glass and with its own private guard. Originally commissioned by . . . [a] diplomat from the Ottoman Empire . . . [m]ore than a century passed before *The Origins* was shown in public."[27]

In what may be the supreme paradox of the genre, the vandal was the art critic and tireless advocate for preservation of medieval art, John Ruskin. Ruskin, a great champion of J. M. W. Turner's art, was named by Turner—who left all his unsold work to the British nation—as one of his executors. In going through Turner's studio, Ruskin discovered a portfolio of sexually explicit drawings. He was horrified: "[M]y hero used to leave his house in Chelsea and go down to Wapping . . . and live there . . . with sailors' women, painting them in every posture of abandonment. . . . What was I to do? . . . For weeks I was in doubt . . . till suddenly it flashed on me that perhaps I had been selected as the one man capable of coming in this matter to a great decision. I took the hundreds of scrofulous sketches and paintings and burnt them where they were, burnt all of them."[28] Fortunately, several of Turner's sketchbooks of erotic drawings escaped Ruskin's attention, and they are now in the British Museum. In a less well known incident, following the death of Degas, the artist's brother destroyed

dozens of his copper plates depicting sexual scenes. Art remains long after its (unwanted) message, or the owner's political or sexual sensibilities, have been relegated to history's attic. That is the essence of the case against a patron's claimed entitlement to destroy. A question that remains is whether some remedy short of destruction is available to accommodate the legitimate concerns of mortified executors like Ruskin, or trapped patrons like Nelson Rockefeller.

Reflecting on the unpalatable alternatives of destruction of the art or an obligation on the Rockefellers to display Rivera's communist propaganda—whatever its aesthetic value—the *New York Times* editorial page had this to say in 1934:

> While there is no reason why a mural painter should not be a propagandist, there is also no good reason for employing him unless you want his propaganda. Not really wanting it, the Rockefellers were ill-advised in assigning a wall to Rivera. On the other hand, he knew, or ought to have known, that he could not give them what they expected. . . . Through the entire history of art, well-decorated walls have come from an agreement between the artist and the patron. They consider together how the room is to be used, what it means, and then find appropriate subject-matter. . . . Merely assigning a wall and letting the artist do as he likes . . . is good neither for the wall nor for the artist.[29]

Once having made the mistake of engaging Rivera for the task at hand, the proper remedy, the editorial writers thought, would have been to invite the artist "to come in and take his fresco away."[30] That is precisely the solution adopted by a California law enacted a half-century after the Rivera affair, and discussed in the next chapter. It provides that if a work of art incorporated into a building—such as a mural—can be removed without causing mutilation or destruction of the work, the owner must notify the artist (or an arts organization) and provide an opportunity to remove the art, at his own expense, within a specified time.[31] The California law makes an important distinction: the owner has no right to destroy a work, even one he has commissioned, but neither is he obliged to display it, or even to keep it. The law rests on a legislative finding that "there is a public interest in preserving the integrity of cultural and artistic creations."

Artists' Rights and Public Rights

The Legislature hereby finds and declares that there is a public
interest in preserving the integrity of cultural and artistic creations.
—California Civil Code, sec. 989

Droit Moral

Until quite recently, it would have been correct to assume a total absence of
restriction on owners like the Rockefellers in the Rivera affair, at least in
America. While some countries, most notably France, took the view that
artists have an interest in works they create, known as *droit moral,* the
United States had resolutely rejected even that limitation on owner auton-
omy.[1] In effect, *droit moral* recognizes that artists retain a continuing inter-
est in their work, even after it has been sold, sufficient to protect the
integrity of the artist's reputation. The idea is that to deform artists' work is
to present them to the public as creators of something that is not their own
and in that way to subject them to criticism for work they have not done.

Droit moral is a fascinating concept because it describes a limit on the
rights that can be acquired by an owner in significant works of art, a central
concern of this book. The California legislator who sponsored the first such
American law had this to say:

> To pass this law, you have to get legislators to rethink their concepts of
> property rights. Property rights are very strong in this country, and that's
> why we have not adopted art preservation laws. You have to begin to
> think that maybe the person who created the work of art, and perhaps
> also the public, retain some interest in seeing that the art is not
> destroyed, not mutilated, and not changed without the artist's consent.
> The first impression that members of the judiciary committee had when
> we presented our bill was "it's mine, I can do anything with it, I can cut
> it up if it's too big for a certain place that I want to put it."[2]

Just as an owned object may embody something more than its material
components (like a fossil that contains the key to important scientific

knowledge), under *droit moral* a work of art is conceived not only as an object, but as a constituent part of the artist's personality. It embodies the artist's reputation, something that cannot be subject to proprietary dominion. That is the theory under which the owner of the work is prohibited from mutilating or modifying it.

But *droit moral* is a right that belongs to the artist. It is not meant to protect society's stake in the art, in the sense that an historic-preservation ordinance protects important buildings. "One of the primary misconceptions regarding the French concept of *droit moral* is the assumption that it seeks to protect the public interest by preserving artworks for posterity."[3] It does not. It is rather a sort of defamation law, under which protection of the objects that are the artist's work is necessary to protect the artist's reputation. Despite the conceptual distinction, writers have frequently and correctly observed that protection of an artist's moral right can simultaneously implement the society's interest in protecting its artistic heritage.[4]

Because in theory only reputation is at stake, the usual duration of such laws is the artist's lifetime, or a specified period thereafter during which (presumably) harm to the artist's reputation would cause economic loss to the artist's estate.[5] Similarly, it is not surprising that in some places *droit moral* law protect works of art against distortion, but not against destruction.[6] New York is even more restrictive; it only protects against alteration of a work if the object is thereafter displayed in a public place, the idea being that only *display* of the mutilated work would harm the artist's reputation.[7] That is apparently the French law as well: private mutilation of a painting only "ripens" as a legal wrong when the work is exposed to others, as when the owner decides to sell it.[8]

When American legislatures finally began to consider enacting *droit moral* statutes, the question understandably arose, why not protect the art, which is the ultimate product of the artist's work and the gift of creative genius to the world, as well as his or her reputation? While most jurisdictions followed the European model, a few states departed from the narrow reputational view of moral rights. Some granted to the artist a right against destruction, as well as mutilation or alteration. In this respect the law was protecting the art, even if only in the name of protecting the artist. Two jurisdictions, California and Massachusetts (which borrowed California's approach), also used the occasion to graft onto the law a dramatically new element that expressly recognizes society's interest in protection of the art. Those states alone expressly command private owners to preserve works of art for the benefit of the public.[9]

The California Art Preservation Act

Before turning to the California experience, it should be noted that a sub-sequent federal statute may preempt much state *droit moral* law, though the specifics still await definitive judicial interpretation.[10] For our purposes, however, the history of the first state legislative effort to protect a public stake in works of art remains significant, regardless of whether particular provisions of the statute are still enforceable.

California enacted two separate bills three years apart.[11] The first is a relatively conventional *droit moral* law, giving artists a right against anyone who intentionally defaces, mutilates, alters, or destroys their work that is "fine art." The law defines fine art as work of "recognized quality," and provides that courts are to "rely on the opinions of artists, art dealers, collectors of fine art, curators of art museums, and other persons involved with the creation or marketing of fine art."[12] Immediately after enactment of this first bill, the *Los Angeles Times* published an editorial saying:

> We think it's a good law. But we think there ought to be another one that would protect the works of dead artists. The name of S[imon] Rodia comes to mind [Rodia had died without a will, and without heirs]. The immigrant Italian tilesetter spent 33 years building the Watts Towers on 107th Street as a gift to the city that had made him welcome. In return, the city did little or nothing to protect his folk masterpiece from the ravages of weather and time.[13]

Watts Towers were extraordinary structures of minarets and turrets built in a poor neighborhood of Los Angeles over a period of decades out of wires, concrete, seashells, crockery, and bits of glass. In the late 1950s, more than thirty years after Rodia began his work, the city decided to tear the tower down, saying it violated building codes. Supporters mounted a lengthy and ultimately successful battle to save the landmark, which is now a national historic monument that attracts more than fifty thousand people a year from all over the world.[14] State senator Alan Sieroty, who sponsored the earlier California bill, wrote to the author of the editorial, saying, "I agree with you that the law should be expanded to provide *the public* with the right to protect recognized artworks such as the Watts Towers when the artist is dead or the artist's heirs are not interested in seeking protection. I have introduced a separate bill (SB 1191) to accomplish this. . . . [W]e will begin the hearing process on this bill next year."[15]

The proposal to which Sieroty referred was enacted in 1982, and it allowed established nonprofit arts organizations to go to court for an

injunction against defacement, mutilation, alteration, or destruction of a
work of fine art as defined in the earlier law, a provision reflecting the fact
that Rodia had died before the city decided to raze his tower. The new law
embodied a fundamental departure from the principle of artist protection
that underlies *droit moral,*[16] instead finding "that there is a public interest in
preserving the integrity of cultural and artistic creations."[17] The California
law is very unusual in this respect, though as Professor John Merryman, an
art law expert, has said, the idea that the public has an interest in preserv-
ing art is certainly not novel.[18]

The law is plainly meant to protect the public's interest in the art, not
merely that of the artist. The rights it creates are not linked to the artist's
lifetime, nor is there a right in the artist's heirs. The law applies to every
work of art that meets the quality standard in the statute, whenever created.
To emphasize its goal of protecting art because of its importance to the
community, Senator Sieroty explained, in his letter asking the governor to
sign the bill, that "works of fine art are more than economic commodities
and they oftentimes provide our communities with a sense of cohesion and
history. The public's interest in preserving important artistic creations
should be promoted and our communities should be able to preserve their
heritage when it is in jeopardy."[19]

Some five years later, the legislature enacted a special provision to pre-
serve a mural that David Hockney had painted on the sides of a hotel
swimming pool, exempting it from a safety regulation requiring that all
pool walls have a plain white finish. In that enactment the legislature stated
the purpose of the law in terms that underlined its intent not to limit itself
to the conventional goals of *droit moral:* "To allow needless destruction of
this unique work of art would be a great tragedy and inconsistent with the
intent of the California Art Preservation Act, which establishes a public
interest in preserving the integrity of cultural and artistic creations.'"[20]

In light of its history, one omission in the 1982 provision is worthy of
note. Senator Sieroty's impetus for the art protection bill was concern
about the neglect of Rodia's Watts Towers. Yet his bill did not specifically
deal with neglect at all (except in a passage relating to framers and restor-
ers). California law thus imposes no duty on owners to care for works they
own. While it would be difficult, and probably impossible in most cases,
effectively to enforce any such responsibility, in principle there is no reason
to prohibit intentional destruction, yet permit knowing or purposeful
neglect. Though such instances are likely to be rare, they do exist.

In one California case an artwork was stored in a shed or outhouse, and
before long the elements destroyed the work.[21] A better known case,

reported in the mid-1970s, involved the Maryhill Museum in Oregon, which was described as the setting for a bizarre story involving both the disappearance and deterioration of important works of art. Known for its collection of Rodin materials, the museum was visited by Rodin expert Professor Albert Elsen, who "was horrified to discover that a major work, the plaster *Eve,* sported a crude patch over a gigantic hole in her left arm. Rodin's bust of Henri de Rochefort-Lucay was in pieces. The Rodin drawings were in very precarious condition."[22] Because that institution was owned by a public charitable trust, the state attorney general had authority over its mismanagement. But no such responsibility would be borne by a private collector or owner, like Winston Churchill's widow, who—as we shall see in the next chapter— stored an unwanted portrait of her husband for many years in the cellar of her country home at Chartwell, next to the boiler.

VARA: The Visual Artists Rights Act

The California (and Massachusetts) approach, which recognizes a public interest in art preservation, has not commended itself to other states that have enacted *droit moral* legislation, or to the Congress, which has sought to enact a uniform national law. Nonetheless, the notion that there is a public stake in protection of important works of art—and that the law should in some way implement that interest—is at least indirectly reflected in the 1990 federal law known as the Visual Artists Rights Act.[23] The federal statute, for example, prohibits destruction as well as alteration.[24] It does so, as one representative explained, because "society is the ultimate loser when these works are modified or destroyed."[25]

The principal sponsor of the federal law, Edward J. Markey, said, "It is paramount to the integrity of our culture that we preserve the integrity of our artworks as expressions of the creativity of the artist."[26] The House report on his bill underlined that point. Witnesses at the hearings were united in their support for the legislation "because of its benefit not only to individual visual artists, but also to the American culture to which these artists make such a significant contribution."[27] It quoted a typical statement to the effect that "the arts are an integral element of our civilization; the arts are fundamental to our national character and are among the greatest of our national treasures."[28] "[D]estruction of works of art has a detrimental effect on the artist's reputation, and . . . also represents a loss to society."[29] Another witness pointed out that "protecting the works . . . against destruction or mutilation . . . may enhance the creative environment in

which artists labor. . . . Equally important, these safeguards enhance our cultural heritage."[30]

Despite the broad rhetorical recognition of a societal claim on the protection of art, the operative provisions of the federal legislation are unmistakably focused on the rights of the artist, rather than of the society. The law limits the duration of the right to the artist's life, or to the duration of copyright. It permits waiver of the right against destruction, and it is also silent about the status of pre-enactment works of art to which the artist no longer holds title. Each of these elements signals legislative uncertainty about protecting the work itself apart from the artist's claim on it. Because of this difference, it was suggested in congressional hearings on the federal law that it should not operate to preempt the part of California law that protects the public interest in works of art independent of any claim by an artist.[31]

Experience under the California Law

The broad provisions of the California statute have now been in place for nearly two decades. What sort of practical response has the law engendered? Though there are few judicial decisions, the law has been invoked numerous times, in almost every instance to protect works against destruction. In that respect it has largely operated to protect art and not just artistic reputation,[32] though so far the plaintiff has always been a living artist seeking to preserve his or her own work. The far-reaching provision granting a public right of action appears never to have been used. Nor have any of the challenges involved eminent artistic masterpieces. Nonetheless, fairly frequent use of the statute suggests that destruction of recognized works of art is a real problem, and that the law can offer significant support to a community's interest in safeguarding such works.

Not surprisingly, the vast majority of cases have involved art in places open to the public, mostly outdoor murals in Los Angeles (which considers itself the world mural capital). An illustrative case involved a mural entitled *Filling Up on Ancient Energies* that had been commissioned in 1980 by the Shell Oil Company to decorate a wall at a gas station in Los Angeles.[33] A local muralist group known as the East Los Angeles Streetscapers painted the twelve-hundred-square-foot work, for which they were paid four thousand dollars. The mural included depictions of dinosaurs in the time of ancient energies, Quetzalcoatl, the mythical ancestor of the Aztec and Chicano people, and modern people in automobiles. Eight years later,

to make way for a parking lot, Shell bulldozed the wall, apparently unaware that to do so without giving the artists an opportunity to remove the work was now illegal in California. The case was settled in 1992, and though the amount was not revealed, the artists called the settlement a victory.[34]

Another notable use of the statute concerned the *Old Woman of the Freeway,* painted by a prominent muralist, Kent Twitchell.[35] Twitchell was hired in 1974 as part of a county art program funded by the National Endowment for the Arts. His mural was painted on the wall of a hotel, chosen by the artist because it overlooked the Hollywood Freeway. Though the work was done with the then-owner's permission, it was whitewashed a dozen years later by the new owner (who was also oblivious of the law) so he could sell the space for billboard ads. The artist sued and received a settlement of $175,000, of which $125,000 was used to restore the mural.

The law has also been invoked on several occasions to deal with the familiar and contentious situation where a city or a corporation has commissioned an artist to provide a work (usually a sculpture) for a public place and then finds itself confronted by an angry public that hates the piece and wants to be rid of it.[36] If removal (even without demolition) of a site-specific sculpture is considered an act of "mutilation, alteration, or destruction" because it takes the work away from the site to which it uniquely belongs, it is prohibited by the California law.[37] According to an expert who was instrumental in drafting the California legislation, the issue of commissioned and then unwanted public sculpture was not a subject of debate when the California statute was under consideration.[38]

The public-place problem has been around for a long time, most famously in the case of Richard Serra's *Tilted Arc* in Jacob Javits Plaza in Manhattan. Serra's work was a massive steel, fencelike structure that was removed in 1989, despite the almost uniform complaint of the art community, following intense objection by people who worked in the area.[39] There is no happy solution to such controversies. Artists often claim, quite reasonably, that to remove a site-specific work elsewhere is effectively to destroy it, or at least to alter it in ways that profoundly distort the artist's intention. On the other side, the essential reason for having public art is to provide an opportunity—not an obligation—to experience creative work. As for the rights of the artists, they would have to be stretched pretty far to include a right to compel unwilling people to experience their work far into the indefinite future, which would be the practical result if a large sculpture (like Serra's *Tilted Arc*) must remain in a public and unavoidably frequented place. Nor do artists have a right of free expression in such circumstances.

28 *Playing Darts with a Rembrandt*

A governmental decision about what it wishes to convey through public art does not transgress the rejected artist's First Amendment rights.[40]

It is, of course, always open to a client to obtain a waiver from the artist if it wants to retain its right to remove the work, and that would certainly be a prudent precaution. Nonetheless, the question remains, what sort of remedy should be available to deal with public-space art when such precautions have not been taken, as frequently they are not: compelling the owner to keep the art in place, or simply to pay damages to the artist? As one writer noted:

> The integrity right granted artists by moral rights legislation saves eyesores as well as masterpieces from destruction. The problem is that there are perhaps more eyesores than masterpieces, so that the public is sentenced to viewing these products of misspent monies for a life term or a term of life plus fifty years, depending on . . . the statute.[41]

In at least one instance the highest court in France recognized a right to compelled viewing in an artist, though hardly for an eyesore. In that case the auto manufacturer Renault commissioned Jean-Philippe Dubuffet to design a sculpture for installation on the grounds of its headquarters in Boulogne "for the enjoyment of its employees and visitors."[42] Before the construction was finished, Renault decided it did not want the work completed. It said its reasons were financial, but it may simply have decided it did not like the work. The company was willing to pay the artist damages for noncompletion stipulated in its contract.

But Dubuffet was not satisfied. He sued, claiming that his moral rights could not be waived by contract, and asserted that he had a right of "divulgation," that is, a right to have the commissioned work completed and made known to the public (presumably Renault would also have had to maintain the work indefinitely). Dubuffet won his judgment, with the result not only that the work had to be completed, but that all those who came to the company's headquarters would have had the sculpture "made known to them," like it or not. In the end, having won his case, Dubuffet decided not to seek enforcement of his judgment. "It displeases me," he said, "to compel the execution of a work in a place where it has been so ill-treated."

The Renault case is probably the most far-reaching instance of its kind ever decided. Other claims for what is called a right of divulgation—usually urged where a writer or filmmaker complains that someone is using ownership of a copyright to suppress a work from being made public—

would ordinarily only give the public the *possibility* to experience the work,[43] not a duty to do so.

Moreover, it seems implausible to read commissions in general as a promise to the artist to keep a work of art on display indefinitely, though the parties certainly may contract for some such arrangement, and do so in some instances. The City of Concord, near San Francisco, signed an agreement with artist Gary Rieveschl that it would not "intentionally destroy, damage, alter, modify or change his massive 'Spirit Poles' sculpture any way whatsoever upon its completion without the approval of the artist" and agreed that the project was "a site specific work and removal to an alternative site would constitute an alteration." Though much of the public in Concord hates the Rieveschl work, they have learned to tolerate it.

Not until public-space cases arose in California was there a problem for owners (often public entities) who simply don't want to look at a work of art they own. That was not the case with the Watts Towers, which was a case of neglect rather than of contempt. Nor is it the case with ordinary paintings or sculpture. Even under the California law, the private owner of a painting is free to remove it from the wall and put it in the attic with a sheet over it. She doesn't have to display it, or to look at it. The owner of a mural on the wall of a building may also get rid of it because the law has a special provision for "art which is part of the building," though a building owner who wants to remodel or demolish must give the artist an opportunity to remove the art if it can be nondestructively done.[44]

Perhaps the most heated California incident developed in Carlsbad, a city in northern San Diego County. The city commissioned a noted New York artist, Andrea Blum, to design a park on a bluff above the ocean, just seaward of the north-south road passing through the town. She produced a work that covered seventy-five hundred square feet, consisting of several reflecting ponds and ice plant surrounded by eight-foot-high galvanized steel bars. To a casual passerby the sculpture could be mistaken for a fence. The work, which Blum entitled *Split Pavilion,* cost the city nearly four hundred thousand dollars, about twenty thousand dollars paid to the artist, and the rest for actual construction. It generated an intense dislike on the part of many residents and was locally known as the gorilla cage, the zoo with a view, and other even less complimentary things, such as "endless Blummer."

Many city residents wanted the sculpture torn down,[45] and lawsuits were brought against Carlsbad on the ground that it had wasted public money and created a traffic and safety hazard. Though she was willing to

make some minor modifications, Blum refused demands to revise her work more substantially. Nor did she make things easier by describing the thousands of local residents who petitioned for the removal of her work as "fascists," or by her explanation of it to perplexed citizens who wondered why their view of the ocean had been closed in by galvanized steel bars: "The work deals with the psychology and sociology of the space," she explained, "which ultimately is the politics of the space."[46] This sort of artbabble led local opponents to accuse her of "effete, elitist and baseless aestheticism."

Presumably Carlsbad residents did not know that only a half-dozen years earlier Blum had, artistically speaking, been run out of town by the public in Boulder, Colorado. People there disliked her proposal for a publicly commissioned sculpture called, interestingly, *Three Pavilions*. A popular outcry about the plan induced the city to reject her design before it was constructed. After seeing Blum's plan, critics piled broken skis, rusty car parts, and empty oil cans at the proposed sculpture site with a plaque saying, "Eat Your Heart Out Andrea Blum."[47]

Eventually the Carlsbad matter was settled in a quite interesting, rather genteel, way. Blum agreed to removal of some ninety feet of the bars on one side of the project that directly fronted an outdoor restaurant, and that was the most obtrusive part of the work, and also to modification of the plantings in the landscaping, while leaving in place another several hundred feet, which were to remain along the inland side of the site. In consideration of the two changes, Blum received an additional twenty thousand dollars, doubling her original fee. The work was to remain as thus modified for seventy-eight months, until August 1998, at which time the city committed itself to hold a public hearing following which it would decide whether the remainder should come down. A press release issued by the City of Carlsbad stated that "the settlement assures Ms. Blum that her work will remain on public display for at least the 78 month period, which protects her creative efforts for a reasonable period of time." At the same time, Carlsbad announced that it had changed its procedures for approving public art projects, retaining a right to remove or replace them as determined by the city council, and requiring artists to waive any rights they have to keep a work on site.

The idea of keeping a work (or most of it) in place for a few years was intended to test the proposition that most people, while they resist unfamiliar art at first, eventually come to appreciate it, or at least come to terms with it, if only it has a chance to work its magic on them. A similar policy was adopted more generally for publicly acquired art by the King County,

Washington, Arts Commission. It provides that no work should be "deaccessioned" within five years after acquisition, and then can be got rid of only if "it has received consistently adverse public reaction for a period of five or more years."[48] If the test of art is a test of time, such solutions seem a desirable way to accommodate the tensions that so often erupt from the installation of cutting-edge art in public places. The underlying assumption is that the general public is notoriously conservative in its tastes, and a negative reaction is almost inevitable for any unfamiliar or adventurous contemporary work. Time, it is thought, tends to cool negative passions, or at least to engender resignation.

As things turned out, that is not what happened in Carlsbad. On June 3, 1998, Carlsbad voters turned out overwhelmingly—about 67 percent to 33 percent—to call for the removal of *Split Pavilion*. The following January, the city demolished the sculpture at a cost of $123,362 and gave the scrap metal bars to a local high school.[49]

Perhaps it is better that the public passionately opts to remove a work than simply ceases to see it. And sometimes art is wrongly site-specific. Erika Doss, who wrote a book on public art, concluded that the Gary Rieveschl sculpture in Concord (mentioned above) missed the boat. While many of the public's negative comments were misinformed or simply cantankerous, she says, others showed an astute aesthetic awareness that the work was too busy, too cold, too overbearing, and remote from the city's Hispanic heritage: "[T]he overwhelming sense that [the] project generated was anxiety and disorientation. Perhaps one Concord citizen put it best when he wrote, 'if this is someone's idea of the Concord family, no wonder the family is in trouble.' With a completely different understanding of who the Concord 'family' was . . . and with an aesthetic treatment of the Concord Avenue site that mostly generated public hostility, Rieveschl['s] intention of fostering civic identity generated, instead, local uproar."[50]

Not every story is bleak, however. Sometimes public art does just what is intended. The classic case is the huge Picasso sculpture in Daley Plaza, at the very center of Chicago's central business district. When the fifty-foot-high sculpture made of steel plates and rods was unveiled in 1967, people were open-mouthed, and not pleased, notwithstanding the fame of the artist. For many months it was the city's favorite topic: "it's a flying nun," some said. No, "it's a cyclops eye with double vision," or "a cow sticking its tongue out at the city." In classic Chicago style, the city's director of public events opined that "if it is a bird or an animal, they ought to put it in the zoo. If it is art, they ought to put it in the Art Institute."[51] Thirty years later,

the *Tribune* reported that "the Picasso sculpture in Daley Plaza is now to Chicago what Big Ben is to London or the Eiffel Tower to Paris."[52] It "is so integrally associated with Chicago that it has become the city's unofficial trademark."[53] There are other notable examples, such as Alexander Calder's sculpture *La Grand Vitesse*, which was condemned as a monstrosity when it was installed in Grand Rapids, Michigan, in 1969, and the image of which now is the city's logo, imprinted on all county and city official stationery, on street signs, and on the masthead of the newspaper; Claes Oldenburg's *Bat Column*, which was picketed at its dedication and is now another item of Chicago's pride; and George Sugarman's sculpture in Baltimore, set in the federal court plaza, and initially objected to in 1976 by the judges as a "potential shelter for persons bent on mischief or assault on the unsuspecting" as well as a hiding place for bombs.[54] Sugarman pleaded that he had never heard of "death by sculpture," the government ultimately relented and kept the sculpture, and time has vindicated Sugarman's art.

Ultimately, the case for an obligation to retain art in any public place is not persuasive, any more than a collector could rationally be obliged to keep an unwanted painting on his living room wall, where he had to see it every day. Nor does any such approach make even strategic sense. Presumably the claim for cutting-edge art in public places is that significant work will ultimately speak to its audience if it is only given a chance. A coerced audience, however, seems most unlikely to let itself yield to art's charms. For that reason alone, the compromise effected in Carlsbad is attractive: the public knows it can prevail, and that it is participating in an experiment that will not last unduly long. It agrees to think about it. As for the artist, this seems the ideal situation to draw a distinction—as the law often does—between a possible right to collect damages for breach of a contract (which may often be appropriate) and a court-ordered injunction that compels a city or other owner to keep a work of art in place and on public view. If the work can be removed and resited in another, mutually acceptable, place, or returned to the artist for reinstallation, the harm may be at least marginally mitigated.

A No Surprises Policy

Whatever other legal ambiguities may surround the California law, one thing at least is clear. Before a work of art is removed, the artist (or an arts organization) is entitled to prior notice and an opportunity to take it away and preserve it. Such provisions at least assure artists against experiences

such as Isamu Noguchi underwent some years ago. In 1980 Noguchi created a sculpture known as *Shinto* for the lobby of the New York branch of the Bank of Tokyo. After customers complained that the work, which was a sixteen-hundred-pound, seventeen-foot-long rhomboid hanging downward, reminded them of poised guillotine, the bank decided to get rid of the piece and didn't even bother to tell Noguchi. Because of its size, the sculpture wouldn't fit through doors or windows, and so the bank had it cut into pieces and stored in a warehouse. Noguchi called it vandalism, but New York law at the time provided no recourse either to him or to anyone else.[55] A representative of the bank reportedly said that Noguchi had not been told of the decision because "the sculpture is the property of the bank."[56]

Another very famous artist, Louise Bourgeois, also had a sculpture removed without being consulted, and much more recently. In her case, the art was entirely inoffensive to conventional taste, consisting of sculpted arms, with hands reaching out to touch each other in quite a tender way. The work had been placed in New York's Battery Park City, across the water from the Statue of Liberty and Ellis Island, presumably as a symbol of welcome. As it happened, however, Bourgeois's work had been placed near a Holocaust memorial of the Jewish Heritage Museum, and museum officials feared that the hands would suggest to visitors images of severed body parts from Nazi death camps. They got park officials to move the sculpture to a nearby spot, where it was obviously, and presumably calculatedly, hidden from view by shrubbery.[57]

The mere existence of a law does not assure it will be followed, of course; but it at least provides some redress for the artist and underlines the emerging concept of qualified ownership. Nearly a decade after the California law was enacted, a twelve-foot sculpture disappeared from a shopping center in the City of Richmond, near San Francisco, where it had stood since 1980.[58] "I was stunned when I found it missing," the artist, Tom Martin Browne, said. What happened is that a tenant complained about the sculpture, and shortly thereafter the half-ton stainless steel and porcelain structure mysteriously "disappeared." The owners of the shopping center claimed to know nothing about it. When the artist sued them, they told him (quite wrongly, at least in California) that "since they owned the sculpture, they could do whatever they wanted with it."[59] The case went to arbitration, and Browne was awarded forty-five thousand dollars, which included an allowance for his attorney's fees.

Such cases keep coming up. In 1994 artist Josie Grant got fifteen thousand dollars in damages when the City of San Francisco whitewashed a

mural she had done for a Chinatown housing project. Some years earlier Monette Kupiec took some friends to see her mural in the elegant Hotel del Coronado near San Diego, but the work was gone. She was told it was in storage, then that it had disappeared, and later that it had been sold. It took two years of legal haggling and a discovery proceeding to find out that her work had been covered over with red wallpaper, which in turn had been covered by a new painting. In another case, the Fresno Art Museum—which apparently had never heard of either the California or the federal artists rights laws—painted over a mural by Maxine Olson because it wanted to redecorate a gallery entryway. Olson sued the museum and was awarded ten thousand dollars in damages: "It was a matter of making those people accountable," she said.[60] Exactly.

The Bonfires of Loyalty and the Flames of Ambivalence

Works of art are the property of mankind and ownership carries with it the obligation to preserve them. He who neglects this duty ... will be punished with the contempt of all educated people, now and in future ages.

—Attributed to J. W. von Goethe

Paint Me, No Warts Please

The preceding chapters dealt with owners as collectors or patrons. Now we turn to those who have a more intimate relationship with a work of art: first a subject (and his loyal widow) who detests the way in which an artist has portrayed him; and then artists themselves who have decided to destroy works they consider inferior, or heirs and executors to whom they have consigned the task. In the first case, which involves a portrait of Winston Churchill, a double dilemma is presented. Not only is a worthy work lost to posterity, but in destroying an unflattering portrait the subject is also diminishing an historical record. Posterity is denied an opportunity to see one version of a leading figure on the world stage as he really was, or at least as he was seen by a major portrait painter. Destruction of such a portrait is similar to the suppression of an unfavorable biography.

Of course no one compels any subject to sit for a portrait, and in that respect the painting only exists because of the subject's willing act. Should that fact give him a greater claim over the fate of the work? I think not, though, as we shall see, some commentators—though opposed in general to the destruction of art—think a portrait of oneself or of a close family member may be a special case. They do not, however, say exactly why. A willing subject is in a position parallel to a patron, in that the object's coming-to-be depended on him. For the reasons set out in the discussion of the Rivera murals, I do not conclude that patronage is sufficient to trump the

claim of the art. Being merely a subject suggests even less association with, or approval of, the artist's "message" than does patronage like the Rocke-feller's. Especially where a work is unfavorable or critical, the subject can hardly be deemed to have endorsed it. He cannot justify destruction on the ground that he will erroneously be thought to have associated himself with the artist's conception of him.

Should the fact that the painting would not exist except for the sub-ject's willing act be decisive? I think not. The portrait is not the subject's own creation, and in that sense the owner cannot claim a right to have the world know him only through those of his works that he considers worthy of him, which is the claim of the artist to destroy what he does not wish to reveal to the world. Rather, the claim is a right to manage what the public shall know of how artists or analysts think of him. That is a wholly differ-ent matter from determining the content of one's own creative oeuvre. Indeed, the only thing that distinguishes the relationship between any owner and a work of art and the owner-subject of a work of art is the opportunity for the owner-subject to exercise control over history's view of him or her. As we shall see in a later chapter, that is precisely the situation whenever public figures destroy documents of historical importance that involve them.

The question is whether such involvement should generate any special claim to edit the historical record. There are several possibilities. In some instances there may be privacy or security considerations. Certainly they are important, but they can almost always be met by an embargo on public use for a suitable time, a matter we shall consider in several contexts in the fol-lowing chapters. There is also the desire—which is often very intense—to protect the reputation of a notable family member. I shall later examine this issue as well. The question pretty much boils down to whether some unpleasant truths shall come out. Once privacy, national security, or like considerations have been accommodated, truth should need no further defense. Finally, there is the claim in some circumstances that a require-ment of preservation may discourage the creation of certain records, and thereby impair the functioning of important institutions (such as candid advice to a president, or confidentiality within the Supreme Court). This is a genuine consideration, and it will be addressed subsequently in the pres-idential and judicial contexts, but whatever its merits elsewhere it hardly seems germane to a portrait. Other than these matters, there is only the raw fact that the work would not have existed except for the subject's coopera-tion. That, however, is not a reason for any particular outcome. It is just a fact, like ownership. Much less art would exist were it not for patrons and

collectors who create a market for it. The central question sought to be raised in this book is what consequences should follow from such facts, where there is some significant public stake on the other side. As the history of the Churchill portrait unfolds, and the background of Sir Winston's unhappiness with it is revealed, the claims in favor of preservation should become increasingly clear.

Graham Sutherland's Churchill

In 1954, Parliament commissioned Graham Sutherland, Britain's most distinguished portraitist, to paint Churchill as a gift to be presented to the former prime minister on his eightieth birthday. The painting was duly presented in public, and then never seen again. No one who witnessed the scene in Westminster Hall when the portrait was presented to Sir Winston, as one observer said, "will forget the idiosyncratic nonsound with which a thousand people stopped breathing when the canvas was revealed." Churchill hated it. He slyly but contemptuously described it as "a striking example of *modern* art."[1] Later, he said, it "made me look half-witted, which I ain't."[2] It was obviously not a flattering likeness. One Tory MP described it as "a study in lumbago," and Lord Hailsham said it was "disgusting, ill-mannered, terrible."[3] Churchill's wife loathed the painting even more than her husband did. Everyone agreed that the portrait captured the stiffness of old age unflatteringly. For years there were rumors about what had happened to the Sutherland painting, but none were ever confirmed.

Churchill himself died in 1965. His wife lived for another dozen years. Shortly after she died, her executors, one of whom was her daughter, announced that Lady Churchill had destroyed the painting on her own initiative some time before her husband's death. She had neither consulted anyone about her decision, nor informed anyone of it. The announcement said that Mrs. Churchill had been distressed to see how much the picture, which both she and Sir Winston detested, preyed on her husband's mind. Following the announcement, an employee revealed that in 1955 his mistress had smashed the portrait to pieces in the cellar of her country home at Chartwell, where it had been stored behind a boiler, and had then given it to him to burn in an incinerator.[4]

Sutherland, who was still very much alive at the time of the announcement, was quoted as saying that the destruction was "without question an act of vandalism."[5] However, he added, he was not unduly distressed, although he had put a lot of work into the picture. "I knew Sir Winston

didn't like it," he said. "I felt his wife disliked it much more than he did."[6]

There is actually a good deal more to the story.[7] Sutherland resisted Sir Winston's requests to see the painting before it was completed, but the artist let Lady Churchill view it and gave her a photo of the painting to show her husband. That was about ten days before the scheduled presentation in Parliament. The next day Churchill sent his limousine with a letter for Sutherland that said, "I am of opinion that the painting, however masterly in execution, is not suitable as a Presentation from both Houses of Parliament. . . . [T]he ceremony in Westminster Hall . . . can go forward although it is sad there will be no portrait." Sutherland, wounded, notified the chair of the committee that had commissioned the portrait, Charles Doughty, and Doughty urged, and finally persuaded, Churchill that it would be hurtful to many members if he rejected the painting.

The ceremony went forward as planned. Churchill was relatively diplomatic in public, as noted above, and outraged in private. He described Sutherland's seated portrait of him to Mrs. Doughty this way: "How do they paint one today? Sitting on a lavatory! Here sits an old man on his stool, pressing and pressing." Lady Churchill later wrote to a friend that her husband was deeply wounded that "this brilliant painter with whom he had made friends while sitting should see him as a gross and cruel monster."

Of course Churchill was far from the first aristocrat to think himself ill served by a distinguished artist. Three centuries earlier the countess of Sussex had said she felt "very ill-favored" by Van Dyck's portrait of her, and "quite out of love with myself, the face is so big and so fat that it pleases me not at all." Unlike Sir Winston, however, she ended by saying, "but truly I think 'tis like the original."[8]

Once it was revealed that the Churchill portrait had been destroyed, the *Times* of London interviewed a number of distinguished experts, artists, museum directors, art historians, and photographers. Each one considered the painting good, or very good art, and its destruction a great mistake, though they could not help admiring Lady Churchill's grit in standing by her man. One expert, writing before it was known that the painting had been destroyed, said the Sutherland portrait was probably the best of the images of Churchill that will be handed down to posterity, "a great artist's vision of a great English warrior when he finally laid down the burden of high office."[9]

A number of those interviewed raised intuitive doubts about Lady Churchill's right to make so significant and permanent a decision. "I don't think it's ever right to destroy a work of art," one of them said. "It does not,

finally, belong to the ostensible owner." David Sylvester, an art writer, put it rather neatly:

> I do not think we have the right to feel we own the works of art we have, any more than the spouse we have. Therefore we should not kill them off just because we do not like them. Still, it is arguable that a portrait of oneself, or of someone near and dear, is a special case.

Roy Strong, the director of the Victoria and Albert Museum, noted that if the picture was the property of the Churchill family, they could "of course" do as they wished with it. He added, however, "But an artist tears something out of himself when he paints a portrait and to burn it is like burning a chunk of Sutherland. Remembering that Churchill was himself a painter of no mean talent, I find it surprising that such destruction could take place."

John Russell, who was then the art critic for the *New York Times,* took an unexpectedly sympathetic position toward the destruction. "To be alone with the painting," he said, "was undeniably a grim experience. Graham Sutherland is a man who sets down exactly what he sees, and what he saw in this instance was an indisputably great human being, the savior of his nation, who had been struck down by illness and would never be the same again."[10] Russell said nothing in his article about the artistic quality of the work, though he had been able to take a long, close professional look at the portrait after it was completed. To destroy the painting, he concluded, was a controversial act, but "Lady Churchill put her husband's peace of mind above all other considerations."[11]

Russell's sympathy for Lady Churchill is touching, but an article written by Christopher Booker in the *Spectator* the same week probed the incident much more profoundly. "There is something archetypally haunting about the shock of some great man, in the evening of his life, being confronted with a portrait of himself by some honest and observant artist, showing him not as he would like to be seen, but as he really is."[12] The Churchill incident, Booker noted, is hardly unique. In the 1920s King George V disliked a portrait of himself that had been painted by Charles Sims, head of the Royal Academy art school. The king remarked to two academy officials that he "would like to see the damned thing burnt." They promptly returned to the academy, cut the canvas into pieces, and fed it into the furnace.[13] Wagner detested Renoir's sketch for a portrait of the great composer, precisely because "the artist had captured what the composer and the faithful felt compelled to deride and dismiss."[14] The great

English actor Henry Irving destroyed a portrait of himself by John Singer
Sargent. Ellen Terry wrote of it in her diary, "Everyone hates Sargent's
head of Henry. Henry also. . . . I think it perfectly wonderfully painted and
like him, only not at his best by any means. There sat Henry and there by
his side the picture, and I could scarce tell one from t'other."[15] The *Times*
reported that Sir Henry so disliked the portrait—which a critic had called
a good but pitiless sort of likeness—that he cut it up into pieces.[16]

The Churchill incident was emblematic of a personality characteristic
that Sir Winston shared with many great men, "psychological 'onesided-
ness' . . . a desire to avoid self-analysis, to escape from the deeper reaches of
oneself at all costs, to live through the ego and to see oneself in the most
favorable possible light as an actor on the stage of the world."[17] He wanted
to be painted as a nobleman, in his robes as a Knight of the Garter, but the
parliamentary committee wanted a portrait as the House of Commons had
always known him, in a suit with the spotted bow tie that was his trade-
mark.[18] Churchill perceived in the painting something that none but he
could see, how some men seek greatness not by trying to understand them-
selves, but by trying to escape from themselves. Booker concluded his arti-
cle with this tantalizing observation: "We may regret the destruction of the
painting as a powerful work of art. But as a footnote to the psychology that
governed Churchill's entire life it could scarcely be more illuminating."[19]
Sutherland himself put it rather more gently. He said that "only those
totally without physical vanity, educated in painting, or with exceptionally
good manners, can disguise their feelings of shock or even revulsion when
confronted for the first time with a reasonably truthful painted image of
themselves; there is a quilted atmosphere of silence; as when it snows."[20]

Illuminating as Churchill's reaction and his wife's subsequent
fulfillment of his wish may be, another sort of illumination has been lost,
the painter's insight on a great man to be compared with the many flatter-
ing and still extant portraits that presumably satisfied Sir Winston's ego.[21]

Churchill was perhaps unfortunate in his artist. Gertrude Stein, who
was famously painted by Picasso, said of her portrait: "And I was and still
am satisfied with my portrait of me, it is I, and it is the only reproduction
of me which is always I, for me."[22] Perhaps Churchill hoped for his own
Van Dyck, who as royal painter in the 1630s had portrayed the short,
diffident, stammering Charles I as the perfect prince, with an ineffable
sense of grace, refinement, and understated grandeur.[23] Nor are all great
figures as sensitive as Churchill. In 1650 Pope Innocent X commissioned
a portrait of himself by the great Spanish painter Velázquez that has
ever since been in the gallery established in 1651 by the pope's family, the

Pamphili's. Innocent X was an ugly and sullen man, and he is depicted quite as his contemporaries described him: "tall in stature, thin, choleric, splenetic, with a red face, bald in front with thick eyebrows bent above the nose . . . that revealed his severity and harshness."[24] His head was "the most repugnant . . . of all the Fisherman's successors," with an expression like "that of a cunning lawyer." The Velázquez work, one of the most admired portraits of the seventeenth century, and perhaps of all time, is anything but flattering. And as a part of one of the great art collections of the world, the painting has long been accessible to the public. Some of our greatest paintings are portraits ruthless in their probing, notably Rembrandt's late self-portraits where physical decay and melancholy are depicted with a force and honesty unique in the history of art.

Certainly much would be lost if we were deprived of such works. There is a strong interest in knowing as much as possible about one who played as large a role on the world stage as Churchill did. Were unflattering works regularly destroyed, we would be left with little but the empty iconic statues that crowd the plazas of dictatorships and banana republics. Fortunately that prospect has been diminished by the presence of photography, which often puts control over representation out of the subject's reach. Where power of control remains, as with paintings or sculpture for which one must sit, no formal rule can deny an individual the right to manage at least to some degree how he or she shall be presented to the world.

Even if Churchill had not owned the painting, there would be little to object to had he insisted that Parliament not display it, at least during his lifetime. As a matter of fact, Churchill did order that the painting not be shown and that no reproductions be published (though photographs had already been printed in the newspapers in the days following the presentation).[25] Perhaps that is where the line should be drawn. Where a personal right demands recognition, it could be enforced during the individual's lifetime or generation, but not beyond. There could have been little complaint if the Churchills had withheld the painting from view during their joint lifetime (as Lady Churchill did), but neither mutilating or destroying it, keeping it in trust to be available at some specified and not excessively remote date following the subject's death.

That was exactly the fate of John Singer Sargent's provocative portrait of Isabella Stewart Gardner, herself one of the best-known American art collectors. Gardner's husband forbade the portrait's display during his lifetime, and Mrs. Gardner kept it hidden even after his death, but she made sure it would reemerge when she died.[26] It now hangs in the museum she created on the Fenway in Boston. Frank Giles, writing in the *London Sun-*

day Times, suggested just such an arrangement for the Sutherland portrait. "Had Lady Churchill stored the painting away, to remain unseen and unoffending until after her and Sir Winston's death, there would now be no controversy." Instead, he said, she "treated Graham Sutherland as a bootmaker who has made an ill-fitting pair of boots. He deserved better than that."[27]

A similar view was expressed by a number of ordinary people, both supporters and opponents of Churchill, interviewed by the *London Sunday Times.* One said that "you can't just destroy a painting, whether or not you think it's bad. . . . Why didn't Lady Churchill just put it in the attic?" Another said, "If they didn't like it, they should have given it to the National Portrait Gallery." And still another remarked, "It was a great shame to destroy a work of art. I do have a certain sympathy for a man who is publicly presented with a portrait of himself that he doesn't like. Disliking it, though, is no justification—they didn't have to look at it." "The painting was presented by the House of Commons and it was something of historical importance. I admired Churchill as a great wartime leader, but to destroy the painting was an act of vandalism." That seems to have been the general view, though a few interviewees took the opposite view, one saying, "[I]f my wife had a picture of me that neither of us liked, I hope she would destroy it."[28]

Artists' Wants and Wishes

At least one exception to the thesis that an owner's dominion over art should be subordinated to public claims for preservation and access deserves recognition: artists or writers who destroy work they consider unworthy of their talents. Such an exception is a variant of the *droit moral* principle. Just as artists are entitled to have their reputation rest on work as they presented it, without modification or distortion, they should be entitled to have their reputation rest on their work as they would present it—that is, as finished work, or a draft with changes they consider appropriate.

Every writer and artist has made efforts that he ultimately decides are unworthy of him and consigns to the trash. Certainly inferior work can diminish one's reputation. A creator should be allowed to implement his own judgment about what is worthy of him. (To be sure, some artists have carried this privilege to an extreme, like Soutine,[29] or Whistler, who had

the notion that he could just take back a painting he had sold and keep reworking it until—if ever—it satisfied him.)[30]

There are of course competing considerations. No doubt there is biographical and critical interest in knowing as much as possible about an eminent artist, and for those purposes every scrap of information is precious, and discarded work may be especially revealing to the art historian. That is not a trivial consideration by any means, but neither is it sufficient, I think, to overcome the claim for self-determination: Renoir or Rubens is what Renoir or Rubens presents to the world as his art. This is distinctly different from the desire of a Churchill, or other great person, to edit events or the judgment of others in order to present a favorable self-image. The appropriate parallel would be Churchill's destruction of a speech draft he had considered, but decided not to deliver because he found it unbefitting his standards or his policy.

Rouault's Bonfire

A nice test case occurred in 1948 when Georges Rouault, in the presence of a photographer, threw into a furnace some 315 of his own canvases (a portion of the work he had recovered from his recently deceased dealer's gallery). They were unfinished and unsigned works, and Rouault's act was explained by his daughter: "Conscientious as he was, what worried him was not doubt that he would not be able to finish a particular canvas to his satisfaction, but fear lest he would never have the time to do so. His principal concern in making the painful choice . . . was the stage of progress of each painting. Thus it was only after long hesitation, and not without great anxiety, that Rouault decided to burn those works which he felt so little advanced that completion would demand too long a time."[31] At the time the editor of the French magazine *Esprit* wondered if it was not a dangerous precedent for a great creative artist to take upon himself the judgment of the ages, saving this work and destroying that one, leaving behind no traces of the doubts and hesitations through which the human side of the artist could be grasped (Similar claims were made about Brahms, who destroyed compositions that did not satisfy him.)[32] Presumably Rouault would say that whatever the judgment of posterity is to be, work that he deems unworthy or unrepresentative of his talents is, by his own definition, not his true work and should not be the basis of history's judgment of him.

Did They or Didn't They?

A more puzzling, and more common, problem involves those writers and artists who leave deliberately unpublished work and thrust the burden of disposition upon heirs or friends, sometimes with ambiguous instructions urging destruction. Here the conflict is threefold: a desire faithfully to execute a deceased artist's wishes, a desire that is usually felt especially strongly by surviving family members or intimate friends; anxiety about loss of precious works of art or literature (which these same intimates tend to value highly); and uncertainty about the true wishes of the artist.

In light of what has been said above, destruction would be appropriate if it was clear that the creator wanted the work destroyed, and emphatically so if for some reason it was obvious that he or she was unable to do it himself. An illustrative incident involved the famously reclusive author J. D. Salinger. In the setting of a dispute in which Salinger prevented publication of an unauthorized biography, it was revealed that his longtime literary agent, Dorothy Olding, had, at the author's request, destroyed over five hundred letters she and he had written to each other. In light of Salinger's unrelenting protectiveness of his privacy—he had previously instituted a lawsuit to enjoin publication of his unpublished letters in an unauthorized biography[33]—it can hardly be doubted that he wanted his letters destroyed. This is not at all to deny that such cases engender a significant loss, but only that there is another trumping value in play. In fact, precisely because Salinger has made himself so scarce and ceased to publish, it would have been utterly fascinating to see his correspondence.[34]

In the absence of such special circumstances, the usual grounds favoring preservation ought to prevail. To promote that outcome in most cases, it would be best to indulge a presumption—always subject to disproof in a particular instance—that an artist or writer who hasn't destroyed work while she was alive meant deep down for the world someday to see it. Good reasons explain why works are sometimes kept, yet left unpublished, by their authors for many years, as an incident involving T. S. Eliot reveals.

In 1922 Eliot sold a notebook full of poems, some scatological and racist, to a friend with explicit instructions as to their fate: "I beg you fervently to keep them to yourself and see that they are never printed."[35] His concerns can easily be appreciated: one of the poems describes the encounter of a highly sexed Christopher Columbus with King Bolo, a well-endowed black monarch. Of course Eliot might have destroyed the notebook without showing it to anyone; he did not. Though a few of the poems turned up in writings over the years, the great bulk of the notebook's con-

tents remained unpublished for nearly seventy-five years. In the 1960s the notebook itself was deposited in the New York Public Library with a proviso imposed by the Eliot estate that permitted scholars to read and refer to the poems, but not to quote or reprint them. The poems themselves were finally published in 1996.[36] Should the material have been preserved and ultimately published? Certainly. Their existence, Eliot scholars say, "offers fresh insight into the poet's early artistry, his strict personal standards and his fervent search for the perfect word and the perfect phrase."[37]

The treatment of these materials may offer a blueprint for balanced resolution of such matters. Eliot's legitimate concern about withholding writings that would have been considered scandalous during his lifetime was respected. The material was handled with delicacy during the years when it might have become a source of personal embarrassment. Consideration was given to the fact that he had an opportunity to destroy the poems. As the editor put it, "[I]f poets don't want things to be published, they usually destroy them." At the same time a reasonable effort was made to accommodate contemporary scholarly interest, though certainly something significant is lost when literary work can only be described and not quoted verbatim. Consideration was also given to the sensibilities of the family, though in this particular instance Eliot's widow, Valerie, softened the problem a good deal. While she has been described as a typically unpredictable executor and as a fierce guardian of her late husband's memory, she concluded some years ago that it was time for publication, and she decided that not even the most unsavory items should be excluded. Publication would have been appropriate, however, even if she had not been as sensitive to literary history as she was, though in such a case it may be best to wait until the artist's own generation has largely passed from the scene. In fact, some letters of Eliot to his close friend Emily Hale remain inaccessible. They are under embargo at Princeton University until 2020.

The Ultimate Case for Preservation: Kafka and Max

> The case of the writer Kafka is unusual in that his minor works were published during his lifetime and the major ones, in so far as the author did not destroy them before his death, posthumously.
> —Franz Blei

There are a number of well-known cases where authorial instructions to destroy papers have been ignored. W. H. Auden asked his friends to burn his letters, which they did not do.[38] Samuel Beckett apparently quite rou-

tinely and unsuccessfully told correspondents to destroy letters he sent.[39] The great modern incident, of course, is that of Franz Kafka.

Kafka burned many of his papers and requested that his friend Max Brod destroy diaries, manuscripts, and letters. Brod, to the enduring benefit of the literary world, did not comply. Kafka's direction was verbally unambiguous. He categorically ordered the destruction of his entire literary remains. Brod found two letters addressed to him, among Kafka's papers after the author's death. "Everything I leave behind me . . . in the way of note-books, manuscripts, letters . . . and so on, is to be burned unread and to the last page."[40] What is more, Kafka directed Brod to destroy all writings and sketches that were in the possession of others, and told Brod to go to those others and to collect all the material they had. Brod did so, not to comply with his friend's wishes, however, but in order to preserve them, and to have them published.

In an epilogue he wrote to the first edition of *The Trial,* Max Brod explained what he had done, expressed his pangs of conscience at having violated his friend's explicit direction, and yet at the same time defended himself. Brod spoke of an attitude of nihilism regarding his own work on Kafka's part and revealed that nearly everything published during his life-time "was rescued from him by dint of persuasion and guile on my part."[41] Moreover, Brod said, "in a posthumous edition many personal arguments cease to apply, such as, for instance, Kafka's objection that the publication of work he had done would lead him astray in the future, or that it would call up the shadows of painful past experience."[42]

Brod further explained that Kafka, while he has was still alive, had told Max that he wanted him to destroy his papers, but that Brod had responded that he could not. Brod recalled his exact words: "In case you should seriously think I would do such a thing, I am telling you now that I cannot fulfill your request."[43] "Franz knew," Brod concluded, "that my refusal was in earnest, and at the end, if he had still intended these wishes to be carried out, he would have appointed another executor."

Brod, not surprisingly, defended his own conduct, so he is not the ideal witness. Still, the evidence points at least to ambivalence on Kafka's part, and to a general attitude about his work consistent with Brod's report. As one biographer put it, "Kafka's choice corresponded exactly to his inner-most state of mind at the moment he chose Brod to be precisely the one to carry it out."[44] A parallel point was made at the time, in response to public criticism of Max for betraying his friend (even collecting his papers from others in order to assure that they would not be destroyed). In 1929, Wal-ter Benjamin wrote that Kafka's "shyness with regard to the publication of

his work sprang from the conviction that it was incomplete and not from the idea of keeping it secret. . . . To cover Brod by ascribing to Kafka Jesuit tricks, a *reservatio mentalis!* To ascribe to him the deepest intent that this work appear and at the same time the author's word against its appearance! Yes, we are saying nothing else here and add: honest loyalty toward Kafka consisted in the fact that this [preservation and publication] happened."[45]

We can never know what Kafka, T. S. Eliot, or any other artist really, most profoundly wanted. Even the presumption suggested above is only a surmise, a sort of exercise in amateur psychology. There may, however, be ground that is a bit more solid. Why not conclude that it is unfair for any creative genius to thrust the burden of decision on friends or family? The responsibility is the artist's. In the absence of some extraordinary circumstance of effective disability, he should know that if he leaves papers or manuscripts, he can assume those documents will be preserved, and ultimately opened to the public. The choice should be Rouault's (personally fed) bonfire, or the judgment of posterity.

Our Architectural Heritage

There are two elements in an edifice, its utility and its beauty. Its utility belongs to its owner, its beauty to everyone. Thus to destroy it is to exceed the right of ownership.

—Victor Hugo

Unlike most culturally important objects, buildings of great architectural or historical distinction are almost always employed as part of everyday life. For that reason they present especially perplexing issues when adaptations to new needs are proposed. No lucid person would suggest that a Rembrandt portrait needs an addition and that a pet dog or a few affectionate children should be painted in by a contemporary artist. Yet plans to modify an architectural masterpiece to fit it to the needs of tenants or the necessities of a new era are both common and rational. Then the question arises, who shall say how such needs ought to be accommodated? Unless the structure is a designated landmark, ordinary property rules will apply and its fate will be left in the hands of the owner. When the building is an architectural classic, however, that often spells trouble. In such circumstances, it is not simply whether the work is worthy of protection (as under the art protection laws discussed earlier), but how it shall be protected, and what sort of changes ought to be permitted. Is there a professional community where some wisdom ought to reside and that ought to have a role; and if so, what sort of role? A striking test case arose in the matter of the Salk Institute in the early 1990s.

The Salk Institute Controversy

In 1962, Jonas Salk, inventor of the polio vaccine, engaged one of America's most distinguished architects, Louis Kahn, to design a structure to house the research institute he had established in La Jolla, California, just north of San Diego. It was one of the great collaborations between architect and

client. Salk and Kahn first met to discuss the project in the year that C. P. Snow delivered his widely publicized lecture on the "two cultures."[1] Dr. Salk envisioned the Institute as a place where the people of the sciences and of the humanities could meet and bridge the gulf between them. In a famous remark, Dr. Salk charged Kahn with designing a place in which he would feel comfortable receiving Picasso.[2] He got what he wanted. The result is one of the premier achievements of twentieth-century architecture. Paul Goldberger described it this way:

> The Salk Institute is a building that makes you want to caress concrete. Here, in this laboratory complex overlooking the Pacific Ocean, the profound magic Louis Kahn exerted over materials, space and light can be felt in its purest form. To come here is to see at once great power and immense restraint; this is architecture, as glorious, as magnificent, as awesome as in any cathedral.[3]

The Salk Institute for Biological Studies was completed in 1965. Louis Kahn died in 1974. By 1989, additional space was needed. Jonas Salk was still alive, and in the spirit of his patronage, he hired two well-regarded architects who had worked with Kahn on the original to design an addition. Both the building they conceived and its placement (in a dense eucalyptus grove that had served as an impressive entry to the sight of Kahn's buildings framed by the sea behind them) generated fierce, and very high-powered, opposition. Not only did Kahn's widow and children object to the proposed new building, but so did a super who's who of American architecture, including Robert Venturi, James Ingo Freed, Philip Johnson, Richard Meier, and Vincent Scully, as well as Richard Moe, president of the National Trust for Historic Preservation.[4] The architecture critic of the *New York Times* called the addition vapid, dull, flat, and lifeless.[5] There were, however, a few prominent supporters of the proposal, including Moshe Safdie, an internationally known architect.

No one denied that additional space was needed. The question was whether it should be provided at some distance from the original building, forgoing any effort to integrate the expansion aesthetically with the Kahn work, and avoiding the eucalyptus grove. To critics the proposed addition was an imitation by lesser architects that diminished the original structure by mimicking it. The argument for separation was that "Kahn's structure is a kind of acropolis; it sits, templelike, above the sea, and an essential part of the way in which this piece of architecture is experienced comes from the way in which it is approached and entered. . . . [O]ne passes through the grove. . . , a landscaped intermezzo intended to serve as a buffer between the world of the automobile—a world Kahn despised—and the refined

land of stone that Kahn had made . . . all a sequence, ordered and intended."[6] The addition's most conspicuous impact, opponents urged, would be to obstruct the dynamic unfolding of space that visitors activate by passing through the grove.

Perhaps the most striking feature of the Salk Institute controversy was that virtually everyone, including Dr. Salk, agreed it involved more than an owner's conventional decision about things he owns. Salk was willing to listen to critics (at least in the early stages of the dispute). Those who opposed the plan did so without rancor. People were torn between admiration for the man responsible for the building's existence and distress over a plan that would diminish it.

In defending his expansion, Salk showed critics drawings from Kahn's office for additional structures at the institute that he believed supported the new plan. Richard Meier, one of America's most respected architects, after noting that Salk had worked closely with Kahn and was instrumental in creating a great place, said "it's complicated. . . . It's not as though someone else is coming in and destroying the work. I think he's gone out of his way to listen to arguments against what he's been doing, but I lament that he hasn't been more receptive to the criticism. This is a mistake. Unfortunately, the Salk is not public."[7] Another opponent commented that "Jonas Salk is not the typical custodian of a landmark building. This landmark would not even exist without him. San Diego donated the building's spectacular site because of the eminence of Dr. Salk. The March of Dimes put up the money to build it on condition that the institute bear his name."[8]

Dr. Salk seems to have seen himself not only as the patron and custodian of an architectural masterpiece, but as the guiding force of an important scientific enterprise that had its own imperatives. Speaking of the opposition of the Kahn children, he said, "I'm sorry for them. I'm sorry that they're in pain. But if we were to comply with their request [to move the expansion], it would be like relinquishing to them the continued creation of the Institute."[9]

Perhaps the most telling analysis was provided by Michael Benedict in the magazine *Progressive Architecture.* Everyone from the young construction worker at the site to Jonas Salk himself is acutely aware of the power of the original buildings and the importance of the stake, Kahn's legacy, his spirit and seriousness about the making of a building, Benedict observed. But adding to a modern masterpiece raises a profound problem that "at once invokes two worlds, two perspectives. The first belongs to us all: it is the perspective of culture, art, and architecture; it is about a masterwork's unique place in those histories, and about the way it also transcends them.

The second perspective belongs to the masterwork's client/owners, to the people, that is, who manage the institution it houses, who come to know the building's inadequacies and dream of solutions to those inadequacies, who feel the need to expand, and, in so feeling, begin to resent the very walls that so idiosyncratically contain them. These two worlds are almost bound to come into conflict, with the former cast as conservative."[10]

Salk himself saw the dispute in the broadest terms and viewed Kahn's building as an architectural realization of his own scientific vision, a true partnership between patron and artist:

> I was trying to create something that would go on forever, and be capable of change, and now we're talking about another school of thought: no change. I'm not unfamiliar with that. That's the difference between discoverers and followers. This is a place for discoverers, explorers. . . . And if I were to do something other than what seems to me to be a sequence into the future I would not be true to myself or to Louis Kahn. I wish that Kahn were here to affirm, himself, what I think is the spirit in which we had worked until now.[11]

Though his final decision was an aesthetic lapse in the view of the architectural community, Dr. Salk plainly saw himself as a custodian and steward, and not simply as an owner exercising dominion. He acknowledged that having built well he was burdened more, and he seemed willing to accept some responsibility growing out of his role as a patron of great architecture. Of course he also viewed himself as a principal whose own conception of the structure was central to its destiny.

Salk did provide a forum for his critics, and he seems to have taken them seriously, though observers differ as to just how open to debate he was. Following a round of protest letters from a number of prominent architects, Salk met privately with several of them to discuss their objections and even modified the proposal somewhat to try to meet their concerns. In November 1992, he met with 135 architects, experts, and scholars at the Urban Center in New York. He personally presented a somewhat modified version of the plan, made in response to earlier criticism, and listened as members of the audience, including Kahn's widow, Esther, as well as a number of distinguished architects and architectural historians voiced their opposition to it. Dr. Salk spoke movingly of his joy in working with Louis Kahn. The opponents spoke with equal feeling of the building's importance to American architecture, and to them as professionals. In the end, though, he did not yield to their judgment, and in fact a groundbreaking for the building had previously been scheduled for just one week after the New York meeting.

Ultimately, the San Diego Planning Commission approved the proposal at a meeting where Dr. Salk himself was present and spoke in its favor. No one appeared to speak against it, though a number of letters opposing the plan had been sent to the commission. The city council then denied an appeal, with a single dissenting vote cast by the one architect on the council. The appeal claimed that the proposed addition violated the city master plan, and an earlier landscape design plan that called for retaining the eucalyptus grove in order to provide "site identity"—weak legal claims, however strong their aesthetic merits. San Diego's Historical Site Board had at one time discussed designating the Salk Institute as historical, but decided not to act. Designation would have required a series of public design presentations. An appeal was even made to the California Coastal Commission, but it concluded that it had no authority to preserve modern buildings, no matter how significant they were. In the end, deference to Dr. Salk carried the day.

The Salk Institute affair suggests how difficult such matters can be. If ownership alone is not self-evidently decisive (and that certainly is the thesis of this book), neither is it obviously irrelevant. Here, unlike the Diego Rivera murals, it may not be possible to separate the patron from the art. The collaboration was profound, and Dr. Salk had a stake in the buildings that went far beyond mere proprietorship. Many other distinguished structures, however, are owned by investors whose interests are primarily if not unreservedly economic. One would be hard pressed to write a regulation that distinguished worthy (Salk-like) owners from mere money-grubbing ones. Similarly, though professionals were predominantly opposed to his plan, some highly regarded architects endorsed it. And, as we are constantly reminded in a variety of situations, why should one expect any special wisdom from a city council or any other collection of public worthies?

Perhaps the best we are likely to do in such cases is to establish a process that enhances the possibility of a desirable outcome. Government has a role in identifying structures that are important, either because of their historic interest, or their artistic significance, regardless of age. For such structures (and their designated environs), proposed modifications should trigger a professional review and recommendation process. The release of the professional report would encourage public discourse and debate, and hopefully influence owners. A permit might then be required, following consideration in light of a policy that historically and aesthetically important structures be protected against unnecessary and destructive changes. That is the rather well established approach taken under historic-preservation ordinances. Alternatively, construction might be allowed to

proceed after a certain time has elapsed unless the city took some action to halt it. A less interventionist approach might call for designation, and a requirement for a moratorium and a public hearing, which would impose the burden of going forward on critics of a proposed change. Whatever the ultimate choice about a regulatory regime, some arrangement that permits the professional and affected public communities to be heard, and to convey to proprietors the importance to the community of the work they own, seems appropriate.

Recalling the experience of other cities with architecturally important structures may help flesh out the range of available experience and opportunity.

The Guggenheim, Whitney, and Kimball Controversies

New York City was able to provide forums for competing visions in two celebrated instances where proposed additions to the work of famous architects generated serious controversy, and in the end, significant change.[12] At almost the same time in the mid-1980s additions were planned for Marcel Breuer's Whitney Museum of American Art, and Frank Lloyd Wright's Guggenheim Museum. In both cases those structures were the only examples of the architect's work in Manhattan (though, ironically, it was Breuer who designed the rejected addition to Grand Central Station that was the subject of the Supreme Court's notable *Penn Central* decision, discussed below).[13]

Each of the proposed additions had its respected advocates and detractors. Though neither museum was old enough at the time to be classified officially as a landmark under the New York City law (thirty years is the minimum age), the Whitney was within a designated historic district, so the planned addition required a "certificate of appropriateness" from the city's Landmarks Preservation Commission. The commission held a daylong hearing at which the fate of the proposed addition was debated by a parade of New York's most noted practitioners, experts, and writers.[14] Opponents were critical both of the proposed structure designed by architect Michael Graves, and of the need to raze a row of brownstones along Madison Avenue. Ultimately, the plan was abandoned in favor of an expansion accomplished by renovation of two townhouses the museum owned behind the main building.[15]

Although the Guggenheim was neither a designated landmark, nor within an historic district, and was therefore ineligible for review by the Landmarks Commission, it was subject to a hearing with quite similar prac-

tical effects before a conventional zoning body, the Board of Standards and Appeals. The usual passionate verbal effluvia were exchanged. A supporter of the addition spoke of the "biological needs" of the Wright structure, and "soft wonderful dialogue" of the addition; while an opponent urged the board "to repudiate the idea of altering this holy building."[16] The original proposal by Charles Gwathmey and Robert Siegel, which would have cantilevered a large structure over the museum, was significantly scaled back, and as modified was then built, and opened to the public in 1992.

While the new Guggenheim structure is considerably less intrusive than the original plan, it has certainly not generated unanimity of response. Brendan Gill, the *New Yorker*'s architecture critic, said "it looks better now than it ever looked—you'll be seeing the museum as Wright dreamed of it."[17] But the president of the organization of Friends of the Upper East Side Historic District concluded that "it wrongs Wright. The museum has disfigured the greatest work of art it owns." *Time* magazine, with admirable restraint, called it "a bland and only slightly annoying intrusion."[18] There's no accounting for taste; more importantly, there's no need for uniformity of taste. The pertinent fact is that a process devoted to the architectural merits of the proposal took place, which created an opportunity for public exposure of a range of views, including those in the architectural community. Changes were consequently made in response to that process, rather than merely as an expression of proprietary prerogatives.

A more informal sort of discourse led to changes at another of Kahn's fine buildings, the Kimball Art Museum in Fort Worth, Texas. There, in 1989, an ill-conceived, imitative addition was about to be built when a number of eminent architects came together to protest. They successfully persuaded the client to back down and saved the integrity of Kahn's work. Such accommodations are most likely to occur when the owners see themselves as custodians.

A Last Word on the Salk Institute

Notably, the law does not give even a living architect the unqualified right to prevent alteration, of the sort that artists hold under the principle of *droit moral*. A federal law known as the Architectural Works Copyright Protection Act provides that owners may alter or destroy a building without permission of the architect or copyright holder.[19] The idea, presumably, is that architects create works for clients in a way that artists generally do not. Architects are, however, allowed to contract for control over alterations,

and where landmark and historic-preservation ordinances apply—mostly to older structures—such laws can also restrict the range of permissible change.[20]

Ground was broken for the Salk Institute addition on Thursday, November 12, 1992. A few days later, the critic Herbert Muschamp wrote the following epitaph for the controversy:

> It cannot be pleasant to be hounded by a posse of architectural busybodies. With building permits in hand, Dr. Salk is not legally obliged to heed their objections. Nonetheless, he should recognize that he is now enmeshed in a cultural conflict of interest. As Kahn's patron, he has gained an honored place in architectural history. As a custodian of Kahn's work, he is responsible for protecting that work from harm. Dr. Salk has yet to understand that the two roles are not one and the same. His immense stature as a patron cannot shield him from criticism of his custodial shortcomings.[21]

To describe Dr. Salk as a custodian is to assume that he, unlike an ordinary owner of an ordinary building, bears a special burden as his reward for having endowed us with a magnificent structure. That seeming paradox has not escaped some, including the chief justice of the United States. It is the very matter he sought to raise in the *Penn Central* case.

The Penn Central Decision

Grand Central Terminal in New York was constructed in 1913.[22] For more than half a century it operated as a railroad station and as one of Manhattan's most familiar landmarks, situated at the intersection of Forty-second Street and Park Avenue. In 1967, following a public hearing, it was designated under the City's Landmarks Preservation Law as an official "landmark." The commission report described the station as "one of the great buildings of America. . . . It combines distinguished architecture with a brilliant engineering solution, wedded to one of the most fabulous railroad terminals of our time. Monumental in scale, this great building functions as well today as it did when built. In style, it represents the best of the French Beaux Arts."

As the owner of a designated landmark, Penn Central had to get permission from the commission to modify or demolish the station, or to make any changes in its facade. In 1968, the Penn Central Company, in order to increase its income, entered into a contract to allow a fifty-plus-story office tower to be built above the existing structure. Two alternative

plans were designed by the distinguished architect Marcel Breuer and sub-
mitted to the commission for approval. One called for the tower to be can-
tilevered atop the existing facade, resting on the roof of the terminal. The
other would have required tearing down a portion of the terminal, includ-
ing the Forty-second Street facade facing Park Avenue. Following four
days of testimony, and after hearing over eighty witnesses, the commission
denied both proposals. "To balance a 55-story office tower above a flamboy-
ant Beaux-Arts facade seems nothing more than an aesthetic joke," its
decision said. "The 'addition' would be four times as high as the existing
structure and would reduce the Landmark itself to the status of a curiosity."

Penn Central sued, claiming that the decision constituted a taking of
its property without the payment of just compensation, in violation of its
constitutional property rights. After fully pursuing its claims in the New
York courts, Penn Central appealed to the U.S. Supreme Court. Surpris-
ing as it may seem, no landmark-designation/property-rights case had ever
been heard by the Supreme Court. While historic-preservation ordinances
had been commonplace in the United States for many years—the Court
noted that there were more than five hundred of them in force—most were
of the sort that established historic districts, such as New Orleans Vieux
Carré or Santa Fe's old town.

The essence of Penn's Central legal claim was twofold: first, that tra-
ditional historic-district ordinances were justified by a theory called mutu-
ality of benefit and burden; that is, that while everyone in a district was
restricted from modifying a building, each was also benefited by the restric-
tions imposed on neighbors, which collectively attracted tourists and
brought economic benefits to all. A similar theory underlies most zoning
laws: height or density is limited in an area, but everyone in the zone has to
comply with the same restrictions in order to get the benefits of light and
air, or lessened congestion. As a result, the value of all property in the dis-
trict is sustained. There was no such mutuality in the New York case, Penn
Central said. The landmarking singled out an individual building such as
Grand Central Station, and while its attractiveness may have benefited
others, others bore no parallel burdens on its behalf. Indeed, owners of all
the neighboring buildings were perfectly free to build skyscrapers and to
reap the economic benefits, while Grand Central Station alone (but like
other such designated structures in the city) had to remain as a low-rise
"landmark."

Penn Central's second argument was that the only justification for
singling out a particular owner for restrictions was if it was doing some-
thing harmful to others. A particular polluting factory could be restricted,

as could an unsafe construction site, or a nightclub that was making noise and disturbing its neighbors. Penn Central, however, was admittedly not engaged in any harmful activity in the sense of threatening safety, health, or morals. Penn Central emphasized that it had created no excessive density, noise, blocking of light, increased fire hazard, or the like. In fact, it urged, all that distinguished it from other, nonregulated owners, was that it had done something admirable. Like Dr. Salk, it had built an especially fine building.

The Supreme Court was not of a unanimous view. It divided six to three. The majority of justices joining an opinion written by Justice William Brennan, rejected Penn Central's claims and sustained the landmark designation ordinance. Justice Brennan and the majority of his colleagues viewed the case as a conventional one, citing both standard zoning and regulatory decisions, but never really addressing Penn Central's point that all those cases rested either on some notion of mutuality, or on some claim of harm. None involved the mere withdrawal of a benefit (the presence of an aesthetically desirable building) that had previously been conferred on the neighborhood.

Chief Justice Rehnquist wrote a dissent. His opinion evinced a strong sense that *Penn Central* was fundamentally unlike an ordinary zoning case, though he did not elaborate the point. He did, however, make one striking and ironic observation: "Penn Central is prevented from further developing its property," he said, "basically because *too good* a job was done in designing and building it."[23] The point is a telling one. In the ordinary case, obligation arises only because the owner has done something undesirable. Justice Rehnquist pointed out that the sole reason Penn Central was worse off than its neighbors was that it had designed and built an especially fine building, and that it now wished to withdraw the benefit that its presence had conferred. Notably, nothing in the proposed demolition itself nor in the increased density Penn Central proposed was prohibited. If the existing building had been an undistinguished one, Penn Central would have been perfectly free to demolish it and build a fifty-story replacement without running afoul of the law.

The conclusion implicit in the Rehnquist opinion is simply that one who owns something deemed especially valuable to the community, by virtue of that fact, and his previous gift of the benefit of that boon to the neighboring community, has somehow incurred an obligation to protect or preserve the object for the benefit of the community. He called this special sort of obligation "an affirmative duty to preserve,"[24] contrasting it with the usual negative duties to refrain from doing harm. He also suggests that one

of the ordinary elements of a property right, the right to "dispose" of one's own property, had been withheld from Penn Central.[25]

Rehnquist is correct in observing that the *Penn Central* case departs from the conventional view of the rights and responsibilities of owners, and acknowledges a new sort of affirmative obligation. Moreover, the benefit Penn Central is required to maintain and confer is its own creation, which would not be there but for its commitment to quality and good taste. It is not the beneficiary of mere luck, finding oil beneath its land, or the possessor of a bounty of nature (such as a grove of ancient redwood trees) to which it has contributed nothing. It is—by ordinary standards—an unlikely candidate to be subjected to governmental restriction.

The question that the majority declined to address is whether "ordinary standards" should apply to the owner of an architectural masterwork. Justice Rehnquist deserved a reply to the paradox he had identified. Perhaps the best answer is that while the patrons (or owners) of an important work of architecture were not obliged to engage with a masterwork, having done so they have by their own voluntary act potentially made the community *worse* off than it would have been if they had never acted. It is insufficient to say that the work would not have existed without their patronage. For they have diverted the time and effort of an artist from other work he might have done, and that—in other hands—might have been better protected or made more widely accessible. In that respect, to engage with an important artist or artifact is to make oneself responsible. In perhaps an even more obvious way, those who patronize a great architect not only divert that individual from other opportunities, but put a structure upon the landscape that inevitably shapes and changes the community around it.[26] It is hardly a purely private act.

Like someone who opts to work with a needed but dangerous substance, or a vital service, his choice puts him in a position where what he does affects a great many people other than himself. One need not have chosen such work, but having done so, he has put himself in an especially responsible position. To be sure, with art or architecture the risk is a loss of cultural opportunity, rather than the physical risk of harm the law has historically recognized. And, to be sure, the law has customarily dealt with material rather than aesthetic and intellectual loss. Yet the impact on others generated by an individual's choice to engage creators and to take dominion over potent cultural icons makes the Rehnquist paradox less problematic than it at first appears.

In any event, these are some of the questions one might have expected the Court in *Penn Central* to address, while recognizing that it would be

staking out previously unexplored territory. For whatever reasons, the majority did not take up Justice Rehnquist's challenge. The courts are apparently not yet ready directly to confront the proposition that the public has a stake in the fate of objects of "special historic, cultural, or architectural significance"[27] and that their proprietors are, as Herbert Muschamp said of Dr. Salk, not just owners but custodians. So Justice Rehnquist's challenge went unacknowledged and unanswered. The owner-as-steward remains the law's awkward little secret.

Collectors: Private Vices, Public Benefits

Art is meant to be shared with the public, not just squirreled away
in someone's private possession.

— Kent Logan, collector

Vast stores of the very greatest works of art are held in private collections.
The Chinese have been collecting art for more than four thousand years,
and collecting was fashionable in ancient Rome. Public museums, as we
know them, only date from the mid–eighteenth century. Until that time,
virtually all art treasures were held in private collections. While royal col-
lections were in a certain sense public, and aristocratic holdings were often
made available to interested connoisseurs, as a formal matter these holdings
were just ordinary private property. Rulers treated their art as their own,
when it suited their needs, and fine works in precious metals were melted
down to support armies on more than a few occasions.[1]

Even today, for all the flourishing of museums, private collectors con-
tinue to play a central role both in sustaining the art heritage of the past and
in nourishing contemporary art. The collector has a very peculiar position
in the society. He or she is crucial to the protection of objects that are of
great importance to a community of national, or even global, scope.[2] The
collector possesses, owns, and has control of these objects, and yet has no
public or official position, and no formal responsibility for their care and
protection. Moreover, a primary value of the collector is the very presence
of individual and eccentric, often advanced, tastes that would never be
reflected in (indeed is all too often rejected by) official canons of selection
or propriety. As Joseph Alsop noted in his book on art collecting, "No one
on earth can define good taste or bad taste in a way that will be valid and
durable, even for so short a period as two generations. There is only the
good taste of a particular time and place, which may be described as the

taste of those men with the best minds and eyes who have cared much about art in that time and place."[3]

Any history of great art collectors is in significant part a story of taste ahead of its time, at best ignored, at worst reviled, by the public. Krzysztof Pomian ends his history of collecting and collectors with the observation that "over a very long period, public collections greatly lagged behind the artistic, historical and scientific interests of . . . collectors."[4] His general conclusion is that private collections were among the most important sources of cultural innovation from the fifteenth century onward. Indeed it is highly likely that they have remained so in the majority of countries, if not all, to this very day."

Dr. Albert Barnes, to whose story I shall come shortly, happened to be a particularly unpleasant man, but he collected French impressionists while the American art establishment still scorned them. A nineteenth-century French collector, Louis La Caze, who left his marvelous collection to the Louvre, bought for virtually nothing paintings by artists in whom nobody at the time was interested, Watteau, LeNain, and even Tintoretto, one of whose masterworks he got for seven francs. The first serious admirer of Cézanne was the collector Victor Chocquet. Chocquet agreed to give the Fine Arts Section of the 1889 Universal Exhibition in Paris some fine furniture they wanted if they would exhibit a Cézanne. The sponsors agreed, but then hung the painting in such a dark corner that it was impossible to see it.[5]

In the early nineteenth century Luman Reed collected American art that was almost universally ignored. When Reed died in 1836, his friends couldn't raise enough money from subscriptions to establish a gallery to house his collection. In desperation, they gave the now-invaluable material, including works by Thomas Cole, to the New York Historical Society.[6] Another nineteenth-century connoisseur, James Jackson Jarves, collected Italian primitives no one attended to, such as Antonio Pollaiuolo, Stefano Sassetta, and Gentile de Fabriano. He gave his collection, some 119 paintings, to Yale University as collateral for a loan. When he defaulted, no buyers could be found for the works, which Yale subsequently sold for twenty-two thousand dollars, less than two hundred dollars each. In 1906, George A. Hearn gave the Metropolitan Museum a fund with an income of one hundred thousand dollars to buy American art, but the officialdom there was so reluctant that they had trouble spending it.[7] The stories are legion.[8]

Notwithstanding their munificence, collectors have always been the objects of criticism, reviled as avaricious hoarders, or condemned for seeking social position by identifying themselves with greatness. S. N. Behrman wrote

that of the twenty-three lines in the *Encyclopedia Britannica* article on the steel magnate Henry Clay Frick "ten are devoted to his career as an industrialist, and thirteen to his collecting of art. In these thirteen lines he mingles freely with Titian and Vermeer. . . . Steel strikes and Pinkerton guards vanish, and he basks in another, more felicitous aura."[9] (A redeeming footnote might have recorded that Frick ultimately left his house and his magnificent collection to the public.)[10]

Will Durant spoke of "perfuming a fortune with the breath of art,"[11] and a recent book analyzing the psychology of collecting observes that collectors' "choice of art is a conscious attempt to design their own smart identity. Collections of high art . . . declare 'I am rich and have a well-developed taste.'"[12] This view has been tellingly confirmed in the so-called cabinet painting of seventeenth-century Antwerp, in which actual collectors are portrayed in their homes surrounded by depictions of the paintings and other valued objects in their collection, as well as by recognizable figures whose presence confirms their taste and the status their distinguished collection confers on them. One of the most prominent such paintings, the *Gallery of Cornelis van der Gheest* painted in 1628 by Willem van Haecht, has been described this way:

> The collector . . . stands to the left and points to a painting of the Madonna and Child. His immediate audience are the two seated figures, none other than the governors, Albert and Isabella, who are known to have visited van der Gheest's house in 1615. However, the painting is more than a document of a transcendental event in the merchant's life; it affirms the nobility of the collector and his collection. . . . Van Haecht was equally scrupulous about recording the appearance of the pictures in the collection, which constitute an anthology of the Antwerp School from Quentin Massys . . . to Rubens. . . . Van Haecht's painting might be classified as a "real allegory." . . . The elaboration of van der Gheest's status is obviously first on the agenda. Not a trace can be found of the mercantile activities which made it possible for him to own works of art worthy of a royal visitation.[13]

Not surprisingly, the unkindest observers of all are the psychologists, one of whom explains that "collecting is a regressive (anal) activity with strong narcissistic and fetishistic traits. . . . [T]o collect is to deny . . . death and castration."[14] While some collectors, like Queen Christina of Sweden, have been highly cultured and passionately interested in learning, certainly one need not be a sensitive or admirable person to acquire a great art collection.[15] The noted French art dealer René Gimpel said a collector of woodcuts told him, "[T]he day after the death of a great engraver, I'd rush round to his widow or see his family and buy the complete works. I've made good

use of my opportunities." His eyes were sparkling, Gimpel says. "What a book could be written on the cruelty of the collector!"[16]

Another view, expressed by Victor Ganz, himself a very distinguished collector, lamented, "People vie with one another. . . . It gets to be a very competitive thing. . . . It worries me because it seems to represent values that have nothing to do with being interested in the art as art. . . . I don't think many collectors are seriously involved with the work. They want to show the world how smart they are, that they go in early. . . . Then there are these collectors who don't even choose the stuff themselves but have curators of their own. They have a paid person who goes out and says, 'I've just gone out and seen so-and-so. I think we should buy it.' Often the curator buys it without even telling the person whose money he is spending."[17]

There is nothing new in all this censure. A classical Greek epigram holds that the image of a collector is a donkey before a lyre, and a French joke describes the croissant collector, with an example from every bakery, who intends to bequeath his hoard to the Louvre. Plainly mania, vanity, and self-importance are common among collectors, and the true connoisseur is exceptional. Yet the public needs the collector and needs collecting to remain a private function, reflecting private desires. The result is the oddity of private parties who are effectively custodians of objects that are vital to the public agenda.

A nineteenth-century book on the history of collecting in France, after noting all the celebrated jibes made against those who devote themselves to acquiring and amassing mere things, bidding against each other to demonstrate who has the most money to burn, concluded that "even the excesses of competition have their good side: they stimulate research and the preservation of beautiful things that otherwise would be ignored or abandoned. It is thus that the collector, even the most irrational, even the most muddled, pays his debt to the nation. . . . To form a collection is to play the good citizen."[18] Bernard de Mandeville put it succinctly two hundred years ago: "private vices, publick benefits."

Hidden Treasures

If a collector's unqualified ownership permits the indulgence of private vice to obliterate public benefits, however, either by destruction or long-term sequestration of important works, all is not well. For the most part, collectors do not mutilate or destroy the objects they collect. On the contrary, unlike the owner of an historical structure whose property stands in the way

of desired development, or the occasional patron who destroys for ideolog-
ical or egoistic reasons (à la Rockefeller or Churchill), collectors usually
treasure their possessions and protect them from harm.

When problems arise, they usually involve access, or more particularly,
lack of access. Such instances are not as rare as one might hope,[19] and they
are usually accepted as one of the privileges that goes with collecting. The
long-term inaccessibility of a great artist's work in a private collector's
hands is usually tossed off as a perfectly normal, even commonplace, fact.
A *New York Times* article spoke of "the archetypal collector who likes to
enjoy his favorite art in the privacy of his home," discussing the late Swiss
collector Josef Mueller, who "liked to gaze at his art . . . and . . . refused to
lend his modern masterpieces."[20]

This accepted practice, together with widespread recognition of the
public stake in important objects, can lead to situations of extraordinary
incongruity. France, for example, restricts the sale for export of works of art
it considers part of its national patrimony, yet when a restricted work is
then sold within France the new owner has no obligation to allow any form
of public access to it. In a study criticizing the French government for
objecting to the export of a Poussin painting to an American museum, Pro-
fessor John Merryman ridiculed the claim that the French people had been
deprived of an important part of their national cultural heritage, saying,
"[T]he obvious response is that the French people had no access to this
painting when it was in the French private collection. . . . [So] in what
sense could it be said that the French had 'lost' the Poussin?"[21]

Similar instances are all too common. The Armenian magnate
Calouste Gulbenkian refused to allow visitors into his house on the Avenue
d'Iena in Paris. He was known to say, "Would I admit a stranger to my
harem?"[22] His treasures, laid out in the most beautiful and lavish surround-
ings, were admired only by two footmen and the night watchman.[23] The
rich German collector Johann George Bögner bought extravagantly and
then, as the rooms of his house filled, he shut them off one by one, for-
ever.[24] An article about Picasso's painting *Pierette's Wedding*, one of the last
important works from his blue period, reported that "it has never been
exhibited at a museum in the United States; in fact, few people have ever
seen it." The painting was so elusive that between the end of World War II
and 1988, when it was put up for sale at auction, it was generally believed
that it had been destroyed. No living scholar had laid eyes on it. It had been
in the living room of a Swedish businessman, Fredrick Roos, for forty
years.[25] As recently as February 1999, a British collector named Nicholas
van Hoogstraten, who is reported to own works by Holbein, Turner, and
Constable, among others, was quoted as saying: "There won't be any riff-

raff coming in, standing on the Persian carpets. The only purpose in creating wealth like mine is to separate oneself from the riff-raff. This is a private museum for me."[26]

Along the same line, a 1995 press report on an upcoming auction reported that "some of the most beautiful books in the world . . . are rarely exhibited. . . . In fact, one collector is so private in guarding his French modernist bindings, . . . that he has kept them in a Manhattan warehouse for a decade. . . . There are all these beautiful things in the sale that no one has seen for 10 or 15 years."[27] And the September 1997 issue of *ARTnews* explained that scholars had finally tracked down the last of the suite of sketches used by Seurat to create his famous painting *Bathers at Asnières*, which had been held for years by a French collector who refused experts' requests to study it, and which only became available after the collector died.[28]

Even objects of scientific importance have sometimes been hidden away. A never-published manuscript, replete with edits in Einstein's hand, in which Einstein elaborated on his special theory of relativity, was undiscovered until 1987, when it was sold at auction to an anonymous owner who kept it behind closed doors until it was put up for sale in 1996. Though it is said to have laid the groundwork for Einstein's general theory of relativity, it had never been available to scholars or the public.[29] Perhaps the most notorious instance of all involved Eugen Dubois, who in 1892 discovered the first fossil remains of a human ancestor, *Homo erectus*, known at the time as Java man. His find, which scientists now agree was highly significant, provoked a major debate at the time. Though Dubois's analysis gained increasing acceptance during his lifetime, there was strong and powerful opposition and his paranoia vanquished his professionalism.[30] In reaction Dubois locked his fossils away in a vault for nearly twenty-five years so that those who doubted his work could not see them. In the 1920s he at last opened his vault and brought the Java fossils out where they could be studied by independent researchers, the result of pressure imposed by the Dutch Parliament and complaints of scientists worldwide who had been denied access to a major scientific discovery.

A Collector's Duty to the Public

Insofar as there is a significant public interest in access to these objects, their effective disappearance for decades, sometimes for generations, cannot be dismissed as a harmless eccentricity. Still, in light of the importance to the society of having collecting as a private—unofficial—activity, and

encouraging free spirits to engage in collecting, a considerable degree of caution is appropriate in suggesting restrictions on collectors. Moreover, it would be self-defeating to do anything that would encourage emigration of major collections out of this country to what might be considered more hospitable venues (a special concern in dealing with the highly mobile superrich).

A simple solution may be the best one: we might see how successful, satisfied, responsible major collectors behave, and inquire whether their conduct could practicably be asked of others with major holdings in their collections. The essential issue is access. Many collectors allow at least artists, experts, and other connoisseurs to see and study works of art in their home, or loan them periodically. Such practices can significantly bridge private and public imperatives. So long as privately held masterworks are open to study and enjoyment even once or twice within each generation, at least the rudimentary demands of the public agenda—that knowledge be maintained and advanced, that artists, scholars, and historians be able to build on the capital of the past, and that interested citizens be able to partake of the cultures that bred them—can be met.

Voluntary arrangements for access are, of course, preferable. Public incentives can provide further encouragement to collectors, as we do by allowing tax deductions for the value of gifts of art to public museums.[31] English laws have given tax benefits to those who sell or give art to the nation, or preserve artworks within national boundaries.[32] The United Kingdom also permits relief from certain capital taxes in exchange for which an owner may be obliged, while retaining ownership, to make a work of art available for public exhibition.[33] In Germany, reportedly, a five-year gratuitous loan to a public museum provides some relief from wealth taxes, and Austria has a similar law.[34] There are other imaginative incentives that encourage public-spiritedness. The Metropolitan Museum, for example, provides a summer loan program. Collectors can lend important works to the museum for exhibition during the hot months when they are on vacation. The public thereby benefits, the owners miss nothing and even gain from the fact that their precious possessions are in good hands, rather than in an empty home or in a vault.[35]

Where no such incentives suffice, consideration should be given to a system of obligatory, expense-compensated loans to public institutions. The idea of a duty to provide access to important works of art has been in the air for many years; it was suggested as early as 1976 by Professor Monroe Price.[36] (The idea has also had vociferous critics who claimed that any such responsibilities would unduly discourage collectors, and that voluntary

loans and gifts adequately serve the public.)[37] If such an obligation were imposed, owners would be obliged to lend previously unavailable works in which there is a strong public or scholarly interest to a major museum or other designated public institution.[38]

Implementing any such duty would be difficult, but by no means impossible. Curators seeking to put exhibitions together are after collectors with important holdings all the time. No collector should have to accommodate every exhibit-planner who has an idea for a new perspective on an artist, or to contribute to a show at all the venues in a proposal. It is also important to be sensitive to the fact that "collectors are very possessive," as the head of the Brooklyn Museum observed, "even the most generous collectors, who lend to museums all over the world. It is like talking a family into lending their children for a while."[39]

While no entirely satisfactory scheme is possible, a limited proposal might look something like the following: a committee of experts operating under the auspices of a national museum, such as the National Gallery of Art, could identify artists and/or particular works important enough to be on an obligatory loan list, and that have not otherwise been exhibited publicly for some specified period. A listed work would be amenable to obligatory exhibition for a limited time (perhaps sixty or ninety days total) at one or several designated major venues within the United States. No such obligation could be demanded more than once within a certain period (perhaps ten years). Were this sort of obligation recognized, it would be appropriate to charge the national museum with ultimate responsibility for every aspect of the loan, such as insurance, transportation, and the like. No such costs should be borne by the owner.

Arrangements such as those suggested here should be a matter of last resort, to be employed only where the usual blandishments of museum directors have failed, and where the work and the proposed exhibition is deemed of special import. The terms of any such obligatory loans should make collectors no better off than they usually are with voluntary loans; obviously one doesn't want to make such arrangements more attractive to collectors than voluntary loans. On the other side, the costs involved in implementing such a compulsory scheme would likely assure that the authority would be sparingly used.

Obligatory loans of this sort could apply to objects such as paintings or movable sculpture, and where privacy concerns were not an issue, it could even be adapted to some immobile works. For example, there are Diego Rivera murals in a private club at the top of the Stock Exchange building in San Francisco. That club has periodically set aside regular times when the

public is admitted to see the murals. If no such gesture were forthcoming, and a work were important enough, such a site, in a club or a school for example, could be opened to public view at certain limited time intervals, and during hours that would not significantly interfere with other activities.

Where privacy is in issue, however, public concerns should give way. The case of a private home that is a great architectural masterpiece, but that has never been opened to public view, and where the owner refuses even to permit photographs to be published or made available, would be illustrative. If the home in question were as significant as Frank Lloyd Wright's Kaufman house, Fallingwater, in Pennsylvania (which is now owned by a conservancy and is open to the public), there would certainly be an unfortunate loss to the public. In any such situation, however, privacy militates against legally compelled openings to the public. Sometimes important values clash irreconcilably. The public will then have to wait for a more public-spirited (or prideful) proprietor.

The Collector as Steward

The proposal outlined above assumes that the owner of a great work of art does not have all the rights of exclusivity that go with conventional ownership. In the preceding chapters, it was urged that there should be no right of destruction as against the public; here that claim is extended to suggest a duty to provide access, under highly limited circumstances, as an additional restriction on ownership. Indisputably, any such imposition takes something away from the owner, but it does not intrude markedly on the core interests of collectors: the pleasure and prestige of acquisition and association; use and enjoyment (virtually) all the time; and the opportunity to benefit from potential increase in monetary value. To be sure, the conventional core right to exclude would be gone, but it is not exclusion in the usual sense of protection of privacy, or the right to reap the usual economic benefits of use and development. Since only costs would be covered, the owner would lose the rental value during the period of obligatory exhibition, but that is unlikely to be a significant matter for the owners of great works of art.

It is a striking fact that many, perhaps most, serious collectors have acknowledged a limitation on their entitlement by some form of restrictive self-characterization of their status. Though collectors are by definition acquisitive people and collect for a variety of reasons that are by no means always admirable ones, those who own important works routinely describe

themselves as trustees or stewards. Living with great art seems to effect a transformation in attitude and approach. It was said of the noted Picasso collectors Sally and Victor Ganz that "their engagement expanded beyond the private interaction of buying for their own satisfaction to the public stewardship that guides our public museums and civic projects . . . placing works in museums, lending pictures to exhibitions, and welcoming a constant stream of visitors into [their] home."[40] Leon Levy responded typically, at least for American collectors, when he described himself as merely "the temporary custodian" of his collection.[41]

To be sure, the operative meaning of such statements is far from clear, as evidenced by the penetration of the vocabulary of stewardship even into commercial advertising. The text of a recent blurb for an expensive watch reads, "You never actually own a Patek Philippe. You merely take care of it for the next generation."[42] The message there, of course, is not that the owner has responsibilities, but that this particular expensive wrist watch is really a work of art. While most collectors would doubtless strongly resist having any legal obligations of trusteeship imposed upon them (including those suggested above), many collectors who own important works of art appear to take their role as custodians seriously. They welcome experts and artists who want to study their holdings. They are commonly willing to lend their works to exhibitions, and by means of their philanthropy (long subsidized in the United States through the tax laws) many, perhaps most, of the greatest works eventually find their way into public museums.

Collectors come in many varieties, and the notion of the owner-steward takes many forms. The frequency with which collectors of the most varied stripe see themselves as the bearers of some special responsibility that transcends indulgence of their own fancies is quite striking. As one author put it, "[S]ome people feel that they are no more than the fortunate, if provisional, trustees of certain works of art, having no right to deprive others who appreciate beautiful objects as much as they do themselves."[43] While most such statements should probably be taken with a modicum of skepticism, I suspect that the following statement by a collector named Douglas Cramer, a very successful television producer, probably comes as close as we are likely to get to what the majority of serious major collectors really think:

> Whether or not I leave my art to MoCA, or the Museum of Modern Art, or dispose of it at auction and then distribute the proceeds is entirely up to me. I don't care if you have a thousand pictures in your possession, you have an American right to dispose of them as you choose.

I do, however, feel an obligation to the art. I don't approve of people who collect and don't lend, or of people who don't make their art as visible and accessible as possible. I've always made this house available to reasonably-sized groups. At one time, the place was open three or four days a week. . . . But this isn't a museum. It's my home.[44]

Probably the earliest collector to characterize himself in stewardship terms was Richard de Bury, who was the bishop of Durham and chancellor of King Edward III in the fourteenth century. He is best remembered for his extensive book collection and for a remarkable little book he wrote, entitled *Philobiblon*. No one knows exactly where de Bury acquired his love of books. We do know that in the service of the king, he frequently visited the Continent, that he was acquainted with Petrarch, that he laid down regulations for the management of his intended library drawn from those made for the Sorbonne in 1321, that he was a visitor to Oxford whose task was to inquire into the state of the king's scholars there, and that he was a member of one of the guilds that founded Corpus Christi College.

In any event, he wrote in *The Philobiblon* of his passionate love of books. Happiness, he said, consists in contemplating the truth of wisdom, and the contemplation of truth is never more perfect than in books.[45] No man, according to his biographer, has ever carried to a higher pitch of enthusiasm the passion for collecting books; he collected everything and he spared no cost.[46] But de Bury worried that his enthusiasms might be thought to be excessive, even avaricious. How could he justify the possessiveness his conduct demonstrated, with the piety and humility that his position demanded? Chapters 18 and 19 of *Philobiblon* provide his answer. The first is headed "Showeth that we have collected so great store of books for the common benefit of scholars and not only for our own pleasure," and the second "Of the manner of lending all our books to students." He intended to endow a college at Oxford, with sufficient funds to maintain a number of scholars, and to enrich it with his books, which would be available for use not only by faculty but by "all the students of the before-named university for ever."[47] That stance set the tone for later collectors of rare and important objects.

On May 23, 1642, another voracious collector, Cardinal Richelieu, put a provision in his will stating that he had made his library as complete as possible "so that it shall serve not only my family, but the public as well. . . . [K]eep it in good condition, and allow admission, at certain hours of the day, to men of letters and erudition, to see the books and to study them in the library."[48] Richelieu and Cardinal Mazarin, who gave to France (and ultimately to the Louvre as a public museum) some of its greatest paintings,

were the first collectors in France to open their libraries to the public and to scholars.[49] These benefactions stand, despite our knowledge that Richelieu, for example, collected first and foremost to enrich his family and to exalt its social position.

It is said that the Medici exemplified the merger of self-aggrandizement with public benefaction. When Francesco I put his private collection on public display in the newly constructed Uffizi Palace in Florence in the 1570s, it was to create a public gallery of sumptuous private property as an expression of the worthiness of an individual life. "Private biography was thereby magnified and projected through public exhibition."[50] At about the same time in Spain, a member of Philip II's entourage, Philip de Guevara, picking up the threads of ideas then current in Italy, suggested that pictures of a bygone age that were being kept in various royal residences should be open to view "for people of artistic sensibility."[51]

By the eighteenth century, Enlightenment ideas were converting aristocratic magnanimity into a public entitlement of sorts. Collections were reconstituted as publicly accessible museums in the modern sense.[52] The extraordinary development by which the great aristocratic collections were opened to the public was followed by a period in which the greatest collectors were the new, fabulously rich industrialists, whose collections became the most private of private property, and whose fate and accessibility turned wholly on the way in which these new monied patricians conceived their proprietorship. For the most part, they established a philanthropic tradition that served the public well.

The American Medici, Pierpont Morgan, was the quintessence of the lordly art collector who collected for his own pleasure, yet he left his artworks to his son under a will stating that "it has been my desire and intention to make some suitable disposition of them . . . which would render them permanently available for the instruction and pleasure of the American people."[53] Nearly half of Morgan's collection went to the Metropolitan Museum in New York, and much of the rest eventually found its way into various other public institutions.[54] John D. Rockefeller Jr. justified his collecting, the self-indulgence of which troubled his Puritan sensibilities, with the thought that the objects "would in time probably come into public possession through their ownership by a museum . . . [and] be preserved for a wider audience."[55] Notwithstanding the shadow of self-interest that inevitably looms over overtly generous behavior, it is a striking fact that collectors over the centuries have repeatedly made a point of characterizing themselves as custodians, or at least as something other than mere possessors and proprietors. Even the rough-edged Joe Hirshhorn, the uranium

king, is quoted by his biographer as saying "the collection doesn't belong to one man."[56] Hirshhorn eventually gave his extraordinary, if uneven, art collection to the people of the United States. The ancient Roman tradition where collectors followed the example of Asinius Polio, owner of the famous Farnese bull, and allowed public access to their houses on certain days, is still alive thanks to the Doria Pamphili family, one of the most august of Rome's princely lineages and the owners of one of the world's great private art collections. They have for decades kept their house open to the public four days a week for three hours each of those days. The practice was described as "a testament to the family's dedication to the idea that its treasures are somehow held in public trust."[57]

The stewardship tradition is obviously powerful and deeply rooted, and impressively it grows out of self-imposed restraint, not as a duty imposed by law or even the strictures of public opinion. Should we leave it at that? If the tradition is as strong as some of the preceding comments suggest, perhaps nothing more is needed. Unfortunately, there are exceptions that suggest the need for some rules.

When in Rome

There is nothing uniquely modern about stashing great works of art where no one else can see them. One of Cicero's famous orations condemns Gaius Verres, who had been governor of Sicily, for having taken great art from vanquished territory and hidden it away in his house, rather than making it available to the Roman public. While looting was then (and for a long time afterward) considered legitimate as spoils of war, the objects were supposed to be taken in order to embellish the victor's state, not as personal enrichment. When other Roman conquerors brought back works of art, Cicero observed, they made them available to the public. "The statues and objects of art which . . . Servilius removed from the enemy city that his strength and valor had captured, he brought home to his countrymen; displayed them in his triumphal procession and had them entered in full in the official catalogue at the Public Treasury."[58] The same was true of Lucius Mummius, "who took the beautiful city of Corinth, full of art treasures of every kind."[59] Verres presented a particularly egregious case. He expropriated large numbers of beautiful statues and works in precious metals for himself, and he did not even refrain from false accusations and murder to obtain objects that struck his fancy. Cicero charged: "What you criminally and piratically stole from venerated sanctuaries we can see only in the private houses of you and your friends."[60]

According to the historian Pliny, the emperor Augustus's chief minister, Marcus Vipsanius Agrippa, held that great pictures and statues should be exhibited in public, a practice, Pliny commented, that "would have been far preferable to sending them into banishment at our country-houses."[61] The Baths of Agrippa, built for the people of Rome, were planned to double as an art gallery and were enriched with many famous works of art. The gardens of the historian Sallust, which was embellished with fine sculptures, were for centuries open to visitors, at least the privileged, if not the general public. According to Pliny, when Tiberius removed the Apoxyomenos of Lysippus from a public building into his own home there was much dissatisfaction among the public, which was unwilling to forgo the enjoyment they derived from its public exhibition and "clamorously demanded [that it] be replaced." The emperor, Pliny said, "notwithstanding his attachment to it, was obliged to restore it."[62]

The Barnes Collection

Among modern-day collectors one man stands alone for his privatizing behavior, Dr. Albert C. Barnes of Merion, Pennsylvania. Barnes grew up in poverty in Philadelphia in the last decades of the nineteenth century, the son of a slaughterhouse worker. Though he was able to break free of his disadvantages through education, earning a scholarship to Central High School, where high-achieving boys from all social classes attended, then studying medicine at the University of Pennsylvania, and doing graduate work in chemistry in Germany, he apparently never forgot or forgave the humiliations he had suffered as a poor boy, or the slights he believed others had inflicted on him.

As a result of research he had done in Germany (with a collaborator who he later bought out for a relatively small sum) Barnes produced a powerful antiseptic called Argyrol, which became a phenomenal commercial success. With the immense income that Argyrol brought him, Barnes, who had developed a taste for art in high school, first began painting and then, recognizing the limits of his talent, decided to devote himself to art collecting. "The fact of it is that I am not an artist," he said, "but I believe I am capable of developing enough taste and discernment to devote my self to seeking out the talent of others. Collecting pictures, done in the right way, can become almost a creative activity."[63]

Through the guidance of an old high school friend, Barnes was introduced to Alfred Stieglitz's gallery in New York, where the first American exhibition of the work of Matisse was being held. In 1912, Barnes began

acquiring the modern French art that would before long comprise one of the greatest private collections in the world. He bought Renoirs, followed by works of Sisley, Gauguin, Pissarro, Monet, Seurat, and Degas. He was the first American to buy a van Gogh. The year of the Armory Show in New York, 1913, he bought a Picasso and a Matisse for ten dollars each, and a Renoir for eight hundred dollars. As prices for these modern masters rose, though some were still unappreciated in America, Barnes kept buying.

Dr. Barnes was not simply a rich accumulator. He was a serious student of art, with real taste (he personally discovered Soutine, who was living in filth and had sold nothing) and extensive knowledge. But he was also deeply unsure of his judgments and unable to bear criticism of any kind, and he was developing his own extremely eccentric views of art criticism. In 1920, he determined to create a foundation that would bear his name and be a repository and showcase for his collection. At that time, according to one biographer, "like almost all American collectors, he regarded his treasures as a trust and considered it his duty to share them with others, for he had not forgotten all it had cost him in time and effort to cultivate and develop his aesthetic taste."[64] Work began in 1922; the Barnes Foundation was located in Merion, Pennsylvania, just outside Philadelphia.

The next year an event occurred that would mark the beginning of an era unmatched in the history of collecting. Barnes decided to exhibit his acquisitions, some ninety-four paintings, at the Pennsylvania Academy of Fine Arts. Contemporary art had hardly been exhibited at all in the United States up to that time, except for the Armory Show of 1913, and the public had little notion of what such an "ultramodern" exhibit would consist of. In fact it comprised works by Matisse, Derain, Picasso, and Soutine, among others. Barnes, unprepared for criticism, thought of himself as allowing his countrymen to see the great collection he had built up by dint of his devotion and tenacity.

The press was very hostile, calling the pictures "indescribable curiosities," and condemning the artists as "depraved exhibitionists" and "moral degenerates." Barnes never forgave or forgot the critics and began inundating the press with unprintable letters attacking their criticisms and denouncing their errors. Most importantly, he gave orders that anyone expounding ideas about art that did not meet with his approval was to be forbidden entrance to the foundation—a decision that was to exclude virtually every recognized scholar, critic, and journalist in the field of art. He refused admittance not only to writers and art critics, but to dealers, other collectors, to members of what he called "society," and, as one writer put it, to "all persons whose education and work could have [given them] serious

reasons for wishing to visit it."[65] He appointed as foundation officials only those who adopted his own eccentric (but by no means crazy) views of art, and provided that no one who held any post at the University of Pennsylvania or at any fine-arts institution in the Philadelphia region could hold any chair or be employed by the foundation.

In theory, the collection was open two days a week except in the summer, but in fact no visitors were admitted without the personal say-so of Dr. Barnes. While he lived, the majority of those who asked to see his collections received by way of reply a letter saying something like "Go to Blazes" or "I think you would do better to go to the cinema."[66] Barnes also refused entry to T. S. Eliot, Jacques Lipschitz, and Le Corbusier, among other notables. The eminent art historian Erwin Panofsky got in by posing as someone else's driver.[67] Barnes refused to admit the director of the Museum of Modern Art, Alfred H. Barr, who had criticized Barnes's book, *The Art in Painting,* and Barr only got into the foundation by using a false name. After Bernard Berenson, the great authority on the art of the Renaissance, criticized some pictures in his collection, Dr. Barnes accused him of knowing nothing about painting and having no taste. Albert Henraux, the president of Friends of the Louvre, after being hurriedly shown the collection by Barnes, asked if he might take a more leisurely view of certain rooms, to which Dr. Barnes replied, "With pleasure, and I advise you to make the most of the opportunity, because this is the last time you will be admitted here."[68]

For those who were given the opportunity to visit, the experience was unforgettable. Here is Peggy Guggenheim describing her day at the Barnes Foundation:

> It took half an hour to get used to the arrangement of the pictures. I have never seen so many masterpieces assembled in such confusion, at times five rows deep. There were about twenty small rooms, apart from the large hall. Here, in a gallery above, there was a large series of paintings by Matisse, done specially for the space. One had to concentrate with all one's will power to look at each picture in turn, as the surroundings were so close. There were about two hundred and forty Renoirs, one hundred and twenty Cézannes, forty-three Matisses, thirty Picassos. . . . There were also some old masters, like Titian, Tintoretto, Cranach, Van de Velde and Franz Hals. . . . The walls were dotted everywhere with early-American wrought-iron arabesques. I was permitted to remain two hours, though I could have stayed a month.[69]

Barnes decreed that no picture could be loaned or removed from the walls, and for more than sixty years no picture from the Barnes collection was ever exhibited elsewhere.[70] All this would have been laughable were it not for

the fact that Dr. Barnes held in his collection some of the greatest impressionist, postimpressionist, and early modernist paintings in the world, all in all some two thousand canvases,[71] of which probably half were indisputable masterpieces of modern French art. His Renoir collection was undoubtedly the finest anywhere.

Oddly enough, though Dr. Barnes ultimately became notorious for his exclusionary behavior, that was not at all his original intent. He actually offered his collection to various local institutions, including the Philadelphia Museum of Art, the Pennsylvania Academy of Fine Arts, and the University of Pennsylvania. Each one turned him down, on the ground that his modernist paintings (such as the Matisse) were not art, though one may assume that the negotiations with those institutions were undermined by his usual bad manners. Even when he decided to establish the Barnes Foundation as an alternative, the document creating it provided that the art gallery was being created to promote "the appreciation of the fine arts" and was to be "open to the public" (though with some restrictions).

That commitment, however, was not kept, either by Barnes during his lifetime, nor by those faithful followers he appointed to manage the foundation after his death in 1951, and failure to abide by the terms of the indenture creating the foundation created a legal opening that otherwise would not have been available. As a public charity, the Barnes Foundation enjoyed exemption from taxation, and Pennsylvania law vests the state attorney general with supervision of public charities. In 1958, the attorney general sued, "calling upon the Barnes Foundation and its trustees to show cause why they should not unsheathe the canvases to the public in accordance with the terms of the indenture and agreement entered into between Albert C. Barnes, the donor, and the Barnes Foundation, the donee."[72]

The case, which went all the way to the Pennsylvania Supreme Court, rested on the proposition that if the benefits of a charity are subject to conditions by which a large proportion of the general public will be excluded, it is a private charity, not a public one, and therefore not entitled to the benefits of the tax exemption law. The court, finding that the trustees had violated the provision of the indenture and sealed off the art gallery to the public, ordered that the rights of the public to access be protected and assured. As a legal matter the victory was a narrow one; it rested on the terms of the document establishing the foundation, and on the foundation's need for tax-exempt status, rather than on any broader public right. But it did call for access to the most important closed private art collection in America.

A somewhat similar situation arose with Isabella Stewart Gardner,

whose extraordinary collection was (and still is) housed in Fenway Court, the Italian Renaissance–style mansion she built for it in Boston. She opened the collection to the public, but capriciously, only on certain days, and entirely at her own whim, which created repeated problems with the customs authorities who levied an impost tax on the ground that her home was not "a proper public museum."[73] Interestingly, when Gardner built the Fenway Court, she had a stone placed on it that read "I. S. G. Museum, 1900," but the stone was covered over so it couldn't be seen, and it wasn't exposed until her death in 1924.

As for the Barnes collection, and despite the court decree, the trustees pretty much continued to operate as Dr. Barnes would have wished. Though the galleries were opened to the public for two and a half days a week most of the year, no large numbers of people came to see the collection. Attendance was limited to just nine hundred visitors each Friday, Saturday, and Sunday, half by appointment and the rest on a first-come, first-served basis. Visitors were made to feel like intruders. One caller said that "the massive front gate is still guarded by dragons."[74] Once inside, he said, visitors found it extremely difficult to make sense out of the variety of paintings and their seemingly haphazard display, and since Barnes also prohibited color reproduction of any of the paintings, newcomers didn't know what to expect.

The spell of the founder was finally broken in 1993, after seventy years. Barnes's hand-chosen successor died, and control of the foundation passed to Lincoln University, a predominantly African-American school in the area that had been founded in the nineteenth century to educate freed slaves. Barnes, for all his peculiarities, had always been interested in the education of poor Blacks, and provided shortly before he died that control over the board of the foundation would eventually vest in Lincoln University, which was given authority to name new trustees as the old members died or retired.

By the 1990s the foundation needed money for repairs of the museum and its surrounding properties, and its new president (who was Lincoln's legal counsel)—following a court battle with the remaining traditional defenders of Barnes's wishes—won the right to do two things that Dr. Barnes had most certainly and explicitly not desired and had in fact explicitly prohibited: to send a selection of the collection's paintings on a museum tour, and to publish a book with color reproductions of the paintings. Both actions were calculated to bring in substantial sums of money to the foundation.

The new board contracted for the publication of two books of color

reproductions, and for some eighty paintings—including a number of very great masterpieces that very few people in the world had ever seen, such as Matisse's *Le bonheur de vivre* and Seurat's *Models*—to be sent on a world tour. The exhibit went to the National Gallery in Washington, the National Museum of Western Art in Tokyo, the Musée d'Orsay in Paris, and finally (ironically), to the Philadelphia Museum of Art. Barnes would have hated everything about it, including the fact that the museums did not display the paintings according to his very clear, strong, and idiosyncratic notions about the proper arrangement of works in a museum.

Does it really make any difference that one collection—however great—is inaccessible, particularly when it deals primarily with modern artists about whom a great deal is known, and whose works are abundant? Knowledgeable experts think it does. Here is what art critic John Russell had to say, commenting on the showing of the Barnes material at the Philadelphia Museum in 1994:

> Only a short time ago, it seemed as if the dossier on Matisse had been closed. Tens of thousands of people had crowded into the great Matisse retrospective organized by John Elderfield at the Museum of Modern Art in New York. . . . What more could there be to see, or to say?
>
> Plenty, is the answer. To prove it you have only to go to the Philadelphia Museum of Art, where the Matisse Dance Mural of 1932–33 from the Barnes Collection is now on view . . . [along with] the many sketches for the Barnes mural . . . [and] some marvelous drawings of single figures, never before seen in this country. . . .
>
> No such confrontation has been brought about before, and it gives us what had seemed impossible: a new notion of Henri Matisse.[75]

For all that has happened, the ghost of Dr. Barnes may have the last word after all. In 1995, record crowds came to see the collection when it was exhibited at the Barnes Foundation itself. The crowds annoyed neighbors in that very upper-crust neighborhood, and they complained of noisy tourist buses and numerous cars on their suburban streets. As a result, they got the local zoning board to rule that the Barnes was operating illegally as a museum in a residential area. The zoning ruling imposes a daily fine of five hundred dollars unless the number of visitors to the foundation is sharply reduced and the days of operation cut back significantly. The old curmudgeon must be smirking in his grave.

Part 2. Paper Trails

6

Presidential Papers

[I]f any proposition collides with constitutional principles it is that the President should be exempted from the obligation that rests upon other officials in government to protect and refrain from appropriating to personal use records produced or received into custody by virtue of the exercise of a public office. To assume otherwise would be to vest in the highest office of the land, or in his heirs or descendants, the right to sell, to destroy . . . or other wise to dispose of documents of the highest official nature.
—H. G. Jones, *The Records of a Nation* (1969)

One of the most counterintuitive facts of American history is that for nearly two hundred years presidential papers, including all those dealing with official business, were considered the private, personal property of the president.[1] When a president left office, he could just pack up all the material evidence of his term(s) of office, take it home with him, and do whatever he wanted with it. And that is exactly what happened in most instances, sometimes with dire consequences. Large amounts of material from the Grant, Harding, Pierce, Coolidge, and Arthur administrations were deliberately destroyed.[2] According to his grandson, President Arthur "caused to be burned three large garbage cans, each at least four feet high, full of papers which I am sure would have thrown much light on history."[3] President Fillmore's son directed the executor of his will "at the earliest practicable moment . . . [to] burn or otherwise effectively destroy all correspondence or letters to or from my father." Fortunately, these instructions were never fully carried out, and some papers were later discovered in the attic of a home in Buffalo, New York.[4]

The most notorious among these losses were President Harding's papers relating to the Teapot Dome scandal. After Harding died, Mrs. Harding went over what was called "private office" material, in order to destroy any material that might have proven harmful to the memory of her husband. She burned some papers while they were still at the White House, and after the rest had been shipped to her in Ohio, she designated

others for destruction. "We must be loyal to Wurr'n and preserve his memory," she said, as she ordered boxes full of documents and letters to be thrown on the flames.[5] The "files destroyed by Mrs. Harding cannot be accurately ascertained; though gaps in the file numbers of the private office papers do indicate that she may have burned as much or more than half the material available to her."[6]

Even where papers were not destroyed, they have often been subjected to extraordinary limitations on access. President Lincoln's son, after destroying what he deemed of little value, deposited the remainder with the Library of Congress pursuant to a very restrictive provision that they remain sealed from public access—which they were—until 1947, eighty-two years after Lincoln's assassination.[7] The John Quincy Adams papers were entirely closed to public access until 1956, 127 years after he left office.[8] McKinley's secretary (and his son after him) controlled access over that president's papers until 1954, more than half a century after his assassination.[9] As we shall see in a later chapter, some Harding letters are still under embargo. The Kennedy family is reputed to be very close with the documents they control. They kept tape recordings of official conversations for approximately twelve years after the president was assassinated before even donating them to the government,[10] and the family's agreement with the Kennedy Library unqualifiedly reserves the right to limit access and the right unilaterally to withhold any materials they choose.[11]

A striking example of what can happen as a result of the privatization of presidential papers occurred in the early 1960s. An important diplomatic question arose whether the French government was wrongly denying that in 1956, at the time of the Suez Crisis, it had received assurances from the United States about our nuclear-deterrence policy. A search was made for a telegram sent to President Eisenhower at the time by our then ambassador to France. No copy could be found at the State Department. The telegram was among the Eisenhower papers, then being administered by Eisenhower's son, John. John refused to make the telegram available except on terms that he set. For some reason, he insisted that Secretary of Defense McNamara personally request the material from his father. Those terms were deemed unacceptable by the Kennedy administration, and the telegram was never produced.[12] President Johnson was similarly obliged to apply to the Eisenhower Library in 1967 in order to obtain previous presidential correspondence with a prime minister of Israel,[13] and President Ford could find the record of negotiations between former president Nixon and Chinese leaders, which laid the basis for America's China policy, only in the Nixon papers, which had been removed from the White House.

Congress seems never to have challenged presidential ownership. In fact on a number of occasions it appropriated funds to acquire privately held collections, including those of Washington, Jefferson, Madison, and Monroe.[14] The government bought Washington's papers for twenty-five thousand dollars in 1833, and in 1848 it paid Thomas Jefferson's grandson twenty thousand dollars for his papers and manuscripts. In the same year it bought the Madison papers from Dolly Madison for twenty-five thousand dollars. Monroe's children sold his papers to the government for twenty thousand dollars. Except for the Nixon estate, however, no modern-day president has sought payment for his papers, though, according to the *Washington Post*, some have taken sizable tax deductions for their donations.[15]

The tradition of presidential ownership dates back to George Washington. It ended, as we shall see presently, with Richard Nixon. When Washington died, he bequeathed his papers, which included the official letters and documents of his presidency, to his nephew, Bushrod Washington. (Thirteen former presidents, including Jefferson, Madison, and Monroe, passed their papers as private property in their wills.)[16] Bushrod authorized a Mr. Sparks to publish a collection of President Washington's writings, along with a biography that Sparks was to write. Sometime later a man named Charles Upham wrote another biography, in which he included verbatim copies of numerous Washington letters that he took from the Sparks edition. A lawsuit was brought on behalf of the heirs and assignees of Washington against Upham for "piracy" of the value of the papers.[17]

Justice Story's opinion in the case gives no very satisfactory explanation for his conclusion that the letters were private property, except to note that President Washington considered them as such, and that it would be very difficult to distinguish between purely private and business letters. No doubt Story was primarily concerned that Upham's work was undercutting economic benefits that Washington had intended his heir to have. As to access, he notes that Upham's edition was intended for school libraries and makes clear he thinks the idea was a good one, since Spark's authorized edition was an expensive multivolume work that was practically unavailable to students. What Story does not say, but perhaps assumes, is that the public benefit from Upham's school edition could have been achieved if only Upham had been willing to pay an acceptable royalty to Washington's heirs.

While Story's decision protected the economic interest of Washington's heirs, it did not recognize a presidential right to withhold historically important material from the public. On the contrary, there is one arresting paragraph in the opinion that shows his appreciation of the importance of

public access. Toward the end of his decision Story says: "In respect to official letters . . . it may be the right, and even the duty, of the government, to give them publicity, even against the will of the writers."

That presidents treated their papers as private property is less surprising than it may at first seem. For many years the government made no provision for such material. There was really nothing for a president to do upon leaving office but to take his correspondence and other papers home with him, as George Washington and his successors did. Until 1897, when the Library of Congress established a Manuscript Division, there wasn't even an available repository for presidential papers.[18] The National Archives was only established in 1934, and the Presidential Libraries Act, which authorized the government to staff and maintain libraries at government expense, was enacted only in 1955. These arrangements saved later presidents from the problem faced by Benjamin Harrison, who in his will noted that he had wanted to collect those of his papers that might have a public interest, and to present them to an historical society, but that "no suitable place or organization . . . [is] now available here."[19] Few if any presidents had either the means or the record-keeping habits of John Adams and his descendants, whose papers were preserved in a fireproof library the family built in 1870.[20]

Notwithstanding proprietary acts of various kinds, most presidents have been keenly sensitive to the public importance of their papers. Washington was fully aware of it, as well as the interest of the public, especially in his military papers. He once described them as "a species of Public property, sacred in my hands."[21] Though he was never to complete the task, he intended to sort and arrange his papers during his retirement, and to construct a building to accommodate them so that a history might be written.

Franklin D. Roosevelt was undoubtedly the president most self-conscious of the public significance of his papers. "I have destroyed practically nothing," he said.[22] A serious student of history, and aware that the great bulk of material from his time in public office would overwhelm the government's existing archival resources, Roosevelt brought together a distinguished group of historians in 1938 in order to discuss his plan to establish a presidential library at Hyde Park to house and protect the records of his presidency.[23] The president determined that his papers should be kept intact, not to be sold at auction, or scattered among his descendants, and that the ownership and title of all the papers, and other materials should be in the federal government for purposes of historical study and research for all time.[24]

Though Roosevelt considered the papers to be his property, he

believed they should be given to the United States, and he gave them to the nation as a gift. He left a memorandum naming three of his close associates to examine his personal papers and select those which, in their opinion, should never be made public as well as those that should remain sealed for a prescribed period of time.[25] He was an owner who conceived of himself as a steward for the nation, and he set an important precedent by determining that the material should be preserved, gifted to the United States, and made broadly accessible to researchers. As one analyst noted, "Roosevelt made his most significant departure . . . by recognizing the paramount right of the public."[26] With the notable exception of the Nixon presidency, that general approach has been followed by subsequent presidents, for each of whom a presidential library has been established.

In 1975, in the wake of the Nixon tapes imbroglio, the historian Arthur Schlesinger Jr., made the following proposal: "[E]nact a law defining the political and personal papers of a President as private property of a partic-ular sort—private property clothed with a public interest and subject to public regulation. If someone owns a house that has been declared an his-toric site, he cannot sell the house, deface it, alter it or tear it down. The personal and political papers of a president should be placed in a like cate-gory. A former president can retain ownership of his political and personal papers until he gives them to the government, and he can give them under stipulated conditions of access. But he must be bound by law to leave his papers to the government; and in the meantime the National Archives should have day-to-day control of the papers in whatever depository the owner decides."[27]

Schlesinger's proposal for a form of qualified ownership suggests that a responsibility of stewardship does not require that all the economic benefits of ownership must be forgone. To be sure, it is unseemly that a president should enrich himself by selling back to the public the papers cre-ated by virtue of his office. On the other hand, it is unlikely the public was disserved by the fact that President Truman held back his most important papers from the Truman Library until he had completed his memoirs (his daughter utilized the papers as well while writing her own memoir about her father).[28] Even the Presidential Records Act of 1978, which terminated the tradition of private ownership of presidential papers, appears—albeit indirectly—to allow memoir rights to a former president. The law permits a president to restrict public access to certain categories of papers, such as national defense, appointments, and confidential communications with presidential advisers for up to twelve years; but the restriction is lifted once information contained in such records has been placed in the public

domain through publication by the former president. That rule permits a former president to have exclusive use of restricted papers in writing memoirs or other such works.[29] Some commentators find even that sort of limited proprietary interest unacceptable, however. As long ago as 1938 Walter Lippmann condemned the commercial publication of Roosevelt's messages, speeches, and press conferences, as creating a private interest in public service.[30] However one believes that issue should be resolved, certainly such economic opportunities are distinct from—and much less intrusive on public values—than a right to destroy or to impose excessively long-term restrictions on access.

The strongest argument against legislating public ownership and formal access requirements is that such rules may actually deter the creation of the sort of frank confidential documents that are of the greatest interest to posterity, a view that was held by President Taft.[31] Undoubtedly the prospect of public access discourages putting very candid, politically sensitive material down on paper, though the exigencies of the job impose limits on the ability of officials to refrain from making a paper or electronic record. According to Stephen Hess, a White House staff member for both President Eisenhower and President Nixon, most presidential advisers do not have unlimited access to the president and so must commit their views and advice to writing to get it before him. In addition advisers write memoranda to protect themselves by assuring that their positions are accurately memorialized. Former presidential advisers as well as former cabinet officials who testified before a National Study Commission set up to examine the status of presidential papers agreed that so long as confidentiality could be protected for a reasonable time, disincentives to creation of written records would be effectively eliminated.[32]

The most important issue, then, is not so much deterring the creation of important material, but controlling its destruction. While there have always been those like the Adamses and FDRs in the White House who are attentive to their historical responsibilities, there are also the Mrs. Hardings blandly tossing stuff into the fireplace. And then there was President Nixon.

Shortly after resigning as president, Richard Nixon executed a depository agreement with the General Services Administration (GSA)—the federal government's property administrator—under which his presidential papers and tapes would be stored near his home in California and would be available for a period of years only to Mr. Nixon or those he authorized.[33] The

most controversial element of the agreement was one by which Nixon could direct destruction of such tapes as he wished. By the terms of the agreement he could begin to destroy the tape recordings on or after September 1, 1979, so that all of them would be destroyed by September 1, 1984, or following the death of the former president, whichever occurred first.

The agreement gave Mr. Nixon possession of 42 million documents and materials relating to his presidency—including the notorious tapes.[34] The United States was to get restricted use of the material for a few years and the promise of eventual donation of those portions of the papers so designated by the former president. As one writer put it, "Nixon, rather than the National Archives, would determine the historical record to be preserved of the administration of the 37th President of the United States."[35] Distressing as that sounds, it is precisely the situation that obtained with every previous president, though the circumstances of public distrust were unique in the wake of the Nixon resignation.

Almost immediately after knowledge of the Nixon-GSA agreement became public, Congress enacted a law to abrogate it and directed the GSA to take custody of the materials and to preserve those having historical value.[36] The law called for the promulgation of regulations to govern eventual public access to some of the materials, but it contained several protections for the former president: return to Nixon of material that was personal and private; protection of the opportunity to assert any legally or constitutionally based right; and assurance of just compensation if his economic interests were invaded. Mr. Nixon sued, challenging the constitutionality of the law on a number of grounds, including transgression of the separation of powers, as a bill of attainder, and as a violation of privacy.

The case soon reached the U.S. Supreme Court.[37] The great bulk of the Court's decision is not germane here, except for its comment on the ownership and status of presidential papers and materials. The Court found it need not determine ownership since the law in question provided for compensation if any property right found to exist was violated. The Court concluded that even if the material was owned by the former president, that fact would not put it beyond regulation. For example, Congress might require papers or tapes to be made public if they were of historical significance. The Court thus reaffirmed Justice Story's 1841 suggestion that public access might be mandated.[38] That was also the view taken by the attorney general in a 1974 opinion. While strongly affirming the tradition of private ownership, that opinion said: "Historically, there has been consistent acknowledgement that presidential materials are peculiarly affected

by a public interest which may justify subjecting the absolute ownership rights of the ex-President to certain limitations directly related to the character of the documents as records of government activity."[39]

While both the Supreme Court's decision and the attorney general's opinion implied that considerable regulation could be justified, they recognized that such constraints might constitute an expropriation of the president's property rights. That is exactly how the matter was ultimately resolved. The U.S. Court of Appeals found that the law invaded Nixon's property rights and that he was entitled to compensation for the economic value of his papers and tapes. After finding an unbroken tradition in which presidents have had total control over presidential material, the appeals court concluded that under the 1974 act,

> the right of access retained by Mr. Nixon is but a thin reed among those associated with the ownership of presidential papers. Although he may still use them, presumably for his own autobiographical and historical work, he has lost all bargaining power with respect to them, not to mention the ability to dispose of them. More importantly, [the act] has completely abrogated Mr. Nixon's right unilaterally to exclude others from the materials. . . . [T]he right to exclude others is perhaps the quintessential property right.[40]

The appeals court thus declined to find that presidents had only a qualified property right in their official papers, rejecting the view of the lower court that "if [presidents] had 'legal title,' it was title in the nature of a trustee holding those papers in trust for the American people and for history."[41] The amount of compensation due has been a subject of lengthy dispute, with estimates running from less than $2 million to several hundred million. A proposed settlement of $26 million, of which $11 million would have financed a government-run Nixon Library, was rejected by the Nixon estate, and the case went to trial in December 1998.[42]

In 1978, Congress enacted a law known as the Presidential Records Act, designed to resolve the matter of presidential materials for the future, to begin with the papers of Ronald Reagan. It enacted an entirely new statute that indisputably vests ownership in the federal government. The law states that "the United States shall reserve and retain complete ownership, possession, and control of Presidential records,"[43] which are defined as documentary materials created or received by the president in the course of carrying out his duties. It excludes personal records, defined as reasonably segregable materials of a purely private or nonpublic character, such as diaries, journals, and personal notes that are not part of transacting govern-

ment business, and materials relating to the president's election to office.[44] Disposal of any presidential records require review by the archivist of the United States, and the archivist is mandated to take responsibility for custody, control, preservation, and access of that material upon the conclusion of a president's term of office. The law also provides that "the Archivist shall have an affirmative duty to make such records available to the public as rapidly and completely as possible consistent with the provisions of this Act."[45]

One interesting feature of the act authorizes a president to restrict access, for not longer than twelve years, to certain specified categories of materials—including national-defense matters, confidential communications between the president and his advisers, and personnel and medical files that would invade privacy. Other presidential records must be made accessible in a maximum of five years. Both the right to extend restriction of access to specified confidential material, and the exclusion of personal materials, are designed to encourage presidents to create and to maintain material for its eventual value as history. As one of the sponsors of the act, Congressman John Brademas, put it during legislative debate on the proposed law, "It is our hope that, in protecting materials such as purely personal diaries from mandatory disclosure, we will encourage their creation in the first place and keep alive the possibility of a voluntary gift of these materials."[46]

The Presidential Records Act reflects a valiant effort to sort out those items that "relate to or have an effect upon" the official duties of the president from those that do not and are of "a purely private or nonpublic character."[47] At the extremes, certainly such distinctions make sense. There is a sharp difference between the tape of a discussion among family members about the wedding plans for a president's daughter, and a conference about how to react to civil-rights abuses in China. But there is also a vast area in which the line between official and personal is at best an unhelpful one. In the dispute over the Nixon tapes for example (though Nixon's presidency is not governed by the Presidential Records Act but by another similar legal provision),[48] there was a category described as "private/political," which embraced a conversation about Nixon's decision in 1974 to get rid of then-senator Bob Dole as Republican national chairman. Such items presumably do not relate to "the carrying out of constitutional, statutory, or other official or ceremonial duties of the President" in the words of the act, but neither are they private in the sense of ordinary family correspondence.

Certainly personal material can be historically significant, and it would be most unfortunate if such material was permanently lost simply because

it was categorized as personal, rather than as a presidential record. What primarily distinguishes personal from other material is (1) there is no public claim of ownership on it and (2) it may be entitled to privacy protection. Neither of those facts, however, suggests that such material is without public importance, or that classification as personal should be taken as an invitation to destruction by the family. Privacy considerations should determine only whether, and for how long, such material should be sequestered. Some among even the most personal papers of a president may have high research value and, when family privacy considerations are no longer weighty, can appropriately be opened to study.

Warren Harding's love letters to Carrie Phillips, and Woodrow Wilson's medical records—each to be noted in a later chapter—have proven to be valuable sources in deepening understanding, according to students of those presidents. The undestroyed "private" papers of the secretive Arthur family that finally came to light enabled historians to take a fresh look at that president and showed that "the benign, reform-minded, ever-honest gentleman of [a standard] biography bore little resemblance to the real Arthur."[49] Almost everything connected with a president's life is likely to be potentially of some public interest. In the cooler atmosphere of historical study, there can be no doubt that character explains, and private life explains character. Of course, no one should be obliged to save every grocery list, birthday card, and draft letter. A good rule of thumb is probably not to destroy anything deliberately out of concern that history will misunderstand, or that unsympathetic scholars or journalists will use it to besmirch the great person's reputation. That is, ordinary trash creation is acceptable, editing the future's view of the past is not.

It is a pity that we ever needed to pass a law in order to protect presidential papers as important artifacts of the nation's history. It would doubtless be preferable to be able to rely on the integrity and responsibility of presidents and their heirs, rather than on legislative mandates. For most of our history, such reliance has worked pretty well, but alas the era of self-regulating stewardship is behind us. Still, it is pleasant to dream of a better day. If only we could be confident that the standard inscribed at the entrance to the Truman Library would unerringly be followed (even at the Truman Library),[50] nothing more would have to be said:

> This library will belong to the people of the United States. My papers will be the property of the people and be accessible to them. And this is as it should be. The papers of the Presidents are among the most valuable sources of material for history. They ought to be preserved and they ought to be used.[51]

There is an interesting English footnote to the story about American presidential papers.[52] When Winston Churchill died, he left his papers to his male (!) heirs. The archive constituted a massive collection stretching over more than sixty years and containing some million-and-a-half pages of material. It is a collection of the most extraordinary interest. It includes the typescripts of Sir Winston's books, and all the letters that had been written to him over the decades, which he diligently collected. There are handwritten and annotated original drafts of his great wartime speeches ("If the British Empire and its Commonwealth last for a thousand years, men will still say, 'This was their finest hour'"). There is a letter in King George VI's own hand describing how he and then-queen Elizabeth watched the bombing of Buckingham Palace during the Blitz; confidential notes from intelligence sources in Germany during the early 1930s describing the rise of Hitler; and a poignant au revoir telegram from Edward VIII as he left the throne. Churchill's wartime correspondence with Roosevelt, Stalin, and de Gaulle is there in its entirety. The archive also contained documents stamped in red, "Property of HMG."

When the heirs suggested selling the archive, which had been on loan to Cambridge University (where access was for years restricted to the official biographer, Martin Gilbert, and not opened to all researchers until 1992), and further hinted that the best price might be realized by selling it abroad, there was a great and immediate public protest. The notion of making the British people pay—as many people saw it—to buy back what they already owned, the record of their sacrifices during the war, was greeted with widespread outrage. Moreover, the heirs planned to keep the copyright, while selling the documents, so they could charge anyone who wanted to quote from them.

In the event, there was no auction and no sale to foreigners. The government purchased the material with money from the National Heritage Memorial Fund, an endowment set up in memory of the British servicemen who died in World War II. The public anger did influence the price the public had to pay. Commercial valuations estimated the archive's value at between £32.5 million and £40 million, and one dealer thought it would have fetched over £50 million at auction. The family trust, however, agreed to accept a much lower figure, £12.5 million. An article in the *Times* of London inquired how the price had come down so much. There were several factors, including arrangements about taxes. The family also retained the copyright. On the issue of ownership, however:

> First of all the valuation was reduced by £10 million to take account of the papers which might be regarded as official rather than private. This is an area in which the law is very doubtful. Do the manuscript notes for

a House of Commons speech belong to the Prime Minister or to the State? Historically, most Prime Ministers have kept them as their own property, but such notes can be regarded as part of the official function. . . . Whatever the legal position, £10 million was knocked off [as a discount for the inclusion of whatever papers in the archive might be deemed "official"].[53]

The reduction was not an entirely voluntary act. The attorney-general had issued a writ to prevent the Churchills from selling the papers on the ground that they were state property. The Heritage Trust then came up with enough money to buy the archive, and the issue of ownership and of separating official from personal papers never had to be resolved. The government's position was that it was only buying the personal papers in the archive, which were then given to Churchill College, Cambridge; and that it was making a gift of all the state papers in the archive to the college. Thus all the material was kept together, and no sorting out was ever done. Apparently prime ministers continue to determine for themselves what they may take home with them as their personal property.[54]

7

Papers of Supreme Court Justices

The problem of how much the historian should know and should tell of the inner life of going institutions of government is not one peculiar to the Supreme Court. It is in part—and, I am persuaded, in the largest part—a problem of which time is the solvent.
—Alexander M. Bickel, *The Unpublished Opinions of Mr. Justice Brandeis*

A member of the Supreme Court is at once a soloist and part of an orchestra. . . . [T]he private rehearsals, as it were, behind the impenetrable draperies of judicial secrecy may tell much more about the soloist and the rest of the orchestra than the public performance even remotely reveals.
—Felix Frankfurter, letter to Charles Fairman

The controversy over the Nixon papers generated concern about the files of other government officials as well. The same 1974 law that mandated that the Nixon materials be turned over to the government established a national study commission to examine all aspects of the ownership and disposition of the papers of federal officials in the three branches of government, and to recommend appropriate legislation. The commission issued its report and recommendations in 1977.[1] One of those recommendations was enacted as the Presidential Records Act of 1978, discussed in the previous chapter, which henceforth made presidential papers the property of the American people. The commission also recommended that the working papers of members of Congress and federal judges should be public property, and that public access be allowed to Supreme Court papers fifteen years after the time a justice left the Court. Those proposals were not adopted, nor did the Court or Congress take any other action. Such materials continue to be held as the private possessions of judicial and legislative officials, to be dealt with at their discretion.[2]

Because the papers of the justices of the Supreme Court are of especial interest, and in light of the small number of individuals involved (there had only been a total of 113 justices in the history of the nation as of 1998), the

fate of their papers has been rather extensively documented.[3] An informal tradition has developed among many justices to maintain their papers, to deed them to a public institution (usually upon retirement), and to restrict access, if it is restricted at all, for on average only about ten years. That certainly seems an acceptable, even admirable, approach, though as we shall see it is by no means a uniform practice. Nothing restrains any justice who has different plans, including the bonfire.

There are very few extant working papers such as notes from conferences, early drafts, or written communications among justices from the early-nineteenth-century Court. Apparently preservation of such materials was simply not considered important or desirable, a view, surveys show, that still prevails among many lower-court judges. For example, no substantial material concerning Chief Justice John Marshall's actual work on the bench remains. There may have been an express desire to destroy such material in the early days, in keeping with Marshall's strong efforts to have the Court reveal itself only through a single, official voice (he opposed the now-common practice of writing separate concurring or dissenting opinions). In addition, the Court has always functioned in a quite secretive manner, and breaches of that secrecy, whenever they occurred, have generated concerns about maintenance of the Court's valued traditions of candor and internal openness.

By contrast, during the last half-century at least, the historical value of the justices' working papers has been widely recognized. Probably the watershed moment was 1956 when Alpheus T. Mason published his biography of Justice Harlan Fiske Stone,[4] the first such work to rely on informal, individual papers. The Stone biography revealed more than had ever been known about the inner workings of the Court and was harshly criticized at the time for its potential detrimental influence on the Court's internal functioning. "If the present trend continues," Edmond Cahn wrote in a review in the *Nation*, "our lecherous curiosity may produce nine bitter adversaries instead of a Supreme Court. No judge will trust any other judge, for though a particular colleague seems to deserve confidence, who knows about his executor?"[5]

When the National Study Commission set out to discover the fate of all the justices' papers, including those in the modern era, it came up with some rather startling information about the twentieth-century Court. Owen Roberts and Edward Douglas White are known to have destroyed their Court papers, as did Joseph McKenna, Rufus Peckham, and Sherman Minton (except for a very few items; Minton said he had burned his papers after reading the Stone biography).[6] A great deal of Cardozo's professional

papers were burned after his death on his instructions by his close friend, Judge Irving Lehman, and his executor, William Freese.[7] The second Justice Harlan was reported to have destroyed his conference notes. Charles Whitaker apparently destroyed his papers. Charles Evans Hughes got rid of almost all his Court working papers of any interest, as did Horace Lurton, James McReynolds, and George Sutherland.[8] In his biography of Justice Byron White, Dennis Hutchinson reports that White "destroyed the bulk of his papers prior to the beginning of October Term 1986. With twenty-five terms of accumulated case files in a storage area of the Court, the justice and three of his law clerks spent successive weekends running files through a paper shredder obtained specifically for the occasion. (One of the clerks, who had academic ambitions, recalls vividly putting one file after another marked *Miranda v. Arizona* through the shredder: 'I thought: well, here's an article; here's an entire book; I couldn't believe how much history was going down the chute.') White gave no explanation for the project other than that 'it was time to clean up the place.'"[9]

Of the 101 justices who had served up to the mid-1980s, 23 left no collections of papers at all, and another 28 left very little. Chief Justice Taft, who retained an enormous body of documents (some seven hundred thousand items in all), seems to have gotten rid of his Court papers though, probably unintentionally, he left his correspondence—including intra-Court letters and much commentary on cases—which has been a gold mine of information for scholars of his judicial career.

Only a few justices have preserved large collections of their working papers, though the list includes many recent members: Harold Burton, Tom Clark, William O. Douglas, Felix Frankfurter, Robert Jackson, Stanley Reed, Wiley Rutledge, Potter Stewart, Harlan Fiske Stone, and Earl Warren. We also have large collections from Oliver Wendell Holmes, Louis Brandeis, Hugo Black, Thurgood Marshall, and William Brennan, though each of these collections is the subject of a distinct story.

The justices who have deposited their papers in public institutions have adopted a rather wide range of restrictions.[10] Justices Tom Clark, Harold Burton, and Thurgood Marshall controlled access during their lifetimes, but made the collections available without restrictions after their deaths. Since death can come at any time, this approach leaves great uncertainty as to when access will be permitted. Controversy over the Thurgood Marshall papers arose because he died only two years after his retirement. Chief Justice Warren's papers became accessible ten years after his death. Justice Blackmun's papers—which are said to be very extensive and detailed—are limited until five years after his death, at which time they are to be available

to any appropriate researcher.[11] The William O. Douglas papers were available ten years after his retirement. Felix Frankfurter closed access to the papers he gave to the Library of Congress, as to each document, for sixteen years from the date of its creation (no one knows why he chose that particular time period). He gave his more sensitive Court papers to Harvard, with access to be controlled by the discretion of (now deceased) Professors Paul Freund of Harvard and Alexander Bickel of Yale. Justices Sandra Day O'Connor and Potter Stewart have restricted access to case files for as long as any justice participating in that case is still serving on the Court. Such restrictions can close papers for a long time. For example, while Stewart retired in 1981, Justices Rehnquist and Stevens were still serving at the time of this writing, some seventeen years later. Judge J. Skelly Wright of the U.S. Court of Appeals, a strong advocate for public ownership and access, made his papers available without restriction upon his retirement.

At the other extreme, Justice Jackson's papers were functionally unavailable to researchers for thirty years after he dropped dead of a heart attack in 1954 while still serving at the Court. His papers were put in the custody of Professor Philip Kurland of the University of Chicago, who had absolute control over access to them, but who never did more than a sketch of the justice, and even that did not rely heavily on the papers.[12] In 1984 the Jackson papers were finally given to the Library of Congress by the justice's family, who kept control over access for yet another five years before allowing them to be open.

Some papers end up among family possessions and are simply neglected. A biographer of Chief Justice Melville Fuller reported how he spent years tracking down Fuller's letters from family and associates and finally found a trunk belonging to Fuller's granddaughter. Inside the trunk were letters from each of the nineteen associate justices who had sat with Fuller, including some seventy letters from Justice Oliver Wendell Holmes.[13]

As we turn to look at the specific histories of several justice's papers and at the views they held about the proper fate of those documents, it is important to keep in mind that the material in question is of a very peculiar kind. Interest in the papers arises precisely from the fact that they are not official documents. They are for the most part notes the justices took for their own reference as they sat in the Court's highly confidential conferences, correspondence among themselves about cases, or early drafts of opinions, and notations on the drafts of others. None of these items are part of the Court's official records, nor are any justices required or expected either formally or informally to create them.

Those facts necessarily raise a number of questions. Should one feel

obliged to keep papers one need never have created? What of a judge who routinely made notes for his own reference during conferences or oral arguments, and just as routinely tossed them away once the case had been decided, with no thought one way or another about their status or importance, but simply to clear his desk and get on with business? Should a Supreme Court justice be thought of in the same way as an artist or writer, who throws away a canvas or a draft of work she decides is unworthy of her? And what of the judge who writes much, keeps it all, and wishes to open it to the public promptly? Does the Court have a collective, institutional interest in protecting the confidentiality of its processes, even against the wishes of one of its members?

There is no easy answer to these questions. In a purely logical sense, the issue may seem to eat its own tail. If, once made, the papers are considered a sort of public property, and if there is no obligation to create them, then the individual who does not want such material made public will not create it, and the very act of deeming it public property to facilitate public access to it helps assure that it will not exist and the public will be thwarted.

Fortunately, or at least interestingly, the world is not ruled by such cleanly logical relationships. As one former official quoted earlier has noted (speaking of presidential papers), reasons independent of rules about the ultimate status of such material often determines their creation: a need to get a position on the record, for example. Parallel considerations no doubt operate even in the tightly knit world of the Supreme Court. A justice may consider it important to his or her own recollection to keep notes on a conference; may wish to recall another justice's exact words; or may wish to communicate in writing rather than in person for any of a number of reasons. Such considerations suggest that informal papers will continue to be generated, though increased consciousness about their potential accessibility will almost certainly have some impact on both their nature and their quantum.

Should a justice feel obliged to preserve material he or she has written? Probably the best answer is a qualified "yes." No one needs to keep every scrap of paper generated, as if it were holy writ. The Presidential Records Act addresses the "what to save" issue in a rather bureaucratic way. It provides that during the term of office, the president may dispose of presidential records that "no longer have administrative, historical, informational or evidentiary value," but must first get the opinion of the archivist of the United States, who can choose to refer the matter to the Congress if he deems it in the public interest that the papers be preserved, though neither

the archivist nor the Congress is empowered by the statute to command preservation. The president may still dispose of material so long as he submits a disposal schedule to the appropriate congressional committee with at least sixty days notice.[14] No such arrangement would likely work for the less-formal setting in which Supreme Court justices operate.

Like every other office, a Supreme Court justice's chambers produce quantities of writings that are best consigned to the recycling bin: duplicates, drafts that don't go anywhere, and the like. Nor should anyone feel obliged to be an unwilling reporter or diarist of the institution's daily life. On the other hand, like a president, Supreme Court justices are aware that they are significant participants in the making of the nation's history, and that records of the Court's activity, formal or not, provide documentary evidence of events and actions of historic significance. Those who have such evidence in hand (whether or not they have created or recorded it) do bear a responsibility to history.

The question may be posed this way: if the material is of historical importance and is in a justice's hands, should he or she be viewed as in a different position from any individual who has possession of an historically important document? In the end, does it really matter that the possessor is also the creator, since the issue is not at its core—as it is for the artist—a question of *droit moral,* what shall constitute his oeuvre, or how history shall consider his accomplishments as a jurist. The materials in question here are the raw material of public decisions, and a justice is recording history rather than releasing a work of art. Ultimately it is a matter of motive. Where one consciously destroys material he or she should know is of public significance because it bears on the business of the Court, or deals with it as if it were a purely private possession, a destructive act is a disservice to history's judgment.

The other side of the preservation debate arises out of the conviction of some justices that public knowledge of the Court's inner workings is harmful to the atmosphere of forthrightness they greatly value, or that an inevitably partial record consisting of bits and pieces from various justices will inevitably leave a distorted view of history. The justices who reflect these views are advocates for destruction. Probably no one can say definitively whether the Court's work suffers from the prospect that its inner workings have from time to time been revealed. Prominent former law clerks have expressed diametrically opposed views.[15]

Some suggest there is no evidence of change in the way the justices do business. Dennis Hutchinson pointed out that turnover in the Court's per-

sonnel, as well as the closeness of votes on many important issues, shows that "inside" information about voting patterns, or views about granting review of cases, grows stale pretty quickly. Others disagree. E. Barrett Prettyman, a prominent Washington attorney and himself the son of a former federal appeals court judge, said, "I do not agree that the publication of the Stone biography had no impact upon the Court. We do not know what effect it had. If you talk to the Justices right now [in 1993], they say that one thing they are disappointed about in coming to the Court is that there is not more collegiality, more discussion, more openness, more give-and-take, back-and-forth about these cases. It may be that they are somewhat reluctant to do more and to commit more to paper because of precisely [what happened with the Thurgood Marshall papers]."[16]

Obviously, different justices themselves have different views. One important question is whether time can solve the problem; if so, it could shift the debate from destruction to delay, though as we shall see mere delay would not have satisfied Justice Hugo Black's anxieties. Still, the greatest criticism has been directed at early accessibility, where matters are revealed concerning still-sitting justices. That is not the whole of the matter, however. One perspective is that the myth of the Court as a lofty expositor of the law is valuable, and that tell-all books, based on justice's private notes, harm the institution even after a substantial time has passed. This is a modern version of the John Marshall position that the Court speaks only through its decisions (and ideally through unanimous opinions). It is rather late in the day to preserve that posture, but if any such views about the needs of the Court as an institution ought to prevail, it would at least seem that they should be institutionalized by the Court speaking institutionally—which it has declined to do and has been unable to do unanimously—rather than through the individual decisions of each justice.

In any event, it may be best to consider the issue in light of some specific instances.

Hugo Black's Papers

Justice Black's papers were left to the Library of Congress. The collection is substantial and very valuable, some one hundred boxes with 56,530 items, consisting of correspondence and formal case files, plus many documents relating to his days in the Senate, and before.[17] While requests for use of the papers are administered through the justice's son, they are generously

granted.[18] However, Black's notes from the justices' conferences, where they discuss cases among themselves, are missing, as are some other internal court documents. And thereby hangs a tale.

Shortly before his death in 1971, Justice Black wrote a memorandum to his longtime secretary, Frances Lamb:

> As I have indicated to you on several occasions, I do not believe that my personal notes on and for Court conferences should be left in the official files or made public. I have decided that the best thing to do is to burn them, as Justice Roberts did. Nobody can get any history out of them that is worthwhile. . . . If you have any questions about what are conference notes to be burned and what are not, . . . Hugo, Jr. will tell you what to do, which is to destroy them all.[19]

In a memoir written shortly after the justice died, Hugo Jr. describes the events leading up to the destruction of some of the missing papers. The health of the justice, who was then eighty-five years old, had deteriorated quite rapidly. He lost his ability to see, became quite ill, lost appetite, and diminished considerably in weight. He was convinced (rightly as it turned out) that he was dying and became very weak, though his mental acuity apparently never faltered. He soon went into the hospital. The son describes what then happened this way:

> Practically the first thing Daddy wanted me to do once he was installed in the hospital was to go out and burn certain papers of his. According to him, publishing the notes of conversations between Justices inhibited the free exchange of ideas. . . . He also felt that reports by one Justice of another's conduct in the heat of a difference might unfairly and inaccurately reflect history.[20]

Hugo Jr. said he tried to put off the destruction, believing it shouldn't be done, by suggesting his father should wait until he retired and then decide for himself which papers he wanted to save and which he wanted to destroy. But the justice insisted his son do the deed, saying that "there isn't time for me." Though the son tried other delaying tactics, his father would not be denied. For example, Hugo Jr. drafted a letter for his father to sign, authorizing him to destroy any papers selected "in my discretion"; but the justice took a pen and wrote in, after the word "discretion," "so long as he destroys them all."[21]

From then on his father asked him for a report on the destruction of the papers every day. "It wouldn't have been possible for me to do this burning," he said, "if I hadn't been absolutely sure that this was not simply my father's spur-of-the-moment decision. Fifteen years ago he had made it clear to me exactly what papers he wanted destroyed, and he let me know

in no uncertain terms that it would be my job to dispose of them if he was unable to do it himself."[22] In the end, the son collected his father's notes from the Court and took them to his home (and later elsewhere, when a neighbor complained about the ashes), where—slowly, reluctantly—he burned them. The justice's biographer, however, says that while Hugo Jr. told his father he had burned all the papers, he purposely had not. "He just couldn't bring himself to destroy correspondence among the justices and drafts of opinions."[23] The justice's secretary, Frances Lamb, spent six months after Black's death deciding which of his personal and official papers should be preserved. She removed enough papers to fill more than six hundred loose-leaf binders and burned them, in accordance with his earlier instructions. All in all, though much remains, much was destroyed.

Surely, in this case, every sympathy lies with the justice's son and his secretary, however much one may regret the act. There could hardly be a more unambiguous case of intent, consistent over a long time; nor an aged author whose mental condition was better, and whose physical condition made it impossible for him to fulfill his wishes himself. Who can ask a son blatantly to deny his dying father's wish, or—worse—to agree and then lie about it? Even when the burning was under way, Hugo Jr. tells us, "Daddy would bear down on me about finishing." The problem is not with anything either the justice's son or Ms. Lamb did. It is rather that Black himself had it wrong with his notion that saving the papers might inaccurately reflect history. He was apparently stung by the fact that a biographer of Harold Burton had mistakenly interpreted Burton's papers, drawing the erroneous conclusion that Black had hesitated to join the decision ending racial segregation. Burton had kept detailed conference sheets as well as a diary during the Court's confidential conferences, and all these papers were made public by the Library of Congress without restriction following his death.[24] Black did not want *his* conference notes available so that some other researcher might later misinterpret what he said about one of his colleagues.

Further insight into Black's concerns was provided by S. Sidney Ulmer, a political scientist who corresponded with Black in the year before the justice died.[25] Ulmer wanted to quote a letter of Black's in the Burton papers and wrote him to obtain permission. In the ensuing correspondence, Black spelled out his views on the private papers of the justices and the uses to which they should be put. The inner workings of the Court with reference to the development of opinions, he thought, should remain obscure. He described judicial papers such as conference notes as "so-called historical sources." He considered them unreliable in determining the main foundations on which the justices base their work, and he felt they

frequently leave a false impression of history. In 1970 Black wrote, "For some years my own view has been that probably the justices would serve history better if they would not leave for comment and inference the necessarily short notes they must take about statements made in Court conference by the Court's members."[26] He had spelled out this view earlier in a letter to Edmond Cahn:

> I have long doubted the wisdom of publishing communications that were confidential when prepared. I have never thought that the diaries or memoranda of public men containing their contemporary personal impressions could be anything but one-sided. . . . From this general view you can surmise how I feel about publishing private confidential communications and memoranda accumulated by Supreme Court Justices during their terms of office. . . . I am inclined to think that public officials can be better judged by their public utterances than by their private correspondence, memoranda, and diaries. There are particular reasons which I need not further elaborate why I think that this Court is not benefitted by digging up old confidential papers and publishing them.[27]

In its issue of December 27, 1971, the magazine *U.S. News and World Report* said, "[T]he staffs of two former Supreme Court Justices, John M. Harlan and the late Hugo Black, are now burning all the notes accumulated by them during their years on the High Court."[28]

Chief Justice Burger held a similar view. Burger said his experience both on the circuit court and as chief justice was that conference notes and other personal court papers were very misleading in that they often did not accurately reflect what had actually gone on at conferences; so that one judge's notes might misrepresent the position of another judge.[29] Burger made no bones about his view of the disposition of conference notes and diaries: they should be destroyed.[30] He thought such writings were simply not reliable. Apparently Justice Rehnquist shares that view. He was reported to have held that necessary frank and open discussion among the justices depends on an understanding that their tentative views "will not become part of the public domain either at the time expressed *or in the future.*"[31]

Justice Black was obviously very much of the same mind. He did, however, retain other of his Supreme Court files. As to them, he imposed restrictions that would seem to give all the protection colleagues might hope for. Access to his case files was completely restricted until the death or retirement of all the justices who were active members of the Court at the time a case was decided, a provision similar to that used by Justices Fred Vinson and Potter Stewart. Such an arrangement would not, in Justice

Black's view, have justified retaining his notes, for he believed their tendency was to distort, rather than to reveal, historic truth. The goal of accuracy is admirable. What Black may have missed, however, is that so long as the Court leaves the matter to each justice's individual discretion (as it does), the problem of misinterpretation may actually be worsened by destruction, since some notes remain to describe recollections of crucial internal events, while others are consigned to the furnace. The question is whether, ultimately, history best sorts itself out, with as little "help" as possible from those who want to set it straight, either by supplementing or pruning the record. Justice Black of all people, as a vigorous advocate of free speech, might have been willing to take the risk that truth would ultimately prevail.

Brandeis and Frankfurter

When Justice Brandeis retired in 1939, he told his successor, Felix Frankfurter, that he was planning to destroy his Court papers and would do so unless Frankfurter wanted them. Frankfurter arranged for the papers to be moved into his office. The files remained closed and in Justice Frankfurter's keeping until August 1954, when he transferred them to the Harvard Law School. Even then he did not make them accessible. Instead he appointed two well-known law professors, Alexander Bickel of Yale and Paul Freund of Harvard, along with the dean of the Harvard Law School, as custodians of the collection. At first, the trio planned to restrict access completely until a biographer they authorized had used the papers. In fact the biography they hoped for was never written, though Professor Bickel later published in book form eleven Brandeis opinions that had never been rendered or released by the justice during his tenure on the Court.

In his preface, Bickel justified his "disclosure" by observing (1) that all the justices involved in the cases were deceased, and that the cases went back at least twenty-five years; (2) that Brandeis himself had not destroyed the material, and that it contained "no trivia . . . no casual gossip or malice"; and (3) that enough has long since been gleaned from the private correspondence of some past justices that whatever inhibitions on free intercourse disclosures could generate had already occurred (though he doubted that free exchange of views had in fact been inhibited).[32]

Otherwise, the Brandeis papers remained inaccessible for many years. Ultimately the custodians deigned to make segments of them available on a permission basis to "serious scholars," and to allow quotation from the

papers only with their permission. There are voluminous Brandeis materials in several other libraries, but they contain very little Supreme Court material of interest. Frankfurter bequeathed his own court files to Harvard with the same restrictions on access to be administered by Professor Freund, that is, with a restriction to serious scholars, and a permission requirement for quotation.[33]

Apparently it was Justice Frankfurter's idea that the various justices should have the "right" people do their biographies, and that their papers should be reserved to those people at least until the biographies were done.[34] His notion was that Brandeis would be done by Paul Freund (or later, by Alexander Bickel), the second justice Harlan by Paul Bator of Harvard, Cardozo by Andrew Kaufman of Harvard, and Jackson by Philip Kurland of the University of Chicago. Except for a very long delayed (but estimable) Cardozo biography by Professor Kaufman,[35] none of these projected—or hoped-for—works was ever done.

One of the more remarkable incidents of withheld access occurred when Alpheus T. Mason, a distinguished professor at Princeton, was working on his biography of Brandeis, which was published in 1946.[36] As early as 1940, Mason asked to see Brandeis material in Frankfurter's possession.[37] In subsequent correspondence, Mason explained that he had seen letters from Frankfurter to Brandeis and hoped to see the letters in which Brandeis replied. Mason was particularly interested in Brandeis's view on the New Deal and noted that he had read with great interest Frankfurter's letters to Brandeis "during the early years of the F. D. Roosevelt administration." Though Mason was not asking for material relating to the Supreme Court, his request generated an immediate reply from Frankfurter saying, "As I pointed out to you when you were here, by Justice Brandeis' specific instructions I find myself under the severest restriction so far as his judicial work is concerned." He then added, "I assume, of course, that you will not publish any of my letters to him or any paraphrase thereof without giving me a chance to see what, if anything, you would like to publish."

This early exchange is notable because a lengthy correspondence ensued in which Frankfurter resolutely refused to let Mason see any letters, insisting repeatedly that he was only following Brandeis's own wishes as to discussion of the work of the Court. Mason as firmly asserted his understanding that Brandeis would not have denied him access to the papers. In fact, Mason began the correspondence by explaining that he was doing his biography with the consent and approval of Justice Brandeis, apparently believing that would open the door to unrestricted access from Frankfurter.

At one point Mason showed how upset he was with Frankfurter's rejection of his request, saying, "I am keenly aware of the discretion implied in the Justice's confidence when he entrusted his papers to me for my unrestricted use." The unstated message obviously was, Brandeis trusted me unreservedly, and by what authority do you act as if my discretion to respect his wishes is not to be relied on? In another letter that is not in the file, Mason charged the justice with having opened the papers to Paul Freund (to whom Frankfurter did ultimately entrust the papers), while denying them to him. Needless to say, Frankfurter was not moved. On December 18, 1945, he replied, "[Y]ou have been misinformed. I have opened Brandeis' 'court papers' neither to Paul Freund nor to anyone else. I have merely made provision regarding the papers upon the contingency of my death." He then spelled out in some detail his justification for refusing to let Mason see the letters:

> Apparently you do not appreciate the significance of the restriction that the Justice laid upon me in regard to the material bearing on his Court work in my possession—not only his working papers but his letters to me. You cite what the Justice wrote to Mrs. Norman Hapgood [of confidence in the discreet use of such materials as she may have] and you strangely suggest some contradiction between his willingness to have you write his life and the restriction he placed upon the material in my possession. There is no contradiction, once you bear in mind that so far as his judicial labors are concerned, he created a unique relation between himself and me. You surely know that he had very uncompromising notions about non-disclosure of Court matters—whether communicated directly or indirectly—and no disclosure of them for a considerable period after the events. I am as confident as I can be of anything that he never talked to you, any more than he did to others including his own daughters, about matters affecting the Court and never gave you access to any material pertaining to his work on the Court. In saying that he made me not merely the depository of his working papers but also his sole confidant on these matters, I am not making any self-enhancing statement. I am simply stating a fact. . . . The fact of the matter is that, so far as I know, I was the only person to whom he would talk about these matters and to whom he would write about them. Hence the restrictions which he imposed on me and which debar me from giving access to his papers or letters to others, either you or to his son-in-law or to anyone else, no matter how high my esteem for them.

That obviously ended the matter so far as Professor Mason was concerned. His book was published the next year without the benefit of the letters. We now know a good deal more about the background of this exchange, thanks

to the superb edition of the Brandeis/Frankfurter letters edited by Melvin Urofsky and David Levy.[38] Mason's original letter to Frankfurter was dated February 19, 1940. Frankfurter immediately forwarded the request letter to Brandeis, with this note at the bottom:

> L.D.B. I shall of course, and gladly, carry out whatever wishes you may have concerning this inquiry. But candor makes me say that my experience with Mason and the quality of his work would not lead me to select him for such a delicate and creative and art-demanding enterprise. Nor do I feel easy in turning over to him your letters during S[upreme] C[ourt] period.

Brandeis replied the next day:

> Mason's letter returned herewith. I have a much better opinion of him than you have, and, at Ben Flexner's suggestion, gave him leave to examine all the papers & other materials sent to Louisville. But I see no requirement that you should give him any definite answer at present. The papers on the Court cases you would, in no event, let him see; and you would not wish anyone to see those of my letters with comments on Court matters, or on any of the justices. And you would have to look over the letters to see which of them should be withheld.[39]

The widely held view that Frankfurter simply didn't like Mason, that he wanted to withhold the Brandeis material for his own chosen biographer, and that he lied about Brandeis having instructed him not to release the letters, turns out not to be quite accurate. We now know that Brandeis himself did impose some restrictions, though some of the material Mason sought could plainly have been given him without transgressing Justice Brandeis's instructions, had Frankfurter not been so eager to stage-manage the writing of the Court's history. Though the Brandeis letters ultimately survived and were finally (in 1991) published, Frankfurter's side of the Brandeis/Frankfurter correspondence has almost entirely disappeared. According to Pearl von Allmen, the late curator of the Brandeis papers in Louisville, shortly after Brandeis's death Justice Frankfurter came to Louisville and carried off large numbers of his letters to Brandeis from the collection. The letters have vanished, and the editors of Brandeis's letters believe Frankfurter subsequently destroyed the letters. So much for the judgment of history.

Now that the Brandeis letters have been published, having been sequestered for more than fifty years after Mason asked for them, we finally know what it was (at least on one side of the correspondence) that Frankfurter, and Brandeis himself, did not want made public. They contain little

confidential information about the inner workings of the Court. But there is a good deal of chat about prominent figures both in law and politics, some of it quite cutting: Brandeis was unsparing in his criticism of President Hoover: "Poor H.H. cuts a pitiable figure. It is truly pathetic . . . the engineer's lack of appreciation of the imponderable, his lack of intuitive knowledge, his lack of broad generalization & of human nature which are of the essence of the statesman."[40]

Perhaps more significantly, at least from Frankfurter's perspective, the letters contain a fair amount of political plotting. The political involvement of the two justices has been a matter of public record since the publication of Bruce Murphy's revealing if excessive 1982 book, *The Brandeis/Frankfurter Connection.*[41] As a result no reader of the Brandeis letters can be surprised to find passages about things such as placing the right people in the right jobs as the first Roosevelt administration gets under way in Washington. Still, it is a bit of a jolt to find such blatant politicking as the following on the part of a sitting justice, from a Brandeis letter of April 26, 1933: "I asked Dean [Acheson] to come in a week ago & suggested that he get Douglas to push him for an Ass. Atty. Gen'l position. We shall really need him when the new legislation is attacked. Can't imagine the A.G. will be adequate for that."[42]

The letters also contain a fair amount of scheming to influence public and professional opinion about legal issues. They are full of Brandeis's suggestions to Frankfurter (then still a professor at Harvard) to see that the right things got written up. On January 6, 1931, he writes, "[M]ake sure that Harlan [Fiske Stone]'s dissent in the C.M. & St. P case is duly appreciated by N[ew] R[epublic], H[arvard] L[aw] R[eview] & other publications." A few weeks later he reiterates, "I hope the law reviews will feature CM & StP decision. Harlan is eager for more recognition."[43] A student in Frankfurter's administrative-law course got the assignment, and an article duly appeared in the 1932 *Harvard Law Review*, as did a *New Republic* article for which Frankfurter supplied the information. Similar instructions are salted throughout the letters. Brandeis tells Frankfurter, "Make sure that Roberts' dissent in Coolidge v. Long is duly appreciated by the Law Reviews."[44] An unsigned note appeared three months later in the *Harvard Law Review*, praising the "most able and exhaustive dissenting opinion" of Justice Roberts.[45]

There is surprisingly little sensitive material on the business of Court, though now and again in the letters Brandeis offers rather unkind vignettes of his colleagues. Perhaps the choicest is this, from a letter dated May 30, 1930:

Hughes is mundane but intelligent. . . . The truth is that Taft for some time had really lost his grip and V[an] D[evanter] and Pierce Butler and McReynolds were running him. . . . Hughes has real energy and intelligence. . . . Hughes' opinions are like his old opinions on the Court—he has no imagination but he is a good artisan. . . . Stone feels very happy— he feels vindicated by all that has happened and he likes the joy of combat. He really does not know how to work, though he likes to be working.[46]

These are hardly world-shaking revelations, but taken together they say a good deal about one of our most important judges. Perhaps it is just as well that Brandeis's Court gossip was stayed for a decent interval, though one cannot help wondering if Frankfurter would have been quite so punctilious with one of his own disciples as he was with Mason, whom he distinctly did not like. We can at least be grateful that Frankfurter only destroyed his own letters.

The Holmes Papers

Another instance of Justice Frankfurter's engineering of history involved Justice Oliver Wendell Holmes Jr. The Harvard Law Library was ultimately the hero of the story, but only after many decades of restrictiveness. When Holmes died in 1935, his executor, John Gorham Palfrey, made the papers exclusively available to Felix Frankfurter, then a Harvard professor, who was Holmes's original choice to write an authorized biography. That was a first, and crucial, mistake, for the great bulk and richness of the Holmes material was more than sufficient to support a number of biographical and editorial careers. As it happened, neither Frankfurter nor his successors as official biographers were able to finish (or, for the most part, even to begin) the job.

Frankfurter himself was appointed to the Supreme Court in 1939. Frankfurter selected Mark Dewolfe Howe, then a law professor at Buffalo, to succeed him. Howe did prodigious work, both in assembling Holmes materials, publishing several volumes of letters and speeches, and in producing two volumes on the justice's early life. But Howe died in 1967, leaving all of Holmes life as a jurist unwritten. Harvard professor Paul Freund, who succeeded Palfrey as executor, then gave Grant Gilmore of Yale exclusive access to the Holmes papers. Gilmore had published no biographical work on Holmes when he died in 1982.

By then, nearly fifty years had passed during which a treasure trove of unpublished Holmes material had been withheld from all but the three

authorized biographers. Finally, in 1985, the Harvard Law School decided to abandon the idea of an authorized biography and to release the papers to the general public. Harvard authorized University Microfilms to produce a microfilm edition of the Holmes papers with an annotated guide and to sell it to libraries. The result, according to Holmes's biographer G. Edward White, is that "a virtually complete version of [the] papers is now readily available . . . [and] access to the Holmes Papers is thus a relatively routine matter for scholars and other interested persons."[47]

It is understandable why an executor might want to be discriminating about access, at least in the short term while contemporaries are still alive, and privacy concerns are at their greatest. She can reasonably believe that a person she knows and trusts will be discreet in using sensitive material in those early years, whereas she does not know what would happen if access were unrestricted. The costs, however, are great. If the authorized biographer fails to produce, as happened with Holmes, important study is thwarted, often for decades. If he does publish, and soon, the claim for making public material upon which the published work is based becomes irresistible: how can one deny critics the opportunity to verify or critique the work of the writer? The material will then have to be released, or the very essence of the scholarly enterprise is subverted. That being the case, why not either embargo some material (as little as necessary to protect privacy, for example) from everyone for an appropriate period, and open all the rest. The Holmes papers perfectly illustrate how much is lost when a very rich lode of source material—enough for a shelf of valuable books—is limited to a single researcher.

The Brennan Papers

While the extreme exclusivity practiced by Justice Frankfurter and the Holmes estate is no longer fashionable, contemporary justices continue to impose, or to allow, various forms of restrictive access. One of the most interesting examples involves Justice William Brennan, who died in 1997.[48] Brennan made a gift of his papers to the Library of Congress in 1967. In doing so, he divided the papers into three parts: legal files, correspondence, and what he called "personal annual reviews of the Terms' work." These last, the annual reviews, were descriptions of each term's cases that were prepared by the justices' clerks, but they also contain editing and other inserts by Brennan and were described by one researcher who has seen them as "juicy."

In his original deed of gift to the library, Brennan provided that during his lifetime the legal files and correspondence could be made available to others with his permission. The annual reviews, however, were to be closed to the public "for my lifetime and for the lifetime of any Justice participating in the decisions reviewed," and only thereafter were they to be publicly available. In 1993, under circumstances that will be described presently, the justice revised his deed, making access more restrictive, but creating more discretion in allowing exceptions.

Under the new arrangement both the annual reviews and the legal files were to be restricted until the later of three years after Brennan's death, or the death of the last surviving justice who participated (but for the legal files, not more than fifteen years after Brennan's death). Correspondence was to be restricted until twenty years after Brennan's death. However, the justice granted to one of his sons, William J. Brennan III, and to his authorized biographer, Stephen J. Wermiel, authority to permit access to all his material under the following guidelines: the anticipated historical and educational value of providing access; the need of the Court for confidentiality in its deliberations; the privacy interests of justices, law clerks, and others; and precautions promised by the person seeking access to safeguard confidentiality and privacy. He added, "I anticipate that access to any Case Histories [another name for the annual reviews] would rarely be justified during the Restriction Period and that if access is granted, it would be under conditions precluding public quotation of any part of any Case History during that period."

Since Brennan died in 1997, pre-1962 materials would become available in the year 2000 (three years after the justice's death), and post-1962 materials would begin to become available on the death of Justice Byron White, who was appointed in 1962. The particular reason for holding back the annual reviews (and what makes them "juicy"), it appears, is that included among them are Brennan's notes of what went on during conferences, as well as draft opinions and memorandums circulated among the justices.[49] These are the most confidential Supreme Court matters. According to Stephen Wermiel, Justice Brennan's authorized biographer, some of the material in the annual reviews is of a sort that no responsible historian would touch with a ten-foot pole—for example, double hearsay, such as, "Brennan heard O'Connor had been lobbied by . . ." or "so-and-so came out of the conference jubilant." On the other hand, Wermiel says, "it is a wonderful resource for a biographer."

Though his gift to the Library of Congress included all three categories of material, both the correspondence files and the annual reviews

remained in the justice's office and were presumably meant to be inaccessible during his lifetime, though the reality has been rather different. Even as to the case files that were in the Library of Congress, for some years, perhaps a decade following the original deed of gift in 1967, the justice is believed to have regularly denied requests for access. Then, sometime in the 1970s, Brennan quietly began to allow some individuals to see these files. Probably Bernard Schwartz, who later wrote a book on the Warren Court entitled *Super Chief,* was the first person to whom Brennan opened the case files. In that book, and a later one entitled *Decision,* Schwartz acknowledges that he had access to papers that were not public, including the conference notes of one justice, though he does not say that they were from Brennan. He does, however, note and discuss the willingness of Justice Brennan to make his papers available to serious researchers.[50] That was the beginning of a period in which Brennan approved access to his files for "legitimate scholarly pursuits," and the files were opened (with limits on more recent files) to a number of law, history, and political science researchers. That situation continued until 1991, when the justice retired.

In 1986, Brennan had agreed that Stephen Wermiel, then a reporter for the *Wall Street Journal,* and subsequently a law professor, would become his authorized biographer. The reasons for what happened next are not entirely clear.[51] Wermiel was concerned that access to the Brennan case files was getting out of control. As he put it, while researchers needed the justice's permission to obtain initial access, "he didn't know what they were doing—once in there they had license" to roam in the files at will, rather than to pursue some clearly articulated research project. Wermiel says that he helped Justice Brennan change the system. Whether Wermiel was concerned that the justice was being taken advantage of, that such openness was a disservice to the Court, that his own position as the authorized biographer was being undermined, or all those reasons, is uncertain. What is indisputable is that Wermiel was distressed by what he viewed as unconstrained use of the files by others, such as Bernard Schwartz, who, in Wermiel's words, "continued to publish books about the Court at a remarkable rate," including *The Ascent of Pragmatism,* which Wermiel described as a "behind the scenes, blow by blow, of the Burger Court."[52]

In any event, according to Wermiel, in late 1990 or early 1991, Thurgood Marshall came to see Brennan to tell him that there was an item on the Court's conference list for discussion as to what the justices should be doing with their papers, and a concern about the inappropriateness of showing outsiders papers containing information about the views or actions of other justices. Marshall reportedly told Brennan his colleagues had discussed and

put before the conference a proposal that justices should restrict access to protect those still sitting, and not include material written by others. The proposal was not adopted, presumably for lack of unanimity.

Then, in the spring of 1991, Justices O'Connor and Rehnquist came to see Brennan to tell him of their concerns about the access Wermiel himself had to Brennan's papers, presumably because it would allow him to see what they and others had said and written, and they suggested to Brennan that he close his files relating to any justice then still sitting.[53] Since Justice White was then still sitting, that would have meant closing all his files from 1962 on (though a number of justices' files from the Warren Court era were fully open, including those of Warren himself). Wermiel says that he spoke to Justice Brennan both before and after the Rehnquist-O'Connor meeting and persuaded him not to accede to their request. Instead they came up with a compromise, formally implemented in the 1993 revision of the deed of gift, described above.

In addition, the following arrangements were to govern requests for access: (1) Permission to use files in the Library of Congress would be valid for only six months and then would have to be renewed; (2) anyone seeking permission had to spell out the nature and purpose of their request, whether it was for publication, research, and so on; (3) files from 1986 on (the Rehnquist Court) would be closed indefinitely, as a concession to Justice Rehnquist, on the ground that such recent material was not yet "historical." Requests for access would be forwarded through the justice's secretary to Wermiel and Brennan's older son, William J. Brennan III, the justice's designees under the 1993 deed, and in turn be forwarded from the Library of Congress. Though the correspondence files were intended to be wholly unavailable, and access to the annual reviews "would rarely be justified during the Restriction Period," Wermiel himself has full access to both these sources and uses them in his research, though he respects the stricture that they not be quoted from during the restriction period.

According to a profile published in the *New Yorker* in 1990, Brennan himself was conflicted about what to do with his annual reviews. "It's a very troublesome question for me as to what the hell to do with them," he said at that time. "None of my colleagues have seen any of my memos. Nobody sees them except me. . . . One of these days, I'm going to have to make up my mind about what I'm going to do."[54] While he was deciding what to do with his annual reviews, Justice Brennan apparently went through his legal files—the material he had been sending over to the Library of Congress, and that he thought would be publicly accessible at a relatively early time—in order extensively to "prune" them. According to one researcher who has

examined them, "almost everything is gone from them. They don't even contain the minimum material that would have been required to do Court business."[55]

As to the annual reviews, it turns out Wermiel is by no means the only one who has had access to them. The material on the Nixon case that Woodward and Armstrong used in their book on the Supreme Court, *The Brethren,*[56] is widely believed to have come from Brennan's annual reviews. Brennan himself gave *New York Times* reporter Anthony Lewis permission to see the annual reviews, and Lewis quoted from one—which he refers to as a clerk's history of the case—in his book on the *New York Times v. Sullivan* case, *Make No Law.*[57] Lewis also got access to the annual reviews for a 1997 article he wrote describing inside-the-Court background on the famous reapportionment case, *Baker v. Carr.*[58] Most recently, Brennan's son gave access to the annual reviews up through 1969 (when Chief Justice Warren retired) to Morton Horwitz, a legal historian at Harvard, who is writing a history of the Warren Court. Each of these incidents should make clear that the old system under which papers were parceled out only to select and privileged individuals has not entirely come to an end (Horwitz explains he did not know he was getting special access to restricted material when he sought permission to see Brennan's papers, but he apparently got it because of his status and reputation).

Wermiel is quite open in describing his selectivity in administering requests for access. His basic rule is that only university-affiliated persons above the undergraduate level can have access (no journalists), and only if they have a well-developed research plan (no fishing expeditions). He noted that he had refused access to Kim Eisler, a writer who was researching a biography of Brennan (according to Wermiel, Eisler did not reveal his true purpose in seeking access to the files). Wermiel conceded that as the authorized biographer he had a conflict of interest with other biographers, especially since Wermiel had acceded to Brennan's wish that no biography be published during his lifetime. Eisler's biography, *A Justice for All*, was published in 1993, without access.[59]

Wermiel did give access to another biographer, Hunter Clark,[60] the distinction apparently being that he viewed Clark as a serious scholar because he had written a book about Thurgood Marshall and had an academic job at Drake University. In 1994, shortly after the *Washington Post* began publishing articles based on the release of the Thurgood Marshall papers, a man named Benjamin Weiser sought access, but Wermiel denied it because he disbelieved the proposal Weiser had presented, and concluded he was part of Bob Woodward's investigative-journalist team.

Another denial involved what Wermiel considered a close case. A writer for a lesbian publication wanted to do an article about the Court's handling of sexual-privacy cases. Though he considered the project legitimate and appropriate, Wermiel turned the request down because it came from someone without academic affiliation. He did so because it was consistent with his "no journalist" policy, and he believes that is an appropriate policy because the era of *The Brethren* has generated an interest in gossip "that is not that insightful or helpful."

It is difficult to determine how typical or atypical the Brennan case may be. There are numerous situations where library administration of papers is subject to the discretion of a donor, an executor, or a biographer. Some biographers have actually been allowed to take the papers of their biographee from the depository library and to keep personal possession of them while they were writing, as John Jeffries did of Justice Powell's papers and Gerald Gunther did those of Judge Learned Hand. Administrators of archival collections are rarely as candid as Steven Wermiel. His openness about how he administers the Brennan papers helps promote understanding of the usual bland terms such as "permission of the donor or his designee," or "discretion of the librarian."

The Thurgood Marshall Papers

Almost all access issues involve concerns about excessive secrecy. An incident involving the papers of Supreme Court justice Thurgood Marshall presented exactly the opposite situation.[61] Though he had at one point threatened to burn his papers,[62] shortly before he died Marshall arranged for them to go to the Library of Congress. Justice Marshall met on several occasions with James H. Billington, the Librarian of Congress, at which time they discussed Marshall's desires. He expressed only one concern, that classified material from his time as solicitor general be specially cared for. Subsequently, an agreement governing the gift of the papers was drafted by the library and signed without comment by the justice. It said simply, "[W]ith the exception that the entire collection shall be at all times available to the staff of the Library for administrative purposes, access to the Collection during my lifetime is restricted to me and to others only with my written permission. Thereafter, the Collection shall be made available to the public at the discretion of the Library."

Marshall died only two years after his retirement, and a few weeks after his death the library opened the papers for public research. Several

months later, a reporter for the *Washington Post* requested access to the papers, and the request was granted without restriction. When the *Post* article was published, with an extensive account of the papers' contents, a great controversy erupted. Material containing detailed information about discussions among the justices on very recent and extremely controversial issues, including abortion, was made public and was soon widely reported in the press. The *Post* published a series of articles based on the contents of the collection, including a detailed look at how the Court almost over-turned the landmark 1973 *Roe v. Wade*[63] abortion rights decision in 1989.

The *Post* stories ignited a firestorm of criticism directed at Billington by a coalition of critics that included Chief Justice William Rehnquist, the Marshall family, the executor of his estate (one of America's leading lawyers, William Coleman), and a number of Marshall's former law clerks. They complained that Billington had mistaken Marshall's intention and had misinterpreted the written agreement donating the papers. Justice Marshall surely did not intend that all the sensitive material in his papers be immediately made available for public consumption, they said. Many people who knew him well insisted he would not have done so. Their underly-ing concern, of course, was protection of the Court's confidential processes, the same issues that flared up when Alpheus Mason's book on Harlan Fiske Stone was published nearly thirty years earlier, and when *The Brethren* was published in 1979. As Justice Rehnquist's letter to Billington put it:

> I speak for a majority of the active Justices of the Court when I say that we are both surprised and disappointed. . . . Given the Court's long tra-dition of confidentiality in its deliberations, we believe this failure to consult [with the justices] reflects bad judgment on the part of the Library. Most members of the Court recognize that after the passage of a certain amount of time our papers should be available for historical research. But to release Justice Marshall's papers dealing with delibera-tions which occurred as recently as two terms ago is something quite dif-ferent. . . . [F]uture donors of judicial papers will be inclined to look elsewhere for a repository.[64]

If Billington's critics were correct in asserting that he misread Marshall's intentions, or that he misused discretion that Marshall's agreement vested in him, the matter would be of little interest here. But if we assume that Billington did—as he said—"adhere[] strictly to the donor's explicit instructions" and that Marshall wanted his papers made public upon his death, a much nicer problem is presented. Assuming that the claim of confidentiality for a time is a legitimate and powerful one, as Chief Justice Rehnquist asserted, the question is whether Marshall's proprietary-type

rights in his papers should prevail over an asserted supervening institutional claim in favor of the Supreme Court. In any event, this may have been the rare case in which a property right was asserted in order to reveal, rather than to conceal.

To say that the papers are Marshall's (or Black's, or Brennan's, or Frankfurter's) and he can do as he wishes with them fails to account for the fact that they are also an artifact of the Supreme Court's institutional processes and its history, and not personal in the usual sense. As a great painting is a part of the artistic enterprise down the generations, these papers are part of the nation's legal history and development. They are even less private than a work of art or a writer's notebooks or diary, which are simply the expression of an individual's genius.

While a justice's files are not official public papers that belong to the nation, the Court as an institution might reasonably claim a stake in them, at least to the extent of calling for a commitment to restricted access for a time, to say nothing of speaking out against destruction. After all, whether critics of the Library of Congress were right or wrong about the importance of temporary confidentiality, the issue goes beyond the desires of any individual justice. In that respect the Society of American Archivists missed an important point when it adopted a resolution saying that "it would be a grave disservice to Justice Marshall . . . to ignore the will of the donor and to close or restrict access to the Thurgood Marshall Papers."[65]

Apparently, the justices can't settle on any single institutional policy other than opposition to congressional action. Even those most unhappy about the revelations of the Marshall papers did not want a legislated solution. Moreover, there is no unanimity of view among them. Notably, Chief Justice Rehnquist's letter to Librarian of Congress Billington stated that he was speaking only for a "majority" of his colleagues, not for the entire Court. Despite congressional hearings and consideration of the matter among the justices, no formal restrictions or guidelines have emerged.[66] Each justice remains free to deal with his or her papers as purely personal property; and any justice who dies without making provision for his or her papers leaves them to the unfettered discretion of heirs or executors. Perhaps the lesson of the Marshall papers is not how much or how little confidentiality is needed. Nor is it whether the Court should seek or exact agreements among the justices about disclosure of institutional proceedings. It is, rather, how unsatisfying the use of mere proprietorship can be in dealing with things in which there is a great public stake.

Access to Library and Museum Collections

An archive (according to the Oxford English Dictionary) is "a place in which public records or other important historic documents are kept."—an institution of collective social memory. Nowadays, an archive is likely to include the "private" papers—letters, diaries, unpublished manuscripts, etc.—of "public" figures. For this reason, they are not always so public.

—James E. B. Breslin

It is perfectly natural to assume that libraries and museums collect things in order to make them available to the interested public, and that—with the exception of especially fragile objects—the materials they have are available for the asking. For the vast majority of things, that is exactly the way things work. But another little-known world exists within this universe, and there quite a different set of operating rules may apply. It is the world that consists of the papers of famous people, original manuscripts, ancient texts, letters and diaries, and all sorts of artifacts that have one thing in common: they almost always exist in only one copy, and that copy rests in one particular institution, and no other. As to these items, they are not always to be had upon request and indeed may not be had at all for many years. They are under embargo. Sometimes even the existence of certain things is difficult to discover, because they may not be cataloged. If the materials are accessible, they may be restricted in a variety of ways: Only "serious researchers" may have access, or permission may have to be obtained from someone, an heir or executor, or a library official. Or the material may be in use by someone who alone has access to it, usually an authorized biographer or a researcher who may hold a mysterious sort of proprietary interest known as "first publication rights."

Whatever the particular situation, it is perplexing because in every case the institutions, whether public like the Library of Congress or private like the Princeton University Library, are thought of as open places, open at

least on some sort of fair and equal terms to those with an interest in the materials they hold. Indeed, openness is the central principle to which such institutions subscribe. For example, the Association of Art Museum Directors states that "the collection exists for the benefit of present and future generations, it should be as accessible as is prudent for the protection of each object."[1] Libraries generally have similar policies of open access, subject only to the exigencies of preservation.

The public knows almost nothing about restricted access to library and museum collections. Little has been written about the subject outside the journals of professional archivists.[2] At the simplest level, collections given to libraries often contain material that deserves privacy at least for a period of time. Upon donation, the papers of a famous medical doctor, like Sigmund Freud, ordinarily include the medical files of still-living patients. Similarly, lawyer's files will contain privileged lawyer-client material. Such collections, at least for a time, can present both ethical and legal questions about accessibility. In 1998, in a case involving Independent Counsel Kenneth Starr's effort to obtain statements made by Vincent Foster to his attorney shortly before Foster's suicide, the U.S. Supreme Court held that the lawyer-client privilege survives the client's death.[3] The Court's opinion does not address the longer-term interest of historians and scholars in papers left to a library by a prominent attorney or a law firm. Privileged items within such material will presumably have to be sequestered for an indefinite period.[4]

An institution can also find itself facing agonizing privacy problems. A notable case was described by Sue Hodson, the Huntington Library's curator of literary manuscripts. The library acquired the papers of Lord Kinross, a journalist and author who died in 1976. Shortly thereafter: "An elderly gentlewoman who had been a friend of Kinross's came to look at the papers. After reading a series of his letters describing some homosexual liaisons, she came to me in extreme distress to plead that such material be restricted to protect his memory. . . . I felt much sympathetic distress at the shock she had received from seeing those letters . . . but by no means could I ultimately restrict the letters. Lord Kinross is dead, he left no descendants who might be embarrassed, and his lifestyle was known to his friends and associates. . . . Of far greater professional concern to me are scores of sensitive letters . . . written by [others] . . . many of whom are still living. . . . [T]he fact that these individuals wrote openly to Lord Kinross concerning rather intimate details of their lives cannot be construed as evidence of an open, generally known lifestyle."

Hodson later explained that after "a good deal of struggle with my

own conscience and my best understanding of archival ethics," she finally decided against "the risk of unwittingly outing someone."[5] She determined to re-review relevant correspondence files and "to restrict only when I have good reason to believe that an individual was not openly gay and that he is likely to be still alive. . . . a restriction long enough to ensure that an individual has died before we open the file." Hodson noted that library practices vary enormously. While many American libraries restrict nothing on their own initiative, at the other extreme is the Bodleian Library at Oxford, which automatically restricts all correspondence by living persons. The Bodleian policy is so rigid that some years ago it refused to release Kingsley Amis's correspondence to his authorized biographer, even with Amis's permission. Amis finally ordered and paid for copies of his own letters, which he then passed on to the biographer, Eric Jacobs.

Unfortunately, not every case of institutionally imposed restrictions is as benevolent as the Kinross case, for example the so-called Ten Box Affair of the late 1970s. The Minnesota Historical Society held ten boxes of papers of the former Episcopal bishop of Minnesota, one of which contained lesbian love letters between his wife and the sister of President Grover Cleveland. The society officially listed the papers as consisting of only nine boxes, and only made the tenth box available when it was "outed" by an anonymous letter to an historian of Gay history telling him of the existence of the box.[6] Not surprisingly, evidence of homosexuality has been one of the prime areas that executors and families concealed, famously in the case of the philosopher Ludwig Wittgenstein, whose literary trustees through close family control of his papers "staunchly covered up any public notice of Wittgenstein's sexual orientation."[7]

Over and above privilege and privacy problems that institutions inevitably face, and deal with more or less well, there is the far more troublesome matter of donor-imposed restrictions, which come in three general forms: access only with their permission; no access for a period of time; access only to one or more specified individuals. Individual archivists and curators, as well as their professional organizations, prefer unrestricted or minimally restricted gifts,[8] precisely because it is their business to promote use of the materials they have, and because they are overwhelmingly committed to the desirability of openness. Two concerns restrain them, however, in their dealings with donors. One is fear that if they do not accede to the restrictions, invaluable material may be destroyed rather than being made public. As one writer put it, "[A]rchivists fear the smell of burnt letters."[9] The other is fear of the competition. If they don't yield, the donor may shop the papers around to another library that is more acquiescent.

This latter concern is not insubstantial: after all, archivists make their reputations largely on the importance of the collections they acquire for their institution. One of their own has put the issue rather bluntly: "That the alternative for an archivist in dealing with a donor is always between preservation with the donor-requested restrictions, or the destruction of some or all of the manuscripts is a canard that ignores the archival avarice that regards a collection that goes 'there' rather than 'here' as effectively destroyed."[10]

Competitive pressures are unmistakably, if not explicitly, acknowledged in the ethical standards adopted by the profession. For example, the Association of College and Research Libraries publishes *Standards for Ethical Conduct for Rare Book, Manuscript, and Special Collections Librarians.*[11] "The library may not reserve materials exclusively for the use of individual scholars except where required by a donor's condition of gift or where such a reservation has been imposed by the holder of the copyrights in the material as a condition of acquisition. . . . The library should attempt to persuade donors and/or copyright holders to refrain from requiring exclusive reservation for individual scholars or other undue restrictions on access to materials under its control and should weigh carefully any decision to acquire materials accompanied by such restrictions."

Finally, there are a variety of internal pressures—rarely documented—that operate to limit public access. For example, in a book describing the management of museum collections, one has to dig in the footnotes to discover the single passage that adverts to "the case of the curator who wants exclusive access to certain records (and possibly collection objects), because he is engaged in active research."[12] One notorious incident involved the historian Francis Lowenheim, who accused the staff of the Franklin D. Roosevelt Library at Hyde Park of withholding documents from outside researchers so that it could publish them first.[13]

Scholars who work abroad tell stories of library officials who dole out material only to known and favored researchers; of keys that are missing when those out of the charmed circle appear with requests; and of uncataloged material that is provided to an authorized biographer but is simply nonexistent when outsiders come looking. One major Italian research center, the Archivio de Stato in Florence, has been described as "Byzantine, hostile, and bewildering."[14] Compared to their European counterparts, American institutions are quite open. Even here, however, there are tales of libraries with uncataloged material that is selectively doled out, and of museums without guidelines where controlling curators capriciously regulate access to objects in their collection.

Why do such practices exist? "Knowledge is power," as the curator of rare books in one university library summed it up. "Power" was an archaeologist's one-word answer, speaking of certain curators in a museum of anthropology. Umberto Eco, who spent many years in European scholarly libraries before becoming a best-selling novelist, created a secret library in *The Name of the Rose:*

> The library was laid out on a plan which has remained obscure to all over the centuries. . . . Only the librarian has received the secret, from the librarian who preceded him, and he communicates it . . . to the assistant librarian. . . . Only the librarian has, in addition to that knowledge, the right to move through the labyrinth of the books, he alone knows where to find them and where to replace them, he alone is responsible for their safekeeping. . . . Only he decides how, when, and whether to give it to the monk who requests it.[15]

Restrictions on access seem to break down into a few essential categories: Legitimate issues of privacy, privilege, and the like; unnecessary donor-imposed restrictions; and internal limitations generated by individual archivists and curators to enhance their own prestige and power. The first of these presents ethical and legal problems that institutions have to work through issue by issue, and sometimes case by case. However difficult the solutions, issues like privacy are familiar and arise in many contexts. The last category is equally clear, if no less difficult to resolve: rogue officials ought to be controlled. The collections are not their personal property. That leaves one class of cases for consideration here: Donor-imposed restrictions, made under the aegis of proprietary right, and institutional responses to them. Curators and archivists generally express dismay at such demands when they exceed legitimate concerns such as privacy or privilege, but consider themselves effectively helpless as against determined donors.

Indisputably archivists have to confront difficult choices. The risk of destruction is real. As we shall see in the next chapter, the papers of Learned Hand, one of America's most distinguished judges, were saved from the fire only because Hand was assured they would be available solely to an authorized biographer he trusted. The Abraham Lincoln papers, mentioned earlier, also only barely escaped destruction. Shortly after Lincoln's son died, Nicholas Murray Butler wrote that "it may be of interest to . . . know that I had the greatest difficulty in inducing Mr. [Robert Todd] Lincoln to deposit these manuscripts with the Library of Congress, since he had fully made up his mind to destroy them without further examination by anyone."[16] An agreed-on lengthy sequestration alone finally persuaded him to leave the papers with the library.

It is also true that a library may have little leverage over a donor, as the following hypothetical instance, posed by an official at the Hoover Institution, suggests: "Suppose an elderly famous person commissions an authorized biography and intends to give the biographer exclusive use of the papers before shipping them to an archive. That would be his right as the legal owner. This happens all the time. Then suppose the papers are in a basement, the famous person is old and sick, and it just works better for the biographer to work on the papers in an orderly reading room. To some extent the famous donor is still the private owner of the papers and has a right to grant exclusive access, prior to formally archiving the materials for the use of the public. It is especially clean if the papers are on deposit and not yet deeded over."[17]

These are plainly real and difficult problems. At the same time, as we are about to see, some troublesome, even abusive, situations exist and deserve attention. I shall suggest that institutions are not as helpless in the face of these dilemmas as they think.

Controlled and Exclusive Access

In what archivists call the bad old days, collections were sometimes accepted with outrageous restrictions. California's Huntington Library at one time accepted collections with the following restrictions (all of which have now been lifted): "never to be used by women; closed to any individuals of British extraction; closed to Jews, Roman Catholics, and the donor's nephew."[18] In the 1940s the Library of Congress not only screened researchers but required that notes taken by them had to be submitted for review to an official of the manuscript division before the person could leave the library so that library officials could withhold direct quotation of material they considered libelous or scurrilous, or of a wholly private or personal nature.[19] Surprisingly, a similar review and approval process is still imposed by the New York State Archives for "confidential internal reports" prepared by Benjamin Cardozo at the Court of Appeals, where he last served in 1932.[20]

As recently as 1995 Richard Noll, the author of a prizewinning book on the psychoanalyst C. G. Jung, was denied access to certain Jung papers held by the Library of Congress. The items in question were notes made by Jung's assistant, J. J. Honegger, dealing with a case that Jung had extensively used to illustrate his theory of the collective unconscious. Noll believed the notes would demonstrate that Jung had falsified the experiences of the patient to advance his theories.

The Jung family in Switzerland, which was unhappy with critical statements in Noll's previous writings (he had called Jung "the most influential liar of the 20th century"), insisted that the library deny Noll access to the papers. The library complied. According to a report in the *New York Times:*

> Marvin Kranz, the administrator of the Honegger papers at the Library of Congress, said the library had accepted restrictions from the Jung family and associates because they had "wanted us to give the papers back."
>
> "We accepted the stipulation that scholars have to get permission," he said, "because we couldn't alienate the family."
>
> Mr. Kranz said it was common for the Library of Congress and other institutions to accept restrictions on papers rather than risk their destruction or damage in private hands.[21]

Another practice from an earlier era is the grant of exclusive use of papers to a particular researcher, to the exclusion of other scholars who seek access to them. In such instances, the individual may have a special relationship to the family, or may otherwise have been instrumental in acquiring the papers. There may, for those reasons, seem to be some claim to special treatment, but the risk, especially if the individual holds the papers for a long time, is monopolistic control over data in which there is a legitimate public interest. A classic example arose with Berkeley's Bancroft Library in the 1960s.

The Sons and Lovers *Manuscript*

An English professor at the University of California, Berkeley, named Mark Schorer, who wrote biographies of Sinclair Lewis and D. H. Lawrence, found and authenticated the manuscript of Lawrence's novel, *Sons and Lovers,* and negotiated for its purchase by the university. Schorer got the library to agree that the *Sons and Lovers* manuscript would be restricted to his exclusive use until he could publish it.[22] That was in 1963.

At that time the university announced—rather misleadingly—that the manuscript would not be available until it had been microfilmed and cataloged. That, however, was not the limit of the restriction. In 1968, a scholar in London asked to see the manuscripts, but Schorer refused to release them. He wrote, obliquely, that as to "the Sons and Lovers manuscript. This is restricted pending its publication by the University Press, once permissions problems have been cleared." A few months later, a library official put it more candidly, stating in a letter denying a request that "these man-

uscripts are at the present time reserved for the use of Mark Schorer of our Department of English."

The next year Schorer again wrote in an effort to justify his refusal to allow others to see the manuscript:

> This is not a matter of my interest but of the University's. The library paid a great deal of money for the manuscript with Berkeley research interests in mind. This is surely obvious enough. . . . Until these [complex permissions problems] are solved, publication cannot proceed, but until publication is accomplished, my advice to the library—and it is only advice; I have no real authority in the matter—is to restrict the use of the manuscripts. If bits and pieces begin to float about, the point of the entire project will be undone.

Whatever Schorer's research project was, not much was ever accomplished. In 1977, fourteen years after the original purchase, he published a facsimile of the manuscripts (that is, a photographic reproduction of the pages) with a brief nine-page introduction, and a supplement with a list of textual variants that he described as having been done by reading the text aloud "through four long pleasant summer afternoons" with his wife and a friend.[23] In his introduction, Schorer repeated the implausible justification for denying others the opportunity to study the manuscript he alone possessed: "To the many scholars who have wished to work with these materials and have been denied access to them, I want to say that it has taken nearly thirteen years to cut through the barbed wire maze of permissions necessary to make the present publication possible."[24]

Schorer's reluctance to permit other scholars to see the Lawrence manuscript, despite their concerted efforts and his own lack of progress, was apparently a source of considerable embarrassment to the university. The then director of the library was reported to have said "never again" to such exclusive arrangements for what Schorer had called "Berkeley research interests." The current policy is that if someone is working on material and others want to use it, the library notifies the first person, but does not otherwise restrict access.

Though Berkeley learned a lesson from the Schorer incident, the bad old days are apparently not entirely in the past.

The Lucy Montgomery Papers

In 1981 the University of Guelph in Canada bought the papers of Lucy Maud Montgomery, the author of *Anne of Green Gables,* one of the most

famous books ever written in that country. The seller was her son, Dr. Stuart Macdonald, who was also her executor. Montgomery had died many years earlier, in 1942, leaving some ten journals comprising her diary. A professor at the university, Mary Rubio, who had a long-standing relationship with the Macdonald family, helped to expedite the purchase. Professor Rubio wanted to publish the diary, and to write a critical biography of Lucy Montgomery. Under the terms of the sale, Dr. Macdonald retained the right for ten years to determine and authorize access to the diary and other papers, and the materials were put under seal, keeping them from everyone except Professor Rubio and her collaborator. Though Macdonald himself died the year after the sale, the diaries and papers remained sealed (as the gift apparently required) until 1992.

Though the diary was then at first opened to researchers, Professor Rubio "prevailed" on the library to close it to general access for all the volumes that had not yet been published except for specific requests that were made for material that related to specific books, people, or events about which researchers were seeking information. The justification offered for this continued closure of the materials was that there were very sensitive remarks made by Lucy Montgomery about certain people, including family members. Rubio apparently urged that sensitive records would have an impact on living persons and should therefore be kept confidential, with the result that she alone would determine what should be published, and when.

The library cooperated with Rubio though all of this occurred some half a century after Montgomery's death. The official who manages the papers justifies these arrangements with the conclusion "that, to the best of my knowledge, scholarly research (as opposed to what might more correctly be called 'journalism') has not been thwarted, though it may be impeded by the number of hoops involved."[25]

Not every story has a bad ending. Institutions can and do stand up to powerful pressures and influential individuals. One very encouraging incident involved the National Archives, which administers the Franklin D. Roosevelt Library.

> [A] request for special privilege came from historian Arthur M. Schlesinger, Jr., who wished to see Roosevelt's correspondence with Felix Frankfurter. Schlesinger knew Frankfurter and knew that he would give him permission to see the letters he had written to the president. Schlesinger tried to convince the Archivist that if the creator of documents gave a researcher permission to see the documents, regardless of whose papers they were, that person should be able to see them.

> . . . All the old ways of the archival world would have allowed
> Schlesinger to see the documents. . . . Finally, a compromise was struck.
> Schlesinger could see the documents identified by Frankfurter, but only
> on condition that the same documents henceforward would be open to
> everyone.[26]

Certainly it is easier to turn back an inappropriate demand when the insti-
tution already owns the material, as the archives did in the Schlesinger case.
However, even then it is no small matter for public officials to turn down
anyone as prominent and well connected as Schlesinger, especially when
playing a famous Supreme Court justice as his trump card.

The more perplexing question is whether there is some way to
empower libraries when they are negotiating for a collection and fear both
competition and potential destruction. To be sure, a potential donor can
always retain a collection and control it however she wishes, as the hypo-
thetical example mentioned earlier indicates. But donors often badly need
the services and facilities libraries offer, and that is the source of the lever-
age archival institutions might reasonably expect to hold over excessively
demanding owners and executors. The first issue is whether libraries are
willing to stop competing on the basis of willingness to accede to inappro-
priate donor demands. If they are, one could rather easily draft a set of
"industry standards" to be adopted as a first step by major archival institu-
tions, and presented as a united front to donors. Such standards would
essentially require that papers be donated (or at least not deposited on
terms that make them vulnerable to recovery if the owners don't like the
library's behavior), and that the terms of the donation specify that any
items made available to any researcher should be made available to all on
equal terms—in short, no exclusive deals.

I would further propose the abolition of various versions of "serious
scholars only" restrictions. The notion that journalists are somehow sec-
ond-class researchers demeans the importance of a free press, makes
artificial distinctions between public information and history, and opens
the way to unaccountable discretion in deciding who shall have access
and who shall not. A number of major libraries have purged themselves
of such distinctions and seem to be none the worse for it. Berkeley's Ban-
croft Library makes no such distinctions. It does not withhold material
from journalists, nor does it deny access to people who may be thought
sloppy scholars, instead taking the view that scholarship should be self-
policing. The Hoover Institution at Stanford has a parallel policy: "We
do not screen researchers. . . . So a famous professor and a journalist are
treated the same. We do discourage high school students, however."[27] If
the result is to delay some "serious" biographers or scholars out of fear of

revelations by "irresponsible" journalists, I would suggest that is a risk worth taking. It is either proper for the public to know certain information, or not. It hardly matters whether they read it in a newspaper or an academic tome.

The next question is what to do about material that is private, privileged, or otherwise sensitive. Unfortunately, as the following incidents suggest, access restrictions can be a powerful tool in the hands of well-meaning but manipulative friends and relatives.

Time-Based Access Restrictions

Libraries have acceded to surprisingly long embargo periods. T. S. Eliot's letters to Emily Hale, his first love, are sequestered at Princeton until 2020, fifty-five years after Eliot's death.[28] The papers of T. E. Lawrence (Lawrence of Arabia) were embargoed in the Bodleian Library to be kept secret by the Keeper of Western Manuscripts until the year 2000. Lawrence died in 1935. Interestingly, the embargo was broken with the permission of Lawrence's surviving brother, when the *Sunday Times* of London was about to reveal the story of Lawrence's paying an army mate to flagellate him. Lawrence's brother believed the papers would provide a sympathetic, and truthful, explanation of the motivation for this perverse behavior, and that is how the papers came into the public domain many years before the specified release date.[29]

On April 5, 1992, the National Library of Ireland released some two hundred letters of James Joyce, many of them correspondence with his publishers.[30] The letters were among items Joyce's secretary, Paul Leon, rescued from the author's Paris apartment after the Nazis invaded and Joyce had fled to Zurich. Leon gave the papers to the Irish envoy in Paris, instructing that they be sent to the National Library in Dublin and sealed until fifty years after Joyce's death (he died in Zurich in 1941). Joyce's grandson, Stephen, who has fiercely opposed the release of private correspondence related to his family, demanded that some of the papers—the exact nature of which were not revealed, but which had earlier been rumored to be Nora's side of a sexually explicit correspondence carried on between Joyce and her[31]—be embargoed until the year 2050. The library agreed. Interestingly, Joyce had come out of copyright on January 1, 1992, fifty years after his death.[32]

These arrangements may be compared to the laws that now govern official secrets. The Public Records Office in Britain, which formerly had a fifty-year embargo rule, has since 1968 reduced that time to thirty years. As

of the year 2000, American material with permanent historical value is to be automatically declassified after twenty-five years, with a few exceptions for things such as confidential sources, information as to development of weapons of mass destruction, and military war plans still in effect.[33] Presidential papers can only be restricted for twelve years.[34] While any number is in a sense arbitrary, a fair question might be this: how many papers of whatever kind are needfully kept secret more than twenty-five or thirty years after the death of their owner?

Like the problem of exclusive use, sequestration excesses might also be addressed by a set of uniformly-agreed-to standards adopted by research libraries and museums. No single time period is necessarily right for material that is private, privileged, or otherwise sensitive, but using the lifetimes of the individuals involved is probably as close as one can come to a balanced solution. As to letters, for example, one might choose the later date of the joint lives of the writer and recipient, but setting a minimum of twenty-five years and a maximum of fifty years from the date of the letter in question. For documents involving national security or similar interests, one might use the lifetime of the individual involved, or alternatively, the statutory period for like public documents, whichever is later. These are only rough suggestions. The important elements are uniform standards, institutional commitment to enforcement, and reasonable periods of time, with reasonableness tied in some way to the span of lifetimes contemporary with the events and documents in question.

Even with the best-crafted and best-implemented standards, doubtless some destruction will still happen when a donor's will is thwarted. However, in most instances a putative donor who is negotiating with a library has probably already decided that the material in question is important and deserves to be saved. Those are precisely the owners who are most likely to be amenable to reasonable and sensitive archival standards for time-limited sequestration, especially if all the most respected institutions embrace identical standards that everyone must meet.

Without some such standards, restrictions on legitimate opportunities for access—even of the most important material—are bound to continue to occur. Perhaps it is best to conclude with the classic object lesson in how not to do it, the Freud papers debacle.

The Freud Collection

The granddaddy of all embargoes must be the Freud collection at the Library of Congress, originally established in 1951, and one item of

which—in a part of the collection known as Series Z—is sealed until the twenty-second century, to the year 2113.[35] While that is an extreme case, and the great bulk of the material is now open, there are a number of other items restricted to dates such as 2020, 2038, 2053, and 2057. Library officials are eager to reduce the number of embargoed items and are working with the donors to increase accessibility. It is not easy to get an exact sense of how much material remains restricted. The person at the Library of Congress who manages the Freud papers said that of the restricted material 95 percent would be available by 2020; or, put another way, of a twelve-page list of material, only about one-half of one page contains material that will be embargoed past 2020.[36]

Despite the best efforts of the library staff to open the maximum amount of material, the status of the collection remains something of an embarrassment. After all, Freud—who was one of the most important figures of the twentieth century—died in 1939. Much of the restricted material consists of tapes and transcripts of interviews with people who knew or were patients of Freud. Not many of them are likely to be around until 2020. As to the 2113 item, which is an "interview with H.R., identity withheld," the only explanation a library official could give was that "we were stupid to take it [with such a restriction]."[37]

In a rather unusual arrangement, the Library of Congress is effectively a depository for much of the collection, with the material under the control of the board of the Freud Archives—a group of psychoanalysts devoted to Freud, and originally organized by Freud's greatest admirer, the distinguished New York analyst Kurt Eissler,[38] or by the representative of Anna Freud's estate. It is largely thanks to Eissler, who continued to control access until his death in 1999, that the Library of Congress has been caught up in one of the most extreme manuscript sequestrations of modern times.[39] Many of the restricted materials are interviews that Eissler himself conducted, and apparently he generally wanted the interviews sequestered for fifty years, but no one is entirely sure about his policies. Though he usually denied requests for access to these items, he did sometimes grant use permission, so some researchers have access to materials that are generally unavailable, wholly at Eissler's unconstrained discretion. As the person at the library who dealt with Eissler put it, "I don't understand why he says yes, and why he says no. I don't like it, no one does. But [such arrangements] may be the only way we can get certain papers; so we swallow it. I believe in democracy, that is, equal access."[40]

One example of the extremity of Eissler's behavior involves the daughter of one of Freud's pupils, who sold to the Freud Archives a collection of Freud letters written to her mother in the 1920s and 1930s. The

archives then transferred the letters to the Library of Congress, imposing an embargo on them until the year 2000.[41] The woman wrote an open letter to the *New York Review of Books* complaining that she had sold the material "believing that these papers would be accessible to serious students and research workers," which she added "seemed a natural and reasonable supposition in dealing with a reputable and responsible institution." She found out to her dismay that she was dealing with the ultrasecretive Kurt Eissler. "Surely," she wrote, "this is a ridiculous situation and a pointless restriction. It is not a matter of state secrets, but of the work . . . of a scientist of world-wide fame and historic importance, long since dead, as are probably all of the people mentioned in the letters."[42]

Eissler explained that shortly after the Second World War, and at a time when there was little interest in Freud's life history, a group of psychoanalysts, headed by himself, determined to gather letters and other material that had survived the war, and to insure against its dispersal and ultimate loss to research. As he put it, "The need for a Sigmund Freud Archives was thus recognized. Subsequently the Library of Congress agreed to accept as a donation all documents collected by the Archives, and to make them accessible to scholars after prearranged dates, to be determined by the Archives."[43] For many years, until 1985, Eissler himself was the director of the archives.

Not all the relevant Freud material was originally in the Library of Congress. Many other things, including personal effects, his library, antiquities he collected, and many letters and other documents, were in Anna Freud's home in London, established as the Freud Museum in 1986. Not to put too fine a point on it, much of the energy of Anna and of Eissler were devoted to protecting the reputation of Sigmund Freud. The result was a policy of selective access to Freud's papers. Much of the Anna Freud material was restricted until the year 2000, and access to that, much of it Freud family material, was also through Eissler. To make matters worse, though Eissler usually didn't give permission, according to Library of Congress officials, he granted exclusive access to one editor who is producing an edition of Freud's letters to his wife.

Administration of the Freud material first became a public cause célèbre after Eissler, to his subsequent great regret, allowed a man named Jeffrey Masson to become his successor as director of the archives and, at his behest, a trusted visitor to the Freud house. Masson subsequently published work critical of Freud that Eissler and his group considered a betrayal of their trust. The ensuing controversy led to Masson's firing, a lawsuit, several books written about the dispute, and a libel case arising out

of one of the books.[44] In the course of all this rancor, a great deal of information about the use of Freud's papers was revealed.

Masson, who for a brief time had access to the entirety of the archive and examined the embargoed and sealed material, gave this explanation:

> The official reason given for the existence of seals in the first place was that patients and their identities needed to be concealed (confidentiality), and no doubt in many cases this was true. In some instances, the families of patients would refuse to donate papers unless such restrictions were imposed. In most cases, however, Eissler himself imposed the restrictions for reasons that were often rather obscure. In my opinion, based on an overview of all the material, a great many of the documents were kept from public view if in the eyes of Eissler or the donor they could prove potentially embarrassing to psychoanalysis.[45]

For example, in 1950 Anna Freud published selections from correspondence between Freud and his close friend Wilhelm Fliess.[46] But she had not published all the correspondence, and among the unpublished letters was one that Masson said demonstrated that Freud had recanted his previous view that patient reports of parental sexual assaults were fantasies, but had for self-interested motives not revealed his true position. The accuracy of Masson's interpretation was a matter of great dispute. Freud biographer Peter Gay described it as preposterous.[47] Whether it was credible or not, there could hardly have been any dispute about the fact that the letter on which it was based was of value to researchers and worthy of analysis. Masson got access to the letter, however, only because of the enormous regard Eissler originally had for him, and because of his ability to ingratiate himself with Anna Freud. For there were a great many letters scattered throughout the house that had never been made available to researchers, and that Anna treated as her personal private property (which, legally, is exactly what they were), and perhaps even more significantly as a means for protecting her father's reputation and memory. Masson described "a huge, dark wooden cupboard that stood on the landing outside her bedroom . . . filled with about a thousand letters from Freud. No one had ever read them. . . . It was a treasure trove! There were all kinds of things in it that no one knew about."[48]

The material in the archive was apparently treated by Eissler in the same proprietary way. In Janet Malcolm's book on the controversy, an analyst is quoted as saying: "Everybody is terribly interested in those papers that Eissler won't let anybody see. . . . Eissler has been so impossible with regard to these papers—as Anna Freud was."[49] Another person who was working on a biography of Freud's friend Fliess said, "I was playing my

cards carefully. . . . I certainly entertained the idea that in winning Eissler's confidence I might get to learn what he had in the Archives, what he was holding back."[50]

One of the most arresting features of Malcolm's book about the Eissler/Masson affair was the candor with which both Anna Freud and Eissler spoke of their management of the papers to maintain Sigmund Freud's reputation as they conceived it. At one point Eissler is complaining about four writers, each of whom have published highly critical things, and he concludes, "[E]ach time something is released by Anna Freud or the Archives, these things are written."[51] Eissler's insensitivity to his role as a censor is utterly stunning. When asked by Malcolm about the injustice to present-day scholars of withholding documents for over a century, Eissler replies, "Injustice! I think it is a far greater injustice that [a critic] may publish whatever he wants about Freud, and that Freud cannot defend himself and prove he is being maligned."[52]

In the acknowledgments, at the end of his magisterial biography of Freud, Peter Gay apologizes for gaps in the book for which, he says, "I am not responsible, gaps I tried in vain to close, with more strenuous eloquence, and more pleading letters, than I care to recall." He then goes on to explain that

> Dr. Eissler has freely and frequently expressed the view that anything—
> I mean *anything*—that Freud had not intended for publication should
> not be published. . . . [H]e voiced the opinion that even the publication
> of the Freud-Jung correspondence had done Freud a disservice, since it
> had been used to denigrate Freud. . . . The addiction to secrecy to which
> Dr. Eissler was—and is—so passionately committed could only encour-
> age the festering of the most outlandish rumors about the man whose
> reputation he was trying to protect.[53]

Although it hardly seems imaginable, Anna Freud was even more blunt. To the same critic, who had asked for access to some letters, she replied, "I have decided that for a time no further such access will be given to anybody, since the consequences are not always what I would wish them to be."[54] If there were any doubt left about Anna Freud's management of her father's papers, Eissler removed them when he wrote to Jeffrey Masson, "Do you remember that I told you I feared that Anna Freud would not agree to it [a complete edition of the Freud-Fliess letters], because her father's letters have been regularly used to diminish his character, or for like purposes."[55]

Anna Freud's posture was probably more complex than a mere reading of her words make it seem. She did permit access and publication of

some sensitive material, both by Max Schur, who had been Sigmund Freud's personal physician, and by Masson while he was still in good graces. A more personally generous, but no less damning, picture of Anna Freud's perspective was painted by Jeffrey Masson some years after his break with Eissler:

> I do not believe that Anna Freud ever consciously concealed material. She was generous and self-effacing to a fault. But I think she assumed or hoped I had the same priorities she had, in which family loyalty played a central role. There was certainly never a plot on the part of the keepers of the flame to maintain the image of a Freud that was clean, even sanitized, but it was clearly intolerable to many close to Freud to think that he was anything less than morally irreproachable.[56]

In 1986, following the Masson affair, Eissler ceded direction of the Freud Archives (though not control over access) to a psychoanalyst named Harold P. Blum, who announced a policy of greater openness. He said at that time that all the papers under the control of the archives would be made available to scholars on the basis of equal access and that nothing would be held back except in the cases of legally binding stipulations by a donor (presumably referring to Anna Freud's will, and among other things, letters to her from her father).[57] Subsequently those letters, as well as Freud's letters to his sister-in-law (with whom he had been thought to have had a love affair), were opened.[58] In 1996 the Freud Archives reported that the collection "is now approximately ninety percent de-restricted and is accessible to all scholars upon application to the Library of Congress."[59] As noted above, this is a rather upbeat characterization of the access situation.

Historians and archivists may properly take a very long view, but timeliness is relevant too. As the daughter of one of Freud's pupils and translators observed (commenting on Eissler's access restrictions), "Those of us who survive, and whose memories might supply a few useful answers to the questions of workers in the field, are likely to be long dead before such questions can be asked."[60]

9

Heirs, Biographers, and Scholars

> Bad history or bad biography can be driven out only by better history or better biography, and these can be written only if documents are accessible to scholars.
> —Peter Gay, *Freud: A Life for Our Time*

Solicitous Relatives, Importunate Biographers

Misplaced family feeling has led to the destruction of many treasures that time would have put in a perspective that heirs, empowered by proprietary rights, too often lack. The editor of Matthew Arnold's letters explained how the letters were excised of material considered inappropriate by Arnold's widow and his sisters, but even so, he reports, they "weathered family surveillance and censorship in better health than, in almost identical situations, those of Tennyson (whose wife and son were pyromaniacs) or perhaps Swinburne (whose sisters and cousin were merely arsonists)."[1] There is as yet no public right that safeguards art or other important documents against overprotective heirs. Ian Hamilton has written a whole book about the subject, filled with sad stories of bonfires, excisions, and inkings-over.[2]

The privacy of an author or artist, and of family and friends, is certainly a legitimate concern. One key question is whether it dwindles away with time. The stories in this chapter make clear that many children and grandchildren—and even more remote relatives—do not think so. Their feelings remain extraordinarily intense long after the events. To be sure, some of the feeling grows out of a commitment to keep their forebear's reputation intact, even where that means disposing of inconvenient facts. One need expend little sympathy on those cases, unhappily exemplified by the Harding love letters, to which I shall turn momentarily. The more perplexing case, illustrated by James Joyce's grandson and Bernard Malamud's widow and daughter, transcends the conventional question of a deceased person's privacy and forces us to ask a more probing question: whether a family—over the generations—is a kind of living entity, so that descen-

dants should have their own right to decide the fate of letters or artistic works, as worthy as that of the parent or grandparent who created them. The writer who posed the question, "To whom does a life belong?"[3] raised a profound question.

On balance, I conclude that the claims of history outweigh those of family feeling, however genuine, but the question is not an easy one. In the end, several considerations are determinative for me: First, as noted in a previous chapter, the failure of the principal to destroy material during his or her lifetime at least suggests a willingness to abide posterity's judgment. Second, unlike the principal, the descendant is not ordinarily well-qualified to make an artistic, literary, or scholarly judgment about the significance of the material. Third, the temptation to distort the record by getting rid of unwanted facts also makes a friend, follower, or family member an unreliable judge. Fourth, though time obviously does not wholly heal wounds or destroy concerns about the privacy of one's own family history, its weight declines as time passes, the more so when neither the participants nor their contemporaries are still alive.

Finally, those who contemplate destroying documents should keep in mind that the future will appraise them from its own perspective. Things that embarrass the current generation may look very different in the fullness of time, as only the most prescient are likely to see. Charles Dicken's daughter Kate planned to burn her mother's letters, believing they reflected poorly on the mother, telling the story of a great man mismated and dragged down by an inferior woman. She was ultimately persuaded by George Bernard Shaw to save the letters and donate them to the British Museum. Shaw saw, as few then would have, that "the sentimental sympathy of the nineteenth century with the man of genius tied to a commonplace wife had been rudely upset by a writer named Ibsen." Shaw predicted that posterity would sympathize more with the woman sacrificed than with the man whose only grievance was that his wife was not a female Charles Dickens.[4]

Warren Harding's Love Letters

> And, he said very earnestly, I do know one thing for certain, that if a President of the United States has written something—no matter what it is, it's a part of history and nobody has a right to destroy it.
> —Don Williamson

In 1963, while he was writing his biography of President Warren G. Harding, Francis Russell obtained a package of letters that Harding wrote to

Carrie Phillips, whose husband had owned the department store in Harding's hometown of Marion, Ohio.[5] Mrs. Phillips had by then died, and the letters were in the possession of a man named Don Williamson who had been her guardian during her last years. Russell soon discovered that they were passionate and very lengthy love letters, some running to thirty or forty pages, in which Harding poured out his emotions. Russell proposed that the letters, from which he planned to quote extensively, be given to the Ohio Historical Society so that they would have a secure institutional home. "Williamson knew," Russell says, "that if he turned over the letters to anyone in the Harding Memorial Association [the defenders of Harding's memory] they would go up in smoke." The letters were duly presented to the society, but soon afterward all hell broke loose.

Once the Historical Society's trustees discovered the content of the letters, they called for their destruction. One local bigwig took the view that "anything damaging to the image of an American President should be suppressed to protect the younger generation." But matters were not so easy. Title to the letters was in question, the Historical Society had no authority to destroy material in its collection, and—in any event—Russell had already seen and copied portions of them. In addition, as it turned out, the curator of documents at the Historical Society, knowing his employers, had made microfilms of the letters "against the possibility that the originals might later be destroyed."

Historical Society officials then worked out a cunning scheme. They got a cooperative judge to establish an estate for the deceased Carrie Phillips, to whom the letters had been written and who had owned them, and to appoint an executor who then demanded that the letters be turned over to him for the benefit of the estate, claiming that the gift to the Historical Society was unauthorized. The Harding family next filed a lawsuit, claiming that publication of the letters would damage Harding's heirs. They persuaded a local judge to issue a temporary restraining order prohibiting any "publishing, producing, copying, exhibiting, or making any use whatever" of the letters. The executor then sought out Carrie's surviving daughter and induced her to sell the letters to Harding's nephew, George T. Harding. (Though Russell himself offered to buy the letters, the Hardings made clear they were prepared to outbid him, whatever he might offer for them. As it turned out, Carrie's daughter sold them to the Hardings for a pittance, eight thousand dollars.)

At this point, one might have expected the letters to vanish from the face of the earth, never to be seen again. The Harding family lawyer admit-

ted that "my clients would like to destroy the letters, but I don't think that will happen. They want to suppress them." Russell, doubtless fearing the worst from the family's machinations, leaked the story to *American Heritage* magazine (a Toledo newspaper already knew some of the story), and asked it to tell the *New York Times* about the letters. The *Times* ran a front-page article headlined "250 Love Letters from Harding to Ohio Merchant's Wife Found" and also quoted portions of one of the letters.[6] The *Times* story ran only a few weeks before the Ohio judge issued his restraining order.

Four years later, when Russell published his biography, the temporary restraining order was still in effect. Russell blanked out a dozen or so spaces in the book to document the family's censorship at places where he had planned to quote from the Harding letters, and to make sure the world didn't forget what Harding's heirs had done. The lawsuit was finally settled in 1971. The Harding family was paid ten thousand dollars in exchange for which they agreed to donate the letters to the Library of Congress, but with a stipulation that George T. Harding was to retain publication rights in the letters until July 29, 2014, fifty years to the day after the issuance of the temporary restraining order, and ninety-one years after President Harding's death. Until that time, the material remains closed.

Has anything of importance been lost, other than the opportunity to satisfy a prurient public interest in Harding's sexual adventures? Russell, though perhaps not the most disinterested observer, thought so, and he—almost alone—has seen the letters:

> Harding told Carrie everything, and his completely candid outpourings consequently shed a strong light on his character, his motivations, his ambitions, his doubts. . . . In this way the letters have much to say to biographers.[7]

The legal tool employed by the Harding family in their lawsuit was both copyright and (ultimately) ownership of the letters themselves, for although Carrie Phillips as the recipient originally owned the letters, the writer of unpublished letters retains the copyright in them, and George Harding claimed as heir to the former president. The descent of copyright to family members has been criticized at least since the nineteenth century as permitting an author's heirs to suppress works whose publication they consider unseemly or embarrassing.[8] Professor Wendy Gordon has urged that an exception to copyright protection be created as an extension of the fair-use doctrine, the right to quote a limited amount of copyrighted material without running afoul of the law.[9] Some countries also recognize a

right of divulgation, which could, for example, oblige an heir who holds a copyright in artworks to permit (upon payment of a royalty) biographers or scholars to reproduce them in a biography.[10]

In contrast to the copyright literature, very little has been written about the parallel power of restriction available to owners of the physical objects who need not invoke copyright in situations where no one has seen, or been allowed to copy, unpublished materials they hold. Though the Harding family was not able to get hold of the letters themselves in time to prevent Russell from seeing them, often family members do have possession and can control the use of the material without having to resort to the courts and their copyright. One of the more distressing incidents of recent years involves James Joyce's grandson.

The Stephen Joyce Affair

At an international conference of Joyce scholars held in Venice in 1988, the audience gathered to hear a presentation by James Joyce's only living direct descendant, his grandson Stephen. Mr. Joyce took the podium to report that he had destroyed all the letters he had received from his Aunt Lucia, the author's daughter, who had spent most of her life in mental institutions.[11] His decision, he explained, was a direct response to a biography of his grandmother,[12] where he had fought to excise material about Lucia that he considered an invasion of privacy. He succeeded there because he owned the copyright to the letters and threatened to deny permission to quote any letters unless the unwanted material was removed. Though Stephen had won that battle, he plainly found the experience painful and was determined not to undergo another one like it. No doubt he was also alert to the uncertainty involved in any legal dispute. In the case of the Lucia letters, he adopted a final solution to make sure they would not be quoted. He burned them before anyone saw them.

Stephen's announcement generated an uproar of disapproval. One member of the audience, the son of the poet William Butler Yeats, said that material about great writers like his father and Joyce belonged to the world, not the family. Joyce vehemently disagreed, deeply offended that explicit, erotic letters between his grandparents had been published previously, and that "amateur psychologists" were rummaging through his mother's and his aunt's mental-health problems. He insisted that Lucia's letters, written to him and his wife by his aunt, had no literary value, and that she was not a writer. He said, "I didn't want to have greedy little eyes and greedy little fingers going over them. No one was going to set their

eyes on them and re-psychoanalyze my poor aunt. She went through enough of that when she was alive."

"Where do you draw the line?" he asked, "Can you imagine trying to explain certain things to [your children]. That would be a nice job if their whole family's private life was exposed!" "Do you have any right to privacy?" The next year, Stephen Joyce wrote a very long letter, explaining his views in detail, that was published in the *New York Times Book Review* on December 31, 1989. While much of the letter repeats the views expressed above, he added the following interesting perspective:

> Question: why cannot such papers and letters be locked up, embargoed, or access be limited to scholars only? Bitter experience has taught me this is impossible. The temptation to come out with a scoop, to get ahead of the competition, even in the world of academe, is too great. This is in fact what happens. If you tell somebody they cannot use a paper or a letter, that person will always find a way of getting around such refusals by paraphrasing or using very short quotations. Pirating is another fairly common practice. I can easily cite chapter and verse. The only way to make sure is to destroy.
>
> . . . Another thing these scholars do is take all the fun and adventure out of reading. Personally, I do not want to be told what to expect in a book. . . . With the possible exception of "Finnegans Wake," any man, woman or adolescent can pick up James Joyce's books, including "Ulysses," understand most if not everything and find pleasure and enjoyment.[13]

No doubt the wounds are real, and the intrusiveness of some biographers and journalists recognizes no limits. Nonetheless, however admirable they may be as individuals, the children or grandchildren of great writers are hardly the best judges of what has literary value. Isn't the point, indeed, that no single individual should be left finally to judge such matters. Nor are the heirs ordinarily even the subjects of the asserted invasions of privacy, though family feeling is often real and intense. In Joyce's case, after all, it was his aunt's privacy, not his (though the material is more than a little remote from the author: these were letters from Joyce's daughter to his grandson, which is much different than Joyce's own letters to his wife). Whatever the literary or historic value ultimately may be, the brute fact is that an heir's power over the material is generated by ownership and possession, not by the moral or artistic strength of his position. Stephen Joyce put it bluntly enough: "What are people going to do to stop me?"

There is probably no practical way to control the behavior of heirs or friends who are determined to destroy material they consider too personal,

or too harmful to a revered memory. But there can be value in setting down a standard that disapproves such ruinous acts even if it cannot, except in rare instances, enjoin them. Surely some possessors will heed the judgment of their community and stop short. Even if no more can be done than to press some individuals to engage their own sensibilities and sensitivities, they may be persuaded to stop short of irreversible acts of destruction and to rely on a time-limited quarantine instead, knowing that the wounds they fear are of the sort that time enough will mitigate, if not heal.

However wrong Stephen Joyce may have been, it must be said that the heirs of prominent people do often have a view of these things that is sharply different from that of historians and biographers. The daughter of a former U.S. attorney general had this to say:

> I reject the notion implicit in the standard donor contract forms, that time erodes the right of privacy. . . . This view fails to recognize that a person's interest in his good name does not die with him. On the contrary, along with his name it is passed on to his descendants. The provision I find most short-sighted is that which protects only *living* persons from the publication of papers which might be used to embarrass, damage, injure or harass them.[14]

Private Matters

On reading about what Stephen Joyce had done, Bernard Malamud's daughter reflected sympathetically, "What do you say to the person who offers your mother cash for her love letters? How often should you write back to the scholar who persistently requests more medical details about your grandmother?"[15] That was in 1989. Eight years later the daughter, Janna Malamud Smith, published a book entitled *Private Matters*. In it she explains that she first began to think about these issues when her father died in 1986, and she and her mother were left to settle his literary estate. Offended by the officiousness of would-be biographers, she was—as she put it—"not eager to have my private father . . . tampered with by someone else's appraisal. . . . Not only did I feel myself vulnerable, but I felt he was."[16] Her first intuition was reflexive protectiveness and sympathy with writers and family members who had burned letters and papers. Then she realized that she had come down on one side of a complex truth.

The product was her book, of which one chapter is a meditation on the tension between the desire for privacy and the uses of biography. What she wrote is a rare, perhaps unique, effort by the descendant of a famous artist to sort out the issues. Interestingly, nothing in her views turns either

on ownership of the materials in question or on the special status, or protective instincts, of a family member. Her observations grew out of an effort to probe the meaning and importance of Leon Edel's masterful biography of Henry James.

James was famously reticent. Not only did he burn letters in his possession and instruct his executor to do the same,[17] he even wrote a book, *The Aspern Papers*, about a poet whose papers are burned to frustrate the efforts of a literary critic/biographer who is determined to get them. But of course many letters *from* James survived and ultimately came into the hands of his literary biographer. Smith's book recognizes the worth of Leon Edel's biography, in particular the effort to understand the author by means of his life, and not only through his art. Through Edel's work, she comes to appreciate the complexity of the relationship of the reader to an admired writer. "It is because an artist or public figure stirs and speaks to our own most private feelings that we wish to know about him. . . . When we read biographies, we search for a friend, a mentor, a kindred spirit, and ultimately for ourselves."

At the same time, Smith is troubled by the exploitative biographer and journalist, the voyeuristic reader, and what she calls the subversion of biography when its subject is "left too naked," exposed to a "public ritual of nakedness and sacrifice." Her concern is not for a right of privacy in the usual sense, since the subject is no longer alive and has no privacy to be violated. Nor is it a fear that the privacy of others, family, friends, or lovers, might be violated. Smith has a more subtle focus: a respect for the dignity and the humanity of the person being written about, regard for his or her memory, and consideration for those who cared enough about the subject to feel keenly the impropriety of unseemly probing behind the necessary and important screen of privacy that is a critical part of every life.

Perhaps no contemporary case more poignantly illustrates Smith's concerns—though she does not discuss it—than that of Sylvia Plath, all the problems of biography spinning wildly out of control, as described in Janet Malcolm's elegant book, *The Silent Woman*:[18] a profoundly troubled poet, a life of wrenchingly intimate and destructive facts, a ghastly suicide, surviving children and husband, insensitive biographers, destroyed journals, the husband's sister (Plath's literary agent) exercising dominion over the literary estate in an effort to shape what is written. Plath's husband, writing one biographer and speaking of the children says, "[T]hey had enough of the facts and the truths living in the mausoleum Sylvia left for them. What your memoir supplies is . . . poison. Poison is no less poison for being a fact."

There simply is no satisfactory remedy when the wounds are still raw, probing in the name of truth is yet more woundingly intrusive, and the survivors are desperately trying to contain the damage through destruction and proprietary silencing. To everyone's surprise, Plath's husband, who had refused every inquiry from biographers and reporters in all the years since her suicide in 1963, finally published a book of poems in 1998 that offered what one reviewer described as "an extraordinarily intimate portrait of their relationship, from their first meeting in 1956 through their marriage and her suicide."[19] Time permitted him to come to terms with his memories, to get beyond the atmosphere of sensation and exploitation that Malamud discusses. If Hughes had not survived to do so, however, we would have only silence, lacking Plath's journal that he is believed to have destroyed in the heat of his earlier passion and despair.

While Smith has no simple formula to propose, she does have some provocative suggestions. Why do we feel comfortable with Edel's biography, why does he not appear as a biographical snoop? Because one earns a right to intimacy only by making a commitment to the human being, even a human being who is no longer alive. When you know that much about a person, it is better if it comes with love and with some sense of obligation. Such consideration is aided by the passage of time. Smith puts it this way:[20]

> Edel's defiance of James's explicit request to be left alone feels a little strange. Yet if a case is to be made for not honoring someone's wishes for posthumous privacy, Edel has made it. But James had been dead for almost forty years before Edel published his first volume, and nearly sixty years when Edel finished the last. Edel's effort suggests that a certain passing of time, a respectfulness on the part of the biographer, are vital elements.

Smith's thoughtful observations do not translate into formal rules, but they do suggest some guidelines for heirs and executors. No facile claims of history's right to know should conceal the real costs that unmitigated probing of private matters can engender. Unfortunately, not every biographee will have a Leon Edel. At the same time, no effort to vouchsafe information solely to an authorized biographer, however sincerely chosen, can overcome history's claim to the benefit of diverse perspectives. We can recognize the value of knowing a life even when the subject has opted for reticence and the heirs are properly uneasy. And we can take comfort in the benefits that time bestows. Perhaps the best a family can do is bide its time, hold back for a while what decency counsels, await history's more measured judgments, and weather the day's voyeurism. Ultimately, however, we take our chances with posterity.

Authorized Biographies

He is a natural courtier, which means he is perfectly happy with the
implied contract usual in "official" biographies, by which the widow
permits access to private papers in return for biographical discretion
and a requisite, though not embarrassing, degree of adulation.[21]
—Robert Skidelsky

One alternative for the subject or family that worries about being exploited,
misunderstood, or dealt with too harshly, is the authorized biography. The
usual practice is to grant exclusive control of papers to the chosen biographer
at least until the book is done, and sometimes even longer. An authorized
work can be first rate, and responsible biographers refuse to grant any edito-
rial control to the family or others. Still, the question is, why should the
material in question not be open equally to all who seek access to it? We have
already seen the usual claims: Some individuals would rather destroy their
papers than see them fall into "irresponsible" hands. Concerns about privacy
generate restrictions to a known and trustworthy individual, but also permit
most information to be published soon, rather than closing the papers to
everyone for many years. And, what hardly needs further reiteration, subjects
know that an authorized biographer, whatever his or her credentials, is not
likely to be an unfriendly interpreter. While at least the first two of these
claims have some merit, when all is said and done, the authorized biography
is a dubious institution. It violates precepts of openness, promotes monopo-
lizing behavior, and invites roseate tinting of the historical record.

Even with the best intentions, authorized biographies are problem-
atic. In his will, the poet Langston Hughes designated Arna Bontemps, his
closest friend, as his literary executor and as his authorized biographer.
Bontemps was also the acting curator of Hughes papers at the Yale Uni-
versity Library. Faith Berry, who set out to write an unauthorized biogra-
phy of Hughes, was denied access to the Yale holdings while Bontemps
was preparing to write his own biography. Bontemps died in 1973, leaving
no trace of a Hughes biography, but new restrictions imposed by the
Hughes estate still prevented Berry from using the Yale materials. Despite
all these obstacles, and the subsequent appointment of another authorized
biographer, Berry ultimately published her biography, relying primarily on
secondary sources.[22] The story is all too common. An authorized biogra-
pher has exclusive access, but never does the book, though holding the
papers for years. An unofficial biographer then actually does a biography,
though without access to the papers.[23]

On the positive side, sometimes an authorized biographer does save precious documents from destruction. The papers of Judge Learned Hand provide a case in point. They were saved by Hand's authorized biographer, Gerald Gunther.[24] When Hand, who was one of America's greatest judges, died in 1961, his papers were put on deposit with the Harvard Law Library. The deposit agreement provided that the papers would largely remain closed until his "authorized biography" was completed. Several years later, Hand's son-in-law and literary executor began calling Gunther urging him to agree to write Hand's biography, and offering to make the Hand papers available for that purpose. Gunther explains that he did not know why he had been chosen, and did not find out until after he had agreed to write the biography, and began to read Hand's correspondence. The story is remarkable.

Before he died, Hand was planning to burn his papers. The reason was that he had been influenced by Felix Frankfurter's views that great damage had been done when Alpheus Mason's biography of Justice Harlan Fiske Stone was published, revealing the views of still-sitting judges about pending matters. Hand concluded, as a result of his correspondence with Frankfurter, that his responsibility to those of his colleagues who survived him obliged him to destroy his papers. But this was not at all what Frankfurter intended. He only meant to persuade Hand that it was important to get the right biographer into possession of his papers so they would be used responsibly (as Frankfurter viewed it).

Frankfurter then set out to unpersuade Hand of the very thing he had just (unintentionally) persuaded him to do. Frankfurter told Hand that Gunther (a former law clerk whom Hand obviously liked and trusted) had agreed to write his biography (which Gunther had not done), that Hand could be confident that his biographer (unlike Justice Stone's) would use his papers responsibly, and that therefore Hand should not destroy them. On this representation, Hand refrained from destroying his papers. Gunther agreed to become the authorized biographer, and the Hand papers were made exclusively available to him.

A happy ending? Certainly saving the Hand papers was momentous. Nonetheless, nearly thirty years elapsed before Gunther's excellent biography was finally published in 1994,[25] and though the Hand papers are now available without restrictions, during all those years they were under Gunther's control. Gunther himself says that he while he had "exclusive access . . . it was not exclusionary access," and that his attitude was "to be very generous in permitting access, for example, anyone doing scholarly work on biography or legal histories pertaining to Hand's years were given my ok." On the other hand, the distinguished Harvard legal historian Morton Hor-

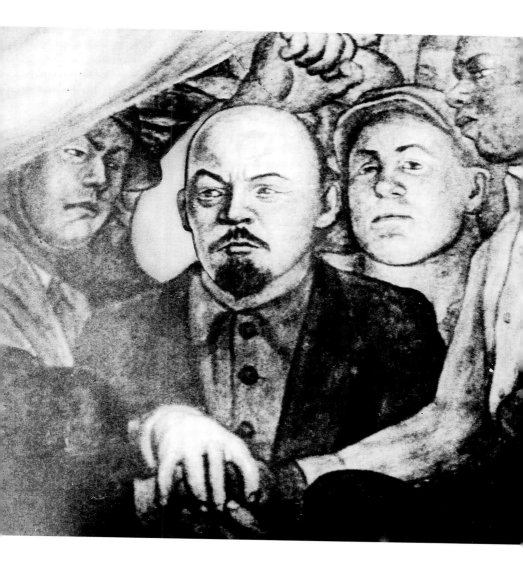

Scene from Diego Rivera's mural, with face of Lenin, for the RCA building in Rockefeller Center, Manhattan (1932)

Photograph courtesy *New York Times Pictures,* The New York Times Company, 229 West 43rd Street, 9th Fl, NYC 10036

Split Pavilion, Carlsbad, Calif.; artist, Andrea Blum

Photographs courtesy of Kathy Dennett (1998)

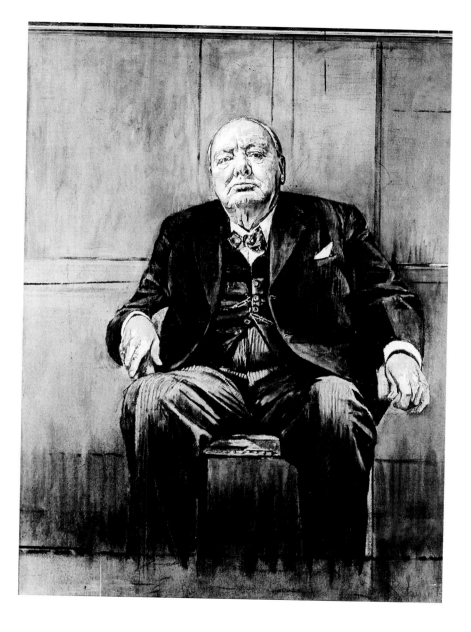

Portrait of Winston Churchill, by Graham Sutherland

Photograph courtesy of the *London Times*

Courtyard of the Salk Institute for Biological Studies,
La Jolla, Calif.

Peter Aprahamian/Corbis

Sketch of the rejected addition to Grand Central Station, New York

Archduke Leopold William in his Gallery,
Madrid, Museo del Prado, by David Teniers the Younger

Dead Sea Scrolls, showing researcher examining
with magnifying glass

Hulton-Deutsch Collection/Corbis

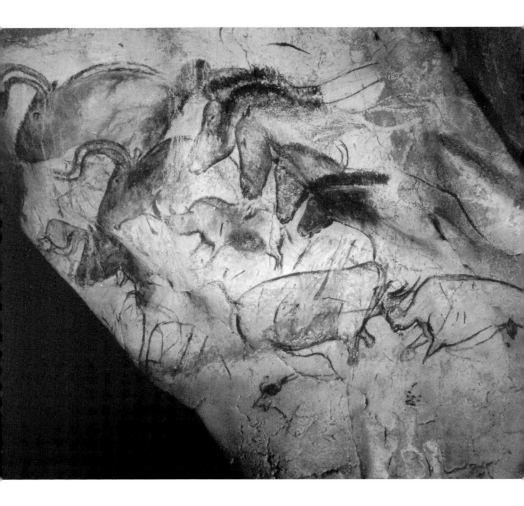

The Chauvet Cave, in southern France

This photographic reproduction was made with the cooperation of the French Ministry of Culture and Communication, Regional Office for Cultural Affairs of the Rhône-Alpes, Regional Archeological Service, and is provided by the courtesy of the Ministry.

witz says, "Gunther treated me shabbily. I was writing about Hand's Holmes lectures and learned there were drafts. The Hand archives were with Gunther. So I called him and asked for the drafts. He brushed me off in an unprofessional way that was not befitting our relationship. He acted as if I was bothering him and wasn't going to take the time to find them."[26] There is no way of knowing how to evaluate those two very different views of Gunther's administration of the Hand papers. One indisputable fact, however, is that such disputes could hardly have arisen if the collection had been in the Harvard Law Library and equally open to all scholars.

Heirs and Economics

Winston and Clementine

Sometimes heirs have a mixed editorial and economic interest; their goal is not to prevent use, but manage it, and to profit as well. One disgruntled biographer of Winston Churchill put it this way:

> No one (much) objected to Churchill, who was never a rich man, making money out of his own great talents; but there is something rather grubby about his less talented descendants extracting the uttermost farthing out of his legacy. The twin aims of making money and protecting the Churchill reputation have had their own effect on the history of the recent past. When writing my own mildly critical biography . . . I had to be careful not to quote anything that was in the copyright of the Churchill family. . . . [N]ot only would I have had to pay them for the privilege, . . . but I would have had to allow them to butcher my text.[27]

The Churchills seem to have a penchant for exclusivity and the benefits that flow from it. In 1997, Joan Hardwick, a biographer of Lady Clementine Churchill, was denied access to personal correspondence by Lady Mary Soames, the Churchills' last surviving child and copyright holder of the letters, who had herself produced a biography of her mother eighteen years earlier and was compiling a book of her letters. In response to Hardwick's request, Soames answered, "I will not be able to give you access to the letters . . . until I have finished working on them. And it is not possible for me to forecast when that will be."[28] Lady Churchill had died twenty years earlier, but Soames holds the copyright on her mother's personal letters, and as one observer put it, "If Lady Soames wants to take the letters home . . . and thereby denies them to a woman who is writing a knocking biography, then . . . she is well within her rights."[29] As noted earlier, access to Sir Winston's papers was for years restricted to the official biographer,

Martin Gilbert, and not opened to all researchers until 1992. And a recent biography of Randolph Churchill by his son "contains many documents and letters to which, so far, only the author has had access."[30]

Robert Henri's Misguided Sister-in-Law

One of the more bizarre instances of an effort to maximize economic value involved the famous American artist Robert Henri, who died in 1929. Several years later Henri's sister-in-law, Violet Organ, who lived in his former studio and was heir to his small fortune, determined that she would review the large cache of his unsold paintings and destroy those of "inferior quality." Since Henri had produced some four thousand oils during his lifetime, his canvases would be more in demand, she reasoned, if there were fewer of them. With the help of her friend and former Henri student Lucie Bayard, Organ destroyed an estimated five hundred fifty Henri works that had been in his Gramercy Park apartment and at the Manhattan Storage Company. Among them were his portraits of Emma Goldman and Bernard Baruch, as well as many nudes. The canvases were slashed and ripped in order to fit them into the fireplace, and then burned in the artist's own studio.[31]

The Legacy of Martin Luther King

Unless a family's desire to profit from the genius of a deceased artist results in distortion of the historical record, or inaccessibility of important works, why not allow heirs to reap the gains that ownership through inheritance provides? Criticism of the Churchills weighs most heavily because of their editorial control. In addition, Churchill having been a public official, reasonable questions could be raised about ownership of at least some family papers, as noted in a previous chapter. The Henri case is distressing only because the heirs' financial motives led to the destruction of valuable work. Where economic interests can be separated from concerns about preserving the historical or artistic record, however, there is little or no reason to deny the heirs financial benefits from an illustrious forbear's estate. No one thinks it odd that Picasso's child should be able to sell his remaining paintings; why should the children of a public figure (as contrasted to a public official, and official papers) not be able to sell his remaining papers? The public interest in preservation and access is ordinarily unaffected by the fact that a surviving spouse, or children, stand in the economic stead of the illustrious individual him- or herself. Yet concerns on behalf of the community are sometimes expressed in such cases.[32] The Martin Luther King case is illustrative.

Dr. King acquired copyrights on hundreds of his writings and talks,

including the revered "I Have a Dream" speech. The King family has been vigilant—some have even said fierce—in enforcing those copyrights. In some respects, their efforts were acclaimed, as in opposing businesses that wanted to make plastic busts of him.[33] The family also allowed schools and other nonprofit institutions to reproduce his words and image without charge. But, as reported in the press, the family "takes a hard stand against companies seeking to profit from them."[34] A case in point was a copyright infringement suit against CBS, which had begun marketing a videotape that included excerpts from its own film of the "I Have a Dream" speech. At the same time the family negotiated a lucrative deal with Time Warner Inc. to publish books and recordings of Kings works.

Some scholars and civil-rights veterans are reported to say that Dr. King "belongs to the ages."[35] One critic has taken the position that some works are "transcendent and should be freely available in reflection of fundamental First Amendment values," though recognizing that the courts have rejected any such view.[36] The family's arrangements were also criticized on the ground that "commercial aggressiveness" was at odds with Martin Luther King's own selflessness. As one writer put it, "Apparently, the King family does not share the view that the slain civil rights leader was a national treasure whose words belong to all of us, a public figure whose legacy should be provided to any and all who want it as cheaply as possible."[37] Obviously, some people were offended that the great man's heirs did not inherit his magnanimity. The *New York Times* wrote a front-page story in the form of a lengthy "special report" describing, not with admiration, the family's efforts to obtain material benefits from the King estate papers and other valuable properties.[38] Dr. King, critics reminded us, had said, "I think I'd rise up in my grave if I died leaving two or three hundred thousand dollars," and he gave away the proceeds of his Nobel Peace prize. He left an estate valued at only sixty-six thousand dollars when he died; today it is estimated that the King legacy is worth $30 to $50 million.

Unattractive as their material concerns may be to some, the pertinent question is whether the estate's aggressive assertion of its property rights inappropriately limits access to Dr. King's legacy.[39] The King archive is rarely open, but that is because of staffing shortages. No doubt copyright does limit dissemination to some extent, and problems do arise with access for educational and scholarly research purposes that may call for some special rules,[40] such as expanded concepts of fair use or regulated compulsory licensing.[41] Unless one is prepared to argue that the economics of copyright itself transgresses the public interest, however, it is difficult to make the case against King's heirs, who presumably did no more than exercise his

copyright entitlement. In the King case, presumably Time Warner will market—with profit to the estate—essentially the same material that CBS would have sold with profit only to itself. And if the family sells all or part of the archive to Stanford University for a large sum, as reports say they may, they would only join a long list of famous figures' families who have benefited economically from papers or works of art that were left to them.

Dispersal of Collections: The Banneker Papers, the Dial, etc.

Yet one more variant of the problem arises when the economic value of papers comes to the fore. An incident that arose in Maryland is illustrative.[42] In 1806 the papers of a distinguished black scientist, Benjamin Banneker, were bequeathed to the family of George Ellicott, a white man who had befriended him. The Ellicotts kept the rare and valuable papers together for nearly two centuries. In 1996, however, the Ellicott family member who had inherited the papers decided to sell them at auction to the highest bidder, to the dismay of historians, admirers, and descendants of Banneker, all of whom hoped for the collection to be housed in a museum. The concerns were that scattering the papers among many collectors would be a loss for historians, and that dispersing the papers outside Maryland would represent a diminution of its patrimony. Certainly the breakup of integral collections is a legitimate concern, though the prospect of a Maryland antiexport ban may be carrying things a bit far.

Dispersal of important collections is a recurrent problem, and one deserving of attention. In 1987 the press reported that the *Dial* papers were to be sold. *The Dial* was widely regarded as the most important American journal of arts and letters of the twentieth century. Its November 1922, issue, for example, contained the first publication of T. S. Eliot's *Waste Land,* as well as work by Yeats, Picasso, Ezra Pound, Bertrand Russell, Sherwood Anderson, and a reproduction of a work by Brancusi. The collection had been given on loan to the Beinecke Library at Yale University several decades earlier by the *Dial*'s co-owner and editor, Scofield Thayer. When Thayer died, at a very advanced age, several remote relatives inherited his estate and decided to have the collection auctioned at Sotheby's. In commenting on the forthcoming sale, the librarian of Harvard's Houghton rare-book library said, "[W]e have laws that protect architectural landmarks, that protect buildings from being torn down, yet we have no laws to prevent the disposal of this major cultural landmark, and there doesn't seem to be any discussion of what we should do to prevent it."[43]

Suggestions that ownership calls for some obligation of stewardship does not mean that owners should be unable to reap their economic value

in the marketplace. It may well be that the owner of a collection like the Banneker papers is lacking in the public spirit shown by her ancestor George Ellicott, who regarded Banneker's belongings "as a trust to be for the public benefit." But to say that such papers "are treasures that belong to the world," as one Banneker descendent did, and as many owners themselves say of their collections, is not to say that the owner is duty bound to eschew the financial benefits of a sale. That has never been an obligation of ownership, and it goes far beyond a duty of preservation or even compelled access of the sort proposed in previous chapters. A more apt analogy is the owner of a "heritage" artwork who proposes to sell it abroad; and a plausible solution to Banneker- or *Dial*-type problems is to mimic British export restrictions, which provide a first right, at the market price, to a buyer who would agree to keep the collection together, either privately, or by lodging it in a library or museum.[44]

The Matthew Arnold Letters

When the first volume of Matthew Arnold's letters were published in 1996, the editor, Cecil Lang, told two remarkable stories in his introduction. The first involved a very highly regarded 1932 edition of one very important set of Arnold's letters edited by a man named Howard Foster Lowry. In his introduction to the new edition, Lang notes that Lowry, in his book, had stated that the manuscripts of all but two of the letters were in the Yale Library. Where were the other two? Lowry did not say, and, Lang notes, the transcription of those two letters alone contained ellipses indicating missing passages. Were these ellipses—a series of three dots—actually a transcription of what Arnold had written in his letter, or had the editor, Lowry, excised a portion of the letters, indicating what he had done by inserting an ellipsis at the spot where he had removed text?

The reason this was of interest was that Lowry was presumably editing the full text of the letters. Why should he edit out something Matthew Arnold had said? And why should he be coy about telling where the original manuscripts of these letters were? Lang says, "One is driven to the conclusion, unpleasant but hardly avoidable, that Lowry himself owned them and sold them at some point to a collector."[45] That is to say, Lowry omitted passages from the letters in order to maintain their market value to collectors (who would then own letters with material that had never been published). The accusation is a serious one: that a scholar-collector has withheld material in an important document—Lang called it "perhaps the best letter Arnold ever wrote"—in order to maximize the value of his holding in the marketplace. As a reviewer put it, "Lang takes a dim view, as well

he might, of letter-owners who for money reasons refuse to release their property for publication."[46]

Nor is suspicion of Lowry the only criticism of letter-owners that Lang makes. He also takes out after a man named Roger Brooks, a professor at Baylor University and director of a library in Waco, Texas. Brooks is an Arnold scholar and the owner of a number of Matthew Arnold letters. Lang says that Brooks had several times expressed a willingness to send Lang copies of the letters in his private collection to include in Lang's edition of Arnold's letters. But, he says, Brooks had not done so, even though Lang had raised the question of remunerating him for the use of the letters back in 1989, and Brooks had written back naming a price of ten thousand dollars as fair and reasonable. When Lang set all this out in the introduction to his edition of the letters,[47] Brooks publicly replied in the letters column of the *Times Literary Supplement*. He denied that he wanted money (though he had raised the issue), says he did finally (seven years later) send *some* letters from his collection to Lang, and then goes on to criticize Lang's scholarship and say that he withdrew his support of Lang's project because he found Lang's work "ill-conceived and inaccurate."[48] Lang seems to have the better of the quarrel. He cites correspondence that strongly suggests the withholding by Brooks of some Matthew Arnold letters from Lang, despite writing that he was sending "all the Matthew Arnold letters in my collection."[49]

The ability of Matthew Arnold experts to squabble so fiercely over a 150-year-old letter is most certainly a tempest in an inkpot (reflecting behavior even more repulsive than that imagined in novelistic accounts of scholarly cattiness—truth, it seems, is nastier than fiction).[50] What makes the Arnold affair so distressing is the light it casts on the uses of proprietary power to channel scholarship and public knowledge in order to enhance an owner's purse. That is precisely the way economic benefit ought not to be tolerated in dealing with artistic or literary artifacts, because it results in distorting or withholding the historical record.

Part 3. Skins and Bones

10

An Academic Scandal
Par Excellence:
The Dead Sea Scrolls

> Over the decades, the scrolls have produced a history of their own,
> some of it rather tawdry, as scholars took issue with one another
> over the translation and publishing rights, over the laggardly
> appearance of the scrolls before the public, over the self-aggran-
> dizement of a small group of learned academics who appeared to be
> hoarding them, parcelling them out in tightfisted fashion to their
> own students, and seemingly deliberately holding back the unre-
> stricted availability of that stunning treasure.
>
> —Chaim Potok

Discovery and Acquisition

In 1947, two young Bedouin shepherds, searching for a lost goat, threw a
rock into a cave opening in the Palestinian desert. The stone struck a pot
stored in the cave. That was the first step in the discovery of the Dead Sea
Scrolls, which ultimately amounted to some eight hundred scrolls, many
in fragments, recovered during the next half-dozen or so years, from
caves located on the northwest side of the Dead Sea, not many miles
south of Jericho.[1] The locating of the scrolls marked the most important
discovery in biblical archaeology of the twentieth century, and perhaps of
all time.

Among other things, the material includes the oldest texts of biblical
books that date from before the time of Jesus. The earliest previously
known texts of the Bible had been written down in the third and fourth
centuries A.D. The scrolls found at Qumrân were written between the third
century B.C. and the first century A.D. "The Dead Sea Scrolls have revolu-
tionized scholars' understanding of Early Judaism (Second Temple
Judaism) and Early Christianity (Christian Origins)."[2] They are our main

153

source of information about the history of Judaism between biblical times and the third century A.D., when the oral law was written down in the Mishnah.

Formal ownership has continued to be a matter of geopolitical controversy, but it was never a matter of practical importance who owned the scrolls; treating the Bedouin as owners in order to obtain possession was an operational necessity. The Bedouin had them in hand, and the only way to be sure of getting the scrolls was to purchase them. Even after the first discoveries were publicly revealed, and despite the assiduous efforts of archaeologists to find more scrolls, the Bedouin continued to make most of the important discoveries, including the richest of all, Cave 4, which contained many hundreds of manuscripts,[3] discovered in 1952.[4] As late as 1993, Palestinians protested continued searching by the Israeli Antiquities Authority for more scrolls, claiming that the Israelis were engaged in "last-gasp plundering" of land that was to come under Palestinian authority as part of the Israel-PLO peace process.[5] Nothing has turned up since the 1950s in any event.

Altogether scrolls were ultimately found in eleven different caves. A number were more or less intact, including an entire text of the Book of Isaiah that was one thousand years older than anything that had been known up to that time. It is on display in the Shrine of the Book in Jerusalem's Israel Museum. By no means were all the materials the subject of controversy. The seven large scrolls found in Cave 1, for example, were promptly published by Israeli and American scholars.[6] By 1956 all texts from the first cave were available for study by anyone who wished to examine them.[7]

In the ensuing years fragmentary texts from most of the other caves were also published and made available to the interested public. But there was one exceptional situation: materials discovered in a cave at Qumrân on the edge of the Dead Sea, then in Jordan, and known as Cave 4, or Q4.[8] No intact manuscripts were found in Cave 4; everything was in pieces. Yet the contents of Cave 4 comprised the great bulk of all the scroll material, some 550 different manuscripts comprising more than five-eighths of all the scrolls found at Qumrân, scattered among some fifteen thousand fragments, some as small as a fingernail. Q4 was the mother lode of scroll material.

Dealing with the Cave 4 material presented a perplexing problem of cultural property logistics. The risk was that the Bedouin who discovered Cave 4 would sell the fragments piece by piece on the antiquities market, in which case it would become impossible ever to assemble them. In order to encourage the shepherds both to seek out the scrolls, to maintain them

whole without cutting them up into smaller pieces for sale, and to prevent their moving into the hands of collectors worldwide, the Jordanian government offered to buy whatever scrolls were discovered at a set (and attractive) price, said to be about $2.80 per square centimeter.[9]

The scrolls from Cave 4 have a complex proprietary history. While they were found on land under Jordanian control at the time of discovery, for centuries that land had been used for grazing by the Bedouin, and its ownership has been in dispute for millennia. After the Six Day War in 1967, Israel took over the territory. The land was ceded to the Palestinian people under the Israeli-Palestinian accord of 1993.[10] At the time of the discoveries, Jordan probably viewed itself as having legislative authority over the scrolls, rather than as having ownership of them. It didn't formally nationalize ownership of the scrolls until some years later. Its strategy was to use economic incentives rather than coercive means to assure that the material would be kept together so that scholars could work on it. The original idea was to deposit the scroll fragments at the Palestine Archaeological Museum (PAM, now the Rockefeller Museum), to be worked on by experts from various foreign schools of archeological and biblical studies located in East Jerusalem, which supported the work of the PAM.

Neither the PAM nor Jordan then had sufficient funds available to acquire all the scrolls. The Jordanian government originally financed the purchases with money provided by the various foreign schools in East Jerusalem, and with money from Rockefeller. Later, as additional material from Cave 4 poured it, and Jordan was concerned about having sufficient funds to keep the material from being sold to collectors, it enacted legislation that allowed foreign institutions to buy scrolls. The arrangement was that the material would remain in Jerusalem while it was being studied and then, after it had been assembled and the texts published, the original fragments would go to the donor institutions. Between 1954 and 1959, manuscripts were purchased by McGill University of Montreal, the Vatican Library, the Universities of Manchester and Heidelberg, McCormick Theological Seminary in Chicago, All Souls Church in New York, and Oxford University.[11]

A central figure in this plan was G. Lankester Harding. Harding, an Englishman, was both curator and secretary of the board of trustees of the Palestine Archaeological Museum and—at the same time—director of the Jordanian Department of Antiquities.[12] He was one of the last of the British colonials left in a position of authority in Jordan. In his dual capacity, he appointed Roland de Vaux, a priest-scholar from the French biblical and archaeological school in East Jerusalem, the École Biblique et

Archéologique Française, as chief editor of the texts.[13] At first de Vaux limited assignments to his colleagues at the École Biblique, but as more material poured into the museum, it was determined that an international team of scholars should be appointed to work on the Cave 4 material. The original team members were nominated by the European and American institutions that supported the work of the PAM,[14] and were then selected by the PAM board, which consisted half of scholars from the participating institutions and half of diplomats from the countries where they were located (France, England, Germany, and the United States).

Seven additional distinguished scholars were appointed (no Jews were included, at the insistence of the Jordanian government). One of the original members, John Strugnell, an Englishman who subsequently became a professor of Christian origins at Harvard, took over in 1987 after De Vaux's successor as chief editor, Pierre Benoit, died.[15] The texts were divided among the members of this elite committee, and it was apparently understood that each team member had the exclusive right to publish the texts that had been assigned to him. In effect that meant they would assemble the material, seek to determine missing text, translate, and provide analysis. The materials were to be published by Oxford University Press in a series with the title Discoveries in the Judean Desert.

Research proceeded apace in Jerusalem until 1960, when the Rockefellers, who had been supporting the scholarly work, ceased funding it. At that time, the director of the scrolls project wrote to the various institutions that had purchased scrolls, suggesting they apply to Jordan for export permits to get the material they had paid for. But the Jordanian government decided to cancel those arrangements, to reimburse the various institutions for their contributions toward purchase of the scrolls, and to keep them in Jordan. It nationalized the scrolls in 1961, and then in 1966, in a further effort to maintain control of its archaeological treasures, it also nationalized the Palestine Archaeological Museum, where the scrolls were deposited, and repudiated any outstanding claims of foreign institutions to them.[16]

Then, in 1967, Israel took possession of Jerusalem and with it the Rockefeller Museum (PAM) and the scroll material. Authority over the enterprise then shifted to the Israel Antiquities Authority (IAA). Israel, however, made no effort to gain control of the publication project and did not even add any Jewish scholars to the official publication team, perhaps out of concern that adverse publicity would suggest it was intruding on the work of distinguished Christian scholars.[17] Israel maintained the original team in place and agreed to recognize the members' "publication rights"—

consistent with scholarly conventions in the field—provided only that the fragments were promptly published. In fact, however, Israel did nothing to achieve prompt publication, or to move things along at all, until external forces prodded it to act many years later. The reason was "inertia, tradition, and, ironically, desire by the Israelis not to rock the boat."[18]

The Nature of the Scholar's Work

The work to be done was difficult and exacting, and involved several distinct tasks.[19] First the existing fragments had to be cleaned and flattened, then read, or made readable, as some of the letters had become virtually illegible. (In a marvelous mixture of ancient and ultramodern, experts at Cal Tech's Jet Propulsion Laboratory were able to identify writing on scroll fragments through spectral-imaging techniques, which enhances contrasts between different parts of images, so that the ink on a fragment can be presented in far greater contrast to the rest than is visible to the naked eye.) Then the pieces had to be assembled. As one observer put it, this was like trying to put together "a giant jigsaw puzzle—or more accurately, five hundred different jigsaw puzzles with 90 percent of the pieces missing."[20] Another team member explained, "the manuscripts of Cave IV are in an advanced state of decay. Many fragments are so brittle or friable that they can scarcely be touched with a camel's-hair brush. Most are warped, crinkled, or shrunken, crusted with soil chemicals, blackened by moisture and age. The problems of cleaning, flattening, identifying, and piecing them together are formidable."[21]

After assemblage of the fragments and transcription (that is, a writing down of each letter of each word in a readable form) the scholar had to try to fill in the many extensive gaps created by missing text. This step involves work of extraordinary difficulty requiring vast knowledge of the history, practices, and literature of the era (biblical scrolls, with known texts, were the easiest to complete). Some publications, particularly earlier ones, consisted only of photographs and transcriptions of the scrolls into printed Hebrew characters. Later, and especially with Cave 4 material, publication awaited the development of full analysis and commentary. Another important task, which could be treated independently, was translation. An English edition of the Dead Sea Scrolls, for example, was done separately by another scholar.[22]

One need not be a biblical expert, or an archaeologist, to recognize

that a work of enormous magnitude lay before the assembled team at the start of their enterprise in 1954. Nor need one be an expert to appreciate that access to some of the material, at some stage before the team's work was fully done, might reasonably be sought by those who were not on the official team. Indeed, a number of questions might have been raised at the outset: Can such a massive work be completed by this small handful of scholars? Will at least the raw, or nearly raw, material—such as reproductions of the fragments, transcriptions, or assembled pieces—be published at some early stage? What sort of access to scroll material will be available to other researchers?

As it turned out, such questions were ultimately to haunt the scrolls enterprise, which became, as one expert predicted it might, "the academic scandal par excellence of the 20th century."[23] The Dead Sea Scrolls were to present in its purest (and least attractive) form the issue of scholarly access to research materials.

By the later 1950s the team had largely completed the assemblage and the transcribing of the fragments. The five hundred different texts were then divided among the team members to be readied for publication. Four other scholars were given the transcripts, and they prepared (but did not publish) a concordance of the nonbiblical texts. The concordance listed every word, noting the text in which it appeared, its place within the document, and the words adjacent to it. One value of a concordance was as an aid to translators of the scrolls' antique Hebrew and Aramaic texts, who could find all the contexts in which every word was used.

Up to this point, around 1960, there was little concern expressed about the arrangements for the work on the scrolls and the plans for publication. While the enterprise had been vouchsafed to a small group of experts with no personal claim on the scrolls (they could take no credit for the discovery, for example), the process was pretty much standard practice in the field. As the most vocal critic of the team put it (plainly meaning to condemn the practice), "[A]ccording to a scholarly convention that is nowhere written or even referred to in writing, a scholar who is assigned to publish a text has complete control over it. That person may take as long as he or she likes to publish it. It can be seen by others only with the scholar's permission. No one else is permitted to print the text."[24]

Though much material was published during the first decade following discovery, during the next thirty years work on the scrolls slowed almost to a halt. In 1991, about 25 percent of the material, consisting of about one-half the titles, remained unpublished, including some very important material.

Unraveling the Monopoly: The Beginning of the End

Things began to come to a head following a 1984 biblical archaeology conference in Jerusalem and a conference on the scrolls held at New York University in 1985. At the New York conference, Professor John Strugnell, then a member of the scrolls team (and later to become its head), delivered a paper on a document he had assembled from the Cave 4 materials. Known by its Hebrew initials, MMT, or "Rulings Pertaining to the Torah," it was described by Strugnell as one of the most important documents from Qumrân. Its contents alone, he said, were capable of forcing major reevaluations of several key assumptions about the writers of the scrolls, a matter described as "a centuries-deep 'black hole' in the history of Jewish law."[25] A colleague of Strugnell, Elisha Qimron, made a parallel presentation at the Jerusalem conference.

The MMT document describes differences between different Jewish groups of the time and is a sort of treatise on laws of religious practice. It spells out some twenty-two points of law on which there is disagreement and summons opponents to amendment of their lives. It apparently casts considerable new light, through contemporary writings, on investigations into the nature and history of the religious communities of that time. The document was of extraordinary interest to experts. The *Washington Post* reported that "scholars in several fields couldn't wait to see it."[26] And the *Jerusalem Post* said, when it was finally published in 1994, that it had been "eagerly awaited by the scholarly community since its contents were first hinted at during an archeological conference . . . a decade ago."[27] Here is how one participant at the Jerusalem conference recalled the event:

> It is hard to describe the audience's shock. We now realized that for forty years, this text, holding the key to many mysteries of the Dead Sea Scrolls, had been hidden from us in the recesses of the Rockefeller Museum's scrollery. . . . [W]e took frantic notes . . . so that we could bring home at least a fragment of this scroll to study even before publication of the full text.
>
> What was so extraordinary about Qimron's revelation? Certainly not the fact that this text had been kept from us—we all knew that much of what was in the cave 4 lot was still unpublished by the official editorial team. No, what galvanized us was the unexpected *significance* of this particular scroll. For years we in scrolls research had grudgingly accepted the status quo of withheld information and limited access for those outside the editorial team. . . . But Qimron's revelation . . . shattered our customary complacency. When we realized that a document so central to the history of the Qumrân sect and, indeed, of Second Temple Judaism, had been withheld from the academic community for so long,

we were outraged. Qimron's disclosure made us acutely aware of the unfair distribution of texts, of the existence of haves and have-nots among Dead Sea Scrolls scholars.[28]

The controversy was intensified by the cumulative impact of three related issues: long delay in publication, unwillingness to share information about the material except with a small circle of favored colleagues, and the fact that some of the remaining material was not marginal, but of primary importance and interest to scholars who had been excluded from the privileged circle. The arrogance of team members toward scholars with whom they chose not to share the treasure that had been entrusted to them is almost incomprehensible.

One member of the original scrolls team, a man named Milik—after castigating the "unhealthy curiosity" of complaining historians about the slow pace of publication—said, "[T]he world will see the manuscripts when I have done the necessary work."[29] This same team member was notorious for ignoring requests from other scholars. One professor noted that in 1979 he was preparing a translation and commentary on the Book of Jubilees, to which extensive references existed in the Qumrân materials. He recalled that "at two-month intervals I turned three times to J. T. Milik (in Paris), the temporary 'custodian' of the remaining Qumrân texts, requesting collegial assistance. To this day [1993] I have received no response. And one has the impression that such is the case for all who do not belong to the inner circle of 'keepers of the grail.'"[30]

One expert said the team members were "like misers, they hoarded the scrolls as currency to enrich their careers and those of their students."[31] Another, Professor Norman Golb of the University of Chicago, explained how things were done. Two of the team members were professors at Harvard, Frank Moore Cross and John Strugnell. Golb said that "both Strugnell and Cross . . . offered individual texts not to already seasoned scholars but to their own students for use in their doctoral dissertations. This gave Harvard students a decided, if inappropriate, advantage, enabling them to publish scrolls that were denied to virtually all others, students and professors alike."[32] Lawrence Schiffman, Professor of Hebrew and Judaic Studies at New York University, put it this way: "My students are now able . . . to write their doctoral dissertations without having to fear that they can be disproved by some unpublished text in the hands of a student of one of the editors. We are no longer dependent on the information furnished to us by others—often ones less competent to study the material than we."[33]

Strugnell reportedly described those whose requests he denied as incompetent or as unknowns.[34] In a television interview he dismissed sixteen major scholars who criticized him as annoying "fleas,"[35] and he called Oxford professor Geza Vermes, of the Oxford Center for Postgraduate Hebrew Studies, "incompetent."[36] (A 1990 festschrift characterized Vermes as "one of the most distinguished scholars of Judaica of our time.")[37] Nor was such invective limited to Strugnell, who at the time was said to have, as it was delicately put, personal problems. Magen Broshi, curator of the Shrine of the Book in Jerusalem and Dead Sea Scrolls adviser to the Israel Antiquities Authority, was quoted as describing non-scroll-team scholars who wanted access to the material as "slime," "fleas," "gang-snatchers," and "manure."[38] When confronted in 1987 by Professor Robert Eisenman about the team's delay, Broshi reportedly replied, "You will not see these things in your lifetime."[39]

In any event during the ten years following the NYU and Jerusalem conferences, Strugnell refused to release the text of MMT except to a few selected scholars of his choosing. Both Robert Eisenman of California State University at Long Beach and Philip Davies of Sheffield University in England, each of whom had written books on Qumrân subjects, requested permission from Strugnell to examine scroll fragments, but were refused access to them.[40] On the other hand, some scholars were ultimately favored with material by Strugnell, such as Lawrence H. Schiffman of New York University. Schiffman attributes a significant share of credit for his own magnum opus on the scrolls to the patronage of the scrolls team in the years following the 1984 conferences.[41] Even these favored researchers, however, commented on how damaging the policy of inaccessibility had been. Schiffman, for example, noted that the eventual release of the entire scrolls corpus "was to recast in a radical manner the work I had already been doing for years on the Dead Sea Scrolls."[42]

MMT was not published until June 30, 1994,[43] nearly forty years after the material had come into Strugnell's hands. What were he and his colleagues on the team doing for decades with this "most important document" and with other Q4 materials? Basically, the enterprise—which had started out quite productively in the 1950s—simply lost momentum. As noted already, Rockefeller family funding that had supported the work came to an end in 1960, and team members had to fit the work into their other academic responsibilities. Several team members struggled with an alcohol problem.[44] The level of desired commentary had also grown dramatically, which significantly delayed publication.

Even more importantly, however, there was for many years a reluctance to enlarge the very small circle of team members, perhaps out of a desire to assure high-quality work. For some time, when a member resigned or died, only one other was nominated, which was obviously inadequate. Finally, in 1987, when Strugnell was made chief editor, and following much public criticism, the team was increased in size to twenty, and then to fifty.

Other less attractive explanations for the less-than-snail's pace of the process have already been suggested. Fragility of the original fragments themselves, however, was apparently never an issue in the dispute over access. Photographs of the fragments existed, and the team itself worked from photographic reproductions of the assembled material (which is what was so controversially withheld from outsiders), rather than from the assembled original fragments themselves.

Many critical stories have circulated suggesting dishonorable motives for the scroll team's tight control of the material in their possession, other than their desire to reap the benefits of monopolization. One was that scrolls contained material thought damaging to established religious beliefs, and that the team secreted material in order to "protect" the faith. Such accusations were also leveled against the Vatican, which financed some of the scrolls purchase or research. The two original team leaders were both Catholic priests, and Professor Strugnell was a convert to Catholicism. Such claims have been extensively scrutinized by independent observers and shown to be entirely baseless.[45] There is no evidence that any scroll material threatens religious belief, that it has been withheld, or that any religious institution has sought to constrain full and open study of the scrolls.

One matter that did contribute to delay in publishing MMT, ironically, was that neither Strugnell nor others on the scroll team were capable of determining the importance of the text, which involved Jewish legal material that was unfamiliar to them, rather than biblical text that they knew well. They only came to understand it when a brilliant outsider thrust himself upon the team. Here is what happened: In the 1950s the document MMT was assigned to Strugnell. There were six tattered copies of it, and by 1959, he had pieced together a common text, though with extensive missing portions. It was evident that the document contained a collection of laws, but their historical and theological context was unclear to team members, and the significance of the scroll was not recognized.

In 1979, twenty years after he had assembled the MMT fragments, Strugnell was visited by a young Israeli linguist named Elisha Qimron. Qimron, the compiler of a historical Hebrew dictionary, had a talent for

deciphering difficult scripts. He offered to help Strugnell decipher MMT in an effort to fill in the missing pieces, and in 1980 Strugnell accepted him as a collaborator,[46] the first Israeli and the first Jew to become a member of the Dead Sea Scrolls team. Because of his linguistic skills and his ability to achieve mastery of Jewish law (Halacha) with help from other colleagues of his, Qimron was able to surmise the content of the missing parts of MMT on the basis of other writings with which he was acquainted. It took Qimron eleven years of intensive research to reconstruct 121 lines of text from more than sixty scroll fragments, from which at least 40 percent of the original manuscript was missing. That portion of the elapsed time, or at least much of it, was not wasted.

Once the importance of MMT was made known at the 1984 conferences, the demand to make still-unpublished scroll material available became irresistible, and the comfortable exclusivity so long enjoyed by the scrolls team was doomed. Events were moved along by a variety of factors. Perhaps the most important element was a crusade begun by a lawyer and amateur archaeologist named Hershel Shanks, who edited a widely read journal called the *Biblical Archaeology Review*, and used its pages to campaign successfully for making all scroll material public.

By 1987, Strugnell at last began to redirect some of the material from unproductive older team members to younger scholars and set a timetable for completion of publication. In 1988, a new director was appointed to the Israel Antiquities Authority, and under his authority the scroll team was expanded and deadlines for completion established. That same year, Strugnell agreed to allow the concordance to be published, and several American experts were able, with the use of a computer, to generate from the concordance transcripts that reproduced with a high degree of accuracy the text of the assembled fragments that had been held in private by the scroll team members. Shanks's Biblical Archaeology Society published the computer-reconstructed transcripts. A version of the scroll text material in a transcription was now, at last, in the public domain.

The monopoly was fully broken after thirty-seven years when the Huntington Library in California, which along with several other libraries had a set of photographs of the assembled scroll fragments that had been deposited with them for safekeeping (but not for distribution), announced that all scholars could have access to the Huntington archive. That same year Shanks published a two-volume edition of photographs of the unpublished scrolls, the scholarly raw material. The final step occurred when the Israel Antiquities Authority in 1993 cooperated in the publication of a very high quality set of positive microfiches of the entire Judean Desert materials.[47]

Probably no one would argue with the conclusion that the Cave 4 material was delayed too long in publication, or that, in retrospect at least, the management of the enterprise was maladroit. Not only was the public deprived of important information for a very long time, but scholars who had been denied access to the material literally spent their entire lives and died without having an opportunity to study the documents in question. Had the raw material been generally available, it is virtually certain that publication would have occurred decades earlier.

Happily, there is an upbeat ending even for this dreary story. In the third week of July 1997, three hundred scholars convened in Jerusalem to celebrate the fiftieth anniversary of the discovery of the first Dead Sea Scrolls. Professor Schiffman of NYU had this to say:

> The most significant thing about the conference, to my mind, is that a field that was in total disarray a few years ago has seen a complete revolution. The publication of the Scrolls has been a complete success, the materials are getting out to the public . . . scholarship is at a level never seen before.[48]

One fascinating detail that emerges from the scrolls story is that those who work within the field of biblical archaeology recognize a form of proprietary right known as a "publication right." This right has no formal legal standing, yet it is accepted within several scholarly disciplines. Indeed, the decades-long passivity of excluded scholars in the Dead Sea Scrolls affair was doubtless largely attributable to their acknowledgment of the "right" that Strugnell and his colleagues held (though, interestingly, it not clear who exactly had authority to grant that entitlement to the original scrolls team). However mysterious or vague it may seem to outsiders, everyone in the field knows exactly what it is: a scholarly convention gives the researcher who is assigned to publish a text complete control over it for an indefinite period. No one else may see, study, or publish that material except with the "owning" scholar's permission. In the following chapter, we will take a closer look at this remarkable prerogative.

The Privatization of Scholarly Research

Intellectual property, as contained in knowledge and documents created through the study of archaeological resources, is part of the archaeological record and, therefore, is held in stewardship rather than as a personal possession. If there is a compelling reason, and no legal restrictions, a researcher may have exclusive access . . . for a limited and reasonable time.

—Principle No. 3, Society for American Archaeology

Both the Jordanian and the Israeli governments were quick to recognize that the Dead Sea Scrolls were precious materials that should be treated as a public heritage, and they took prompt steps to insure acquisition, preservation, protection against dispersion, and delivery into the hands of qualified experts who could discern and interpret their contents. Despite the governments' enlightened policies, they nonetheless permitted a form of reprivatization pursuant to a convention in the scholarly world that appears to have received little attention or scrutiny: "publication rights" that the scrolls team asserted and aggressively utilized over four decades to create an intellectual monopoly.

The practice followed by the scrolls researchers is standard in disciplines such as archaeology, anthropology, and papyrology. In all these fields the fact that publication is delayed for many years is not unusual. Papyri dating from the time of Alexander the Great awaited publication for decades, presumably due to the other academic duties of the professors who held publication rights.[1] In 1977, a book on prehistoric archaeology noted that "archaeologists are notoriously slow in reporting the results of their excavations. Many reports are never written, and many that are written are never published."[2] The author of a recent book on Assyrian sculptures blandly observes that he had "worked in the same areas that the assyriologist L. W. King had excavated in 1903–4, and since his work had never been published, I spent the late Spring of 1992 studying the King

archives . . . in order to be able to incorporate his results into my report."[3]

A 1995 article in *Archaeology* magazine begins with this passage:

> Some years ago, I attended a retirement party for a distinguished colleague at a prominent midwestern university. Several generations of former students were on hand. . . . But they were tactful not to mention one problem with their beloved mentor's career: only one of his excavations had ever been published in full. Alas, the professor has now passed on, leaving behind nothing but sketchy field notes.[4]

The author's point is that such practices result in a serious loss to research and the digging of new sites before established ones are fully documented. What the article doesn't say, because it is obvious to professional readers in the field, is that no else published the excavation either. Because that site "belonged" to the professor, other archaeologists would not have presumed to encroach on his "property."

The origin of the practice of allocating research rights as a sort of intellectual property is rather obscure, and it is by no means general in the scholarly world. One likely explanation is that fields like archaeology have been very small at least until very recently, everyone pretty much knows everyone else, and interpersonal relations are strong because people work rather intimately together on excavations. Archaeology was also to a large extent a preserve of gentlemen of means who operated by gentlemen's agreements. Patronage rather than competition dominated. Perhaps most importantly, it is a field that focuses on material objects and breeds a sense of possessiveness. Researchers were often also important collectors. Apparently the standard way to make one's reputation in archaeology was by excavating a site; that site and its significance was then associated with the person who excavated it, even if it was never published. As one authority put it, "Discovery and excavation is the thing that gets prestige; you can't make your fame and fortune by working on material in the public domain. Tons of stuff sits in museums unstudied."[5]

To be sure, change is occurring. The profile of the academic and research worlds has changed in recent decades, and archaeology is less of a closed club than it was. Funding now depends more on a record of publication; and the old free-and-easy attitudes about "ownership" of sites has been restricted by the claims of Native peoples and by limits on excavation of historic sites and other permit requirements. Nonetheless, proprietary attitudes are still powerful, and old traditions hang on. A professor of archaeology described a very recent case in which a young graduate student was permitted to come onto an unpublished site that belonged to an estab-

lished scholar and to do her dissertation work on one particular element of that site (prehistoric tools).[6] The professor was surprised that even this sort of by-permission intrusion was tolerated, but the graduate student, she said, probably got access because she had good connections. In any event, she did her work there and completed her dissertation, but the individual to whom the site is assigned insisted that she seal her dissertation and not publish or distribute it generally, until after he published his work on the excavation. "Of course," I was told, the young researcher complied.

Such control is apparently standard practice. Once an individual or team has a site staked out (and in most places they would have to obtain a permit to excavate the site, which in practice establishes one's exclusive right), no one else would dare put in another hole without negotiating with them, the professor explained. Frequently exclusivity is created through government permitting, but it is embraced and utilized by researchers to glean the benefits of privatization. A notable example in the highly competitive field of paleoanthropology (the study of human origins) comes from the area in Ethiopia where the famous Lucy fossils were found. The time was around 1972, and the individual described, Taieb, is a distinguished French researcher.

> [T]he EAA [Ethiopian Antiquities Administration] gave Taieb a "concession," an exclusive franchise to explore a 30,000 square kilometer area of northeastern Ethiopia in a desert region known as the Afar Depression. . . . Because of the concession, no one could explore or work any sites in the area without Taieb's expressed permission.[7]

Another book on paleoanthropology, entitled *Bones of Contention*, says, "With a limited number of fossil sites available to work, and a still pitifully small inventory of fossils to analyze, all of which may be in the control of just a few people, research access has always been a sensitive issue."[8] According to Donald Johanson of the Institute for Human Origins in Berkeley, rivalry in the field "sometimes results in instances where—it has recently been written—only those in the inner circle get to see the fossils; only those who agree with the particular interpretation of a particular investigator are allowed to see the fossils."[9] "Virtually every anthropologist has a tale or two to tell about a rival professional improperly preventing others from working on fossils in his possession. . . . 'There are lots of ways of simply making it difficult for someone to come to your lab and work with the fossils, if you choose not to have them come,' comments one senior anthropologist."[10] All this grows out of the strict protocol in the field

that the discoverer of a fossil is to have the first opportunity to describe it formally and to analyze it.

While the desire to be recognized for making a significant discovery is both understandable and appropriate, the subsequent notion of openness in research seems not to be prized in these fields. It is rare to come across any recognition that research material belongs in the public domain. One such instance did apparently emerge a few years ago when the fabulous Chauvet cave, containing ancient wall paintings, was discovered in France (more about that affair appears in the next chapter). The government expropriated the site and, in what the press called an unprecedented move, asked competing experts to submit proposals to lead research work at the cave site. Subsequently two of the country's most eminent specialists in prehistory submitted competing bids to the government. One of the contenders was Jean Clottes, the Ministry of Culture's own specialist in prehistoric art, and the other was Denis Vialou, an authority in prehistory at the National Museum of Natural History in Paris, who submitted a proposal for a research project including some seventy-five French and foreign experts. Vialou urged the government to hold the contest because, he said, "the choice must be made on a scientific basis rather than by appropriation of the caves." The choice was to be made by a jury of nine prehistory experts as advisers to the minister of culture.[11] Clottes ultimately prevailed.[12]

It is far from clear why exclusivity is so prominent in fields like archaeology, but not in others. Perhaps not surprisingly, there is no single or consistent view even among those in the field as to what the rules of the game are. Stephen A. Kaufman of the University of California, San Diego, writing in *The Comprehensive Aramaic Lexicon,* a newsletter published by the Hebrew Union College in Cincinnati, explained the existing system this way:

> Every library and museum in the world . . . controls access and publication rights to its collection, in a more-or-less standard fashion. It must be that way. Typically, an interesting text or object sits in locked cases for years or decades before some scholar happens across it or scholarly fashion turns its way. Anyone interested may study the object, but only one scholar can be given publication rights at any one time. Imagine being given rights to publish an antiquity held by a library, working on it day and night for several years, only to find that someone else has "scooped" you just as you are ready to publish your findings. On the other hand . . . if publication is not made after a reasonable amount of time, exclusive rights are withdrawn. In order to see that such rights are preserved, reputable journals and publishers will only publish photographs and transcriptions of such material with explicit authorization from the holding collection.[13]

Professor Norman Golb of the University of Chicago disputed Kaufman's statement about library practices. He says that "libraries do not generally have the kind of restrictive policies that Kaufman attributes to them, except, for example, in the case of a particular scholar who, while studying a manuscript to which others have had free access, makes a unique discovery that then gives him a moral right to reserve first publication of that text, within a reasonable time span."[14] Moreover, there appears to be no regular practice of withdrawing exclusive rights after some reasonable time has elapsed without publication.

Another field in which the practice of publication rights exist is papyrology, the study of ancient manuscripts and documents written on papyrus. The arrangements have no formal status, such as a deed of gift or a contract. They too are effectuated informally by what used to be called gentlemen's agreements. When a library or museum has papyrus documents, the practice has been to permit an individual scholar (apparently the first to ask, at least among recognized researchers) to lay claim to them—that is, to claim the right to transcribe, annotate, provide commentary, and publish the documents. Until that individual has published, no one else may publish any part of the material, or even have access to it without that person's permission. The system is implemented by what was described as an internal notation on the library records saying "restricted to. . . ," but those records are not available to the public.[15]

One notable instance described in interviews is the extensive papyrus collection of the Austrian National Library in Vienna, which consists of more than forty thousand items that were acquired at the beginning of the nineteenth century. The library divided the material into lots and gave them out to various scholars and institutions as exclusive rights of publication. Each such right is noted in a registry and is considered a personal property. In one case, the original assignee of a collection of papyri, a scholar named Boswinkel, gave some of his material to his pupil, F. A. J. Hoogendyk of Leiden. She subsequently discovered that a professor in Amsterdam, P. J. Sypesteyn, had published one of her texts and was apparently quite incensed. She wrote indignantly to Vienna to ask how such an inappropriate thing could happen. (I was unable to learn what, if any, reply she got from the library.)

At least one instance of such alleged misappropriation has been elaborately documented in writing and illustrates just how seriously this informal property system is regarded. A Swiss library held in its collection some literary material known as Bodmer Papyri, which were assigned to two

researchers named Hurst and Rudhardt, of the University of Geneva, who were working on them in preparation for publication. They allowed a visiting expert, Professor Enrico Livrea, to see the material and the work they were doing, assuming he would respect their rights as understood within the profession. He did not do so, at least in the view of some, for shortly thereafter Livrea published one of the manuscripts himself in a leading journal in the field, *Zeitschrift für Papyrologie und Epigraphik.* Thereafter Hurst and Rudhard published the following note on the papyrology discussion list e-mail:

> We regretfully announce that the publication by Prof. Enrico Livrea of *Un poema inedito di Dortheos: Ad Abramo* must be considered as a form of theft. The courtesy we showed Prof. Livrea in divulging to him our pre-publication work while he was a guest at the Fondation Hardt in Geneva has been poorly rewarded.
>
> Quite apart from the fact that publishing a document without having been given the right to do so is not acceptable behavior in our profession, Prof. Livrea plagiarizes our work in progress, occasionally quoting it as if it were already a publication, while adding to it quite needless mistakes of his own. Prof. Livrea might be a great scholar; there are now serious doubts about his being a gentleman.[16]

Livrea responded, defending himself essentially on the ground that the others had worked with him, that he had contributed help to them, that he had expected imminent publication by them, but when a year passed and the work did not appear, he published it himself. Essentially his defense was that Hurst and Rudhardt must have anticipated that he might publish the work.[17]

The former colleagues were not mollified. "We do not wish to engage in a polemic with M. Livrea," they replied (polemically), but "we note that he has abused our spirit of openness and confidence. His communication [defending what he did] shows that he was aware he was publishing an unpublished manuscript."[18] Even more interesting than the views of the contending scholars is a statement published in the journal by Hans Braun, the director of the Bodmer Foundation, to which the manuscript in question belongs:

> The publication of an unpublished poem [from the library] was not authorized by the Martin Bodmer Foundation. The foundation condemns this act of literary piracy. M. Livrea certainly should have known that the foundation was not according him authorization to establish an "editio princeps" [a first publication of an ancient and rare work]; the fact that he entitled his article "An unpublished . . ." demonstrates

incontestably that he knowingly violated the rights of the Martin Bod-
mer Foundation and, additionally, contravened the most elementary
professional ethics. . . . Professor Livrea has engaged in the practice
[described] from a document that had been shown to him under the seal
of confidentiality.[19]

Papyrology, like archaeology, suffers from the combination of exclusive
rights combined with chronic long delays in publication. When questioned
about delay, an interviewee had numerous cases at the tip of his tongue, for
example:

> A fragment from Euripides known as the Tebtunis Papyri, in the Ban-
> croft Library at the University of California, that an Oxford professor of
> classics named W. S. Barrett asked for, and got, permission to publish in
> 1956 but has still not published more than forty years later and conse-
> quently was not mentioned in the most recent, 1996, Oxford edition of
> Euripides.

> Papyri given to the Louvre at the beginning of the century (part of the
> archive of Pisentius, a Coptic bishop who lived in the seventh century
> A.D.) and given, in turn, to several different scholars, the most recent a
> Belgian researcher who has done nothing with it during the last fifteen
> years.[20]

Libraries and museums have not been unresponsive to these difficulties.
The material in the Louvre, mentioned above, is illustrative. A group of
younger scholars decided to take action: first they wrote the individual to
whom the material had been assigned asking her intentions and, having
received no response, contacted the Louvre, which acknowledged that it
had not heard from her for some years either and finally agreed to "take her
off the register" and give the material to the new group who believe it is
important material, and promised they could publish it quite soon.

The electronic revolution may also contribute to the decline of the old
system (a parallel technological advance that allows for production of high-
quality casts may have a similar impact on fossil research in paleoanthro-
pology).[21] A number of institutions are now putting images of all their
papyri on the Internet. The Bancroft Library at Berkeley is doing it; Duke
University has already done so and has an open-access policy. Not every
institution is following suit, however. The University of Michigan has been
reluctant to put unpublished papyrus material on the Web in order to pre-
vent what the archivist describes as "avoid[ing] duplication of efforts,"
which seems to be a euphemism for protecting publication rights.[22]

Is Exclusivity Desirable?

In many, probably most, fields, the raw material of research is open to everyone, even though some researchers may do shoddy work (as, indeed, one of the original Dead Sea Scrolls team members did, despite being one of the elect), or a scholar who has slaved over a problem for years may find himself preempted by another who publishes first. The object of literary criticism, if not all biographical material, can be had at the local bookstore. In mathematics the hard questions are no secret. The raw material on which physicists work and the essential material of most social-science research is in the public domain. While there are constraints, such as permissions for interviewing subjects and the like, exclusive rights are not thought necessary to sustain incentives. Indeed, the opposite is more likely the case: it is generally thought that competition stimulates good work and promotes quality. Much research is based on publicly available data, and the fundamental precept of intellectual property is that data is not proprietary: "all facts—scientific, historical, biographical, and news of the day. They may not be copyrighted and are part of the public domain available to every person."[23]

These very points were addressed by Michael Bar-Zohar, the chair of an Israeli parliamentary committee that held hearings in October 1991 on the withholding of Dead Sea Scroll material. Bar-Zohar, a historian himself, observed that it makes little difference in scholarship if someone produces a half-baked report, "since this occurs in all research and corrections are inevitably made in time by other scholars." Moreover, he said, "I spent 12 years researching my biography of Ben-Gurion. Then someone else came along, Shabtai Tevet, and did his biography of Ben-Gurion. Neither he nor I were harmed by competition. Now others are doing further research. This is the nature of research, building on the work of others."[24]

Is there any reason to conclude that researchers in fields like scrolls research and archaeology are different and ought to have at least a limited sort of exclusivity for a time? Perhaps.

 ↭ In some cases the researcher has made a discovery, of a site or of manuscript material, and a first right of publication may be an effective way to reward discovery and to discourage the most egregious sort of poaching. Alternatively, a scholar may have made an important contribution by raising money that permits important work to go forward or have acquired material through persuasion and assiduous efforts at purchase, as the Israeli

scholar Yigael Yadin did in buying the Temple Scroll from a dealer in Bethlehem. First rights reward such activities.

⚭ There may also be difficulties in enforced sharing of a site or of fragile materials, particularly when excavation work is in its early stages. In light of these considerations, a brief period of exclusivity offers a practical solution.

⚭ At least some of the reconstructive work in fields like scrolls research tends to be very exacting and time-consuming, and it would eventually be done essentially the same way by every competent expert (i.e., the one right way to put the text together and to transcribe it). In this respect, fields like archaeology, papyrology, and the like, may be distinguishable, even from other problem-solving areas where there is a "right" answer, such as mathematics. In mathematics, recognition comes not only from finding the solution, but from the elegance of the proof, which makes it more understandable that various people are working on the same problem at the same time. Where essentially all experts would come out with identical results, there may be a stronger case for exclusivity. So, paradoxically, one might obtain greater rights by demonstrating that his work is less creative.

⚭ A related point is that this more exacting work is usually intermediate to a final product, such as analysis and commentary on texts one has restored. If the intermediate work must be shared as soon as it is done, there is a risk of appropriation of one's efforts by others who simply take the intermediate work and use it in their own research. The question here is not whether some protection is appropriate for such intermediate work, for certainly it is; but how far such protection should extend? If one is allowed to withhold intermediate work (such as assembled and transcribed fragments) entirely until full scholarly exploitation of the material has been completed, as the scrolls team did, a long-term monopoly on a whole scholarly arena can effectively be created. A more appropriate solution would assure that those who utilize the work of others acknowledge their debt.[25] It is even possible that such work would qualify for formal protection under the copyright laws.[26] (As we shall see presently, the intermediate-work problem is of great consequence in modern scientific research, where economic stakes can be great.)

Beyond these explanations for the tradition, deference should doubtless be given to a consensus among scholars in a given field favoring a system of exclusive rights, where a consensus exists. Interviews with a small sampling

of scholars suggests that tradition, more than conviction, is responsible for the maintenance of most exclusivity practices. While there is broad recognition that abuses have occurred and still occur, there seems to be little taste for picking a fight.

Professional organizations, however, are beginning to take a critical look at established practices. No single view has emerged, and proposals range from clearly acknowledging the tradition of "prior rights to publication"[27] to allowing exclusive access only "if there is a compelling reason."[28] The one thing they all agree on is the importance of timeliness. The Society of Professional Archeologists, for example, provides that "failure to complete a full scholarly report within 10 years after completion of a field project shall be construed as a waiver of an archaeologist's right of primacy with respect to analysis and publication of the data."[29] In light of all the competing and overlapping considerations, a brief period of exclusivity may be the best practical solution. If the period is brief enough, neither the public interest nor that of other researchers is likely to be significantly impeded. Israel's Antiquities Law now provides that a permittee of an archaeological excavation must publish within five years from the end of the dig. If she does so, she then has an exclusive right to publish for ten years from the end of the dig. Otherwise the material can be reassigned to another.[30] Efforts to assure that such strictures are actually implemented is probably the most fruitful path for reform.

Getting researchers to release intermediate data is by no means a problem restricted to fields such as archaeology. Indeed, it is a subject of intense concern at the forefront of modern scientific research, where financial stakes are great because of the potential value of products like new drugs. In those areas, holding back on publication of intermediate discoveries (or protecting them through patent from going into the public domain) can provide large potential rewards, while such strategies potentially deter important research that might be done by others.[31] The traditional view was that scientific discoveries are to be published promptly, then to be in the public domain, on the understanding that increases in knowledge result from a cumulative process in which each new discovery builds on the work of predecessors.

The financial stakes in modern science, as Professor Rebecca Eisenberg noted in her pioneering work in this area,[32] put economic incentives and the canons of scientific openness in tension with each other. Among scientific researchers, one much-mooted question is whether patenting

intermediate discoveries promotes or retards the progress of research. Does granting greater incentives to a successful researcher by giving him some exclusivity of right outweigh putting more information in the public domain? While Eisenberg is addressing a particular problem of government-sponsored research, her observation is of more general interest:

> The course of scientific discovery and product development is incredibly complex and variable and unpredictable. Neither the old-fashioned approach of leaving all new discoveries in the public domain, nor the current approach of assigning exclusive rights in such discoveries to private parties, should be uniformly applied across the entire range of publicly-supported discoveries. In our eagerness to avoid the inadequacies of the public domain approach, we may have moved too quickly and too emphatically in the opposite direction, to the point where today patent rights in some government-sponsored discoveries may actually be undermining, rather than supporting, incentives to develop new products and bring them to market. . . . Patent protection is most likely to be an effective device for achieving technology transfer in the case of a patent that covers an end protect for sale to consumers. It is least likely to be effective, and most likely to interfere with subsequent research and product development, in the case of a patent on a research tool that is to be used in subsequent stages of R&D but will not be incorporated into the end product as it is ultimately sold.[33]

The assembled Dead Sea Scroll fragments—or any such more-or-less raw material like papyrus texts—are scholarly versions of what Eisenberg calls research tools. Certainly the case of the scrolls, or of papers and archives discussed in previous chapters, gives credence to her intuition: in all those cases, from the papers of Justices Brandeis and Holmes to the Dead Sea Scrolls, greater availability of the raw or intermediate research material in question to other researchers would have promoted further research, leading to a variety of valuable "end products." Moreover, in the scholarly realm, it would seem that the argument for extended exclusivity diminishes as one moves further away from the more mechanical tasks, and in the direction of analytical work. There may be a good argument for giving one individual or group a reasonable opportunity to assemble a basic text and get exclusive credit for that arduous task. Such a result can be characterized—in Eisenberg's words—as "fairness . . . along the path of cumulative innovation."[34] But when it comes to commentary and analysis, one wants to hear a variety of voices, reflecting differing perspectives and approaches.

Postpublication Secrecy

While exclusive rights of publication, and prepublication access restrictions, are problematic, an even more troublesome issue arises when restrictions extend beyond the date of publication. One rather extraordinary revelation about how things were done in the old days involved the greatest previous discovery of early Jewish materials prior to the Dead Sea Scrolls. In 1896, Solomon Schechter, a renowned scholar and lecturer in Talmud at Cambridge University in England, sailed to Egypt, where he discovered in the storeroom of a Cairo synagogue the so-called Zadokite Fragments dating from the tenth and twelfth centuries, and based on original texts from more than one thousand years earlier.[35] It was the most important document then in existence for understanding the history of the Essene sect in the times of the Second Temple. Schechter published his transcription of the Hebrew text, with an introduction and translation, but he did not publish a facsimile of the original text, which made it impossible for other experts to check his readings of the text. To make matters worse, he gave the originals of the documents to Cambridge University with the remarkable restriction that no scholar would be allowed to inspect them for five years. Among others, the renowned scholar R. H. Charles was denied permission to see the manuscript because of this restriction, and he wrote, "Even if Dr. Schechter's edition were thoroughly satisfactory this extraordinary action on his part could hardly fail to call forth the reprobation of scholars generally. . . . [H]e ought at all events to have published a facsimile of the entire MSS—only a matter of eighteen pages."[36]

No one knows how many other such arrangements existed, but they are by no means simply a vestige of another era. At a 1986 meeting, Dr. Harold Blum made a presentation about a collection of letters between Sigmund Freud and his fiancée that no one else had been allowed to see, including a leading Freud biographer who remarked that "repeated attempts on my part to gain access to the . . . letters were repulsed."[37] Nearly a dozen years later, those letters were still unavailable. Blum, incidentally, is the head of the Freud Archives who was quoted in a previous chapter as introducing "a policy of greater openness" for the Freud Papers in the Library of Congress.

As recently as 1997 the press announced the forthcoming publication of a newly revealed manuscript said to contain the account of an Italian Jewish merchant who voyaged to China four years before Marco Polo.[38] It was reported that the translator of the document, an English scholar named David Selbourne, "cannot make the original text available to anyone else.

Mr. Selbourne says he was allowed to see the manuscript and publish it only on condition that he not show the original to others or reveal anything about the identity of the owner."[39] The reason, according to Selbourne, is that "both its provenance and rights of ownership over it are unclear."[40] Putting it mildly, one expert was quoted as saying the inability of other scholars to examine and authenticate the manuscript is "a major problem." Another, writing in the *Times Literary Supplement,* called Selbourne's edition "a work of fiction sailing under false colors."[41] Then, only a week or so after the story about planned publication was reported in the press, the American publisher announced that it was postponing publication, though the book has been published in England and is widely available.[42] In a sort of ultimate irony of the inaccessibility problem, the decision not to publish in America was made after several respected scholars—without seeing the manuscript, which was forbidden to them, but only the galleys of Selbourne's book—nonetheless concluded it was a fake.[43]

One of the most curious incidents of postpublication exclusivity involves analysis by scholars of Woodrow Wilson's self-defeating behavior in the two great crises of his political career. The question was whether Wilson's conduct was the result of illness or of a psychological problem. Two historians, Alexander and Juliette George, had advanced the latter theory in a psychobiography, which was attacked as erroneous in an article coauthored by a Dr. Weinstein and the distinguished Wilson scholar Arthur S. Link (who died in 1998).[44] Weinstein and Link supported their view that Wilson's problem was medical and strongly criticized the Georges' work, on the basis of new evidence Weinstein and Link had uncovered. The Georges responded with this comment:

> The "new evidence" is not given. Our efforts to learn the basis for the diagnosis . . . have been unavailing thus far. Professor Link writes us that confidential material about Wilson's illness in Paris was shown to him and to Dr. Weinstein, that they are both under a pledge of confidentiality in the matter and that he intends to say no more about it.[45]

The restriction in this instance, which prevented scholars from verifying assertions made by professional colleagues who had criticized their scholarship, applied to a president who had at the time already been dead for over fifty years![46]

Perhaps the last word on postpublication access restrictions should go to a humorist. The setting is an improbable one—an essay by an English scholar, Douglas Osler, writing about as esoteric a subject as there is, Renaissance commentaries on Roman law.[47] It is a tale of a famous scholar who falsely claimed he had in his possession a perfect manuscript of

Roman law, a claim that was accepted for several hundred years, though in fact the manuscript never existed.

Osler explains that there was a writer of the time named Alciatus who was famous for his writings correcting others and providing more accurate versions of the Roman law texts than otherwise existed. In explaining his emendations, Alciatus referred, in the manner then apparently common, to his reliance on some ancient manuscript (an *antiquus codex* or a *volumen antiquissimum*). In the practice of the time, those volumes were not available to other scholars, however, so they could not verify matters for themselves. The most significant of the texts was known as the Florentine manuscript.

As Osler explains, "By this time, Alciatus had acquired a singular advantage over his fellow humanists. . . . For he had gained access, albeit at second hand, to many of the authentic readings of the Florentine manuscript. At this time the Florentine was kept securely under lock and key in the Palazzo Vecchio, and was, as now, considered much too important a possession to be shown to scholars. Alciatus was quick to perceive the possibilities."[48]

In fact, Osler says, Alciatus was a "third rate liar, forger, and imposter,"[49] who made his reputation from his willingness to exploit the fact that the texts he purported to interpret would be unavailable to others, creating a scholarly milieu that made his frauds essentially unchallengeable. "His touch was as daring as it was assured; for during all those years he seems to have lived with complete insouciance under the sword of Damocles suspended in the Palazzo Vecchio. Did he ever . . . speculate on the likely consequences if someone with either pretensions to scholarship or even a degree of honesty were to be granted access to the Florentine manuscript, and so reveal the impostures which he had spent his life perpetuating against an unsuspecting public?"[50]

Apparently not. Indeed, by the time one of his students actually did get access to the manuscript and note various discrepancies, Alciatus's reputation was so firmly established that the student (ever faithful) attributed those discrepancies to others who, he said, must have reported their work erroneously to Alciatus. Alciatus, the student said, being the soul of honesty himself, would have been incapable of conceiving of dishonesty in others. And so the reputation of this scholarly scoundrel lived on unblemished. A parable for those who deal in restricted access to manuscripts.

12

Antiquities Business

In the United States, which is not true of other countries, if you own a site, you can go out with dynamite and blow it to kingdom-come, you can go out there with a backhoe, you can do whatever you want, pretty much.

—Keith Kintigh, archaeologist

I think the United States should have a system as in Great Britain, that the past in all heritage sites belongs to the country, to the crown, and if it happens to be on your private land, then you're responsible as a steward of the past. . . . You cannot go out and dig that site unless you have permission of the government.

—Kathleen Reinburg, Society for American Archaeology

The American Way

America is virtually alone among the nations of the world in treating objects found on private lands as none of its business. Unquestionably, we are more protective of private property rights than most other countries, but even that does not adequately explain our neglect. For example, we could quite easily adapt to American circumstances an idea for protecting buried antiquities recently put forward by an English expert:[1] The finder (or landowner) would have good title, but that title could only be secured by reporting the find, and lodging the item (or, in the appropriate case, securing a site), for a specified period, with a designated authority such as a regional museum. Failure to do so would subject one to criminal prosecution. The authority would examine the item (or site) and decide whether acquisition was desirable in the public interest. The object would then either be returned to the finder with a certificate of good title (which would be necessary in order to sell to dealers or at auction), or it would be acquired, and compensation paid. Though such a proposal could be costly, and goes further than most countries do in recognizing private claims to antiquities, to the extent it could be effectively enforced, at least scientific values would be more secure. I suspect as well that some such 'realist'

approach is likely to be more fruitful than efforts, in the name of science, to treat all collecting and commercial trade in antiquities as illegitimate.[2]

A Dinosaur Named Sue

The risks inherent in the system we follow was dramatically illustrated in the much-publicized case of "Sue." In 1992, a federal court in South Dakota was asked to decide who owned the fossil remains of a *Tyrannosaurus rex,* called "Sue" after the person who discovered it, Sue Hendrickson.[3] The specimen was discovered in 1990 on the South Dakota ranch of an Indian named Maurice Williams. The Black Hills Institute, a commercial company that collects and restores fossils, had paid Williams five thousand dollars for the right to excavate on his land. Under ordinary circumstances that would have been the end of the matter. But "Sue" was said to be the most complete and best articulated skeleton of a T-rex ever found. Of the twenty-two T-rex skeletons extant, only this one was 90 percent complete. According to the Sotheby's catalog from which Sue was eventually sold, "not simply the largest and most complete example ever discovered of the largest meateater to walk the earth, she is, in the words of Sue Hendrickson, 'the Mona Lisa of dinosaurs.'" The significance of the dinosaur promptly set off a legal battle over ownership. Williams had made a very bad deal indeed, for estimates were that the dinosaur would bring millions in the collectors' market.

Under American law, a dinosaur on private land is just another object, like coal or a cow. Under ordinary circumstances, Williams would have had to settle for five thousand dollars, and the lucky fossil hunters would have had their million-dollar dino. But because of the peculiarities of Indian law, the title to the ranch land was actually in the United States, as trustee for Williams, while other things like his cows and his tractors were his personal property. As a result, one of those uniquely legalistic problems arose: Was the dinosaur part of the land (in which case it actually belonged to the United States, as trustee for Williams), or was it personal property, like a cow, in which case it belonged to Williams. If it was the latter, Williams was out of luck—he would be stuck with his five-thousand-dollar payment. But if it was part of the land, then the sale was void, since the United States as the title holder had never consented to it. The United States, apparently deciding that Williams had been taken advantage of, sued to invalidate the sale. The idea was to have the dinosaur returned to the United States so

that it could then re-sell it and give Williams (as beneficiary of the trust title) the vastly greater proceeds.

A three-judge federal appeals court concluded that "Sue" was part of Williams's land. The judges had this to say:

> We hold that the fossil was "land" within the meaning of [the statute]. Sue Hendrickson found the fossil embedded in the land. Under South Dakota law, the fossil was an "ingredient" comprising part of the "solid material of the earth." It was a component part of Williams' land, just like the soil, the rocks, and whatever other naturally-occurring materials make up the earth of the ranch. . . . That the fossil once was a dinosaur which walked on the surface of the earth . . . [is] irrelevant.[4]

Having won the case, the United States consigned Sue to Sotheby's, the auction house, to be put up for sale to the highest bidder, proceeds to Maurice Williams, who must think American property law is the most wonderful institution ever devised by the human mind.[5] Presale estimates were that Sue was likely to fetch around $1 million,[6] most likely from a private collector, whereupon it could disappear into a private museum. Alternatively, a dealer could acquire it, and break it up into any number of "collectibles" for resale. On the eve of the auction, the *New York Times* opined that "wherever Sue's bones end up . . . they should be treated as part of the world's natural history patrimony, not as the private preserve of the lucky owner."[7] *Time* magazine was having parallel thoughts at the same time: "Bill Gates could buy her on a whim. So, for that matter, could Steven Spielberg, Michael Crichton or Madonna. She would make a terrific conversation piece. No one knows what will happen. . . . She may well end up in a natural history museum, rather than as a lawn ornament of the rich and famous."[8]

In fact Sue was sold on October 4, 1997, for a staggering $8.36 million to the Field Museum of Natural History in Chicago. The bidding took only nine minutes and the winner was never in doubt. In a fittingly bizarre end to this extraordinary affair, it turns out that the cost was underwritten by McDonald's Corporation and Walt Disney World Resort, along with some others. Both companies plan to display casts of the fossil. Disney's will be located at the Animal Kingdom in Orlando, and McDonald's plans to have two life-size casts traveling the world.

The real Sue, fortunately, will reside at a major museum. But that is solely because the outlandish situation made for a story that amused the press and thus attracted corporate attention. For everything else, the usual rules apply: no law exists to protect important artifacts found on private

land against destruction, dismemberment, or disappearance. The striking fact is not that Williams pocketed a lot of money. After all, undeserving people get rich all the time when oil and other valuable minerals are found on their lands. What is astonishing is that no provision exists to assure that the scientific value of such objects is protected: that excavation is done properly, that appropriate research can be done before the object is removed or modified, and that provision is made to assure future research opportunities will not be lost.

While Sue's case had a satisfactory outcome, the risks of loss to science are by no means merely hypothetical. Important specimens often go into collections, never to be seen again. One of the only six known specimens of archaeopteryx, important to the study of the relation between dinosaurs and birds, is believed to have been sold by its private owner to a collector, and its whereabouts are unknown.[9] Sometimes an unskilled or overzealous owner, eager to make some quick money, will destroy a valuable specimen while trying to hack it out of the ground with a spade.[10]

In September 1997, the press reported an incident in Montana where a family named Walton—claiming that a tract was theirs, though they had lost it to the federal government by failing to make mortgage payments— were outraged because a dinosaur fossil on the land was being excavated by a university paleontologist, Keith Rigby, under a federal permit. The family, seeing opportunity slipping away, sent a backhoe to the site and started to dig at the fossil. When told to leave, one of them brandished a rifle and warned of possible bloodshed. A family member explained, "We need food for our families and fuel for our machines. . . . Rigby and those people earn money to pay their mortgages and put food on their tables, don't they?"[11]

The Scope of Protection under the Law

Today we still have no paleontological protection law in the United States, even for protection of the public lands. Senator Max Baucus of Montana introduced a bill that would have created a permit system for collection of fossils on public lands, banned commercial collection and sale, required deposit of significant objects in public institutions, and retained federal ownership of all such resources, but it died in committee.[12] For many years, we did not even regulate the excavation of aboriginal antiquities on the federal lands, and enormous quantities of Native American artifacts were removed from the federal domain by collectors and dealers, a good deal of which turned up in European museums.[13]

Finally, after several decades of totally uncontrolled rummaging of Indian sites, almost always by commercially motivated artifact hunters, and to the detriment of scientific study of the sites, Congress enacted the Antiquities Act of 1906, which forbade taking any "historic or prehistoric ruin or monument, or any object of antiquity" from the federal lands without a permit.[14] Permits are only granted to qualified institutions for the benefit of museums, universities, or other educational or scientific institutions, and the statute provides that objects collected must be permanently preserved in public museums. Even back in 1906, advocates for the legislation emphasized the sharp contrast between the excellent protection afforded antiquities by most foreign governments—Turkey, Greece, the Barbary States, and Persia, as well as France and Great Britain, were mentioned—and the almost total absence of such protection in the United States.[15]

The Antiquities Act is hardly a model law. Not only does it exclude private land from its coverage. It does not define the term "object of antiquity." One federal appeals court found the provision so vague as to be unenforceable.[16] And the law does not mention fossils. Its limitations have been remedied to some extent by a 1979 law, the Archaeological Resources Protection Act (ARPA).[17] ARPA is much more explicit and comprehensive than the earlier statute, but it too extends protection only to human-made artifacts (archaeological resources) on federally owned or Indian Lands. As to objects on private lands, ARPA prohibits interstate trafficking but only for artifacts obtained in violation of a State or local law. Under ARPA, only if it can be shown that a local law has been violated and in addition that the remains have been taken across state lines, may the artifacts be seized by federal authorities.

The situation under state law is not much more reassuring. While most states claim ownership of archaeological materials found on public lands, some control aboriginal grave looting,[18] and a few impose some modest controls on excavations,[19] there is no general or widespread protection for material of scientific or archaeological value on private land. Only one state, Alabama, has followed the European model, reserving to itself "the exclusive right and privilege of exploring, excavating or surveying" and asserting state ownership of the excavated material.[20] Enacted in 1906, the Alabama statute seems to be a dead letter in practice. It has never been interpreted in a reported judicial opinion, and the state seems never to have asserted its ownership of antiquities, or at least it has never done so in a way that has risen to public notice. In any event, no other state has followed the Alabama approach.

The absence of control has allowed a trade in vandalism to flourish.

Relic hunters made the news when ten men were discovered methodically tearing up a field in Western Kentucky looking for Indian artifacts. They were professional pothunters, looting an old Indian burial ground, and the forty-acre site "looked for all the world as if a low-flying squadron of bombers had just swooped over on a practice run. More than 450 craters, each edged by a mound of raw earth, pocked the surface."[21] But the site was private land, and the relic seekers had paid the landowner ten thousand dollars to lease digging rights between his fall harvest and spring planting. The only law they violated was a Kentucky statute forbidding "desecration of venerated objects," which comes into effect when one disinters human remains for the purpose of commercial sale or exploitation of the remains or objects buried with them.[22] At the time of the vandalism just described, violation was a misdemeanor punishable by a maximum fine of five hundred dollars and a year in jail (it has since been made a felony).

Another recent report described a backhoe operation that dug through Indian graveyards eight hours a day, five days a week, at a place called Fourmile Ruin near Taylor, Arizona, a five-hundred-year-old pueblo that had been on a major trade route that connected the Salado, Hopi, and Zunis. In that state "it is legal to excavate ruins on private land with the permission of the owner. At Fourmile, the owners say, the site was purchased solely to obtain the artifacts."[23] The absence of even minimal notification or permitting laws virtually assures that such incidents will continue in many states.

The Rest of the World

The United States stands virtually alone in its reluctance to restrict landowners from treating archaeological and paleontological objects as ordinary private property.[24] The notion that antiquities, which are usually buried in the soil, are elements of the national patrimony is almost universally recognized. Lyndel Prott and P. J. O'Keefe, who have written the leading work on the law of cultural heritage,[25] explain that nations accomplish quite similar and extensive protective goals through a variety of different means.

The most far-reaching notion appears in international law where phrases like "the world heritage of mankind as a whole" or "heritage of outstanding universal value" are employed to describe objects of exceptional historic and cultural importance.[26] Such things are said to be the joint possession of all peoples, who have a common responsibility to protect them

against neglect, decay, and destruction. Nothing nearly so broad could be said at this time to describe the domestic law in any country, but other nations are nonetheless far more protective than is the United States.[27]

At one end of the spectrum are countries like Mexico, which simply assert that all pre-Columbian artifacts belong to the nation.[28] Some countries in this category, most notably Italy, have a strong commitment to concepts of private property, but are willing to make an exception for the sake of their cultural heritage. Others do not assert ownership, but impose a range of duties upon private owners. A law may regulate excavations, requiring permits even for activities on private property. Other nations grant the state authority to acquire such objects by compulsory process, with compensation, though the measure of compensation may be quite restricted. And still others, while permitting private ownership of objects, give the state a first right of purchase (preemption). Some countries merely prohibit destruction, require notification of discovery, registration, or restrict or forbid export.

Within the various categories created by legislation are a rich mixture of techniques that often blur formal distinctions to a point where the presence or absence of a claim of state ownership may not be very revealing. For example, nations that assert full ownership nonetheless often provide "rewards" to finders or landowners. While some countries provide that a reward may reflect only the intrinsic value of metals or precious stones, but not artistic or archaeological value,[29] others allow rewards to approach full value.[30] As the Dead Sea Scrolls affair demonstrated, practical wisdom suggests that finders ordinarily need to be compensated generously or the public is unlikely to get the found objects, regardless of the formal rules. The goal is usually a practical one: a sufficient incentive for finders to direct the object into official or scholarly channels, though some compensation laws do appear to reflect an unease about the idea of an individual in effect owning historic or scientific value. For example, the Iraqi Antiquities Law of 1936 provides that in valuing "historic site" acquisition, "no account shall be taken of the existence or value of antiquities which are existing or have been found on or in such land."[31] A similar Sudan law of 1952 allows the government to remove antiquities from private land, but require it to pay "only for actual loss occasioned to the owner and occupier of the land."[32] Whatever the differences among them, the one common thread that runs through the law in almost every country is regulation designed to prevent destructive excavations, interference with scientific study, or denial of access by the public.[33]

The Chauvet Cave

All this is not to say that governance of antiquities is trouble-free in other countries, or that difficult public/private issues are absent. A celebrated recent discovery in France, and the controversy surrounding proprietary claims that arose out of it, provides not only an opportunity for comparison with the American approach, but a veritable playground of issues concerning the entitlement of private parties when objects of great scientific or historical importance are found on their land.

On December 18, 1994, three weekend speleologists were exploring the cliffs above the Ardèche River in Southern France, some 40 miles northwest of Avignon.[34] The group was led by Jean-Marie Chauvet, a watchman employed by the French archaeological service, and two friends, Elliette Deschamps, a winegrower, and Christian Hillaire, a technical worker at the electric power station. While tramping around in familiar territory, they came upon what seemed to be a cave entrance they had never seen before. The usual clue is a draft of air coming from a hole in the ground. Where the draft is strongest, there is likely to be a cavern below. The standard technique is to clear away the rocks or other barriers, and try to enter the underground.

On this occasion, the three explorers found themselves in a small, sloping vestibule with a low ceiling. As they could still feel air coming from below, they pulled out rocks and found a tiny passageway about eight feet wide and slightly over a foot high. The slimmest among them squeezed in first, and discovered an underground gallery below. In the following days, after clearing debris and getting needed equipment, they continued the search. Lowering themselves on a rope, they entered a great cavern through its ceiling which led to an enormous chamber, some 30 feet in height, with bear bones and teeth strewn all over the floor. Using the lamps on their miners' helmets, they scanned the cavern walls and were astonished to discover crude cave drawings in a kind of red chalk on the walls. The first image they saw was a little red-colored mammoth on a rocky spur hanging down from the ceiling.

They knew at once that Prehistoric people had been there before them. What they didn't know was that they had just discovered the oldest cave drawings yet found in Europe, subsequently determined to be more than thirty thousand years old. In fact they had found the oldest known paintings in the world. The discovery, soon to be known as the Chauvet cave, was extraordinary in many respects. No decorated cave of this size had

ever been found in this part of France. The cave was completely intact, with evidence of both human and animal presence. The artworks were not merely the primitive outlines the discovery team had first seen, but were remarkable and abundant sophisticated drawings of a wide variety of animals, in particular horses, lions, reindeer, and rhinos, the latter almost unknown previously in European Ice Age cave drawings. As in most paleolithic art, there is not a single complete human figure in the Chauvet cave. Here is how the trio described their discovery:

> Suddenly our lamps lit up a monumental black frieze that covered 10 metres of the left-hand wall. It took our breath away as, silently, we played our torches over its panels. . . . We felt gripped by madness and dizziness. The animals were innumerable: a dozen lions or lionesses (they had no manes), rhinoceroses, bison, mammoths, a reindeer. . . . A magnificent bison—with a curly mane, its horns drawn full face but its head in profile and with its muzzle half-open—was covered with bear clawmarks. . . . [W]e were filled with admiration at the refinement of the composition. One of the lions seemed to dominate the pride with its penetrating gaze; its head was drawn with darker lines. With theatrical effect, a horse had been placed at the back of a niche and some bison heads were superimposed like hunting trophies. . . .
>
> It is a veritable museum. Wherever one looks, one is gripped by the beauty of the mineral forms or the drawn figures. Almost all the drawings are in a remarkable state of preservation.[35]

The three immediately recognized the exceptional importance of their discovery, and took steps to protect the cave by marking fragile areas and the path they had taken, and securing the entrance. To their great credit, they removed nothing and took pains not to damage the floor of the cave. They then announced their discovery to the government, in this case the Regional Administration of Cultural Affairs for the Rhône-Alpes Region. The authorities kept the discovery a secret for nearly a month, to give themselves time to seal off the cave and screen it from casual tourists and vandals.

Few other places could so indisputably claim status as treasures of the world cultural heritage. As Chauvet and his colleagues put it, "[o]ur main concern had always been to preserve the cave and deliver it intact, just as we discovered it, to humankind. Mission accomplished."[36] However, matters were not to be quite that simple. In fact the discovery set off a series of legal battles that illustrate just about every facet of the question, "who owns history?" For one thing, the cave's entrance, located in the commune of Vallon-Pont-d'Arc, was on private land, owned by a family named Coulange.

Two other families owned land overlying portions of the cave. When the State expropriated the caves, as it soon did, each of the families demanded compensation, and a major battle ensued over its proper measure.

In addition controversy erupted over rights to photographs taken in the cave. They were of especial interest since the cave was almost immediately closed by government officials (scientific study was held in abeyance until lawsuits concerning ownership were settled and the entrance could be enlarged), and it is permanently closed to the public,[37] as are a number of other important decorated caverns, such as the very famous one at Lascaux. Only about half of the 50 or so decorated caves in France are open to the public.

Decorated caves have quite an interesting and varied history in France. Some, like Lascaux, Font de Gaume, and Cap Blanc, are owned by the State. Some others are owned by individuals, such as the Grotte de Merveilles, and still others by the local commune, such as Pech Merle. All of the latter caves are open to the public. At Pech Merle, the family that originally owned the cave shares the profits of tourism with the commune. Grotte de Merveilles is operated by the daughter of the woman who, with her father, discovered it. He had bought the underground rights back in 1924, shortly after they found the cave. Apparently, up until 1947 the government allowed private individuals to own such things, and existing private rights were recognized and could be retained. At private caves such as Grotte de Merveilles, all economic rights are retained by the owners, subject only to government regulations that compel protection (such as prohibition on touching the walls). Since 1947, however, all newly discovered ancient caves have been taken over by the government.

During their initial explorations, and before they even notified the government, Chauvet and his friends took about three hundred pictures, and videos, with the permission of the landowners. When the Ministry of Culture publicly announced the discovery of the cave, Chauvet and the others were astonished to find that the Ministry had prepared a nine-minute film for journalists covering the press conference. That film consisted of extracts from movies that Chauvet's team had taken and shared with government officials; which they had—as they put it—"gratuitously put at the disposition of the government," when they had first reported their discovery. What was more, the film carried a copyright in the name of the Ministry of Culture.[38]

The nine-minute film was marketed by the ministry to television stations all over the world at a price of six hundred dollars per minute. Another series of films taken by Jean Clottes, the conservator general in the

Culture Ministry responsible for decorated caves, and the first scientist the government brought into the cave, had been taken without permission of the landowners.[39] Nonetheless those films were sold on an exclusive basis to a commercial photographic agency, Sygma, for about three thousand dollars. Only four slides were kept to be distributed without charge for news purposes. Altogether, it appears that the Ministry of Culture profited to the extent of over a million dollars.[40]

This behavior on the part of the government greatly distressed Chauvet and the other two. The trio thereupon sold their rights to the same agency, Sygma, and demanded that the government cease commercializing the film which, they said, did not belong to it. Chauvet and the other two also published an illustrated book with reproductions of their photos. Altogether the three (after some sharing with the landowners) are said to have earned about one hundred thousand dollars, almost all of which they subsequently spent on legal fees fighting about their rights.[41]

The Ministry responded that Jean-Marie Chauvet was an employee of the government at the time of discovery and therefore had no authority to sell the pictures, which belonged to his employer, the French government. Chauvet replied that his job was simply to keep guard over a variety of nearby sites as a sort of watchman, and not to do research or excavation for the government. His cave exploration was strictly a hobby, he insisted, done on his own initiative, and on his own time.

To make matters worse, a letter to Chauvet from the government authorizing him to survey the area for prehistoric caves, had been backdated by an official named Patrice Beghain, a regional cultural affairs official,[42] to make it seem that Chauvet was working within the scope of his employment on December 18th, when the discovery was first made.[43] Chauvet instituted a complaint accusing Beghain of wrongdoing, and the investigating magistrate concluded that Beghain had wrongfully backdated the letter and that Chauvet was not on official duty when he discovered the cave.[44] As a result, Chauvet is to receive royalties from reproduction of his photographs,[45] as French law is said to grant such rights to "fortuitous" finders. Other rights arising from the diffusion of the cave's images, such as tourist revenue from a facsimile cave being planned by the government, remains unsettled.[46]

Chauvet's lawyer also claimed that his client was the "finder of a treasure" and under French law entitled to half of the value of the discovery. He cited the French Civil Code provision dealing with "treasure trove."[47] Needless to say, the ministry disagreed, and rightly so. Legally a cave isn't

treasure trove, a category usually reserved for precious metals. The ministry said the cave is an "artistic and archaeologic patrimonial artifact" that does not call for payment under the treasure trove law.[48]

The landowners then stepped forward to argue that the cave is merely the underground of their land, and the law says that the owner of the surface owns the underground. So, they said, the cave belongs to them, and that means that they alone have the right to authorize photographing of the artworks that belong to them, and any benefits that come from reproductions of the paintings. The landowners filed a lawsuit to enjoin the Ministry from any commercial exploitation of photographs of the paintings, and sued the photographic agency Sygma for over a million dollars as their share in the earnings from worldwide dissemination of the images.[49]

As if all this wasn't enough, there then ensued a surveyor's dispute about where the landward boundaries of the cave were, and whose land was actually above it. A local court in the Ardèche took jurisdiction of this question, which was decided in mid-1996.[50] In February 1997, the government announced that issuance of a postage stamp commemorating the discovery of the cave had been canceled due to "legal problems between the government and those who discovered the cave."[51]

Not surprisingly, Vallon-Pont-d'Arc, the town nearest the cave, also sought to capitalize on the discovery. Mayor Jean-Pierre Ageron was anticipating the construction of a facsimile cave that would annually draw hundreds of thousands of visitors to the town, à la Lascaux (the press reported in September 1997, that a replica was under construction). As the mayor put it, not quite in the universal-heritage-of-mankind spirit, "One thing is for sure; the artists of the cave were from Vallon. And Paris better not forget it."[52]

Meanwhile, posters showing the herds of bison and rhinos are to be seen in every Vallon shop window. The community hall was transformed into a museum, with mock-ups of cave dwellings and cave artists, and with flint and bone samples from many of the caves in the area.[53] Since the cave itself was sealed, the primary attractions in the museum were photographs of the Chauvet cave paintings, presumably supplied by the Ministry of Culture, which encouraged the town to benefit from the find. All this occurred to the distress of the Coulange family, whose land embraced the cave entrance. They felt betrayed because they were not benefiting in any direct way from the increase in tourism (their business was a canoe rental shop in town), and their desire to manage visits to the cave had been frustrated by its closure. Their major hope was to be compensated when their land was expropriated (as it was) by the ministry.

Chauvet got the satisfaction of having the cave officially named after him, something the government could offer in settlement. It had previ-

ously gone out of its way to refer to the discovery as the cave of Vallon-Pont-d'Arc, after the nearby village.[54] Chauvet also got a medal[55] and a permanent job with the archaeological service.[56] And, as noted above, he profited from publication of an illustrated book on the cave, and from photo rights sold to the Sygma agency. Nonetheless the discovery team described themselves as "excluded, dispossessed."[57] Chauvet told the newspaper *Le Figaro*, "we had no intention of making a profit out of our discovery, but after the way the Government has failed to keep its word and made money out of us, we decided to defend ourselves."[58] The landowners got nothing but compensation for their land, and (as we shall see momentarily) not much of that.

Who should have gotten what? From an artistic and historical perspective the Chauvet cave is priceless. But it is not simply "beyond price." It obviously has the capacity to produce substantial economic benefit from reproductions of its paintings in photographs, posters, books, and probably even T-shirts and coffee mugs. If it weren't for government intervention, there would have been the opportunity to exploit the site as a touristic destination. The owner might even have been able to profit as a result of controlling access by interested scholars and historians. In any event, the replica cave will doubtless be a popular and profitable tourist attraction.

Most of these possibilities were cut off when the state classified the cave as an historic monument under French law,[59] and expropriated it. Those acts posed in pure form the question, to what extent is private property to be recognized in a cultural artifact such as the cave? A French court had to grapple with the issue in the form of a valuation proceeding arising from the expropriation. A trial court decision was issued in February 1997, a little more than two years after the cave was discovered.[60]

The three owners of land overlying the cave, Pierre Peschier, Sully Ollier, and Henry Helly, sought a total of 70 million francs, about $14 million. The Coulange family, whose land embraced the cave entrance, claimed the stupefying sum of $150 million,[61] which one local wag described as pricing scrub land at the square-inch value of a Picasso.[62] Their demand was based on a calculation that the cave could attract about one million visitors per year at ten dollars each gross revenue, equal to a capital value of $8.4 million; plus a capital value for reproduction rights of the images—including T-shirts, postcards, and hotel revenues[63]—totaling $3 million; and finally, the value of the cave itself as an artistic treasure, which they valued at $136 million.

The landowners said that one basis for the size of their claims was the experience at the most famous of all decorated caves, Lascaux, which was discovered in 1940, and generated revenues of eight dollars each from some

four hundred thousand visitors a year (before it was closed to the public). The owner of Lascaux, Monsieur de la Rochefoucault, was given an indemnity of about $1 million when he deeded over the cave to the nation, a very large sum at the time. However, the Chauvet cave, they pointed out, is about ten times larger and almost twice as old. Moreover, whereas Lascaux had sustained considerable damage from tourism before it was turned over to the government, the Chauvet cave is in virtually pristine condition. All this suggested to the claimants a much larger award than had been given for Lascaux. In addition, they said, the famous Château at Chambord in the Loire Valley, one of the most popular tourist destinations in France, which was acquired in 1932, has a present-day value of $700 million, though the court did not explain how the claimants had arrived at that eye-popping figure.

In any event, the expropriation judge was not impressed. The Coulanges were awarded a total of fourteen hundred dollars, a sum representing the square-meter value of scrub land *(garrigue)*. The others, by the same measure, got six thousand dollars.[64] The total land involved was about thirty-eight acres, so the valuation was about two hundred dollars per acre.[65] The court decided that the cave should be valued as ordinary subsurface land according to conventional property law.

The court first explained that it did not have jurisdiction to decide the rights of reproduction and exploitation of the images, which apparently the government did not expropriate (this may be parallel to the situation where a museum owns a painting, but someone else owns the copyright in the image, and the right to reproduce it).

As to the value of the cave itself and its potential for exploitation, the court first considered whether the owners had actually been made worse off by the expropriation as to values connected to the cave. They had not, it said, because the existence of the cave was unknown and it was inaccessible. The only loss in that respect was the loss of the land for its agricultural value. Next, the judge asked whether the owner had lost some opportunity it could have exploited but for the expropriation. For example, if there were coal that could be mined—though it was as yet undiscovered—that would be compensable. There was no such valuable mineral. Moreover, the owner could not claim even ordinary development value for housing because the land was already in a protected area and had in effect been zoned against development. The reason for this had nothing to do with the cave; it was because this is a very scenic area frequented by tourists, and the government had previously restricted it from housing or commercial development.

As to the cave itself, the judge explained that a French law dating back to 1941 prohibits private archaeological excavations, and requires all discov-

eries to be reported to the government. That means there was no right to exploit the cave at the time the government expropriated it, so no value attributable to such exploitation is compensable (apparently this does not necessarily bar exploitation of photographic images under French law, though the decision is unclear about this).

For these reasons, the only compensation to which the landowners were entitled, the court said, was its quite small current use value. The interesting result is that even though France does not assert state ownership of antiquities, and is prepared to compensate landowners for actual losses realized, its regulatory regime—which denies any right to engage in excavation except upon terms set by the state—in practical effect vests the value of buried antiquities in the state.

Moreover, by exercising its authority to classify important discoveries as "monuments historiques," and by exercising the power of expropriation, the state assures that the objects will be protected against destruction, and will be made accessible to scientific researchers. The result is dramatically different from that in the parallel American case of dinosaur "Sue" where no mechanism was in place either prior to discovery or thereafter to assure protection of the fossil and accessibility to scientific researchers. Though in both cases courts found that the objects were simply elements of the land, the practical outcomes were utterly different. One landowner called the decision scandalous. The judge, he said, had simply adopted the position of the Ministry of Culture. He used a French expression that has no exact English equivalent: "C'est la lutte du pot de terre contre le pot de fer" (essentially, "You can't beat City Hall").

The Chauvet cave affair, and the dinosaur "Sue" case, reveal how very different outcomes can be even in countries that superficially abide by the same property rules: both France and the United States treat the artifacts as components of the overlying land. The Chauvet case also indicates how many different sorts of proprietary interests can arise out of a single object; the value of the object itself, rights of reproduction of images, rights of exploitation attributable to proximity, and finders rights.

Perhaps the most attractive feature of the French approach is that by vesting in the state a right to control all future excavation of antiquities, it provides a barrier against both destructive or mutilative behavior by landowners and against extortionate economic demands, and permits to government researchers a right of temporary occupation for purposes of study and preservation. Owners are compensated for actual losses to current use or permitted development value, but not for historic or scientific values. In addition, if in the course of state-controlled excavations a

landowner experiences actual economic loss (such as delay in construction while archaeological work is being done), indemnification for that loss is permitted.[66] The owner is not permitted to profit by exacting value that is attributable to opportunities (such as allowing unlimited public viewing) that could threaten the object's scientific or artistic value.

Where controls are needed, as in the case of the Chauvet cave, the classification as a "monument historique" permits the cave to be closed to public use, and thereby protected, while expropriation makes it accessible for research. If the state does not find it necessary to regulate use, access, or management, it need not exercise its authority to designate property interest as a "monument historique." Nor need it exercise its powers of eminent domain and expropriate the object or the land containing it. It remains unclear (at least to me) how French law treats a claimed right to exploit secondary values, such as photographic images or reproductions of such artifacts. (As an interesting footnote to the question of reproduction rights, it may be noted that the company authorized to salvage artifacts from the wreck of the *Titanic* was also given the exclusive right to take and sell photographic images of it. But the court said that because the wreck was in a public place, there could be no legal right to exclude others from visiting, observing, and photographing it.)[67]

American law, as typified by the dinosaur "Sue" matter, seems not to have any of the range of techniques other countries have engaged to deal with cultural treasures where private owners are involved. The absence of a regulatory regime for private lands offers no permitting or regulation to protect against destructive excavations. Nor, once an object is found, does the government have an established scheme for identifying those artifacts that should be regulated or acquired. Moreover (although no such question arose in the dinosaur case itself), if acquisition is thought desirable, the owner would seem to be free to demand the highest price that could be obtained in the marketplace, even if that value reflected the higher prices that might be obtained by cutting up an integral object into numerous small pieces for which collectors or the curious would pay.

Unfortunately even such things do have a market. In 1988, the Fine Arts Museum of San Francisco devoted an exhibition to a collection of painted wall murals from the ancient civilization of Teotihuacán in Mexico that had been in the hands of a collector in the city.[68] In that cases chunks of wall from a buried one-thousand-year-old civic compound, and ranging up to five inches in thickness, were pried out by looters using chisels, mallets, wrenches, and crowbars.

The remaining question is how to benefit finders and landowners

where—as is often the case—finding objects like a decorated cave or a remarkable fossil is considered desirable. While Chauvet and his companions expected no reward initially (until they felt they had been mistreated), and while an artifact like the cave is less amenable to a surreptitious trade, it would be desirable to offer some substantial reward to those who find important objects, and to the landowners who permit finders on their land, to encourage prompt reporting of finds, and to discourage vandalism.

The Chauvet case suggests that assignment of reproduction rights to both finders and landowners could be an appropriate reward. Indeed, had the French government assured Chauvet and his friends of those rights (even as shared rights with the government) they would probably never have gone to court. The same may not have been true of the landowners in the case, but a grant to them of a percentage of reproduction rights might well have led them to feel that they were appropriately sharing in the permissible economic benefits that flowed from the find on their land. A grant of reproduction rights, as French law recognizes, is consistent with what seems to be the principle of the reward concept, that finders should get some share of the value of their find.

One way to sort out the appropriate from the inappropriate is by recalling the suggestion made earlier that a distinction should be recognized between an object and the ideas, information, or inspiration embodied within that object, and that ownership need be qualified only to the extent necessary to assure the preservation and availability of those ideas. In the case of the Chauvet cave, insofar as protection of the art requires limits or prohibitions on visitation, no proprietary right to reap the economic value of harmful visitation should be recognized, though there might be a market for it. On the other hand, since dissemination of reproductions of the cave art is consistent with the public interest, there seems no reason to deny to landowners or others at least for a limited time some of the economic benefits dissemination can generate (high prices might limit adequate distribution, but presumably the market will function as acceptably in these circumstances as it does generally with copyrighted photographs and books). As to the proposed replica cave, compensation to the finders and landowners for rights of reproduction is appropriate, though presumably government would have some leverage to withhold the decision to build a replica until acceptable terms were agreed upon.

A similar approach would be appropriate for objects like dinosaur "Sue." Paleontologists have expressed some dismay at the judicial decision recognizing the fossils as the property of the landowner, and its consignment to an auction house for sale to the highest bidder. The issue might

usefully be broken down alone the lines suggested above, distinguishing the object itself from the knowledge it contains. Following that line, the landowner would not be allowed to destroy the scientific value of the fossils. For example, insofar as that value required an opportunity to study the dinosaur on site, any rights of sale should be subordinated to that opportunity. Indeed, if maintenance of the dinosaur at the discovery site was considered necessary on a long-term basis, that requirement might properly make the dinosaur unsalable altogether (just as the Chauvet cave was determined to be unvisitable). In such a case the government could expropriate the land, and compensate the owner for loss of ordinary land use rights, and designate the site as a locus for scientific study.

Alternatively, if removal were permissible consistent with preservation of the fossil's information value, but it was necessary to keep the entire dinosaur together, or it was necessary to assure its accessibility to researchers, those constraints might be imposed on any sale to collectors. Any such limitations might reduce the value the landowner might exact. But those reductions would be appropriate, if it were recognized that the owner could not assert proprietorship in the underlying knowledge or ideas the fossils contain. Insofar as such restrictions are not necessary, however, there is no reason why the landowner should not be able to sell the fossils to collectors, where there is a market, and to reap the economic benefits of that market. This would be similar to the English approach in treasure trove, where the practice is to return to a finder items not required for public institutions.

To be sure, one might take a more extreme view, and determine that only where important objects are fully available to the public at all times is the public stake in the information they contain adequately satisfied. There may be such cases. However, where there is value in encouraging private searchers and collectors, as in the art world (recognizing that private and commercial fossil hunting is much more controversial in the scientific community), there is much to be said for a system that qualifies ownership only to the extent necessary to separate the object as a possession and source of private aesthetic and intellectual pleasure from the knowledge it contains, which deserves to be in the public domain. Such an approach, seeking to exact benefit from private as well as public interests, may bring us as close as we can get to the best of both worlds.

Conclusion

All the arts are brothers.
—The Abbé Grégoire

Many things that we classify as ordinary property are important to our common agenda. Artistic treasures, objects of great scientific moment, and documents of scholarly, historical, and literary interest all offer similar difficulties. Conventional notions of ownership and dominion are unable to provide adequately for public access, openness, and preservation. The shape of the problem in the large, however, is clearer than the details of any particular remedy. Plainly no single or simple prescription can suffice.

The difficulties are many: Collectors will not easily slip into the role of steward. Curators must struggle as claims of privacy vie with the demands of history. Who is to lay down mandates for justices of the Supreme Court? How should unruly heirs be brought into tow, and what can be done about unseemly alliances between the famous and their authorized and privileged biographers? How much public concern should there be about scholarly practices that are at least tolerated by those who work in the field? Children and grandchildren care, and understandably, about their forbears' reputations. The temptation to shape history by feeding the fireplace will not die easily or fully.

The goal here has not been to enunciate a set of rules, but rather to draw attention to issues that have largely languished untended, and to illuminate the common themes they display. This book does have an agenda: it calls for recognition of a species of qualified ownership founded on the recognition that some objects—modern versions of the relics mentioned in the opening pages—are constituent of a community, and that ordinary private dominion over them insufficiently accounts for the community's rightful stake in them.

At the most general level, the preceding pages affirm the general understanding that while one can own things, no one can own ideas or knowledge. They belong in the public domain because they are basic build-

ing blocks of our common agenda: the acquisition and dissemination of knowledge, and the encouragement of genius. The fate of objects important enough to be pivotal to those enterprises should not be at the mercy of purely private will.

Any effort to find solutions, however, is complicated by the difficulty of identifying a substitute for the precepts that govern ordinary ownership. Property rules, whatever their limitations, for the most part have the virtue of clarity: the owner decides the destiny of things. What can serve as an alternative? We might begin by recognizing that the question posed by Stephen Joyce (who is to stop me?) is as hollow and unpersuasive in the case of his family letters as it would be with the Dead Sea Scrolls or a great work of art. Whatever sensitivity is appropriate to accommodate family feeling needs first to be separated from imperatives uttered in the name of proprietary rights. Once we acknowledge that, we can begin thinking about some positive responses.

For private papers—especially where family members are involved—almost certainly one ought to leave the formal power of disposition to the discretion of the creator and the heirs, hoping that there are far more Malamud families than Hardings or Joyces. There is, however, something to be said for inserting nonbinding language, perhaps in a copyright law or another suitable legislative setting, recognizing the importance to society of protecting its historical, literary, and artistic records, and calling on the families and executors of major figures to make papers and other materials available to institutions that are willing to preserve them.

Of course, everyone need not save everything, on the chance it will turn out to be of historical or literary importance. While there is no sure way to know—an obscure philosopher or artist may later be recognized as the undiscovered genius of his or her time—some workable guidelines can be suggested. For example, significance might be measured by the willingness of designated institutions to act as permanent custodians for the material, and to offer specified reasonable periods of sequestration in exchange for preservation and a gift or sale of the material. Any such offer should generate a moral duty on the owner to preserve. If no such institution wants the material then the owner should feel free to chuck it.

In some settings, where privacy concerns are absent, formal constraints are appropriate. A law such as California's art preservation act might have prevented the destruction of the Rivera mural and of Sutherland's portrait of Churchill, while an embargo on the portrait's display during the lifetimes of Sir Winston and his wife would have spared the two of them unnecessary pain. Some sort of compelled loan for display of specified

masterworks of art could have tempered the excesses of a Dr. Barnes. The Israel Antiquities Act, or something like it, if enforced, could get antiquities and excavations published in a timely fashion, or open opportunity to other researchers. Regulation of excavations—archaeological and paleontological—on private lands certainly is called for, with at least minimum controls in the form of permits, opportunities for scientific study before objects are decontextualized, and a right of timely public purchase in appropriate cases.

For other issues raised here, modest adaptations of existing practice seem justified. We already have well-established systems for classifying and protecting historic structures, and it would be a rather small step to create a new category that designates distinguished, newer architectural masterworks, and offers them some protection. That would at least assure that the professional community and other knowledgeable sources are heard in matters like that of the Salk Institute. The Salk case also cautions that the views of an owner—particularly a patron and connoisseur like Dr. Salk himself—are by no means to be ignored as mere self-interest, and should not lightly be set aside. Neither should mere ownership be determinative. In such matters, communities can choose between regulation, of the sort usually applied under historic-preservation laws, and more modest process requirements designed only to guarantee some form of public discourse. Either may work, and both may fail, but in no event should the public stake in protecting masterworks of architecture be put at naught.

Other matters call for possible action of a different kind. Libraries and museums probably underestimate the leverage they have over donors. It would surely be helpful if a donor who was shopping a collection around from one institution to another were to find that the same limitations on unreasonable sequestrations and inappropriate exclusivities applied everywhere. While there is no realistic way to affect what owners do while collections are still in their possession, institutions may underestimate the need owners have for the services they perform. Storing, cataloguing, and administering collections is a very considerable task, and should position institutions to implement reasonable, identical basic rules for gifts. No doubt some things will be lost to destruction if extreme donor desires are not met, and no one can say with confidence just how great the risk is. Whatever the ultimate decision about whether to take that risk, libraries and museums would benefit by asking whether the time has come to adopt and enforce common policies on embargoes and access.

Certain practices are particularly suspect, and would appropriately be repudiated both by libraries and museums, and by scholarly associations:

Postpublication embargoes insulate a writer from honest and informed criticism, and cannot be justified. Exclusivity arrangements, while they may have some justification, undermine the principle of a level playing field, and too often work to advantage those already on top, at the cost of younger, less well known, or less pedigreed, researchers. Protracted periods in which institutions are called on to deny open access in order to implement exclusive publication rights held by a particular scholar, despite nonpublication, impose inappropriate burdens on those institutions. Where relatively brief periods of exclusivity are thought appropriate within a field, the rules should be explicitly and uniformly set out for institutions to administer. Scholarly communities should do their own dirty laundry.

Another troublesome version of selective openness arises from practices in some institutions to screen researchers to determine whether they are "serious," or whether they are scholars rather than "mere" journalists. Requiring such judgments of curators and archivists, or executors and heirs administering a collection, seems quite at odds with the simple and fundamental notion that work should speak for itself in the intellectual marketplace. To have someone filtering out proposed work in advance by deciding that an individual is unworthy of the opportunity to participate in that marketplace is inappropriate. Awareness that the person doing the filtering is sometimes a competing biographer, a protective relative, a curator with research interests of his or her own, or a power-aggrandizing administrator, should be enough to demonstrate the unseemliness of such distinctions. A simple rule seems best: material is either closed (for a reasonable period, to everyone) or it is open to all adults, with whatever qualifications are necessary to protect fragile materials from risk or excessive handling.

There should be no constraints on an author or other creator from discarding his or her own creations if the creator considers them unsatisfactory or, for whatever reason, does not wish to be associated with them. An artist should be entitled to decide how the world will remember him or her. On the other hand, public figures—including our Supreme Court justices—should be strongly discouraged from destroying working papers, even though we may continue to recognize private ownership in them. There is a public claim on such material, once created; they are, after all, part of the history of the institutions under the aegis of which they were created, whether it be the executive, the judiciary or the legislative branches. The purely individual judgment that such materials are irrelevant to history, or inappropriate for biography, should be subordinated to the maturer, and more varied, judgments of history. Justice Black erred, from this perspective, in seeking to preempt history's judgment, as did other

officials who destroyed their papers on the assumption they were immaterial or misleading. Perhaps these obligations are, as Congress has generally thought, best left to the institutional sense of obligation, rather than being made a mandate of law. It is understandable that no one wants to tell Supreme Court justices how to behave, but that doesn't mean they are necessarily behaving appropriately. The Supreme Court could help by articulating nonbinding guidelines that acknowledged the importance of historical knowledge, and sought to draw some line (in time) to accommodate the competing demands of confidentiality and of public understanding of its judiciary.

Whatever the mechanisms ultimately chosen, the goal throughout, and the core intuition of this book, is to let history make its own judgments, and not permit mere proprietors to prejudge what sort of artistic, scientific, or documentary material is germane to that judgment. History and art, even science, has its fashions, and matters once thought entirely unsuitable for public attention—sexual matters and in particular evidence of homosexuality by famous and accomplished people—may at another time be considered highly relevant. To destroy is to foreclose the prospect that different views may prevail in another era.

The model is the responsible collector who does not destroy and who does not conceal his treasures. Collectors assure we will not be limited by official taste. As Bernard de Mandeville put it two centuries ago, "private vices, public benefits." Collectors have long embraced the idea that owners of cultural treasures are only temporary custodians. They exact great personal benefits from their holdings, and often profit economically as well as in other ways. But they welcome experts and artists who want to study their holdings. They are commonly willing to lend their most important works to responsible institutions that serve the general public and through their philanthropy (often subsidized by the state) many, perhaps most, of the greatest objects eventually find their way into public institutions. Collectors, like all of us, come in many varieties, and the notion of the owner as a steward of some sort takes many forms. What is most reassuring is how often collectors of the most varied stripes see themselves as the bearers of some special responsibility that transcends indulgence of their own fancies. As one author put it, "some people feel that they are no more than the fortunate, if provisional, trustees of certain works of art, having no right to deprive others who appreciate beautiful objects as much as they do themselves."

Notes

Introduction

1. Franklin Feldman and Stephen E. Weil, *Art Law* (Boston: Little, Brown, 1986), §5.11, p. 434. For a proposal to change the law see Comment, "Protecting the Public Interest in Art," 91 *Yale Law Journal* 121 (1981).

2. Whether law has ever recognized a right to destroy, technically *jus abutendi* (right of abuse), is uncertain. Views conventionally expressed (like those about the capricious Rembrandt owner) reflect the highly individualistic "will" theories of property, e.g., *Goodeve's Modern Law of Personal Property*, 9th ed., by R. H. Kersley (London: Sweet and Maxwell, 1949), 21–22. Writers on the civil law take a more measured view: "[T]he abuse of things that belongs to us may be without punishment, it is never permitted." C. B. M. Toullier, *Le Droit civil français suivant l'ordre du Code*, 4th ed. (1824–37), 3:57.

3. Igor Kopytoff, "The Cultural Biography of Things," in *The Social Life of Things: Commodities in Cultural Perspective*, ed. Arjun Appadurai (Cambridge: Cambridge University Press, 1986), 67.

4. This is not to suggest there is a single, monolithic community. Demands by Native American tribes for repatriation of artifacts may reflect a willingness (on their part) to forgo benefits to scientific inquiry, or artistic development, that may be lost by removing material from a museum. A society that values tolerance and diversity may prefer to let those values trump its own dominant cultural values. A prominent modern instance involves the so-called Kennewick Man, an ancient human skeleton, that Native Americans want to bury and scientists want to study. Diedtra Henderson, "Head-To-Toe-Exam . . . on Ancient Remains of Kennewick Man," *Seattle Times*, September 15, 1998, A12. See, generally, *Native American Graves Protection and Repatriation Act*, *U.S. Code*, vol. 25, secs. 3001–13.

5. Wendy Gordon, "An Inquiry into the Merits of Copyright: The Challenges of Consistency, Consent, and Encouragement Theory," 41 *Stanford Law Review* 1343, 1410–11 n. 303 (1989), and Gordon, "A Property Right in Self-Expression: Equality and Individualism in the Natural Law of Intellectual Property," 102 *Yale Law Journal* 1533, 1556, 1557 (1993).

6. From a letter to Robert Hooke, February 5, 1676, reprinted in J. W. N. Sullivan, *Isaac Newton, 1642–1727* (New York: Macmillan, 1938), 59.

7. Kenneth Clark, *What Is a Masterpiece?* (New York: Thames and Hudson, 1979), 35.

8. Ibid., 11.

9. Ibid.

10. *Vanna White v. Samsung Electronics America, Inc.*, 989 F.2d 1512, 1513 (9th Cir. 1993).

11. Art. 1, sec. 8, cl. 8.

12. Justice Story in *Emerson v. Davies,* 8 F. Cas. 615, 619 (No. 4, 436) (CCD Mass. 1845).

13. A. S. Byatt, *Possession: A Romance* (New York: Vintage International, 1991), 110, 126.

14. Joseph L. Sax, "Heritage Preservation as a Public Duty: The Abbé Grégoire and the Origins of an Idea," 88 *Michigan Law Review* 1142 (1990), and Sax, "Is Anyone Minding Stonehenge? The Origins of Cultural Property Protection in England," 78 *California Law Review* 1543 (1990).

15. John Malcolm Russell, *From Nineveh to New York* (New York: Yale University Press, 1997), 70, 78.

16. Christopher Knight, "The Hammer Falls on the Public's Trust," *Los Angeles Times,* November 15, 1994, F1.

17. *Los Angeles Times,* November 13, 1994, A20 (quoting Eli Broad of the UCLA/Hammer Museum).

18. Margaret J. Radin, "Market-Inalienability," 100 *Harvard Law Review* 1849 (1987), and Radin, "Property and Personhood," 34 *Stanford Law Review* 957 (1982). Radin's theory is applied to cultural property in John Moustakas, "Group Rights in Cultural Property: Justifying Strict Inalienability," 74 *Cornell Law Review* 1179 (1989).

19. Carol Rose, "The Comedy of the Commons: Custom, Commerce, and Inherently Public Property," 53 *University of Chicago Law Review* 711 (1986).

20. John F. Hart, "Colonial Land Use Law and Its Significance for Modern Takings Doctrine," 109 *Harvard Law Review* 1252, 1276 (1996).

21. *Munn v. Illinois,* 94 U.S. 113 (1876); *German Alliance Ins. Co. v. Kansas,* 233 U.S. 389 (1914).

22. See Nicole Herrmann-Mascard, *Les Reliques des saints, formation coutumière d'un droit* (Paris: Editions Klincksieck, 1975); Patrick J. Geary, *Furta Sacra: Thefts of Relics in the Central Middle Ages* (Princeton: Princeton University Press, 1978).

23. René Gimpel, *Diary of an Art Dealer* (New York: Universe Books, 1966), 76, 112.

24. *Daily Telegraph (London),* May 15, 1991, p. 7; Cynthia Saltzman, *Portrait of Dr. Gachet: The Story of a van Gogh Masterpiece* (New York: Viking, 1998), opp. pp. 320, 324.

25. Julius Held, "Alteration and Mutilation of Works of Art," 62 *South Atlantic Quarterly* 14, 1 (winter 1963). See also Avis Berman, "Art Destroyed, Sixteen Shocking Case Histories," *Connoisseur,* July 1989, 74.

26. Patricia Failing, "The Case of the Dismembered Masterpieces," *ARTnews,* September 1980, p. 71 (the work was ultimately reconstituted and is in the Louvre).

27. Held, "Alteration and Mutilation," 19; Failing, "Case of Dismembered Masterpieces," 68.

28. *New York Times,* June 10, 1988, B1.

29. *New York Times,* May 30, 1987, p. 7.

30. *New York Times Magazine,* March 17, 1996, p. 33.

31. *New York Times,* July 30, 1997, B1 (west. ed.).

32. *New York Times,* December 7, 1997, "Arts and Leisure," 43. A "momentous" death portrait of Napoleon was held unseen in a private collection since 1821. *New York Times,* July 1998, p. 32.

33. Saltzman, *Portrait of Dr. Gachet,* 321ff.

34. *Art Newspaper,* December 1997, p. 45.

Chapter 1

1. Diego Rivera, *Portrait of America* (New York: Covici-Friede, 1934), 24.

2. Cary Reich, *The Life of Nelson A. Rockefeller: Worlds to Conquer, 1908–1958* (New York: Doubleday, 1996), 108.

3. Quoted in *Newsweek,* February 24, 1934, p. 33.

4. Rivera, *Portrait of America,* 27.

5. Reich, Nelson A. Rockefeller, 110.

6. *New York Times,* February 19, 1934, p. 13.

7. Quoted in *New York Times,* February 13, 1934, p. 21.

8. David Shapiro, ed., *Social Realism: Art as a Weapon* (New York: Frederick Ungar, 1973) 105, 116.

9. *New York Times,* May 9, 1935, p. 13; May 10, 1935, p. 19.

10. *New York Times,* February 23, 1934, p. 17.

11. Rivera, *Portrait of America,* 54.

12. Jane Clapp, *Art Censorship: A Chronology of Proscribed and Prescribed Art* (Metuchen, N.J.: Scarecrow Press, 1972), 254.

13. *New York Times,* July 21, 1934, C14; July 22, 1934, E4.

14. Hank Burchard, "Diego Rivera, the Mexican Master," *Washington Post Weekend,* August 23, 1996, p. 51.

15. *ARTnews,* November 1996, p. 29.

16. *New York Times Magazine,* February 25, 1934, pp. 12–13.

17. Ibid., 13.

18. David Freedberg, *Iconoclasts and Their Motives* (Maarssen, Netherlands: Gary Schwartz, 1985), 45 n. 47; Julius Held, "Alteration and Mutilation of Works of Art," 62 *South Atlantic Quarterly* 1, 8–12 (winter 1963).

19. Freedberg, *Iconoclasts and Their Motives,* 128–29 (the book erroneously says Gregory XII); see Carlo Pietrangeli et al., *The Sistine Chapel: The Art, the History, and the Restoration* (New York: Harmony Books, 1986), 194.

20. André Françon and Jane C. Ginsburg, "Authors' Rights in France: The Moral Right of the Creator of a Commissioned Work to Compel the Commissioning Party to Complete the Work," 9 *Art and the Law* 381, 391 n. 39 (1985).

21. Joseph L. Sax, "Heritage Preservation as a Public Duty: The Abbé Grégoire and the Origins of an Idea," 88 *Michigan Law Review* 1142, 1155 (1990).

22. Reich, Nelson A. Rockefeller, 111.

23. Susan E. Milligan and Judd Tully, "Endless Problem," *ARTnews,* October 1995, pp. 126, 128.

24. Stephanie Barron, ed., "Degenerate Art," *The Fate of the Avant-Garde in Nazi Germany* (New York: Los Angeles County Museum of Art and Harry N. Abrams, 1991).

25. Anita Brenner, "Art's Storied Debate Renewed," *New York Times Magazine,* February 25, 1934, 23.

26. Moshe Carmilly-Weinberger, *Fear of Art: Censorship and Freedom of Expression in Art* (New York: R. R. Bowker, 1986), 53–54.

27. Penelope Rowlands, *"Origins* Bared," *ARTnews,* October 1995, p. 71.
28. "Memories of John Ruskin," in Frank Harris, *Life and Adventures* (London: Richards Press, 1947), p. 289.
29. *New York Times,* February 18, 1934, E4.
30. *New York Times,* February 14, 1934, C18.
31. California Civil Code, secs. 987(h), 989(e); see also *U.S. Code,* vol. 17, sec. 113(d)(2)(A)–(B).

Chapter 2

1. Martin A. Roeder, "The Doctrine of Moral Right: A Study in the Law of Artists, Authors, and Creators," 53 *Harvard Law Review* 554, 569 (1940); *Carter v. Helmsley-Spear, Inc.,* 71 F.3d 77, 82–83 (2d Cir. 1995).
2. Former California state senator Alan Sieroty, quoted in *Arts and the States: A Report of the Arts Task Force, National Conference of State Legislatures* (Denver, 1981), 30. Golden Gate University law professor Thomas Goetzl drafted the bill for Senator Sieroty.
3. Franklin Feldman and Stephen E. Weil, *Art Law: Rights and Liabilities of Creators and Collectors* (Boston: Little, Brown, 1986, 1988 Supp.), 533.
4. Patricia Failing, "The Case of the Dismembered Masterpieces," *ARTnews,* September 1980, p. 78; Colleen P. Battle, "Righting the Tilted Scale: Expansion of Artists' Moral Rights in the United States," 34 *Cleveland State Law Review* 441, 468–69 (1980).
5. One study found that only eighteen of fifty-five jurisdictions studied provided for perpetual moral rights (France being the most prominent, while in Germany moral rights expire with copyright). James M. Treece, "American Law Analogues of the Author's Moral Right," 16 *American Journal of Comparative Law* 487, 505 (1968).
6. E.g., the Berne Convention is concerned only with distortion, mutilation, or other modification, 4 Nimmer on Copyright 27–1, app. p. 27–5 (1987). Roeder, "Doctrine of Moral Right," 569. See *Crimi v. Rutgers Presbyterian Church,* 194 Misc. 570, 573, 89 N.Y.S.2d 813, 816 (1949) (destruction of mural did not damage creator's artistic reputation).
7. N.Y. Art and Cultural Affairs Law, sec. 14.03.
8. In a 1934 case, *Lacasse et Welcome c. Abbé Guenard,* the Court of Appeals of Paris permitted the abbé of a church to destroy wall paintings without notifying the artist, on the ground that disappearance of the work would not distort the artist's reputation. André Françon and Jane C. Ginsburg, "Authors' Rights in France: The Moral Right of the Creator of a Commissioned Work to Compel the Commissioning Party to Complete the Work," 9 *Art and the Law* 381, 385 n. 22 (1985).
9. California Civil Code, sec. 989; Massachusetts Statutes, chap. 231, sec. 85S.
10. Cf. *Lubner v. City of Los Angeles,* 45 Cal.App. 4th 525, 531 (1996); *Pavia v. 1120 Avenue of the Americas Associates,* 901 F.Supp. 620, 626 (S.D. N.Y. 1995).
11. Civil Code, secs. 987, 989. California also enacted what is known as *droit de suite,* which requires California residents who resell a work of a living artist valued at one thousand dollars or more to pay the artist 5 percent of the sales price (Civil Code, sec. 986).

12. For a discussion of the statute's test of recognized quality see Peter H. Karlen, "Moral Rights in California," 19 *San Diego Law Review* 675, 696ff., 728 (1982).

13. *Los Angeles Times,* editorial, "Art: Neglect Can Be Defacement," August 6, 1979, pt. 2, p. 6.

14. *Los Angeles Times,* November 2, 1992, B1.

15. Letter, Alan Sieroty to Roy Ringer, editorial writer, *Los Angeles Times,* August 20, 1979.

16. New York considered, but did not adopt, a bill that would have allowed the state attorney general to bring a suit to protect the public right to any work in public view if the artist was deceased.

17. Civil Code, sec. 989(a).

18. John H. Merryman, "The Refrigerator of Bernard Buffet," 27 *Hastings Law Journal* 1023, 1041 (1976).

19. Letter, Alan Sieroty to Hon. Edmund G. Brown Jr., September 3, 1982, p. 2 (from California State Archives, on SB 1757).

20. Statutes 1988, chap. 34, sec. 1(c), quoted in *Botello v. Shell Oil Co.,* 229 Cal.App.3d 1130, 280 Cal.Rptr. 535, 538–39 (1991).

21. Peter H. Karlen, "Moral Rights and Real Life Artists," 15 *Hastings Communications and Entertainment Law Journal* 929, 934 (1993).

22. Patricia Failing, "The Maryhill Museum: A Case History of Cultural Abuse," *ARTnews,* March 1977, p. 87.

23. In the interest of uniformity, the federal law preempts equivalent provisions in state laws, *U.S. Code,* vol. 17, sec. 301(f)(1).

24. *U.S. Code,* vol. 17, sec. 106A(a)(3)(B).

25. 136 *Cong. Rec.* H3111–02 (daily ed., June 5, 1989) (Statement of Rep. Kastenmeier).

26. 135 *Cong. Rec.* E2227 (daily ed., June 20, 1989).

27. H.R. Rep. No. 101–514, pt. 2, p. 6916 (1990), reprinted in 1990 *U.S. Code Congressional and Administrative News,* pp. 5763, 6915.

28. Ibid., 6917, quoting Arnold L. Lehman, in House Committee on the Judiciary, Subcommittee on Courts, Intellectual Property, and the Administration of Justice, *Hearings on H.R. 2690,* 101st Cong., 1st Sess. (1989), p. 1.

29. H.R. Rep. No. 101–514, p. 6915 (quoting Hon. Ralph Oman, Register of Copyrights).

30. Ibid., p. 6924 (quoting Prof. Jane C. Ginsburg).

31. Committee on the Judiciary, *Moral Rights in Our Copyright Laws: Hearings before the Subcommittee on Patents, Copyrights, and Trademarks of the Committee on the Judiciary, United States Senate,* 101st Cong., 1st Sess., on S. 1198 and S. 1253 (1989), Serial No. J-101–25, p. 113 (Peter H. Karlen, referring to California Civil Code, sec. 989).

32. The similar Massachusetts law has also been invoked on a number of occasions: *Patriot Ledger,* November 8, 1995, 1995 WL (Westlaw) 10698358; *Boston Globe,* July 14, 1992, 1992 WL 4183910; *Boston Globe,* February 11, 1992, 1992 WL 4162728; *Boston Globe,* September 13, 1991, 1991 WL 7435148; *Boston Globe,* November 5, 1989, 1989 WL 4835270; *Moakley v. Eastwick et al.,* 423 Mass. 52, 666 N.E.2d

505 (1996) (law does not apply to art created prior to enactment of statute, in contrast to California law).

33. *Los Angeles Times,* May 6, 1991, "Calendar," F1; August 25, 1991, "Calendar," p. 86.

34. *Los Angeles Times,* July 18, 1992, F4. For an earlier decision in the case see *Botello v. Shell Oil Co.,* 229 Cal.App.3d 1130, 280 Cal.Rptr. 535 (1991).

35. *Los Angeles Times,* March 20, 1992, F1; March 21, 1992, B7.

36. See generally Erika Doss, *Spirit Poles and Flying Pigs: Public Art and Cultural Democracy in American Communities* (Washington, D.C.: Smithsonian Institution Press, 1995).

37. There is, however, a provision that allows an owner, without incurring any legal liability, to get rid of a work that "cannot be removed from real property without . . . mutilation . . . or . . . destruction." California Civil Code, sec. 989(e)(1).

38. Interview with Professor Thomas Goetzl, Golden Gate University, September 2, 1997.

39. *Tilted Arc* was commissioned by the federal government and was ultimately removed to a motor vehicle storage building. It has been widely discussed: American Council for the Arts, *Public Art, Public Controversy: The Tilted Arc on Trial* (New York: ACA Books, 1987); Calvin Tomkins, "Tilted Arc," *New Yorker,* May 20, 1985, p. 95; Eric M. Brooks, "'Tilted' Justice: Site-Specific Art and Moral Rights after U.S. Adherence to the Berne Convention," 77 *California Law Review* 1431 (1989); Barbara Hoffman, "Law for Art's Sake in the Public Realm," 16 *Columbia-VLA Journal of Law and the Arts* 39 (1992); *Serra v. General Services Administration,* 847 F.2d 1045 (2d Cir. 1988).

40. See, e.g., *Piarowski v. Illinois Community College,* 759 F.2d 625 (7th Cir. 1985) (removal of sexually explicit work from a college corridor). For the other side of the coin, see Sanford Levinson, "The Tutelary State: 'Censorship,' 'Silencing,' and the 'Practices of Cultural Regulation,'" in *Censorship and Silencing,* ed. Robert C. Post (Los Angeles: Getty Research Institute for the History of Art and the Humanities, 1998), 195 (public monuments).

41. Peter H. Karlen, "Moral Rights and Real Life Artists," 15 *Hastings Communications and Entertainment Law Journal* 951 (1993).

42. The case is described in Françon and Ginsburg, "Authors' Rights in France," 387.

43. See Carl H. Settlemyer, "Between Thought and Possession: Artists' 'Moral Rights' and Public Access to Creative Works," 81 *Georgetown Law Journal* 2291, 2294 (1993).

44. Another law requires the state architect to cooperate with artists to insure that any work of art acquired for a public building is "properly maintained and is not artistically altered in any manner without the consent of the artist." Cal. Government Code, sec. 15813.3(e).

45. *Los Angeles Times,* March 19, 1992, F1; July 10, 1992, B14; July 11, 1992, B1.

46. *San Diego Union-Tribune,* April 24, 1992, B11.

47. Doss, *Spirit Poles,* 64–66.

48. American Council for the Arts, *Public Art, Public Controversy,* 34.

49. *North County Times (San Diego),* June 3, 1998, A1; *Carlsbad Coastline Review,* January 15, 1999, p. 1.

50. Doss, *Spirit Poles,* 61.

51. *Chicago Tribune Sunday Magazine,* August 14, 1997, p. 7, zone C.
52. Ibid.
53. *Chicago Tribune,* editorial, August 14, 1997, p. 22, zone N.
54. Holliday T. Day, *The Shape of Space: The Sculpture of George Sugarman* (Omaha: Joslyn Art Museum, 1981), 47.
55. *Los Angeles Times,* March 8, 1990, B10.
56. *Arts and the States,* 30.
57. *New York Times,* August 25, 1997, C9.
58. See Peter H. Karlen, "The Tom Martin Browne Case," *Art Calendar,* September 1992, p. 9.
59. *San Francisco Chronicle,* September 21, 1988, A22.
60. The Grant and Olson cases were reported in the *San Francisco Chronicle,* February 12, 1998, A21.

Chapter 3

1. Roger Berthoud, *Graham Sutherland: A Biography* (London: Faber and Faber, 1982), 197.
2. *New York Times,* January 12, 1978, p. 2.
3. *Times (London),* January 15, 1978, p. 4.
4. *New York Times,* February 13, 1978, p. 7.
5. Ibid.
6. Ibid.
7. Berthoud, *Graham Sutherland,* 183–200.
8. Quoted in *The Art Book* (London: Phaidon Press, 1994), 145.
9. Douglas Cooper, *The Work of Graham Sutherland* (London: Lund, Humphries, 1961), 59.
10. *New York Times,* January 16, 1978, F13.
11. Ibid.
12. Christopher Booker, "Man of Misery," *Spectator,* January 21, 1978, p. 14.
13. Avis Berman, "Art Destroyed, Sixteen Shocking Case Histories," *Connoisseur,* July 1989, p. 77.
14. Ibid.
15. Charles Merrill Mount, *John Singer Sargent: A Biography* (New York: Norton, 1955), 146.
16. William Howe Downes, *John S. Sargent: His Life and Work* (Boston: Little Brown, 1925), 28, 153.
17. Ibid.
18. John Hayes, *The Art of Graham Sutherland* (New York: Alpine Fine Art Collections, 1980), 134.
19. Ibid.
20. *Times (London),* January 15, 1978, p. 4.
21. There is a Sutherland oil sketch of Churchill's head and shoulders, done while Churchill was sitting for the portrait. It is in a private collection in London. Hayes, *Art of Graham Sutherland,* 134.
22. Aline B. Saarinen, *Proud Possessors* (New York: Random House, 1958), 184.
23. Anthony van Dyck's *Hunting Portrait of Charles I* is in the Louvre.

24. Eduard A. Safarik, *Galleria Doria Pamphilj* (Florence, Italy: Societa Arti Doria Pamphilj, 1993), 44.

25. Cooper, *Work of Graham Sutherland*, 58. A photo of the portrait is reproduced in Hayes, *Art of Graham Sutherland*, 135.

26. Saarinen, *Proud Possessors*, 28.

27. Frank Giles, "A Great Lady's Sad Mistake," *London Sunday Times*, January 15, 1978, p. 16.

28. *Times (London)*, January 15, 1978, p. 4.

29. *New York Times*, April 24, 1998, p. 31.

30. Stanley Weintraub, *Whistler* (New York: Weybright and Talley, 1974), 407–8.

31. Pierre Courthion, *Rouault* (New York: Harry N. Abrams, 1962), 296.

32. Michael Kimmelman, "Life Is Short, Art Is Long," *New York Times Magazine*, January 4, 1998, p. 20 (saying Brahms "skew[ed] his legacy").

33. *Salinger v. Random House, Inc.*, 811 F.2d 90 (2d Cir.), reh'g denied, 818 F.2d 252 (2d Cir.), cert. denied 484 U.S. 890 (1987).

34. Salinger's desire for privacy was shattered in 1998 by the publication of a memoir by a woman with whom he had an affair several decades earlier. Joyce Maynard, *At Home in the World, A Memoir* (New York: Picador U.S.A., 1998).

35. *New York Times*, September 23, 1966, C11.

36. T. S. Eliot, *Inventions of the March Hare: Poems, 1909–1917*, ed. Christopher Ricks (New York: Harcourt Brace, 1996).

37. Ibid. See also Anthony Lane, "Writing Wrongs: What Do the Early Poems of T. S. Eliot Reveal?" *New Yorker*, March 10, 1997, p. 86.

38. Leon Edel, *Writing Lives: Principia Biographica* (New York: Norton, 1984), 22.

39. Caryn James, "The Fate of Joyce Family Letters Causes Angry Literary Debate," *New York Times*, August 15, 1988, C13, C16.

40. Max Brod, epilogue to *The Trial*, by Franz Kafka (London: Minerva Paperbacks, 1992), 253.

41. Ibid., 252.

42. Ibid., 255.

43. Joachim Unseld, *Franz Kafka: A Writer's Life*, trans. Paul V. Dvorak (Riverside, Calif.: Ariadne Press, 1982), 360, quoting Brod, "Franz Kadkas Nachlaß," *Die Weltbühne*, July 17, 1924, pp. 106–9.

44. Unseld, *Franz Kafka*, 278.

45. Ibid., 278–79.

Chapter 4

1. C. P. Snow, *The Two Cultures; and a Second Look* (New York: New American Library, 1963).

2. Herbert Muschamp, "The Wrong Prescription on Architecture," *New Republic*, February 10, 1992, p. 10.

3. *New York Times*, June 23, 1991, p. 30.

4. See Patty Gerstenblith, "Architect as Artist: Artists' Rights and Historic Preservation," 12 *Cardozo Arts and Entertainment Law Journal* 431 (1994).

5. Paul Goldberger, "Imitation That Doesn't Flatter," *New York Times,* April 28, 1996, sec. 2, p. 40.

6. *New York Times,* June 23, 1991, sec. 2, p. 30.

7. Richard Meier, interview by Peter Slatin, *Omni,* September 1993, p. 69.

8. Herbert Muschamp, "Art and Science Politely Disagree on an Architectural Jewel's Fate," *New York Times,* November 16, 1992, C11.

9. *Los Angeles Times,* May 12, 1993, F3.

10. Michael Benedict, "Between Beakers and Beatitudes: The Salk Institute's Dual Role of Function and Landmark," *Progressive Architecture,* October 1993, p. 52.

11. Michael J. Crosbie, "A Talk with Jonas Salk," *Progressive Architecture,* October 1993, p. 47.

12. *House and Garden,* July 1987, p. 16.

13. *Penn Central Trans. Co. v. New York City,* 438 U.S. 104 (1978).

14. *Architecture,* July 1987, p. 15.

15. *New York Times,* August 20, 1995, sec. 9, p. 1.

16. *Architecture,* August 1986, p. 11. See also Martin Filler, "Wright Wronged," *House and Garden,* February 1986, p. 42ff.

17. *Los Angeles Times,* July 26, 1992, A16.

18. *Time,* July 6, 1992, p. 64.

19. *U.S. Code,* vol. 17, sec. 120(b).

20. See generally, Raphael Winick, "Copyright Protection for Architecture after the Architectural Works Copyright Protection Act of 1990," 41 *Duke Law Journal* 1598, 1622 (1992).

21. *New York Times,* November 16, 1992, C11.

22. For background see Daniel T. Cavarello, "From Penn Central to United Artists I & II: The Rise to Immunity of Historic Preservation Designation from Successful Takings Challenges," 22 *Boston College Environmental Affairs Law Review* 593 (1995). Quotes below can be found in the Court's opinion.

23. *Penn Central Trans. Co. v. New York City,* p. 146.

24. Ibid., pp. 140, 141, 146.

25. Ibid., p. 143. The dissenting judge in the appellate division said that imposing a duty to maintain the station "is to clearly lessen Penn Central's estate. . . . Otherwise stated, ownership entitles one to destroy as well as to preserve." *Penn Central Trans. Co. v. City of New York,* 377 N.Y.S.2d 20. 36 (App. Div., 1st Dept., 1975, Lupiano, J., dissenting).

26. A rather more legalistic view is that by setting a building out in public view the owner has impliedly made a dedication to public use, at least to some extent. See, e.g., Note, "Protecting the Public Interest in Art," 91 *Yale Law Journal* 121, 126 (1981).

27. *Penn Central Trans. Co. v. New York City,* p. 108.

Chapter 5

1. Jean-Pierre Babelon and André Chastel, "La Notion de patrimoine," 49 *Revue de l'art* 5, 9–10 (1980).

2. My focus here is on the fine arts made for the market, rather than antiqui-

ties or contextual objects of archaeological (or other scientific) significance, where a debate is raging over harmful effects from commercial trade and collecting. See chapter 12.

3. Joseph Alsop, *The Rare Art Traditions: The History of Art Collecting and Its Linked Phenomena Wherever These Have Appeared* (New York: Harper and Row, 1982), 395.

4. Krzysztof Pomian, *Collectors and Curiosities: Paris and Venice, 1500–1800,* trans. Elizabeth Wiles-Portier (Cambridge: Polity Press, 1990), 274, 275.

5. Pierre Cabanne, *The Great Collectors* (New York: Farrar, Straus, 1963), 59.

6. Aline B. Saarinen, *Proud Possessors* (New York: Random House, 1958), xxi.

7. Ibid., 266.

8. Nicholas A. Basbanes, *A Gentle Madness: Bibliophiles, Bibliomanes, and the Eternal Passion for Books* (New York: Henry Holt, 1995), 356, 369, 400; Saarinen, *Proud Possessors,* 137–38.

9. S. N. Behrman, *Duveen* (New York: Random House, 1952), 232–33.

10. Charles Ryskamp et al., *Art in the Frick Collection* (New York: Harry N. Abrams, 1996), 17.

11. Quoted in Barry Hyams, *Hirshhorn: Medici from Brooklyn* (New York: J. P. Dutton, 1979), viii.

12. John Windsor, "Identity Parades," in *The Cultures of Collecting,* ed. John Elsner and Roger Cardinal (Cambridge: Harvard University Press, 1994), 64.

13. Jonathan Brown, *Kings and Connoisseurs: Collecting Art in Seventeenth-Century Europe* (Princeton: Princeton University Press, 1995), 155.

14. Naomi Shor, "Collecting Paris," in Elsner and Cardinal, *The Cultures of Collecting,* 256, describing the analysis in J. Baudrillard, *Le Système des objets* (Paris, 1968). See also Mieke Bal, "Telling Objects: A Narrative Perspective on Collecting," in Elsner and Cardinal, *The Cultures of Collecting,* 105, and Werner Muensterberger, *Collecting, an Unruly Passion: Psychological Perspectives* (Princeton: Princeton University Press, 1994), 229 ("cupidity and collecting mania . . . have their correlating determinants in the infantile attitude toward feces").

15. But see Hugh Trevor-Roper, *Princes and Artists* (London: Thames and Hudson, 1976), 125.

16. René Gimpel, *Diary of an Art Dealer, 1918–1939* (New York: Universe Books, 1966), 23.

17. Artsreview, *Portrait of the Artist, 1987: Who Supports Him/Her?* (Washington, D.C.: National Endowment for the Arts, 1987), 59–60.

18. Edmond Bonnaffé, *Les Collectionneurs de l'ancienne France* (Paris: Chez Auguste Aubry, 1873), ix, x.

19. Public access is itself a cultural value. "Whereas Americans tend to think of a museum primarily as an educational institution that mounts displays for the public, the Chinese think of a museum as a storehouse that safeguards cultural treasures." Andrew Solomon, "Don't Mess with Our Cultural Patrimony!" *New York Times Magazine,* March 17, 1996, p. 33.

20. Alan Riding, "Wanting the World to See what Pleases Him," *New York Times,* July 13, 1997, p. 35.

21. John Henry Merryman, "A Licit International Trade in Cultural Objects,"

in *Legal Aspects of International Trade in Art*, ed. Martine Briat and Judith A. Freedberg (Paris: ICC Publishing S.A., 1996), 16.

22. Kenneth Clark, intro. to *Great Private Collections*, ed. Douglas Cooper (New York: Macmillan, 1963), 15.

23. Niels von Holst, *Creators, Collectors, and Connoisseurs: The Anatomy of Artistic Taste from Antiquity to the Present Day* (New York: G. P. Putnam's Sons, 1967), 17.

24. Ibid., 200. See also Maurice Rheims, *The Strange Life of Objects* (New York: Atheneum, 1961), 17, 33, 96.

25. Carol Lutfy, "The Lady Vanishes," *New York Times Magazine*, March 30, 1997, p. 36. It disappeared again following its sale to a Japanese theme park owner in 1989. *Art Newspaper*, October 1998, p. 47.

26. *Art Newspaper*, February 1999, p. 1.

27. *New York Times*, May 21, 1995, p. 35.

28. *ARTnews*, September 1997, p. 60.

29. Robin Pogrebin, "Einstein Manuscript on Sale Shows Science Can Be Art," *New York Times*, March 15, 1996, A1.

30. Stephen Jay Gould, in Gould and Rosamond Wolff Purcell, *Finders, Keepers* (New York: Norton, 1991), 58.

31. Ralph E. Lerner and Judith Bresler, *Art Law*, 2d ed. (New York: Practicing Law Institute, 1998), 2:1182–83.

32. See P. H. Karlen, "What Is Art? A Sketch for a Legal Definition," 94 *Law Quarterly Review* 383, 385 nn. 16, 17 (July 1978).

33. Norman Palmer, "Art Loans," in Briat and Freedberg, *Legal Aspects*, 316 n. 106. See, e.g., *Nevada Revised Statutes Annotated*, § 374.291 (tax exemption, fine art for public display).

34. Ibid., 316 n. 105; *New York Times*, December 24, 1997, B5.

35. Michael Kimmelman, "Masterworks on Vacation at the Met," *New York Times*, August 9, 1996, C17.

36. "State Arts Councils: Some Items for a New Agenda," 27 *Hastings Law Journal* 1183, 1188–90 (1976). See also Lawrence Beyer, "Intentionalism, Art, and the Suppression of Innovation: Film Colorization and the Philosophy of Moral Rights," 82 *Northwestern University Law Review* 1011, 1080, text n. 224 (1988); Note, "Protecting the Public Interest in Art," 91 *Yale Law Journal* 121 (1981).

37. Albert Elsen, "Introduction: Why Do We Care about Art," 27 *Hastings Law Journal* 951, 958 (1976); Judy Gechman, "Rescuing Cultural Treasures: The Need for an Incentive Generating Doctrine," 24 *Houston Law Review* 577, 596–98 (1987); Paul M. Bator, "An Essay on the International Trade in Art," 34 *Stanford Law Review* 275, 299–301 (1982).

38. An analogy would be compulsory licensing. See, e.g., Robert Cassler, "Copyright Compulsory Licenses—Are They Coming or Going," 37 *Journal of the Copyright Society* 231 (1990).

39. Arnold L. Lehman, quoted in the *New York Times*, October 2, 1997, B8.

40. *A Life of Collecting: Victor and Sally Ganz*, ed. Michael Fitzgerald (New York: Christies, 1997), 8.

41. Ariel Kozloff Bordkey, curator of ancient art at the Cleveland Museum, in Briat and Freedberg, *Legal Aspects*, 136.

42. *New Yorker*, November 24, 1997, inside back cover.

43. Rheims, *Strange Life of Objects*, 43.

44. *Washington Post*, July 9, 1989, G1.

45. *The Philobiblon of Richard de Bury*, ed. and trans. Ernest C. Thomas (London: Kegan Paul, Trench, 1888), 167.

46. Ibid., xxxvii–xxxviii.

47. Ibid., 243.

48. Auguste Bailly, *The Cardinal Dictator: A Portrait of Richelieu* (London: Jonathan Cape, 1936), 292–93.

49. Edmond Bonnaffé, *Recherches sur les collections des Richelieu* (Paris: E. Plon, 1883), 14 (Richelieu), 58 (Mazarin).

50. Anthony Alan Shelton, "Cabinets of Transgression: Renaissance Collections and the Incorporation of the New World," in Elsner and Cardinal, *The Cultures of Collecting*, 186–87.

51. Von Holst, *Creators, Collectors, and Connoisseurs*, 88.

52. Ibid., 205–9.

53. Last Will and Testament, 1913 (Morgan Library Archives).

54. Saarinen, *Proud Possessors*, 76.

55. Ibid., 352.

56. Hyams, *Hirshhorn*, 135.

57. Celestine Bohlen, "Princely Family in Rome Deigns to Dust Off Its Art for Public Display," *New York Times*, December 27, 1996, A9 (west. ed.); Alfred MacAdam, "Palazzo Doria Pamphili," *ARTnews*, October 1997, p. 96 (suggesting less munificent motives).

58. Cicero, *The Verrine Orations*, trans. L. H. G. Greenwood, vol. 1, *Against Verres* II 20554–21556 (London: William Heineman, 1928), 181.

59. Ibid., 179.

60. Ibid., 181.

61. Pliny, *The Natural History*, trans. John Bostock and H. T. Riley (London: Henry G. Bohn, 1857), vol. 6, bk. 35, chap. 9, p. 233.

62. Ibid., p. 175.

63. Cabanne, *The Great Collectors*, 166.

64. Ibid., 176.

65. Ibid., 185.

66. Ibid., 162. See William Schack, *Art and Argyrol: The Life and Career of Dr. Albert C. Barnes* (New York: T. Yoseloff, 1960).

67. Stanley Meisler, "Say What They May, the Feisty Doctor Had an Artful Eye," *Smithsonian*, May 1993, p. 96.

68. Cabanne, *The Great Collectors*, 199.

69. Peggy Guggenheim, *Out of This Century: Confessions of an Art Addict* (New York: Universe Books, 1979), 361–62.

70. Similarly, Sir William Burrell, whose 1944 will left Glasgow one of the world's great art collections, provided in his will that no work from his collection could ever be loaned overseas, but the restriction was disregarded by a Parliamentary Commission. Ian McCulloch and Jessica Koravos, "The Burrell Showcase—

The Public Interest and Compliance with Bequests," 3 *Art Antiquity and Law* 193 (1998). The Frick Collection may not loan works that belonged to Mr. Frick. *New York Times*, Sept. 7, 1998, B8.

71. Different sources give different numbers. A 1992 article in the *Economist* (UK ed.), August 1, 1992, p. 77, says there were 171 Renoirs, fifty-seven Cézannes, and fifty-four Matisses.

72. *Commonwealth v. The Barnes Foundation*, 398 Pa. 458, 460, 159 A.2d 500 (1960). An earlier unsuccessful suit to enforce the charitable trust had been initiated by a newspaper reporter, *Wiegand v. Barnes Foundation*, 374 Pa. 149, 97 A.2d 81 (1953). See also *In re Barnes Foundation*, 453 Pa. Sup. 243, 683 A.2d 894 (1996) (effort to amend charitable trust denied).

73. George L. Stout, *Treasures from the Isabella Stewart Gardner Museum* (New York: Crown Publishers, 1969), 30.

74. Meisler, "Say What They May," 96.

75. *New York Times*, April 7, 1994, B4.

Chapter 6

1. Harold C. Relyea et al., *The Presidency and Information Policy*, Center for the Study of the Presidency, Proceedings, vol. 4, no. 1 (New York: Center for the Study of the Presidency, 1981), 79–91; Herbert Brownell, "Who Really Owns the Papers of Departing Federal Officials?" *New York State Bar Journal*, April 1978, 193–95, 230–34.

2. *Nixon v. United States*, 978 F.2d 1269, 1294 (D.C. Cir. 1992).

3. Thomas C. Reeves, "Search for the Chester Alan Arthur Papers," 25 *Manuscripts* 172 (1973).

4. Relyea et al., *Presidency and Information Policy*, 81–82.

5. Francis Russell, *The Shadow of Blooming Grove* (New York: McGraw-Hill, 1968), 605.

6. Andrea D. Lentz, ed., *The Warren G. Harding Papers* (Columbus: Ohio Historical Society, 1970), 2–3, and n. 3. See also Carl Sferrazza Anthony, *Florence Harding* (New York: William Morrow, 1998), 486, 497–98.

7. *Nixon v. United States*, pp. 1291–92.

8. Ibid., p. 1289.

9. *Final Report of the National Study Commission on Records and Documents of Federal Officials* (Supt. of Documents, March 31, 1977), Lib. of Cong. Catalog no. 77-78411, pp. 3–4.

10. Comment, "Government Control of Richard Nixon's Presidential Material," 87 *Yale Law Journal* 1601, 1611 n. 48 (1978), citing a letter from the director of the John F. Kennedy Library.

11. *Nixon v. United States*, p. 1295.

12. National Study Commission on Records and Documents of Federal Officials, "Memorandum of Findings on Existing Custom or Law, Fact, and Opinion" typescript, n.d., p. 40 n. 69.

13. Arthur Schlesinger Jr., "Who Owns a President's Papers," 27 *Manuscripts* 178, 180 (1975).

14. Brownell, "Who Really Owns Papers," 195.

15. *Washington Post,* April 5, 1997, A1, A14.

16. *Nixon v. United States,* p. 1278.

17. *Folsom v. Marsh,* 9 F.Cas. 342 (Cir. Ct. Mass., 1841).

18. Brownell, "Who Really Owns Papers," 193, 195.

19. National Study Commission, "Memorandum of Findings," 13.

20. Ibid., 11.

21. Ibid., 7.

22. *Nixon v. United States,* p. 1294.

23. Relyea et al., *Presidency and Information Policy,* 83.

24. *In the Matter of the Accounting of James Roosevelt, et al., Executors,* 190 Misc. 341, 73 N.Y.S.2d 821 (New York: Surrogate's Court, 1947).

25. Ibid.

26. Relyea et al., *Presidency and Information Policy,* 83.

27. Schlesinger, "Who Owns President's Papers," 182.

28. Relyea et al., *Presidency and Information Policy,* 82.

29. *U.S. Code,* vol. 44, sec. 2204(b)(1). See also 124 *Cong. Rec.* 34895 (October 10, 1978); House Report No. 95–1487, House of Representatives, Government Operations Committee, August 14, 1978, reprinted in *U.S. Code Congressional and Administrative News* 1978, p. 5735.

30. Walter Lippman, "The Sale of Official Opinions," *New York Tribune,* March 3, 1938, cited in Relyea et al., *Presidency and Information Policy,* 95.

31. See W. H. Taft, *Our Chief Magistrate and His Powers* (New York: Columbia University Press, 1916), 34.

32. National Study Commission, "Memorandum of Findings," 51–52.

33. *Nixon v. Administrator of General Services,* 408 F.Supp. 321 (D.C. D.C. 1976). Access required two keys, one of which was to be in the GSA's possession.

34. Excerpts have been published as *Abuse of Power: The New Nixon Tapes,* ed. Stanley I. Kutler (New York: Free Press, 1997).

35. Relyea et al., *Presidency and Information Policy,* 85.

36. *Presidential Recordings and Materials Preservation Act,* Pub.L. 93–526 (December 19, 1974), 88 Stat. 1695, *U.S. Code,* vol. 44, sec. 2107 note, 3315–24.

37. *Nixon v. Administrator of General Services,* 433 U.S. 425 (1977).

38. Ibid., p. 445, n. 8.

39. 43 Op. Atty. Gen. 11 (September 6, 1974).

40. *Nixon v. United States,* 978 F.2d 1269, 1286 (D.C. Cir. 1992).

41. *Nixon v. United States,* 782 F.Supp 634, 641 (D.C. D.C. 1991).

42. *Washington Post,* March 29, 1998, A3; December 3, 1998, A21.

43. *U.S. Code,* vol. 44, sec. 2202 (1996).

44. *U.S. Code,* vol. 22, sec. 2201(3)(A–C); *American Historical Association v. Peterson and Bush,* 876 F.Supp. 1300 (D.C. D.C., 1995) (President Bush's effort to give a very broad definition to the category of personal records).

45. *U.S. Code,* vol. 44, sec. 2203 (1996).

46. 124 *Cong. Rec.* 34895 (October 10, 1978).

47. *U.S. Code,* vol. 44, sec. 2201(2,3).

48. A court required return to the Nixon estate of all material that is "personal and private in nature." *Kutler v. Carlin,* 139 F.3d 237 (D.C. Cir. 1998).

49. Reeves, "Chester Alan Arthur Papers," 178.

50. One historian has complained that national-security justifications unduly limited his access to the Truman papers, Alonzo L. Hamby, in *Access to the Papers of Recent Public Figures: The New Harmony Conference,* ed. Alonzo L. Hamby and Edward Weldon (Bloomington, Ind.: Organization of American Historians, 1977), 18–19.

51. 3 *Whistle Stop: The Harry S. Truman Library Institute Newsletter,* no. 2, 1 (1975).

52. A French one too: "High-level civil servants and political officials traditionally demonstrate a certain propensity to consider archives produced in the exercise of their official functions as personal property. Since the sixteenth century, public authority has endeavored to combat that waywardness, where necessary putting the material under seal." Hervé Bastien, *Droit des archives* (Paris: Direction des Archives de France, 1996), 66–67 (trans. by author).

53. *Times (London),* May 1, 1995.

54. Rodney Brazier, "Who Owns State Papers?" 55 *Cambridge Law Journal* 65, 79 (March 1996).

Chapter 7

1. *Final Report of the National Study Commission on Records and Documents of Federal Officials* (Supt. of Documents, March 31, 1977), Lib. of Cong. Catalog no. 77–78411.

2. Committee on Governmental Affairs, *Public Papers of Supreme Court Justices: Assuring Preservation and Access, Hearing before the Subcommittee on Regulation and Government Information of the Committee on Governmental Affairs, United States Senate,* 103d Cong., 1st Sess (June 11, 1993), p. 3.

3. Much of the information on the fate of the justices' papers is drawn from Alexandra Wigdor, *The Personal Papers of Supreme Court Justices* (New York: Garland Press, 1986), and from the Senate Committee, *Papers of Justices.* Some collections have published guides, such as *The Lewis F. Powell, Jr. Papers,* published by John N. Jacob, at Washington and Lee University Law School. Other sources, such as biographies of individual justices, are cited in the notes to this chapter.

4. Alpheus T. Mason, *Harlan Fiske Stone: Pillar of the Law* (New York: Viking Press, 1956).

5. Edmond Cahn, review of *Harlan Fiske Stone,* by Alpheus T. Mason, *Nation,* January 5, 1957, p. 15.

6. S. Sidney Ulmer, "Bricolage and Assorted Thoughts on Working in the Papers of Supreme Court Justices," 35 *Journal of Politics* 286, 289 n. 11 (1973).

7. Andrew L. Kaufman, "Adventures of a Biographer" 49 *Harvard Law Bulletin* 4 (summer 1998).

8. Ibid., 296.

9. Dennis J. Hutchinson, *The Man Who Once Was Whizzer White: A Portrait of Justice Byron R. White* (New York: Free Press, 1998), 2.

10. See generally Senate Committee, *Papers of Justices,* n. 2, and Wigdor, *Personal Papers of Justices.*

11. Interview with David Wigdor, Manuscript Division, Library of Congress, October 20, 1997.

12. Leon Friedman and Fred L. Israel, eds., *The Justices of the United States Supreme Court, 1789–1969: Their Lives and Major Opinions* (New York: Chelsea House in association with Bowker, 1969–78), 4:2543–90.

13. Willard L. King, "The Quest for Material in the Writing of Judicial Biography," 24 *Indiana Law Journal* 363, 392 (1949).

14. *U.S. Code*, vol. 22, sec. 2203(c–e).

15. Senate Committee, *Papers of Justices,* 18–19 (E. Barrett Prettyman Jr.), 19–22 (Dennis J. Hutchinson). See also J. Woodford Howard, "Comment on Secrecy and the Supreme Court," 22 *Buffalo Law Review* 837 (1973).

16. Senate Committee, *Papers of Justices,* 28.

17. S. Sidney Ulmer, "Some Further Reflections on Working in the Papers of Supreme Court Justices," 73 *Judicature* 193, 194 (1990).

18. Wigdor, interview (only two items are withheld, a medical file and material dealing with a family member "of no relevance").

19. Tinsley E. Yarbrough, *Mr. Justice Black and His Critics* (Durham: Duke University Press, 1988), 303.

20. Hugo Black Jr., *My Father: A Remembrance* (New York: Random House, 1975), 250–51. See also Nat Hentoff, "The Constitutionalist: Justice William Brennan," *New Yorker,* March 12, 1990, p. 69.

21. Black, *My Father,* 252.

22. Ibid., 254–55.

23. Roger K. Newman, *Hugo Black: A Biography* (New York: Pantheon Books, 1994), 622.

24. E. Barrett Prettyman Jr. and Allen R. Snyder, "Breaching Secrecy at the Supreme Court—an Institutional or Individual Decision?" *Legal Times of Washington,* June 12, 1978, pp. 6–7.

25. Ulmer, "Bricolage," 286, and "Further Reflections," 193.

26. Ulmer, "Further Reflections," 194.

27. Quoted in Newman, *Hugo Black,* 609.

28. Ulmer, "Bricolage," 288–89.

29. Senate Committee, *Papers of Justices,* 10.

30. Prettyman and Snyder, "Breaching Secrecy."

31. Ibid.

32. Alexander M. Bickel, *The Unpublished Opinions of Mr. Justice Brandeis: The Supreme Court at Work* (Cambridge: Harvard University Press, 1957), viii–ix.

33. Giving such a crucial role to the phlegmatic Freund was, in the event, unfortunate, as was his appointment as editor-in-chief of the Holmes Devise. Sanford Levinson, book review, 75 *Virginia Law Review* 1429 n. 2 (1989).

34. For example, Kaufman exclusively had Frankfurter's collection of his correspondence with Cardozo.

35. Andrew L. Kaufman, *Cardozo* (Cambridge: Harvard University Press, 1998).

36. Alpheus T. Mason, *Brandeis: A Free Man's Life* (New York: Viking Press, 1946).

37. The letters are reproduced on Library of Congress microfilm rolls no. 50 and 51 of Frankfurter correspondence.

38. *Half Brother, Half Son: The Letters of Louis D. Brandeis to Felix Frankfurter,*

ed. Melvin I. Urofsky and David W. Levy (Norman: University of Oklahoma Press, 1991).

39. Ibid., 627, no. 661.

40. Ibid., 425, 427.

41. The full title is *The Brandeis/Frankfurter Connection: The Secret Political Activities of Two Supreme Court Justices* (New York: Oxford University Press, 1982).

42. *Half Brother, Half Son,* 519.

43. Ibid., 451.

44. Ibid., 456.

45. Note, "*Coolidge v. Long:* A Criterion of Retroactivity in Inheritance Taxation," 44 *Harvard Law Review* 1103, no. 4 (1931).

46. *Half Brother, Half Son,* 431.

47. G. Edward White, *Justice Oliver Wendell Holmes: Law and the Inner Self* (New York: Oxford University Press, 1993), 592. See also Sheldon M. Novick, *Honorable Justice: The Life of Oliver Wendell Holmes* (Boston: Little, Brown, 1989), xvi.

48. Much of the information about administration of the Brennan papers comes from telephone interviews with Steven Wermiel on October 14 and 29, 1997, and with David Wigdor on October 20, 1997.

49. Wermiel, interviews; telephone interviews with Professor Morton Horwitz, March 3 and April 24, 1998; Hentoff, "The Constitutionalist," 69.

50. Bernard Schwartz, *Super Chief: Earl Warren and His Supreme Court—a Judicial Biography* (New York: New York University Press, 1983); Bernard Schwartz, *Decision: How the Supreme Court Decides Cases* (New York: Oxford University Press, 1996), vii–xii.

51. Most of the description of the ensuing events comes from the telephone interviews with Steven Wermiel.

52. Bernard Schwartz, *The Ascent of Pragmatism: The Burger Court in Action* (Reading, Mass.: Addison-Wesley, 1990).

53. Schwartz, *Decision,* viii.

54. Hentoff, "The Constitutionalist," 69.

55. Horwitz, interview, April 24, 1998.

56. Bob Woodward and Scott Armstrong, *The Brethren* (New York: Simon and Schuster, 1979).

57. Anthony Lewis, *Make No Law: The Sullivan Case and the First Amendment* (New York: Random House, 1991).

58. Anthony Lewis, "In Memoriam: William J. Brennan," 111 *Harvard Law Review* 29, text following n. 13 (1997).

59. Kim Isaac Eisler, *A Justice for All: William J. Brennan, Jr., and the Decisions That Transformed America* (New York: Simon and Schuster, 1993).

60. Hunter R. Clark, *Justice Brennan: The Great Conciliator* (New York: Carol Publishing Group, 1995).

61. See "The Marshall Files: The Complaints and the Library's Response," *Washington Post,* May 27, 1993, A20; Benjamin Weiser, "Librarian Rejects Restrictions; Mall Files to Stay Open Despite Pressure from Court, Family," *Washington Post,* May 27, 1993, A1.

62. Much of the information in this section is based on Senate Committee, *Papers of Justices.*

63. *Roe v. Wade*, 410 U.S. 113 (1973).

64. *Washington Post*, May 27, 1993, A20.

65. Resolution of June 13, 1993, printed in *Archival Outlook*, July 1993, p. 4.

66. Apparently the Texas Supreme Court is also unable to achieve a consensus. Michael Widener, "The Working Papers of Texas Supreme Court Justices," address at Tarlton Law Library, University of Texas, May 30, 1997. The Federal Judicial Center, however, has issued a *Guide to the Preservation of Federal Judges' Papers* (1996) that explains the historical significance of judicial working papers.

Chapter 8

1. *Professional Practices in Art Museums: Report of the Ethics and Standards Committee* (New York: Association of Art Museum Directors, 1992), 7.

2. A fascinating view from the inside is Raymond H. Geselbracht, "The Origins of Restrictions on Access to Personal Papers at the Library of Congress and the National Archives," 49 *American Archivist* 142, no. 2 (1986). See also articles cited in Mark A. Greene, "Moderation in Everything, Access in Nothing? Opinions about Access Restrictions on Private Papers," 18 *Archival Issues* 31, no. 1 (1993); Gary M. Peterson and Trudy Huskamp Peterson, *Archives and Manuscripts: Law* (Chicago: Society of American Archivists, 1985); Alonzo L. Hamby and Edward Weldon, eds., *Access to the Papers of Recent Public Figures: The New Harmony Conference* (Bloomington, Ind.: Organization of American Historians, 1977); and materials cited in this chapter, *infra*.

3. *Swidler & Berlin and James Hamilton v. United States*, 1998 U.S. Lexis 4214.

4. At some point courts will have to determine whether anyone still has "standing" to invoke the privilege.

5. Correspondence to author from Sara S. (Sue) Hodson, December 29, 1997. See Sara S. Hodson, "Private Lives: Confidentiality in Manuscript Collections," 6 *Rare Books and Manuscripts Librarianship* 108, 111, no. 2 (1991). Such item-by-item screening is controversial within the profession, Greene, "Moderation in Everything."

6. Judith Schwarz, "The Archivist's Balancing Act: Helping Researchers While Protecting Individual Privacy," 79 *Journal of American History* 179, 183–84, no. 1 (June 1992).

7. Elena S. Danielson, "The Ethics of Access," 52 *American Archivist* 55, no. 1 (1989).

8. The ethics and standards committee of the Association of Art Museums Directors advises that "gifts and bequests should be unrestricted whenever possible." American Association of Art Museum Directors, *Professional Practices*, 7.

9. Mary Sarah Bilder, "The Shrinking Back: The Law of Biography," 43 *Stanford Law Review* 299, 331 n. 176 (1991).

10. Geselbracht, "Origins of Restrictions," 152. There may be one notable exception, the British Museum. Some years ago, its director asserted that "the museum . . . has never, to my knowledge, accepted any collection with conditions of restricted access." David Wilson, "Return and Restitution, a Museum Perspective,"

in *Who Owns the Past,* ed. Isabel McBryde (Melbourne: Oxford University Press, 1985), 100.

11. *Standards for Ethical Conduct for Rare Book, Manuscript, and Special Collections Librarians,* 2d ed. (Chicago: Association of College and Research Libraries, 1994), pt. 2, p. 4 ("Access to the collections"). See also "American Library Association/ Society of American Archivists Joint Statement on Access to Original Materials in Libraries, Archives, and Manuscript Repositories," *Archival Outlook,* July 1993, p. 15; Society of American Archivists, Code of Ethics and Commentary, in *SAA Newsletter,* May 1991, p. 3.

12. Malaro, *Legal Primer,* 295 n. 22.

13. Danielson, "The Ethics of Access," 53.

14. *Art Newspaper,* April 1998, 34.

15. Umberto Eco, *The Name of the Rose* (New York: Warner Books, 1983), 35–36.

16. John C. Broderick, in Hamby and Weldon, *Access to the Papers,* 61.

17. Personal communication from Elena Danielson, chair of the ethics committee, Society of American Archivists, Hoover Institution, Stanford University, October 23, 1997.

18. Hodson, "Private Lives," 109.

19. Geselbrach, "Origins of Restrictions," 148.

20. Application form to the New York State Archives and Records Administration (provided by Andrew L. Kaufman, July 9, 1998).

21. Dinitia Smith, "Scholar Who Says Jung Lied Is at War with Descendants," *New York Times,* June 3, 1995, sec. 1, p. 1.

22. The following information was supplied by the Bancroft Library at the University of California, Berkeley.

23. D. H. Lawrence, *Sons and Lovers: A Facsimile of the Manuscript,* ed. Mark Schorer (Berkeley and Los Angeles: University of California Press, 1977), 609.

24. Ibid., 8.

25. Personal communication from Bernard Katz, head, Special Collections and Library Development, University of Guelph Library, Canada, March 31, 1997.

26. Geselbracht, "Origins of Restrictions," 159.

27. Personal communication from Elena Danielson, October 22, 1997.

28. Lyndall Gordon, in *The Craft of Literary Biography,* ed. Jeffrey Meyers (New York: Schocken Books, 1985), 174.

29. Phillip Knightley, in Meyers, *Craft of Literary Biography,* 156.

30. *Herald (Glasgow),* April 22, 1992, p. 12; *New York Times,* April 7, 1992, C13.

31. *Washington Post,* July 10, 1988, F1.

32. Three years later, Britain extended copyright to life plus seventy years, in line with a European Union directive, and Joyce went back into copyright, except for works in process of publication in the interim (Duration of Copyright and Rights in Performances S.I. 1995/3297, pt. 2, 5). In 1998, the United States also extended copyright by twenty years, Public Law 105-298.

33. Executive Order No. 12958 (April 17, 1995).

34. *U.S. Code,* vol. 44, sec. 2204(a)(1–6).

35. *New York Times,* November 12, 1985, C1; telephone interview with Marvin Kranz, Manuscript Division, Library of Congress, October 24, 1997.

36. Kranz, interview.

37. Ibid.

38. A similar group, the Sigmund Freud Copyright, administers permissions for publication of any work by Freud, or for quotations from his works.

39. Peter Gay—who in his biography of Freud wrote a ferocious attack on the withholding of Freud material—takes special pains to thank Ronald Wilkinson, who was the administrator of the Freud papers at the Library of Congress, for his support and assistance. Peter Gay, *Freud: A Life for Our Time* (New York: Norton, 1988), 782. In 1985 Wilkinson was quoted as saying that "we'd like to see all the restrictions lifted." *New York Times,* November 12, 1985, C1. Similarly, Jeffrey Moussaieff Masson, in *Final Analysis: The Making and Unmaking of a Psychoanalyst* (Reading, Mass.: Addison-Wesley, 1990) wrote that staff at the Library of Congress agreed with his plan to open everything up, immediately. But the library as an institution is bound by the restrictive directions of the board of the Freud Archives (p. 183).

40. Kranz, interview.

41. Diana Riviere, letter in the *New York Review of Books,* June 2, 1983, p. 51.

42. Ibid.

43. Quoted in Janet Malcolm, *In the Freud Archives* (New York: Knopf, 1984), 6.

44. Ibid.; Masson, *Final Analysis.* A detailed report on the libel suit appeared in the *Village Voice,* November 29, 1994.

45. Masson, *Final Analysis,* 182.

46. *The Origins of Psycho-Analysis: Letters to Wilhelm Fliess, Drafts and Notes, 1887–1902,* ed. Marie Bonaparte, Anna Freud, and Ernst Kris, auth. trans. by Eric Musbacher and James Strachey (New York: Basic Books, 1954).

47. Gay, *Freud,* 751.

48. Malcolm, *In the Freud Archives,* 34.

49. Ibid., 57.

50. Ibid., 99.

51. Ibid., 114.

52. Ibid., 117.

53. Gay, *Freud,* 784. See also 743, 744, 751, 753, 782.

54. Malcolm, *In the Freud Archives,* 131.

55. Ibid., 153.

56. Masson, *Final Analysis,* 170.

57. *New York Times,* July 29, 1986, CX3; Reuters North European Service, July 31, 1986, BC Cycle (Nexis).

58. Peter Gay, "Sigmund and Minna? The Biographer as Voyeur," *New York Times,* January 29, 1989, sec. 7, p. 1.

59. <http://plaza.interport.net/nypsan/sfa_loc.html> (Feb. 9, 1996).

60. Riviere, letter.

Chapter 9

1. *The Letters of Matthew Arnold,* vol. 1, ed. Cecil Y. Lang (Charlottesville: University of Virginia Press, 1996), xix.

2. Ian Hamilton, *Keepers of the Flame: Literary Estates and the Rise of Biography* (London: Hutchinson, 1992). See also Karl E. Meyer, "Need a Sure Way to Settle an Argument or Hide a Scandal? Burn the Letters," *New York Times,* February 7,

1998, A13 (west. ed.). D. T. Max, "The Carver Chronicles," *New York Times Magazine*, August 9, 1998, p. 39 ("widow's work").

3. Lois G. Forer, *A Chilling Effect: The Mounting Threat of Libel and Invasion of Privacy Actions to the First Amendment* (New York: Norton, 1987), 208.

4. Phyllis Rose, *Parallel Lives: Five Victorian Marriages* (New York: Knopf, 1984), 191.

5. Dr. Wanda J. Finney's paper "Donor Restrictions and Historical Research," May 9, 1994, alerted me to the Harding story, which is set out in detail in Francis Russell, *The Shadow of Blooming Grove: Warren G. Harding in His Times* (New York: McGraw-Hill, 1968), ix, 650–63, and in Russell's article, "The Harding Papers: How Some Were Burned," *American Heritage*, February 1965, 24–31, 102–9. Russell tells the story of the love letters in "The Harding Papers," 25ff. See also Carl Sferrazza Anthony, Florence Harding (New York: William Morrow, 1998), 545, 546, 563.

6. "250 Love Letters from Harding to Ohio Merchant's Wife Found," *New York Times*, July 10, 1964, p. 1.

7. Russell, "The Harding Papers," 31.

8. Carl H. Settlemyer, "Between Thought and Possession: Artists' 'Moral Rights' and Public Access to Creative Works," 81 *Georgetown Law Journal* 2291, 2294 (1993), quoting Thomas Babington Macaulay's 1841 speech on copyright. An exhaustive modern discussion is Mary Sarah Bilder, "The Shrinking Back: The Law of Biography," 43 *Stanford Law Review* 299 (1991). See also Wendy J. Gordon, "A Property Right in Self-Expression: Equality and Individualism in the Natural Law of Intellectual Property," 102 *Yale Law Journal* 1533 (1993); Diane L. Zimmerman, "Information as Speech, Information as Goods: Some Thoughts on Marketplaces and the Bill of Rights," 33 *William and Mary Law Review* 665 (1992).

9. Wendy J. Gordon, "Fair Use and Market Failure: A Structural and Economic Analysis of the Betamax Case and Its Predecessors," 82 *Columbia Law Review* 1600 (1982). See also Pierre N. Leval, "Commentary: Toward a Fair Use Standard," 103 *Harvard Law Review* 1105 (1990); Jon Newman, "Not the End of History: The Second Circuit Struggles with Fair Use," 37 *Journal of the Copyright Society* 1 (1990), discussing *Salinger v. Random House, Inc.,* 650 F.Supp. 413 (S.D.N.Y. 1986), rev'd 811 F.2d 90 (2 Cir.), reh'g denied, 818 F.2d 252 (2d Cir.), cert. denied 484 U.S. 890 (1987).

10. See Jane C. Ginsburg, "French Copyright Law: A Comparative Overview," 36 *Journal of the Copyright Society* 269, 276–79 (1989), discussing the refusal of the painter Leonard Foujita's widow to permit a reproduction of his published artworks in a biography.

11. *New York Times*, August 15, 1988, C11.

12. Brenda Maddox, *Nora: The Real Life of Molly Bloom* (Boston: Houghton Mifflin, 1988).

13. Stephen Joyce, letter, *New York Times Book Review*, December 31, 1989, p. 2.

14. Regina C. McGranery, in *Access to the Papers of Recent Public Figures: The New Harmony Conference*, ed. Alonzo L. Hamby and Edward Weldon (Bloomington, Ind.: Organization of American Historians, 1977), 55.

15. Janna Malamud Smith, "Where Does a Writer Draw the Line?" *New York Times*, November 5, 1989, sec. 7, p. 1.

16. Janna Malamud Smith, *Private Matters* (Reading, Mass.: Addison-Wesley, 1997), 3 .

17. Leon Edel, *Writing Lives: Principia Biographica* (New York: Norton, 1984), 22.

18. Janet Malcolm, *The Silent Woman: Sylvia Plath and Ted Hughes* (New York: Knopf, 1994). Another notable instance is the withholding of sensitive family material from Anne Frank's diary by Anne's father, Otto. *New York Times,* September 10, 1998, p. 1.

19. Michiko Kakutani, in the *New York Times,* February 13, 1998, B43 (west. ed.), reviewing Ted Hughes, *Birthday Letters* (New York: Farrar, Straus and Giroux, 1998).

20. Smith, *Private Matters,* 163.

21. Robert Skidelsky, *Interests and Obsessions* (London: Macmillan, 1993), 335.

22. Berry tells this story in the foreword to her biography, *Langston Hughes: Before and Beyond Harlem* (Westport, Conn.: Lawrence Hill, 1983), ix–x.

23. Hughes's papers were later made available to Arnold Rampersad by the successor executor-trustee of the Hughes estate, George Houston Bass, who asked him to take over the task Bontemps had been unable to complete. Rampersad then produced a biography more than twenty years after Hughes's death. Arnold Rampersad, *The Life of Langston Hughes,* vol. 1 (New York: Oxford University Press, 1986), acknowledgments, 439–40.

24. Gerald Gunther, "'Contracted' Biographies and Other Obstacles to 'Truth,'" 70 *NYU Law Review* 697 (1995).

25. Gerald Gunther, *Learned Hand: The Man and the Judge* (New York: Knopf, 1994).

26. E-mail correspondence with Gerald Gunther, March 13, 1998; May 5, 1998. Telephone interviews with Morton Horwitz, March 3, 1998; April 24, 1998.

27. John Charmley, "Cashing in on Winston," *Guardian,* June 5, 1997, p. 21.

28. Ian Burrell, "Rival Biographers in a Row over Churchill Family Archive," *Independent,* June 2, 1997, p. 3.

29. Ibid.

30. Kenneth Harris, review of *The Life of Randolph Churchill, New York Times Book Review,* August 31, 1997, p. 4.

31. Bernard B. Perlman, *Robert Henri: His Life and Work* (New York: Dover, 1991), 138.

32. Some years ago, John Philip Sousa's children authorized a magazine to establish a Sousa Award; the magazine later sued and prevailed against the Marine Corps, which had established a Semper Fidelis award. A critic of the decision urged that "in the case of John Philip Sousa, his career cannot sensibly be made the exclusive property of anyone. As with any other figure in American history, he belongs to the American people, individually as well as collectively, and I would think to the United States Marine Corps, to whom he owed much, as well." David Lange, "Recognizing the Public Domain," 44 *Law and Contemporary Problems* 147, 172 (1981).

33. See *Martin Luther King, Jr. Center for Social Change v. American Heritage Prods.,* 694 F.2d 674 (11th Cir. 1983).

34. *New York Times,* January 15, 1997, p. 1 (west. ed.).

35. *New York Times,* August 19, 1997, A16 (west. ed.).

36. Melvin L. Wulf, in *New York Times*, January 21, 1997, A18 (west. ed.). See *Harper & Row v. Nation Enterprises*, 471 U.S. 539 (1985). But see David Stout, "'Dream Speech by King is Held as the Public's," *New York Times*, July 23, 1998, p. 12.

37. Cynthia Tucker, editorial page editor, the *Atlanta Constitution*, in *San Francisco Chronicle*, January 18, 1997, A18.

38. *New York Times*, August 19, 1997, p. 1 (west. ed.).

39. Scholarly access to the papers themselves has been limited because the King Center has not had the funds to manage the archive effectively, though there was no desire to limit access. In 1997 negotiations were under way for the sale of the archive to a university, where it could be better managed. The family would keep the copyright. *New York Times*, July 16, 1997, A8 (west. ed.).

40. The problem arose with the Zapruder film of the Kennedy assassination, where use was at one time priced so high that it was beyond the means of noncommercial documentary filmmakers. An owner's economic best interest may be advantaged by limited circulation, lest the material become too commonly seen. *New York Times*, November 25, 1988, B9. Copies are now available for purchase at about twenty dollars. The original is to be acquired by the United States, though the price was still in dispute in mid-1998. *New York Times*, July 6, 1998, A7.

41. J. H. Reichman and Pamela Samuelson, "Intellectual Property Rights in Data?" 50 *Vanderbilt Law Review* 51, 155 (1997).

42. The story is related in Susan Saulny, "Banneker Kin Decry Auctioning of His Artifacts," *Washington Post*, August 16, 1996, A1.

43. *New York Times*, March 12, 1987, p. 16. Patrick J. O'Keefe, "Incidental Collections: Protection Against Dispersal," 3 *Art Antiquity and Law* 165 (1998).

44. See chapter 12.

45. *Letters of Matthew Arnold*, xxiv.

46. Ian Hamilton in *TLS*, July 11, 1997, pp. 3, 4.

47. *Letters of Matthew Arnold*, xliii.

48. *TLS*, August 22, 1997, p. 17.

49. *TLS*, September 12, 1997, letters to the editor, p. 17.

50. See A. S. Byatt, *Possession: A Romance* (New York: Vintage International, 1991).

Chapter 10

1. The story is recounted in Frank Moore Cross, *The Ancient Library of Qumrân*, 3d ed. (Minneapolis: Fortress Press, 1995), p. 19ff.

2. James H. Charlesworth, gen. ed., *The Dead Sea Scrolls*, in the Princeton Theological Seminary edition (Louisville: Westminster John Knox Press, 1995), 1.

3. Lawrence H. Schiffman, *Reclaiming the Dead Sea Scrolls* (Philadelphia: Jewish Publication Society, 1994), 10.

4. Cross, *Ancient Library of Qumrân*, 19.

5. *New York Times*, November 15, 1993, A3.

6. *The Dead Sea Scrolls after Forty Years: Symposium at the Smithsonian Institution, Oct. 27, 1990* (Washington, D.C.: Biblical Archaeology Society, 1991), 8.

7. James C. VanderKam, *The Dead Sea Scrolls Today* (Grand Rapids: William B. Eerdmans, 1994), 188.

8. See Hershel Shanks, ed., *Understanding the Dead Sea Scrolls* (New York: Vintage Books, 1993), xxiii ff.

9. Cross, *Ancient Library of Qumrân*, 39.

10. Cindy Alberts Carson, "Raiders of the Lost Scrolls: The Right of Scholarly Access to the Content of Historic Documents," 16 *Michigan Journal of International Law* 299, 311, 312 (1995).

11. Schiffman, *Reclaiming Dead Sea Scrolls*, p. 12; Cross, *Ancient Library of Qumrân*, 39.

12. Anne Wells Branscomb, *Who Owns Information?* (New York: Basic Books, 1994), 122.

13. VanderKam, *Dead Sea Scrolls Today*, 189.

14. These were the Centre National de la Recherche Scientifique of France (CNRS), the American School of Oriental Research in the United States, and institutions in Britain and Germany. The Jewish Palestine Exploration Society was also entitled to representation on the PAM board, but its representatives were not permitted to enter Jordan, and so it did not participate in the selection. Branscomb, *Who Owns Information?* 123.

15. Schiffman, *Reclaiming Dead Sea Scrolls*, 23.

16. Branscomb, *Who Owns Information?* 126.

17. See, e.g., Otto Betz and Rainer Riesner, *Jesus, Qumrân, and the Vatican* (New York: Crossroad, 1994), 13; Schiffman, *Reclaiming Dead Sea Scrolls*, 16; Michael O. Wise et al., eds., "Methods of Investigation of the Dead Sea Scrolls and the Khirbet Qumrân Site: Present Realities and Future Prospects," 722 *Annals of the New York Academy of Sciences* 455 (1994).

18. Wise et al., "Methods of Investigation," 456.

19. The process is described in Cross, *Ancient Library of Qumrân*, 39–41.

20. Shanks, *Understanding Dead Sea Scrolls*, xxiv.

21. VanderKam, *Dead Sea Scrolls Today*, 190, quoting Frank Moore Cross.

22. Geza Vermes, *The Dead Sea Scrolls in English*, 3d ed. (Sheffield: Sheffield Academic Press, 1987).

23. *Washington Post Magazine*, May 10, 1992, W20, quoting Geza Vermes, of the Oxford Centre for Postgraduate Hebrew Studies, on the thirtieth anniversary of the discovery of the scrolls at Qumrân. (Most newspaper citations in this chapter are taken from the Lexis news library, Arcnws file, and thus have no page references.)

24. Shanks, *Understanding Dead Sea Scrolls*, xxvii.

25. *Jerusalem Post*, July 1, 1994.

26. *Washington Post*, May 10, 1992.

27. *Jerusalem Post*, July 1, 1994.

28. Schiffman, *Reclaiming Dead Sea Scrolls*, xvii–xviii.

29. *Time*, August 14, 1989, p. 71, quoting J. T. Milik, of the National Center for Scientific Research in Paris.

30. Klaus Berger, *Jesus and the Dead Sea Scrolls: The Truth under Lock and Key?* (Louisville: John Knox Press, 1995), 6.

31. Schiffman, *Reclaiming Dead Sea Scrolls*, 21.

32. Norman Golb, *Who Wrote the Dead Sea Scrolls? The Search for the Secret of Qumrân* (New York: Scribner, 1995), 181.

33. Schiffman, *Reclaiming Dead Sea Scrolls*, 30.

34. *Washington Post Magazine*, May 10, 1992, W20.

35. *Scientific American*, November 1990, 38.

36. Ibid.

37. 43 *Journal of Jewish Studies* 137 (autumn 1992).

38. "Huntington Library Head Blasts Scrolls Officials," *Jerusalem Post*, October 29, 1991.

39. Michael Baigent and Richard Leigh, *The Dead Sea Scrolls Deception* (New York: Summit Books, 1991), 77.

40. VanderKam, *Dead Sea Scrolls Today*, 193; Schiffman, *Reclaiming Dead Sea Scrolls*, 26. Eisenman's work has been severely criticized (e.g., Betz and Riesner, *Jesus, Qumrân*, 74ff.; VanderKam, *Dead Sea Scrolls Today*, 185; Berger, *Jesus and Scrolls*).

41. Schiffman, *Reclaiming Dead Sea Scrolls*, xv.

42. Ibid., xviii.

43. *Jerusalem Post*, July 1, 1994, 2A.

44. Betz and Riesner, *Jesus, Qumrân*, 14; Schiffman, *Reclaiming Dead Sea Scrolls*, 17.

45. VanderKam, *Dead Sea Scrolls Today*, 197–98.

46. Strugnell describes the origin of his collaboration with Qimron in John Strugnell, "MMT: Second Thoughts on a Forthcoming Edition," in *The Community of the Renewed Covenant*, ed. Eugene Ulrich and James VanderKam (Notre Dame, Ind.: University of Notre Dame Press, 1994), 58.

47. *The Dead Sea Scrolls on Microfiche: A Comprehensive Facsimile Edition of the Texts from the Judean Desert*, ed. Emanuel Tov (New York: E. J. Brill, 1993).

48. *New York Times*, July 27, 1997, p. 6.

Chapter 11

1. Daniel Wood, "Dead Sea Scrolls Stir Lively Debate," *Christian Science Monitor*, October 8, 1991, pp. 12–13. The Nag Hammadi Library, a collection of Coptic Gnostic codices, were also subject to very long delays. John Dart, *The Jesus of Heresy and History: The Discovery and Meaning of the Nag Hammadi Gnostic Library* (San Francisco: Harper & Row, 1988), 33–36.

2. F. Hole and F. F. Heizer, *Prehistoric Archeology* (New York: Holt, Rinehart, and Winston, 1977), 121.

3. John Malcolm Russell, *From Nineveh to New York* (New York: Yale University Press, 1997), 11.

4. Brian Fagan, "Archaeology's Dirty Secret," 48 *Archaeology* 14, 14–17 (1995).

5. Telephone interview with Alison Wylie, University of Western Ontario, April 2, 1998.

6. Interview with Prof. M. Conkey, University of California (Berkeley), December 19, 1997.

7. Robert Bell, *Impure Science: Fraud, Compromise, and Political Influence in Scientific Research* (New York: John Wiley and Sons, 1992), 9.

8. Roger Lewin, *Bones of Contention: Controversies in the Search for Human Origins* (New York: Simon and Schuster, 1987), 23.

9. Ibid., 24.

10. Ibid.

11. Tara Patel, "Passions Run High over French Cave Art," *New Scientist,* May 4, 1996, p. 8.

12. *Le Figaro,* November 14, 1996. (Some journal and newspaper references in this chapter are taken from the Lexis news library, Arcnws file, and may not have page references.)

13. *The Comprehensive Aramaic Lexicon,* February 1992, p. 5. This is also the justification given by Prof. Frank Moore Cross of the Dead Sea Scrolls team, quoted in Anne Wells Branscomb, *Who Owns Information?* (New York: Basic Books, 1994), 124.

14. Norman Golb, *Who Wrote the Dead Sea Scrolls? The Search for the Secret of Qumrân* (New York: Scribner, 1995), 233.

15. Much of the information on papyrology is taken from interviews with Arthur Verhoogt, visiting scholar, Bancroft Library, Berkeley, in August 1997 and January 1998.

16. Submitted by HURST@uni2a.unige.ch, February 12, 1994.

17. 103 *Zeitschrift für Papyrologie und Epigraphik* 154 (1994) (quotations from these exchanges translated by the author).

18. Ibid.

19. Ibid.

20. Verhoogt, interviews.

21. Lewin, *Bones of Contention,* 24.

22. E-mail from Traianos Gagos, archivist in papyrology, assistant professor of Greek and papyrology, University of Michigan, to author, September 12, 1997.

23. *Feist Publications, Inc. v. Rural Telephone Service Co., Inc.,* 499 U.S. 340, 346 (1991).

24. "Knesset Committee Debates Access to Dead Sea Scrolls," *Jerusalem Post,* October 16, 1991.

25. For a specification of poaching charges in the Dead Sea Scrolls context, see comments of Lawrence Schiffman in Michael O. Wise et al., eds., "Methods of Investigation of the Dead Sea Scrolls and the Khirbet Qumrân Site: Present Realities and Future Prospects," 722 *Annals of the New York Academy of Sciences* 455, 465–67 (1994). They are sharply challenged by Golb, *Who Wrote Scrolls?* 473–74.

26. See Lisa Michelle Weinstein, "Ancient Works, Modern Dilemmas: The Dead Sea Scrolls Copyright Case," 43 *American University Law Review* 1637, 1659–60 (1994). American copyright law is rather exacting in denying recognition to results of mere labor, however impressive, and rejects the so-called sweat-of-the-brow approach, demanding some "modicum of creativity." *Feist Publications, Inc. v. Rural Telephone Service Co., Inc.,* 340.

27. The Society of Professional Archeologists, in *Archaeological Ethics,* ed. Karen D. Vitelli (Walnut Creek, Calif.: AltaMira Press, 1996), no. 5, pp. 254, II(2)(1)(c), 257, VI(6)(2). See also Code of Ethics of the Archaeological Institute of America, 7 *International Journal of Cultural Property* 190 (1998).

28. The Ethics in Archaeology Committee of the Society for American Archaeology, in Vitelli, *Archaeological Ethics*, p. 265, no. 5.

29. Vitelli, *Archaeological Ethics*, p. 257, VI(6)(3).

30. 32 *Laws of the State of Israel, Antiquities Law*, 5738—1978, no. 27, par. 12 (a). While the Israel Antiquities Authority imposed a timetable for publication on the scrolls team, it never enforced it.

31. In some circumstances the inventor of an intermediate or threshold invention or process is appropriately permitted to further exploit it before others can take advantage of it. See, e.g., Mark F. Grady and Jay I. Alexander, "Patent Law and Rent Dissipation," 78 *Virginia Law Review* 305, 331 (1992).

32. Rebecca S. Eisenberg, "Proprietary Rights and the Norms of Science in Biotechnology Research," 97 *Yale Law Journal* 177 (1987).

33. Rebecca S. Eisenberg, "Technology Transfer and the Genome Project: Problems with Patenting Research Tools," 5 *Risk: Health, Safety, and Environment* 163, 165–66, 168 (1994).

34. Rebecca S. Eisenberg, "Genetics and the Law . . . The Case of Large-Scale CDNA Sequencing," 3 *University of Chicago Law School Roundtable* 557, 561 (1996); Jon Cohen, "The Culture of Credit," 268 *Science* 1706 (1995).

35. The story is told by Raphael Levy in Hershel Shanks, ed., *Understanding the Dead Sea Scrolls* (New York: Vintage Books, 1993), chap. 5, p. 72.

36. *Documents of Jewish Sectaries*, vol. 1, *Fragments of a Zadokite Work*, prolegomenon by Joseph A. Fitzmyer, S.J. (New York: Ktav Publishing House, 1970), 19.

37. Peter Gay, *Freud: A Life for Our Time* (New York: Norton, 1988), 785.

38. *New York Times*, September 21, 1997, p. 1.

39. Ibid.

40. Jacob d'Ancona, *The City of Light*, ed. and trans. David Selbourne (London: Little, Brown, 1997), 1.

41. Bernard Wasserstein and David Wasserstein, reprinted in *Jerusalem Post*, December 5, 1997, p. 20.

42. d'Ancona, *City of Light*.

43. With the cancellation of an American edition, the planned review was published as an essay; see Jonathan Spence, "Leaky Boat to China," *New York Times Book Review*, October 19, 1997, pp. 20–21.

44. Edwin A. Weinstein, James William Anderson, and Arthur S. Link, "Woodrow Wilson's Political Personality: A Reappraisal," 93 *Political Science Quarterly* 585, 594 (winter 1978).

45. Alexander L. George and Juliette L. George, "Dr. Weinstein's Interpretation of Woodrow Wilson: Some Preliminary Observations," 8 *Psychohistory Review* 71, 72 (summer–fall 1979).

46. Harold C. Relyea et al., *The Presidency and Information Policy* (New York: Center for the Study of the Presidency, 1981), 98.

47. Douglas Osler, "Graecum Legitur: A Star Is Born," 2 *Rechtshistorisches Journal* 194 (1983).

48. Ibid., 196.

49. Ibid., 198.

50. Ibid., 201.

Chapter 12

1. Neil Cookson, "Treasure Trove: Dumb Enchantment or New Law?" 66 *Antiquity* 399, 400–401 (1992). See also Patty Gerstenblith, "Identity and Cultural Property: The Protection of Cultural Property in the United States," 75 *Boston University Law Review* 559, 642 (1995).

2. For a discussion of those issues see Alison Wylie, "Ethical Dilemmas in Archaeological Practice: Looting, Repatriation, Stewardship, and the (Trans)formation of Disciplinary Identity," 4 *Perspectives on Science* 154, no. 2 (1996).

3. Michael Milstein, "Battle for the Bones," *High Country News*, September 21, 1992, p. 1; *New York Times*, May 21, 1992, A14.

4. *Black Hills Institute of Geological Research v. United States*, 12 F.3d 737, 742 (8th Cir. 1993).

5. David J. Lazerwitz, "Bones of Contention: The Regulation of Paleontological Resources on the Federal Public Lands," 69 *Indiana Law Journal* 601, 607 n. 32 (1994); Patrick K. Duffy and Lois A. Lofgren, "Jurassic Farce: A Critical Analysis of the Government's Seizure of 'Sue,' a Sixty-Five-Million-Year-Old Tyrannosaurus Rex Fossil," 39 *South Dakota Law Review* 478 (1994).

6. Sotheby catalog, New York, October 4, 1997, "estimate: $1,000,000 +."

7. *New York Times*, October 4, 1997, A20.

8. *Time*, October 6, 1997, p. 74.

9. Lazerwitz, "Bones of Contention," 607 n. 32, citing Michael Benton, *On the Trail of the Dinosaurs* (1988), 17.

10. Judy Pasternak, "Monstrous Bones of Contention," *Los Angeles Times*, October 2, 1992, A1, A22.

11. *New York Times*, September 17, 1997, A12; David Roberts, "Digging for Dinosaur Gold," *Smithsonian*, March 1998, p. 41.

12. Vertebrate Paleontological Resources Protection Act, S. 3107 (102d Cong., 2d Sess. (1992).

13. Ronald F. Lee, *The Antiquities Act of 1906* (U.S. Dept. of the Interior, National Park Service, Office of History and Historic Architecture, November 16, 1970), 31.

14. *U.S. Code*, vol. 16, sec. 433 (1994).

15. The history of the law is recounted in Lee, *Antiquities Act of 1906*, 49.

16. *United States v. Diaz*, 499 F.2d 113 (9th Cir. 1974); but see *United States v. Smyer*, 596 F.2d 939 (10th Cir. 1979).

17. *U.S. Code*, vol. 16, sec. 470ee(c) (1994). *U.S. v. Gerber*, 999 F.2d 1112 (7 Cir. 1993), sustains a conviction of a defendant who stole objects from a burial mound on private land. See generally Stephanie Ann Ades, "The Archaeological Resources Protection Act: A New Application in the Private Property Context," 44 *Catholic University Law Review* 599, 611 n. 91 (1995).

A separate and very important enactment governs repatriation of Indian remains and artifacts to tribes, and declares tribal ownership of items excavated on federal or tribal lands. *U.S. Code*, vol. 25, secs. 3001–13 (1994); Gene A. Marsh, "Walking the Spirit Trail: Repatriation and Protection of Native American Remains and Sacred Cultural Items," 24 *Arizona State Law Journal* 79 (1992).

18. E.g., California Public Resources Code sec. 5097.99.

19. E.g., *Department of Natural Resources v. Indiana Coal Council*, 542 N.E.2d

1000, 1002 (Ind. 1989), cert. denied 493 U.S. 1078 (1990) (regulation of mining to protect historic sites); Indiana Code, sec. 14–21–1–29 (1997); Washington Revised Code, sec. 27.53.060 (1997) (to excavate an archaeological site other than a burial site the investigator must have a state permit as well as the landowner's permission); General Statutes of North Carolina, sec. 70–1; Arkansas Code of 1987, ann., sec. 13–6–301; Oklahoma Statutes Annotated tit. 53, 361 M (West 1991) (landowners urged to refrain from unsupervised excavations).

20. Alabama Code, sec. 41–3–1, 3 (1991). See generally, Constance M. Callahan, "Warp and Weft: Weaving a Blanket of Protection for Cultural Resources on Private Property," 23 *Environmental Law Journal* 1323, 1326–29, 1338–39 (1993).

21. Harvey Arden, "Who Owns Our Past?" *National Geographic*, March 1989, p. 378; Brian Fagan, "Black Day at Slack Farm," 41 *Archaeology* 15 (1988).

22. Kentucky Revised Statutes, sec. 525.105 (1990).

23. Susan Kroupa, "Backhoe Roots Around in Indian Graves," *High Country News*, August 29, 1988.

24. It has been more active in dealing with shipwrecks. The *Abandoned Shipwreck Act of 1987, U.S. Code*, vol. 43, secs. 2101–06, asserts governmental title in abandoned wrecks embedded in state submerged lands, and abrogates private ownership under the law of finds and salvage, which allowed private ownership. Cf. *California and State Lands Commission v. Deep Sea Research*, Inc., 118 S.Ct. 1464 (1998) (deciding Eleventh Amendment issue, remanding on ownership questions).

25. P. J. O'Keefe and Lyndel Prott, *Law and the Cultural Heritage* (Oxford: Professional Books, 1984), vol. 1, chap. 6. An earlier work, describing the original laws protecting cultural property, is G. Baldwin Brown, *The Care of Ancient Monuments* (1905), 62ff.

26. Convention for the Protection of the World Cultural and Natural Heritage (1972); see Alice Erh Soon Tay, "Law and the Cultural Heritage," in *Who Owns the Past*, ed. Isabel McBryde (Melbourne: Oxford University Press, 1985), 122–23.

27. Frits Hondius, "The Foundation: Time-Honored Model for Heritage Conservation," in *Legal Aspects of International Trade in Art*, ed. Martine Briat and Judith A. Freedberg (Paris: International Chamber of Commerce, 1996), 259; O'Keefe and Prott, *Law and Cultural Heritage*, vol. 3, sec. 143.

28. Mexican law is discussed in *United States v. McClain*, 593 F.2d 658, 666–68 (5th Cir. 1979).

29. O'Keefe and Prott, *Law and Cultural Heritage*, vol. 1, sec. 639, p. 212.

30. E.g., the English law of treasure trove, revised in 1996. Though the find belongs to the Crown, it rewards finders, ex gratia, full market value (usually shared with the landowner who permits the use of her land). See "Treasure Act of 1996, Draft Code of Practice," 2 *Art, Antiquity, and Law* 632, no. 1 (1997). In Turkey, the finder and landowner share 80 percent of the value of objects found on private land, and 40 percent of the value of objects found on state land. Janet Blake, "Export Embargoes and the International Antiquities Market—the Turkish Experience," 2 *Art, Antiquity, and Law* 233, 241, no. 3 (1997). The United States abandoned treasure trove, awarding treasure trove to the finder under the common law. Leanna Izuel, "Property Owners' Constructive Possession of Treasure Trove: Rethinking the Finders Keepers Rule," 38 *UCLA Law Review* 1659 (1991).

31. O'Keefe and Prott, *Law and Cultural Heritage*, vol. 1, sec. 615, p. 196.

32. Ibid., 197.

33. Ibid., chap. 10, 306ff.

34. The following description of the discovery draws primarily upon a book by the three individuals who discovered the cave. Jean-Marie Chauvet, Eliette Brunel Deschamps, and Christian Hillaire, *Dawn of Art: The Chauvet Cave*, trans. Paul G. Bahn (New York: Harry N. Abrams, 1996).

35. Ibid., 58, 70.

36. Ibid., 76.

37. *Times (London)*, January 19, 1995, p. 14. Many of the newspaper references following are taken from Lexis news library, and therefore contain no page references.

38. *Le Figaro*, November 14, 1996.

39. *Washington Post*, March 15, 1995, B3.

40. *Times (London)*, November 15, 1996.

41. *Le Figaro*, November 14, 1996.

42. DRAC (the regional office) of the Rhône-Alpes region.

43. *New York Times*, December 9, 1996, A7; *Le Figaro*, November 14, 1996.

44. *Le Monde*, July 23, 1998; *Times (London)*, July 22, 1998.

45. *Art Newspaper*, September 1998, p. 39.

46. Pierre-Laurent Frier, *Droit du patrimoine culturel* (Paris: Presses Universitaires de France, 1997), 339.

47. Code Civil, art. 716.

48. *Le Monde*, May 12, 1995.

49. *Le Monde*, December 6, 1996; Tara Patel, "Passions Run High over French Cave Art," *New Scientist*, May 4, 1996, p. 8.

50. *Le Monde*, January 15, 1997.

51. *Le Monde*, February 22, 1997.

52. *Le Monde*, January 15, 1997.

53. *Independent*, June 25, 1995, p. 17.

54. *Washington Post*, March 15, 1995, B3.

55. La Medaille de la Jeunesse et des Sports.

56. *Le Monde*, January 11, 1997.

57. Ibid.

58. *Le Figaro*, November 14, 1996.

59. See *L'Express*, February 2, 1995, p. 27.

60. *Le Monde*, February 17, 1997. Decisions of February 14, 1997, Tribunal de Grande Instance de Privas, No. 6/96 and No. 7–8–9/96, Marc Bouvier, expropriation judge.

61. 740 million francs.

62. *Le Monde*, January 15, 1997.

63. Ibid.

64. *Le Monde*, February 17, 1997 ("L'Etat s'offre la grotte Chauvet au prix de la garrigue").

65. *Washington Post*, March 15, 1995, B3.

66. Law of September 27, 1941, art. 10. Pascal Martel, "La Responsabilité administrative du fait des fouilles archéologiques," *La Semaine Juridique* (JCP), Ed. G, no. 40, 1993, Doctrine, sec. 3706, p. 400–402.

67. *R.M.S. Titanic, Inc. v. Haver,* 1999 U.S. App. LEXIS 5154 (4th Cir. 1999).

68. Kathleen Berrin, ed., *Feathered Serpents and Flowering Trees: Reconstructing the Murals of Teotihuacan* (San Francisco: Fine Arts Museum of San Francisco, 1988), 29–30.

Index

DATE DUE

			Printed in USA

HIGHSMITH #45230